Five + Two = Perfection
Does Luck Hold The Key To Life Or Does Love Have It?

A Thought By Thought Process towards Finding and Understanding the Key for Rebuilding Our Hearts.

SAMUEL ROSETTE JR.

WESTBOW·
PRESS
A DIVISION OF THOMAS NELSON
& ZONDERVAN

WestBow Press books may be ordered through booksellers or by contacting:

WestBow Press
A Division of Thomas Nelson & Zondervan
1663 Liberty Drive
Bloomington, IN 47403
www.westbowpress.com
1-(866) 928-1240

Because of the dynamic nature of the Internet, any web addresses or links contained in this book may have changed since publication and may no longer be valid. The views expressed in this work are solely those of the author and do not necessarily reflect the views of the publisher, and the publisher hereby disclaims any responsibility for them.

Any people depicted in stock imagery provided by Thinkstock are models, and such images are being used for illustrative purposes only.
Certain stock imagery © Thinkstock.

ISBN: 978-1-4908-0311-1 (sc)

Library of Congress Control Number: 2013913141

Print information available on the last page.

WestBow Press rev. date: 6/29/2015

I would like to dedicate this book to my family

In Loving Memory
Jovannah Joyce Rosette
1966-1969

The righteous perisheth, and no man layeth *it* **to heart: and merciful men** *are* **taken away, none considering that the righteous is taken away from the evil** *to come.*

He shall enter into peace: they shall rest in their beds, *each one* **walking** *in* **his uprightness. —ISAIAH 57:1:2, KJV**

"I consider art to be a 'refreshing' approach to a person, place, or thing already beautiful."

—Samuel Rosette Jr.

TABLE OF CONTENTS

PREFACE

Some time ago, I was sleeping…years later; I went from sleeping, to being in a state of sleepwalking. Years later after that, I went from being in a state of sleepwalking, to becoming half-awake! God realized this crucial moment in my life and he helped. It was not by luck that he helped me, but it was by his alarm clock set before time began, to go off, *right now!* Yes, that is when he did so; it was by his love.

You see, I smelled the "fresh coffee" brewing one morning as he was preparing breakfast. This special brew was prepared for me from a personal blend of God's Spirit. I could not help, as this was an intimate intrinsic blend, but to inhale the fumes. It was not until I took a sip that I realized how good it was. I then fully drank from this cup, and ate of his "sweet bread," too. Now I am fully awake from my slumber! As I stand today before the world, allowing his word to perpetuate me as I ingest this *gift*, I now live to express it. In a variety of ways and deeds, it penetrates my mind and my heart; it seeks an escape route.

One way of doing this amazing deed for God, this escape route of expression, is through my writing, or should say I, Our Writing. It is as though one day while reading, the Holy Bible pulled me inside of its many pages. Once on the inside of this *holy book* of God I stood up, dusted myself off, and began to walk in it…

That day for me would become a milestone in my life to which I would begin to personalize the Holy Bible in a special way and make aware of its impression upon others, but not without resistance from some. It is not an issue for me though because in doing so my interpreting, bridging, and associating the lives and principles of those biblical characters historically and allegorically living on the inside of it, blend. It blends because I have learned to associate it with the principles and lives of us relevant characters physically and abstractly living on the outside of it. After all, as time will inevitably tell, even within the complexities of this life, well into the tranquilness of the next life we will come to realize this very important fact: We were all in, His Book!

ACKNOWLEDGMENTS

I would like to thank primarily, God, my heavenly Father and Lord and Savior, Jesus Christ. Thank you my Lord, for the Holy Spirit inspired creative vision, to establish for and in this generation, ©Rose Point WriteNow! Artworks. ™ "Art is who God is. Works of Art is what we are."™

God made known to me that there is a time and place for everything and the place to write is here, right now! Because of that miraculous epiphany, without the Holy Spirit in my life, I know without any doubt that I would not be in this exciting and humbling position. As a published writer for the Lord, through the literary ministry he has given me, my team and I are blessed.

Personal thanks go out to WestBow Press for having faith in my writing abilities. Thanks for being patient with me also. The remarkable staff there is, and was very helpful during the publishing process and was a real pleasure to work with. I take my many hats off to them.

A very special thank you goes out to my own *flesh* and *bone*—my lovely wife and ministry partner at ©Rose Point Ministries ᔆᴹ, "A Ministry That's Different But Real. Abnormally Born Out Of Truth." ᔆᴹ Sindy *(Raindrop)* my darling, you stood by my side through everything. When I say everything, I am not talking only about this *New Life* in the Lord, we share presently, but the *old life* we both shared over the past years, also. Thanks for your patience and for putting up with me during this exciting yet, time consuming process, and for the role you played in leading me back to God, as this was a true turning point for me; one of the *many* great things you have done for me and by far, the most important. Keep enduring through and remember this; I love you to no end, my dear. Lets you and I complete our journey together, well into the future.

Thanks go out to my *heart*, my *spirit*, and my *soul*,—my son, my daughter and my stepdaughter. You three are all very special, each of you in your own right. Quinton *(Q)*, May God keep that courageous heart of a lion in you; may he use it for his glory, my son. Mandy *(Moo)*, May you never lose that liveliness, chic, even during the melancholy moments! Devin *(Princess)*, May you always remember the joy in helping other souls when and wherever, the need calls for it, and also accepting it in return, young lady. I love all three of you so much, even always. I thank God for bringing you all into my life through your mother whom you all share,

truly a blessing each one of you have been, and continue to be as all four of you, to include your mother, inspire me. Love I give to, "the girls," my two precious little ones, my step granddaughter, and granddaughter, my little *sunshine*, Autumn *(Loopie)* and my little *moonlight*, Nyah *(Nahnah)*.

I would like to thank the rest of my family to include my parents, Samuel Sr., and Dorothy, and my sisters, Robin and Rachael for sharing life with me and for your prayers as well; I love you all, forever. Humble thanks go out to two dear friends, brothers and colleagues of mine, Reverend Stephen Simpkins, for not doubting my apostolic call upon our first introduction and meeting of each other, and Pastor James Bradley, over at, Indeed Transitional Outreach Ministries, for opening an additional potential platform for me to introduce my ministry. I appreciate our ongoing friendships after these many years.

Thanks to my friend, the late Hector Villanueva, over at the USPS Annex where we met. Hector inspired me with added confidence in pursuing what God had me to accomplish for him in this season of my life before his passing. I remember Hector saying to me that he and his wife really enjoyed my unique style of writing. Although the referenced writing style he spoke of was actually involving, an entirely different project, the remnants of that style, along with the added confidence and accomplishment is what we see produced in the very writing of this book.

Sadly, Hector would not see the finished product we have here before us, but he envisioned it all the same. Thanks to you brother Hector, for the memories of the three years of listening at times when we were eating from the word of God, and drinking from the Holy Spirit, you know, sharing spiritual things in the right now, time of the Lord. Farewell, ol' friend and I will see you *up there* someday. Amen.

INTRODUCTION

Luck (unlucky) - *Luck, or the absence thereof, can be often described by many as an occurrence of circumstances that may, or even, may not, take place due to chance or coincidence.*

Love (unconditional) - *Love, in its impartial state, is an emotion of grace in its absolute, that takes place on the account of self-sacrifice for not only another, but for others, as well.*

No more speaking or thinking up excuses of, "I am anything if not nothing at all. I will always amount to nothing because anything outside of being human in the eyes of humanity is who I have become. In my life, I have not a thing going for me except failure and imperfection. I am neither beautiful enough nor am I handsome enough. Society looks down on me because I am just...different, I guess. I am so unlucky."

On the other hand, perhaps no more speaking or thinking up excuses of, "I am beautiful and I am handsome, and without flaw and everything in my life is, perfect! Even in the eyes of humanity, I am greatness! Society looks up to me because I *am* different, and I know it! I am so lucky." The both of them are just that, excuses.

Our feeling sorry for others, or glorifying others, even in reverse order; having others, feel sorry for us or glorifying us, structure these sometimes masking subtle excuses in order to feel appreciated by others, or appreciate others when we believe that we are *not* appreciated, or do not *render* appreciation. This need not be the case in our fragile lives. This need not be the case at all. You see, there is so much more to life than just social status symbols, or lack thereof, and appearances! We do not need to feel alienated to this degree of self-pity and loathing or even, self-absorption and arrogance, even in reverse order, pity others or glorify others for who they are or even, what they may or may not have. You see, the aardvark may not present itself as pleasing to the eyes, but on a picnic, as likened unto a dog (less competent in this particular setting), can also not only prove, but serve to be man's best friend; man can learn to appreciate them both.

Ladies...Gentlemen...may I please have your attention? Lend me your eyes and ears! We are but a single eyelash in the multiple colored iris, and black pupils of God's eyes never to be detected by the enemy of our soul. This enemy being, the one who is green with envy because of how different God made us from the light bearing morning star (son of the dawn), and the

others, in all respects. In agreement with that, we are to be protected from the enemy of our soul as well; at least that is the plan. Become the eyelash in God's eyes it will not irritate him; he is not human like us. Become a part of his plan. I will show you how later on in these writings.

Listen, in this world, as we know it, there will always have, or better stated, assume to have a lower class, middle class and an upper class within it, at least to some degree. Here's the thing though! "What makes a 'great artist' is absorbing everything outside of you, yourself while at the same time, reaching deep down inside of yourself to the sum of expression and impression." In other words, regardless of our *social statuses*, it is high time we knew our *worth* as a whole within humanity, which God created, and build upon that premise. It's time to get real and take off the masks or at best, rely upon the one who *is* real, while undergoing the many stages *of* change.

However, I do not want to lose sight of my own premise; the premise I started building with in our Introduction. Therefore, in saying that, I want you to know this: luck can change in either circumstance or change quickly, as like in the blink or twinkling of an eye. My hope is that if, and when, it does change, "they" would somehow shift luck towards the direction of love and thus come to the realization of what is more important, and also, *who*. I say this because in reality, there is only one thing that prioritizes in this life and stands worthy of true importance. Everything else is obsolete; or at best comes in, a weak second.

Now, having cast that vast net out there on the right-hand side of the boat, hoping to capture the attention of some, I know that the word, *luck*, is a term loosely used in our world, society, and communities I mean…I do get it, and its meaning! To be honest with you I have often used this term myself. Therefore, I am not slow in my learning of this word but instead, I am down to earth in my assessment of life and the usage of this word, in life—as we know it.

Even though, while I speak in a sense of this term as one being overrated, again, this word *does* infiltrate the system of my vocabulary sometimes. I would like to say that I use this word in the sense of, well…you know, *opportunistic* potentials as much as potentials of *chance*, but I would not be honest with you by saying that. But for the sake of this book and the many teachings within its overall message—which we will eventually get to—let us push ourselves away from Luck's table for a moment, shall we. Let's all do this before we become too enlarged in our central area from feasting on such potluck, or lack thereof—no pun intended—and may you rest in peace King Eglon, of Moab. What say you? Push away, yes! That's great! We are already making progress.

Instead, let us tighten up on the word, *love*, for a time. In my assessment, this term is underrated. It is time to change the game. It is time to raise an eyebrow, set the bar a little higher, and order up a fresh course of this love, you know, the mercy and grace of God. Let us feast on this fresh order of food served from the other side of life—as we will come to know it—instead of continuing to over indulge ourselves in happen-stance occurrences.

Beloved and friends, let us peel back the onion's skin until we get to the edible core of the onion, itself, even though there may be plenty of tears in the process. Tears are good for us you know. As they, in fact act as cleansing agents for our eyes washing away the dust particles obstructing our view. Once these dust particles wash away, it gives way to a more clear sight picture—a sharper vision if you will—not only, *on* life, but *in* life, also. This sharper *vision* is a better *version* for our mind's eye. Not only that, but it is also a pleasing flavor to the spiritual palate, as well.

I say these words in ways such as this in order to get you to understand the thought depth behind the mind, and the various flavors behind the different and diverse tastes of the heart. In other words, I want you to dig deep, and then, think deeper, perhaps in reverse order. As human beings, these are abstract ways, out of many other ways—analytically—, of how we express ourselves uniquely. Moreover, I want you to be mindful of this my beloved dear ones: the expressions are not limited just to our generation. No indeed not, in fact, it goes back in time to a special *someone* who contours to neither side of the previous characters circumstance (s).

This *someone* understood many years ago, and still understands, even until this day—because life for *someone*, on both planes and everywhere else in between, exist—the essence of humanity (mind, heart, body, soul, spirit), body soul spirit as seen in its brief account. Wait! There is more to which I have just mentioned though. This *someone* also experiences both sides *of* life. *Someone* then experiences both sides *in* life, as well. Who is this *someone*, you ask. Well we will get to that in about a few more sentences, and elaborate in-depth at about a few more turns of the pages, but for right now, trust me when I say that *someone* expresses concern by grace and through the kind acts of, not luck, but love.

If by now, you are speaking or thinking along the lines of this, "I cannot do otherwise on my own; to a certain degree, I cannot change myself. I am neither lucky nor am I unlucky; I am just housed here in a body, breathing and waiting for my opportunity to take *on* life while undergoing changes, *in* life. In the process, perhaps I will find genuine love, too, no matter what social classification I am in according to myself and or, others within humanity.

"I am not a loser but I am a contender and you know what, I feel good about it, and yet I do desire more; I feel something is missing. I am not perfectly beautiful or handsome but I do take a healthy stance in how I look, such as in my humble appearance. Still though…somehow, I desire more inwardly. I feel something is missing. I am not perfect in and of myself; I am near perfect because God creates me, and I am okay with that. Yet and still, I'm *designed* for longing to experience more because I feel incomplete; as if by default like a vacuum, I am *drawn* to experience life and its fortunes more completely because spiritual riches are more valuable than they are, tangible." May I say to you that you are right?

I guess that is where faith comes in, faith that God can make the change for you. However, that is not all though; there is more, yet again… You see, not only did Jesus Christ—he is the *someone*—understand the mind, heart, body, soul and spirit of humanity back then—he still does today—but he executed an amazing physical miracle by feeding well over five thousand men, women and children, no matter their social statuses and or, appearances. He did this in order to display his understanding of them back then and his understanding of us, even today. He does this by offering salvation in a most unique, abstract, and analytically impressing way.

Yes, because of his compassionate love for us, and our failed, unimpressive and not to mention most importantly, unsaved human condition towards him, he still went right to work. He *illustrated* for us a wholesome, brilliant picturesque piece of *literature*, from which to cling. He *painted* a beautiful picture, through words of truth and spirit, for us to place our hope in. I must mention too, that he uses multiple brushstrokes and a vast array of colors for the purpose of diversification and illustration. I suppose he understands our love and appreciation for *art* (a refreshing approach to what already considers being, beautiful) and the semi-understanding thereof, perhaps this "semi" understanding will change into a completely wholesome understanding someday. God made it to where change is inevitable you know. Therefore, change must, and or, can be, a good thing, right; change does not always have to be bad. However, there is certainly a balance regarding, change; hmm imagine that!

Perhaps you may have thought that his grace given to you unto salvation through faith was all of it—even in the, *right now*, sense of the word. However, strange as it may seem to some, did you know that God's grace never runs out. Well the truth of the matter is that God wants to, not only save you, but he wants you to grow in his grace, as well. How, you ask? The answer is by looking past the temporal state of *physicality* well into the eternal state of *spirituality*.

Because of the fact that God's grace never runs out but continues as

you and I learn of him, we both can change from *a* state of unsaved, to *the* state of salvation. Moreover, we both can grow from being babes in Christ to becoming mature Christians in Christ as well; sort of like this other "colorful" young man I'm about to introduce you to, amen! The inevitable change faced him too, when he least expected it! You see, there is a time and place for everything and the place to write is here, right now!

As it stood, the day, which started out, would not be the same in which it would end, for one, Mr. Lieumas Leumas Ettesorde, as he sat in his study one evening. Beloved, this is Lieumas' tale to us, uniquely bound up in God's message for humanity. Friends, this is a collaborated work for all three classes of people. I do not mean social statuses' treated as stand-alones such as upper class, middle class, lower class apart; trust me, any one class can get their hands on this written piece but instead, Christians, Jews and Gentiles, alike; for they too, religious make-ups or lack thereof, within these social make-ups are not exempt. Beloved and Friends, together this integrated piece is just the *genesis* of what would become, Their Story!

Restrictions of His Holiness

Being afraid does not end the conquest. Check…

(A) The Beginning:

The day, which began as routine for, we will just call him Lieumas Leumas, or perhaps, Mr. Ettesorde, nah…how about just Lieumas for now, and this name usage mostly will be throughout our time here, was located somewhere in the United States of America, and in a rich historical city situated in the state of Texas. We have since narrowed it down to the city of Round Rock, which is located north, just 15 miles outside of the popular and major city of Austin, which is also in Texas. The month of the year is January, a new season, and the day of the week is Friday.

Now, this young man in question is mild mannered and easy going, quite humble and expresses humility, too. His demeanor is generally relaxed. He is patient and gentle as well, but that is not all, far from it! You see, many find him, at times, to be a bit bold and courageous, like that of a lion, intriguing and mysterious also, like that of a masquerades man, but trustworthy nonetheless.

The "word on the streets" is that he was a legendary nobleman of some kind; you know, one of renowned status. They continue in their lofty speech by saying he is one of which who was, in nineteen hundred and ninety nine, knighted by the Lord in titanium, armed with sword and shield coated in Teflon, and then get this; issued four shades of aura. The four shades of aura from bottom to top consists of bronze about his feet and legs, silver about his back and shoulder blades, gold about his arms and chest, and sapphire round about his neck and head. The picture that the Artist paints of this esteemed noble character conveys the embodiment of a valiant soldier possessing the full armor that God provides for him.

Some voices go as far as even saying that his sending is of this same Lord, as this lone equestrian—Lieumas—rode out into sunset's oblivion on his charcoal gray horse. Others say that the last sign of him was seen

while at sunrise, as his mail bag straddled his shoulder, spurs pressed against the sides of his horse and the sound of "heeyah" sounded as the strands of his whip lightly struck the backside of his longtime companion, Sadie, his mustang, with its reddish coat and tan mane. His mission in life, if he should choose to accept it: assist the unconsciousness of humanity in raising their awareness of God's righteousness. His desire while engaged in his mission: to rescue the beautiful maiden from her captors and continue caring for her afterwards. His interests: protect it at all times; protect it at all, costs. He was to fulfill these tasks through literary expressions of *spiritual art* and not to mention, through other means of expression, to which he would engage in after receiving Intel from his *handler.*

Others even believe—and this is a bit of a s t r e t c h— that he carries within him, the trace elements of the infamous nephilim. The Holy Bible speaks about these crude characters in, The First Book of Moses, Called GENESIS, which its finds are in chapter 6. These beings of who categorizes as harboring "superhuman" strength—hybrids: those of human/angelic essence, almost etheric in nature. As for Lieumas however, his reputation of having a unique and uncanny ability to draw others into his subtle yet, obvious personality defines him despite these giant negative stereotypes.

Now I mentioned the term, *nephilim* however, having run ahead of myself, he is not of the standard stereotypes that seem to create chaos across the land—by which people know of and thus associate them. No, but those infamous creatures who counters it instead, an elite breed within the breed, if you will; you know, a special dispensation for the, right now! See, I told you that it was a bit of a stretch, a long shot in the dark, if you will!

On the contrary, though, there is almost with certainty a dualistic at play here, if your hearts and minds should happen to recognize it without the need of, or desire to, poke holes in my linens as like pesky moths. For this reason, others opt for the lighter side of the mirror like reflection. They conclude with the adjective of his being of the priestly order of the *Jesuit* line (member of the Society of Jesus) although he is not Roman Catholic, as opposed to nephilim.

Perhaps he is just the opposite of both these labels though. Perhaps he is sent by God to spy out the land where these nephilim giants dwell, like in, The Book of JOSHUA; if detected of course, slay them and their "pet dragons," and this technique not with slingshot and stone, but with his invisible ink instead. You *have* heard that the pen is mightier than the sword have you not? Well in his case he is armed with both, the pen and the sword, with both equaling of the same might.

On the other hand, it just may be that he is one of these *unknowingly*

entertained angels the Holy Bible also speaks about, but in, The Epistle to the HEBREWS chapter 13 and verse 2 and not associated with the Jesuit priestly lineage at all. This all sounds a bit exaggerated I know but... Okay, I suppose only he would know to which ancestral race he belonged to and or, trickled down from though, right?

Joe Rumor, and his wife, Joan, also the Doe's, John and Jane too, have it in their minds that he's a "shape-shifter," you know, one chosen as being able to change into and or, adapt to, many different things and or, ways; perhaps they have thought right! He is said to be blessed by a Holy God just as Odom-Edom was, and submit to whatever and wherever the Lord needed. In this case, he is able to transition between a hay-baler who thinks (?) and then thinks (!), to a baby cub all grown up in encouragement, to a shiny hollow encasement with a heart of compassion enclosed. One must be careful when looking into his eyes or else they would need a flashlight to find his or her way, out. Wait dear beloved and friends, that would be his evil...well, "not so evil" twin, even though they do have an uncanny similarity in their eyes (hence the term, twin). Yes, these things are also difficult to fathom I know, but just hang with me for a second, even though it *is* beginning to sound like a drama movie or something similar and we haven't even started with the message yet; forgiveness accepted.

Going forward, "the streets" also say that as an artisan and or, craftsman, his work seems to transform also, from wood, hay and stubble, to gold, silver and precious jewels of blue sapphires, red rubies and topaz gemstones. Again, only he would know these things I'm sure. Perhaps his *employer* would have the ultimate and not to mention, final say-so in this matter at the end of the day though, after testing with orange fire that is, his works of construction.

Anyway, enough of that "he say she say" stuff, I will tell you what I do know to be true about the repertoire of Mr. Ettesorde...Lieumas, as he is often referred—at least in my own research and perception of him; at least from the vibes he gives off or translates. However, who knows, right! I mean...he just might be one who is capable of perfectly masking his true identity, since he *does* wear sunglasses not only during the day outside, but also during the late evenings, inside; this tends to baffle some spectators. Then again, maybe oblivion *has* actually suited him and he *has* forgotten who he really is. Maybe, just maybe...tiny fragments of memory remain intact; at least for right now, that is; because as "they" say: "God's wisdom and knowledge are like puzzle pieces with some of them being of, interestingly enough, *vintage* pieces, but beautifully connecting and fitting with some of the other pieces we find today perfectly, kind of like a catalyst." Yeah, pretty sure I heard that somewhere...

First off, this is what I gather from Mr. Ettesorde's body language etc: Like the essence of Jesus, he is a bit of a "misfit" and shunned in the world at times, or for lack of a better word, "misunderstood" within society, which is questionable, but indeed fully human, as one should think? This should free up anyone from feeling as though he, and or, she, should glorify him, to which he, and or, she, should not. Be mindful though my dear ones, we should not worship angels whether they are of heavenly and or, earthly domain. However, in his "angelic humanness," a white light has cast itself upon him or as "Luminous" will so colorfully and creatively, put into context for us a little later on, "God's light within me has indeed broken through my flesh." In his mind though, he believes that he does not need an entourage, for angels, of a higher order, surrounds him and at times even, make their vague appearance openly known. This explains the second truth of Lieumas; he is a servant of God, in the misty colored dew of the morning, in the golden colored heat of the day as well as in the, blue colored coolness of the night, and these three shades of distinct colors has been seen in scarcely limited portraits of him.

Moving right along, as a kid, he was "even handed." Please, allow me to explain: Lieumas batted using his left hand during games of playing neighborhood baseball. The use of this technique was familiar in the Major Leagues and he adapted to this as well although, he was a "righty" at birth. This would tend to throw his opponents off their game at crucial times during said game because he also could bat with his right hand as well, being he was not a "lefty" at the time of his birth. So yes, he was indeed "even handed" and could play both sides just as impressively. May I add that he was pretty good at throwing curve balls too! By the way, he never played Major League Baseball; we are still talking neighborhood baseball, just so we're clear on that.

Other interesting cases highlight his unusual behavior as well. Like for instance, with a hybrid (probably where the nephilim speculation stems from), appeal in the sense that he has a, Type B Plus or a, Type A Minus, personality, whichever way you choose to view it, or him, he is often classified as having an, Abstract Personality Type. Because of this character trait or, traits, some, as one having a critical thinking capacity, classify him. Most view him as one who is very analytical in assessing situations and firm in his opinions of how to solve them, also. With this being said, many spectators believe him to be an extrovert; yet he is strongly reserved (go figure) and a bit of a recluse—introvert—but admiringly, training in the field of, balance.

Although he does not let his left hand know what his right hand is doing and even in reverse order, he still sees one thing with his right eye

and another, with his left eye, and yet another with his third eye; for he sees 1 who is Sovereign, interestingly, in 3's. He still hears one thing with his left ear and with his right ear, yet another. He still thinks (?) with the left hemisphere of his brain but now, thinks (!) with the right hemisphere of his brain as well; again, as mentioned previously, he is training in the field of, balance.

However, to some other people, something else is very peculiar about Lieumas, a certain je ne sais quoi, if you will. Yes, interestingly enough, there is something altogether rather different about his personality that "they," just cannot seem to put a finger on. Something is strange in a way that for some of us, "it," does not quite seem to add up. Perhaps for some people, "it," will add up though, over time. Perhaps time has caught up with itself and, "it," has added up for humanity already... I will say this though, he often thanks God for disfiguring what the enemy—non-flesh and blood—is so desperately trying to figure out, in him; he—the enemy—is so green with envy.

Mr. Ettesorde is also a free thinker as well and understands the fact that God has given each of us—he included—the capacity to think. Moreover, it is because of this understanding that he brings a certain personable element to the table, too. This also, is where the Plus, in the wake of the B, or the Minus, in the wake of the A, comes into play. Allow me to explain...

You see, he has always had a vernacular disposition underneath the surface, perhaps by choice. However, he could not; in fact, he would not cease chasing his dream even though it would soon break the plain above the surface to which he would be seen; that issue would cease to exist as well. How, you ask. Well, he would endeavor to be, not in the background, but at the forefront of something spectacular and then, artistically incorporate fresh prolific new innovative campaign ideas, launching them into successful integrated projects. Be aware though, I have to tell you; here lately...he has been unsuccessful—humanly speaking—in that particular area of his life, as they are only, wandering thoughts that seems to be, pursuing him.

I say that right now but perhaps it was that way in seasons past. Perhaps it will continue on that way in seasons ahead, too. Perhaps it is not this way at all. Perhaps you may come to draw upon your own conclusions in the near future concerning him. In your conclusions though, may I remind you of something? May I remind you that he is training in the field of balance where wandering thoughts potentially manifest into, grounded ideas...!?!?

However, floating aimlessly or firmly grounded, either way this is not to worry you concerning his situation because he is not alone in this. I can assure you, God is with him. Trust me; he should not be afraid of what

is around the corner because what is around the corner had to face God there, first. Let that one sink in for a minute... My hope right now, is that you take this little faith snippet I have just given to you and tuck it away in your pocket for a rainy day; this will get you through to the next wave of sunny days. You never know when the torrential rains may fall. You might even forget to pack an umbrella on that day. This is your umbrella and the forecast calls for gray cloudy skies, and dark torrential downpours, too! Then again, it calls for moon lit clear midnight blue skies and many bright sunshiny days, as well!

Anyway, continuing... He has always had heart though, Mr. Ettesorde, that is. In addition to that, he has always been a prompt, punctual, loyal and not to mention, focused worker in the work place over the years, too! For Lieumas, this has attributed to his success in the occupational arena, even now. Personally, I do not consider him lucky at all. I believe it was by the grace of God, alone—you know, the love of God, all by itself. Many people tease him all the time about the many various colored pens he carries around on his person (shirt pocket, collar) but his response, jokingly enough, is that he considers himself, an important artist and employee at his *employer's* place of business, where his *handler* resides.

Now, as we fast-forward to a place rewound, at about 12:00 o'clock noontime, Lieumas' ears tickle as he feels the winds rushing by subtly, and the sound of bronze wheels squeaking in the nearby distance. The breeze lightly blows the electric blue curtains as they sway back and forth and side to side like twin Hawaiian hula dancers fluently moving to the mild tune of ukuleles. As he finds himself sitting by the open window in his study, he thinks it would be nice to just relax and unwind a little from the strenuous workweek he had just endured. He is off duty from work that day and again once over, so he pours himself a moderate glass of old vintage red wine and begins feeding his mind through the reading of a black leather bound book.

This man is also an aspiring literary artist extraordinaire—writer-poet entrepreneur—thanks to his childhood love interest in reading and information gathering from Childcraft books, Britannica encyclopedias, and the like before the popular Internet boom! Perhaps this answers the many pens issue, underneath in one's own mind. He reminisces, at times, the bittersweet joy of two literary worlds playing a game of tug-o-war with him in-between the pages. One world was of non-fiction-geographical places, social economics, and historical events—the sometimes bitter—and the other world were of fictional/non-fictional poetry, fantasy-fairytales, and poetic nursery rhymes—the often sweet. In his mind though, both literary worlds engulfed him and when necessary, balanced the other out.

Lieumas dreamt as a child, as he still does today, dream even as an adult, of being personally involved in the overall literary works field somehow. However, he finds it quite difficult, if not next to impossible, to duplicate successfully, the exaggerated thoughts in his mind into black ink, and then transfer the heartfelt contents of the black ink onto white paper, mixed with an array of colorful imagination and black and white facts. He finds that this quest may be out of touch for some folks within society because of the lingering, "gray areas," and therefore, out of reach for him, you know, to transform physically, the mind and heart of his work into real life pieces of his soul and spirit for his would be audience.

Because he feels this way, avoiding the public above ground in order to dwell below the surface underground cloaked in safety, he finds comfort in constructing his craft, all so it would seem. It is not surprising to feel or even act this way I mean after all, Mr. Ettesorde's body, is busy sustaining a full time job, remember! Yet and still, again, I say to you, do not worry yourself concerning his situation, he is not alone in this. I can assure you, he will transmute from, aspiring to inspiring as like in a twinkling of an eye because God is with him there, also.

Remaining underground where it is dark, damp and cold will capture God's attention! Honestly, I believe it has captured God's attention already! I believe it is time for him to emerge from the damp shadowy hideout, just beneath the depths of the underground's surface, and like a "changeling" who has become the recipient of the "giving of switch-a-roo orders" to the angel of the LORD and not fairies, suppress his alter ego there, for a time. In a recent dream, I do believe I remember seeing a small dirt covered hand slowly puncturing a hole through the top of the earth, but in reverse order…perhaps from within.

Now his mental works, which are in the works as we speak, are of a *messenger* typewriting forte. The time has elapsed now, it is about 3:00 o'clock in the evening, and the year status is A.D. (after the death of Christ). Suddenly, while sitting in his study, he hears a slight distorted voice and a bold knock!

Thump! Thump! Thump! "Oh dear, a knock at the door… I am determined to read and must continue to read, right now! For if, I am to continue, I must not be disturbed. Never mind the knock it's probably not important," he says to himself in a low-pitched voice. "I'll just ignore it; it's probably no one anyway." Another three knocks later… Thump! Thump! Thump! "Oh dear, there is that knock again! I'll go see who it is then…" The verse he had been reading that faithful day and from within, his black leather bound book was from, The Book of REVELATION 3:20, KJV. It was found in the Holy Bible where Jesus is speaking. It reads:

"Behold, I stand at the door, and knock: if any man hear my voice, and open the door, I will come in to him, and will sup with him, and he with me." —KJV

As he looks through the peephole embedded in the gray door, he sees no one standing in front of it. Moreover, he convinces himself that it is all in his mind. Therefore, he returns to the chair in his study and continues reading. Suddenly, he hears a slight distorted voice and another bold knock!

Thump! Thump! Thump! "Oh dear, another knock at the door... I am determined to read and must continue to read, right now! For if, I am to continue, I must not be disturbed, for the second time. Never mind the knock it's probably not important," again he says to himself in a low-pitched voice. "I'll just ignore it; it's probably no one anyway, again."

Another three knocks later... Thump! Thump! Thump! "Oh dear, I'll go see who it is, yet again," he says, this time with a drab induced sighing gesture... As he looks through the peephole embedded in the gray door, still he sees no one standing in front of it. However, instead of returning to his study, he stands there in front of the gray door. Not convincing himself that it is all in his mind once more, he is compelled to do something completely different this time. Although afraid, but without putting up resistance, he responds; this time he follows his heart. Yes, this time he opens the gray door...

...Ten minutes, at four times over, has passed, Mr. Ettesorde, with a strong fluorescent orange glow about his face, an even brighter translucent yellow mark of some kind on his forehead, and yes, rainbow colored eyes seeming as though dilated from a trance like state, returns to the chair in his study next to the open window. He pulls the chair from beneath the desk and he sits down and resumes his place, and excitingly flips through the many other pages of his Holy Bible. He is compelled to do something completely different this time.

Without putting up resistance, he responds; this time he gently reaches for his nearby black leather briefcase, which houses his gray carbon fiber laptop that he keeps also beneath his brown oak desk. He cautiously retrieves the laptop from storage within his briefcase as if he is retrieving a ukulele or even a prize guitar like a guitarist. He slowly opens it, wipes away the dust particles, and sets his fingertips atop the black and white keys of the keyboard.

Like a skilled pianist, musician extraordinaire preparing to captivate his audience with unique and intriguing sound pitches and crisp brash melodies, he begins to mentally typewrite. He attempts to settle comfortably into his cozy brown leather chair; the chair, which by the way, is squeaking

like a mouse as he positions and repositions himself. After becoming comfortably content though, he strokes the letter key hitting his first alphabetical note, with other notes following. This is done in order that others might know and come to love the God-Man that he, himself, have come to know and love; this being a, *knowing at soul level,* type of love after having personally met him about 40 minutes earlier upon opening the gray door.

Life to him makes a bit more sense now. *I am free and nothing can hold me back!* He thinks this to himself before regurgitating out of his mouth these same words, which then fills the study in which he regularly reads and generates ideas. "I am free and nothing can hold me back!"

As the literary notes in his mind dissipate into thin air as though visions sent from the Lord, and reappear onto the metallic silver colored screen stationery that is before him, with gray thin framed eyeglasses affixed to his face, he begins preparing to write his next series of words. Lieumas does this hoping not to be disturbed once more, that is, unless it came from the same visitation he had received earlier while reading his black leather bound Holy Bible. He would not hesitate this time for surely he would welcome him into his home a second time, for they are roommates; yes, he actually lives there now.

The thoughts in his mind are on rapid fire now! Aside from that, his heart races against his lungs like a couple of black thoroughbreds and white quarter horses competing for a chance to stand with their handler in the winners circle at the end of the day with green and red wreaths hanging about their necks! He composes his thoughts though, and slows down his breathing... Once more, Lieumas is ready.

Now focused, he inhales a deep breath into his lungs through his nostrils, and then recycles it back into the air through his mouth. Lieumas thinks to himself that if he exhales hard enough and long enough, he just might create a powerful windstorm, tossing into the air, every negative thing and thought like a winnowing fork. "After all," he says lightly beneath his own breath, "Some do jokingly mistake me for being somewhat of a windbag, anyway."

Like a "mad scientist" about to go to work in his lab as white smoke pour out from his ears, with palms facing each other just beyond his nose, and tapping his fingertips together like dominoes falling one by one, Leumas, grins of indifference at this point. Funny thing, his eyebrows do likewise. Mr. Ettesorde is determined more so now, than ever before as he looks at the metallic silver canvas of his laptop screen as though it were a beige easel and white canvas laid out for an artist's creative juices to flow.

At this same point, he interlocks his hands at the fingers, turns his

9

wrists outward and extends his arms making a popping sound about his knuckles. Again, after wiggling them, his fingers are set as the tips of them make contact with the black and white keys on the keyboard. His index finger gently pushes the letter key again, and then the rest of his fingers follow suit as they once again find themselves dancing the "Jitterbug" as they make their way across the rest of the other keys on the keyboard's surface.

For him there is no stopping now as he pulls off this seemingly amazing typewriting riff as if he were Jimi Hendrix live on electric strings playing the Monterey Pop Festival, or even, the great pianist, Arthur Rubinstein; for he (Lieumas) has protruded from underground and has risen to its surface! He proceeds to write, not what *he* wants, but what *God* wants him to communicate, instead. He anxiously and excitingly flips through the pages more and more, faster and faster pausing in between for thinking and typing, and is thrilled by what his now, prism like eyes of blue, yellow and violet, finds within them. He is even eager to speak about the very personal, and not to mention, special encounter that he had with Jesus publicly and openly now, and he plans to do so ASAP.

Realizing now (thanks to the Holy Spirit) that it is not all about his *own* emotions and passions, but about *others'* as well, he loses his "mad scientist" grin of indifference and mentally converts the lab into a studio. He hopes that his fingerprints now resting about the keys of his work will leave behind an indention for those others of us who are just like him, a legacy if you will for this generation; a different kind of a windstorm; perhaps a whirlwind instead. After all…being different has its advantages you know, to say the least. Also, when sowing the wind one shall harvest the whirlwind, you know what I'm saying. Besides, it is what it is and he is who he is, and he is okay with that. He prays aloud and trusts that his first recorded published piece will be nothing short of perfection, and that it will make a positive impact on him, and the rest of humanity at large. He hopes that it will resonate as it comes to life for all of God's people, both Jew and Gentile alike, with Christians also not being exempt.

I want you to pause right here for a moment; can you do that. Beloved and friends, I want us to understand something very important before we go any further. I want us to examine this, "perfection." What does this word, *perfection* mean? Think about it now… Does enough time allot for such thinking! Great, I just want to be fair before going on.

The word, *perfection* means, *having a completed work that surpasses all of the potential boundaries of said work, without flaw and excellent in every way possible.* In other words, it is a state of reaching the apex of all that is or explained, and of good quality beyond the scope of quality, or

even quantity, to put it mildly. Good luck with that right! Anyway, we are continuing so please follow suit…

Faster and faster, he—Luminous—, excitingly flips through page after page of his black leather bound book when suddenly, with the strength like that of a tall black Clydesdale horse, and the turbulence of a mighty gale force black whirlwind! Mr. Lieumas Leumas Ettesorde mysteriously vanishes. As if visions sent from the Lord and dissipates, he disappears into thin air. The Holy Ghost mysteriously carries him away to God knows where, but where could he possibly be taking him!?!?

Now then, as we rewind to a place fast-forwarded, about twelve o'clock noontime, the darkening of the sky will fall across the whole land for three hours. Suddenly! The veil in the Temple will tear in two from top to bottom! The earth will shake! The splitting of the rocks will occur! The tombs will open but first…there would come something else. There would be the acts of torture coming. There would be the taunts of ridicule coming. There would come about what others had expected and anticipated, and later…what they had not anticipated and expected, at all!

"Alright listen up you proud Roman soldiers lay the cross down and then get the hammer and the nails will you? Take his right hand, bound it to the right side of the cross, and begin nailing. Now take his left hand, bound it to the left side of the cross, and begin nailing. Take his left and right foot, overlap them, and bound them as well, to the bottom of the cross. Now begin nailing…

"Men, according to Caiaphas, the high priest, and the Jewish leaders of the Sanhedrin, this man walked around on foot using his hands to heal people and he did it unauthorized. He claims that he can rebuild God's Temple in three days, they say. He claims to be the Messiah, a king, *King of the Jews*, they say. He claims to be the, *Son of God*, which according to their Jewish Mosaic Laws is punishable by death, they say. For the reasons noted, we must crucify him, they say. Therefore, men, we as Roman soldiers under Governor Pilate's rule, shall carry it out. This is what *we* say! Moreover men, we have the authority to do so!"

Pause right here for a moment and again, just think… Just think for a moment now. Before all of this took place, Roman Governor, Pilate, had the authority, opportunity and the option to release Jesus Christ before reluctantly opting to release another prisoner by the name of Barabbas, that day. Giving this turn of event, to me, he even had the audacity to do such a thing! However giving what I know right now, maybe not so much. Anyway, this personal pardon of release was due to a special Passover celebration that the governor (s) conducted each year by their custom. Even so, albeit under pressure from the Jews perhaps, Pilate *did* have the

final say-so concerning Jesus' death; he put the final nail in the coffin, so to speak. However, did he, really?

Now the Sanhedrin was the ruling body—religious and political governing officials of the Jewish people—but they were still under the ultimate rule of the Roman government. They policed themselves in other cases involving their Jewish communities but when it came to being put to death or in Jesus' case, putting someone to death, namely him (Jesus), they—Jewish Sanhedrin—needed permission from the Roman government in order to carry out this death sentence. This supports my personal opinion that we both—Jews and Gentiles—had a hand in the death of Jesus; for no one class of people can place the blame on the other, even in reverse order. Nevertheless, my views on certain subjects do not end with my opinion. Neither do they start there.

Even so, the question remains as this, "Was Barabbas perhaps lucky that day? Was Jesus perhaps unlucky that day?" In addition to that, the very materials he, himself, used, as a carpenter (wood, nails, and hammer) was the very materials used in his own crucifixion. Some may indeed find this ironic and a bit of a coincidence. However, is it? Was it? Let us continue…

"Put the crown of thorns on his head. Yes men bound his mind. Injure him with the crown of thorns. Let us humiliate, embarrass and disrespect him further for somehow thinking that he is some sort of king or something; King of the Jews, he admits to being. I tell you for this Jesus; this is the only crown he will ever receive. Now lift him up! Men, I need you all to heave-hoe, heave-hoe, and heave-hoe, some more!"

The sky darkens across the whole land as the time, in its sixth hour three times removed from the ninth, is about 12:00 o'clock noontime. The crowd begins to cheer louder at this point. Hours later at about three o'clock as he innocently hangs on the cross betwixt two thieves, he speaks seven last words to include these words spoken by him, whom he asked of his Father:

And about the ninth hour Je'-sus cried with a loud voice, saying, E'-li, E'-li, la'-ma sa-bach'-tha-ni? that is to say, My God, my God, why hast thou forsaken me? —MATTHEW 27:46, KJV

Now then, the question remains as this, "Did he forsake him? Did he leave Jesus to die on that cross all alone because of humanity and their wickedness? Did God forget about Jesus, his own Son, because of your sins and my sins as well?" This we shall find out soon enough!

Again, we have this message of, **"My God, my God, why hast thou forsaken me?" KJV**, spoken to his Father in heaven up above who acts as a

witness (two) to this heinous, but necessary act from the Jews and Gentiles. Three hours later, he, Jesus, faithfully gives up his spirit. Suddenly! The veil in the Temple now tears in two from top to bottom! The earth now shakes! The splitting of the rocks now occurs! The tombs now open! Later that evening, we find these words from the Roman brass in the following paragraph...

"Is he dead Roman? Pierce him in his side Roman soldier (5) to make sure he is dead! Now do not worry if his heart is punctured and damaged in the process death is what we want and death is what we shall get!" At this point death seems to have succeeded in conquering Jesus... Over two thousand years later, Mr. Lieumas Leumas Ettesorde, will hear something. His ears will pickup on a strange but yet, familiar silence.

"Wait a minute," he will say, "I hear a rushing of wind and I hear the sound of horses. I hear the beating of hooves like great horses and the squeaking and squealing of wheels like those of a chariot too, wait perhaps two or more chariots..." He will then ask himself this very important question, "Are my mind and heart playing tricks on me right now after being trapped in this state of desperation for so long? God I hope not! Please hear my cries and answer me Lord! My soul cries out and longs to be filled!"

At this point time catches up to itself but in reverse order. Mr. Ettesorde shakes his head from side to side as though he were "snapping out of it!" He then thinks to himself, these curious words... *What is happening? What just happened?*

1) **I therefore, the prisoner of the Lord, beseech you that ye walk worthy of the vocation wherewith ye are called,**

2) **With all lowliness and meekness, with longsuffering, forbearing one another in love;**

3) **Endeavouring to keep the unity of the Spirit in the bond of peace.**

4) *There is* **one body, and one Spirit, even as ye are called in one hope of your calling;**

5) **One Lord, one faith, one baptism,**

6) **One God and Father of all, who** *is* **above all, and through all, and in you all.**

7) **But unto every one of us is given grace according to the measure of the gift of Christ.**

8) **Wherefore he saith, When he ascended up on high, he led captivity captive, and gave gifts unto men.**

9) **(Now that he ascended, what is it but that he also descended first into the lower parts of the earth?**

13

10) He that descended is the same also that ascended up far above all heavens, that he might fill all things.)

11) And he gave some, apostles; and some, prophets; and some, evangelists; and some, pastors and teachers;

12) For the perfecting of the saints, for the work of the ministry, for the edifying of the body of Christ:

13) Til we all come in the unity of the faith, and of the knowledge of the Son of God, unto a perfect man, unto the measure of the stature of the fulness of Christ:

14) That we *henceforth* be no more children, tossed to and fro, and carried about with every wind of doctrine by the sleight of men, *and* cunning craftiness, whereby they lie in wait to deceive;

15) But speaking the truth in love, may grow up into him in all things, which is the head, *even* Christ:

16) From whom the whole body fitly joined together and compacted by that which every joint supplieth, according... —EPHESIANS 4:1-16, KJV

The Rendezvous Point: Many years later after that, out of nowhere, we find Lieumas! As though he drops from time somewhere (yes, you read this right), drops from time somewhere, but out of nowhere, landing in the center of the world...he makes his morning debut. He picks himself up, dusts himself off, and settles in; he gives way to an awesome yawn, gives thanks to his *employer* and becomes situated in his bunk.

Later that afternoon after awakening, Lieumas gives way to another awesome yawn but this time, followed by a great stretch. He locates his parchments and his staff and begins to walk making his long awaited journey to the spot marked with a big bold black, **X**. As the evening near its close and after traveling by foot for miles on end, an exhausted Lieumas arrives at the podium. He smiles, takes his place there at the big bold black, **X** and stares off into the distance at what looks to be...trees? Lieumas clears his throat, looks to the heavens and prays silently. With his time sensitive parchments in hand, leans his sturdy staff against the right side wall of the pulpit, which was prepared by his handler before time began, and with a firm posture rubs his eyes. Mr. Ettesorde puts on his spiritual eyeglasses and then, with calmness and clarity accompanying him, faces the people.

"Ahh, you have arrived we see; we have been waiting for your presence; we have been waiting all day long to be quite honest, sir!" says Mr. Peeples. "I guess this is what, 'out of the blue' looks like in person," says Mrs. Peeples. "May I say, warm greetings to you both, Mr. and Mrs. Peeples?

May I follow through with greetings to your children and to your children's children also? Thanks for your patience, I see that you have all arrived safely as well; I have been expecting you likewise, for a millennium it seems," says Lieumas. He continues with, "Wow, you have a very large and unseemly told number in your family, like thousands of bright yellow stars in the heavens or white sand along the seashore, but it is a good thing and not to be taken otherwise."

"Yes, our ancestry dates back generations upon generations," says Mr. Peeples. "Did you just say, 'generations upon generations,' did I hear you right?" says Lieumas. He continues with, "Wow, again! Well, let me express gratitude for meeting with *us* this evening so that we can openly discuss truth concerning humanity. Please, have a seat and make yourselves comfortable. It seems, as though there has been two chairs *prepared* for you both. Your entire family and the children, and their children also, can take up seating on *our* many couches situated throughout this *vast space*, as well.

"I am glad you made it here on time by the way; we have so much to cover. In keeping with that thought, we have so much to uncover, as well. I sincerely hope the engagement of ours finds you in God's good graces. Oh look, we seem to have many spectators gathering. Well guess what, we have room enough for them as well, all of them. How convenient this is. I must remind myself to thank my *employer* upon my safe return; surely he knew there would be others coming and most certainly, others joining me. By the way, my *employer* who sent me has sent reconnaissance before me. In other words, he sends me ahead of him after by whom he already conditioned or prepared the hearts of those I am to see. Those perhaps, are the same one (s) anticipating and awaiting my arrival, kind of like you all. This confirms and affirms his coming, his arrival. Therefore, I trust that you have received the exciting memo that there has been a changing of the guard! Let us get started shall we; I will explain the memo as we proceed throughout our time here!

"It has been a beautiful day has it not been," says Lieumas. "Yes, it has indeed been a beautiful day quite so," says Mrs. Peeples. "No, it hasn't been beautiful; not so much this day for me; quite frankly, not many of these days this past week, just to be honest. Even so, I'm just lucky to be alive I guess, and at least I have food on the table, I suppose," says Mr. Peeples. "Well may I say to you, Mrs. Peeples, that I am glad to agree with you that it *has* been a beautiful day? Before I prepare to go any farther though, here is a thought that I cannot help but express verbally but for the entertaining of the short 'attention spand' of your children's children, as they seem a bit restless:

15

"As I draw back the shades inside of my mind and look out past my eyes dingy grayish brown windows at the world outside, I can see the electric blue sky above awaiting its encore tomorrow. Moreover, with its pristine rolling white clouds seeming as though they are flowing like white and pinkish blue cotton candy from a carnival or county fair even, I feel a cool breeze of freshness. In addition to that, might I add, amidst the tall brown trees and branches, looking between the green leaves at God's own children, and his people playing as though they are in an amusement park or some other fun establishment or gathering, our minds are at ease as the ice has melted. The water rushes in therefore, it places my heart in this pleasant and unmistakable, exciting and joyous mood of properly introducing me, my own self and I am! Our names are Lieumas, Leumas, and Ettesorde, and *I* 'run' with, The Twelve. Somehow, I knew the children would like that."

"Lieumas Leumas Ettesorde?" asked Mrs. Peeples, "What an interesting name or, shall I say, interesting names; does the surname roll off the tongue?" "Yes, it is as you say, madam." This, I politely answered while smiling at the both of them. I continue with, "When the names are compartmentalized, it means, *someone who replaces another; lion of many faces.*" I gave way to another smile and said, "No my dear, it doesn't 'roll off the tongue' as you say, but if that is what's fun to you then go ahead, suit yourself." Mr. Peeples decided he would just stick to the traditional pronunciation. I agree while laughing and further continued with my presentation.

"As for the significance of my middle name, Mr. and Mrs. Peeples, Leumas, i.e. *lion of many faces* (LEU-MAS), the breakdown of such is quite fairly easy to explain. Although some, that my ancestors were from Spain, believe it to be, the word, *leu*, comes after the Indo-European language from the Romanian culture, and is a derivative of Latin, although I am not Latin or Romanian either, this means, lion—leu. In addition to that, Peeples family, the word, Mas—short for masquerade; mask—, has its roots embedded in the French meaning, *masquerade* and or, *costume party.*

"You see, Mr. and Mrs. Peeples, by God's grace, I am bold in the Lord, like that of a lion but compassionate as a kitten, because of him also. That is not all though, I am able to blend in with my natural surroundings and then transfigure into different costumes. I do these things as I take on the multiple ministerial leadership roles associated with the five-fold leadership ministry. This leadership ministry (integrated for me, stand-alone for others) consists of apostle (messenger); prophet (spokesman); evangelist (preacher), pastor (shepherd), teacher (nurturer); kind of like a, 'Jack of all trades,' 'coat of many colors,' sort of thing; so to speak.

Interestingly enough, this is leading up to where my first name, Lieumas, derives from.

"The breakdown of that name is as such: (LIEU-TENANT), which means, *someone who replaces another*. This derives from the French also. It is a rank held by an individual and utilized when someone holds the *title* such as a Sergeant or even perhaps a, Captain in the military, and who may be unavailable for any amount of time. Well in light of the absence of the ranking authority of a sector, the person holding the title of, Lieutenant, would then take his or her place (Sergeant-Captain) for the time being completing the mission and or, missions at hand. May I add that the second part of this name has its meaning rooted in the French as well, which is, *tenir* and which may mean, *to hold a place*. Also in Latin, it pronounces as, *tenere*, which may mean, *to hold or keep*. This is where the spelling and or, the actual pronunciation of, tenant, comes from.

"Now my friends joke a lot with one another by calling me, 'Luminous,' as an alias. This name has its association in the lighting of something, or in the glowing of a particular object or, objects—illumination. The reason for this nickname stems way back to when I was first introduced to the 'white light,' or as I sometimes explain it when others inquire of my disposition, God's light within me has indeed broken through my flesh.

"Upon my meeting and gathering of friends, even to some who were, and still are, very dear to me, they would say to me that I looked different in a way. They said that I glowed and looked as though I was 'lit up' somehow or appeared brighter than normal, or even as they remembered from my past. In my humble opinion though, boldness, definitely, brightness however, well maybe just a little…! That would be my amazing twin who has that warm golden glow set about the face, but with a little touch of boldness buried deep within; perhaps even in reverse order.

"Anyway, that's another story far removed from this one. As far as what my friends would say about me though, to me that was confirmation of what God has done by placing this, 'white light' within me. Ever since then, I have been attracted to this, 'white light' and even have been affected by this, 'white light.' Although I am no, 'mad scientist,' (smoke dispensing ears included) I tend to generate some of this, 'white light' and radiate some of this, 'white light' unto others, as well.

"Now then, having explained the background regarding my name and nickname, please allow me to make a very important statement. Apologetically, be aware that I will stand behind this statement if and or, when questioned: If your day or perhaps days, aren't, or hasn't been going so well these last couple of months or years Mr. Peeples, may I say to you that my hope and faith in God says that they will. And no sir, I haven't

forgotten what you said upon our initial meeting. Together you and I will reach a very satisfying conclusion and new and fresh experiences will come into play for you.

"My faith in God says that the overcast gray clouds obstructing your mind's eye will become more clear shortly, and bringing with it, the marriage colors of electric blue guised in the form of trust. In addition to that, pristine white clouds guised in the form of purity, which accompanies it. Yes, even during the dark storms that may currently be passing through in your life...the days ahead will get better, amen! Say it with me Mr. Peeples..." "Even during the dark storms that may currently be passing through in my life, the days ahead will get better! Amen!" repeats Mr. Peeples.

Lieumas continues with, "Now I am no expert in the books and or, field of *study* in regards to culture, such as social anthropology or social psychotherapy even, however, I have been *innately gifted* in the involvement of social realism, to say the least. Moreover, I do believe, in terms of common sense reasoning, that I have a bit of a handle on how the world thinks as well as acts. More so than that, I believe I have a lock on the biblical assessment of how the world works in general, as well. The word of God, alone, is the power of God, alone, Mrs. Peeples. However, he has called me to visit with you all, the entire Peeples family, that is of course, lest we—from both ends—choose to ignore his reasons as to why.

"Perhaps he has dispatched me for this task in order to confine the self-inflicted, if that is the case, emotional overwhelms, perhaps brought on by someone else, and open the thought process and strengthen the vital signs of some of you even further. This bold maneuver is in a not so desperate, but more like anxious, due to the severity *of* my message, attempt to stimulate the gray matter we call a, *brain*, and as a result, travel through the conduit to the location of the red muscle known as the, *heart*. These two organs are our thinking and processing mechanisms in the realm of thought, feelings, emotions, vitality, life etc; I believe this is fair.

"Now if you are a critical thinker as I am, you may have some reserves about me and I sincerely understand that. However, if you are a non-critical thinker, unlike me, you are almost certain to have some reserves about me as well, and even more so; I mean I do get it. Either way though, you may never have even heard of me and I sincerely thank you all for taking up interest in *our* wanting to meet with you all regardless of that fact.

"The reason you may not know of me is that the two of you are generations beyond generations older than I am. Please do not get me wrong, I mean to say that respectfully. What is that Mrs. Peeples?" Lieumas asked.

"Are you a motivational speaker?" she repeats. How about an activist, are you one of those types?" followed up Mr. Peeples.

Lieumas continues with, "The answer to that question is no, I am not a motivational speaker, per se or, intrinsically speaking; I am not an activist either, Mr. Peeples. It is however, a new journey for me in the realm of ministry, especially ministering through writing though, as God has beckoned me to be *his* Minister; I have been that for close to seven or eight years now. Having said that though, believe it or not, sometimes I have this vague thought of being in partnership with God since before time began as well as in, future times to come; sometimes even, as if right now, I get the feeling we are, partners in time and space...

"Anyway, for over ten years, well, probably close to fourteen years now up to this point of our discussion on truth, I have been a, 'recognized saved soul,'—*public profession of faith in Jesus Christ*—and this even before the *absolute call* to ministry from the Lord. Therefore, I suppose I am not 'actually new' to the world of ministry in and of itself, amen. As some may say, 'I got skin in the game.' Now Mr. and Mrs. Peeples, having said that, in that respect your children and your children's children just may very well know who I am. They and I may be a little more closer in age though, at least in this generation and perhaps, a portion of the next.

"I am still the same person they knew at some time in the past, but now I see things differently; I see things more clearly now thanks to my, *new version* of a, *better vision*, perhaps in reverse order; *new vision* of a, *better version*. I still enjoy life as I did before when some of us—your offspring and I—hung out, but I enjoy it in all its fullness now. Besides though, Mr. and Mrs. Peeples, if I *were* a motivational speaker in the sense of a full range capacity in professional ministry, or perhaps in a professional non-ministry campaign even, the chances of you *not* knowing of me would be slim to none. I say that even in this present age as 'speakers' both, motivational and non-motivational, are quite popular amidst the masses, activists' also, not that there is anything wrong with that, may I add.

"So there you have it, I am 'so not' a motivational speaker, intrinsically. Now I will say this though and I will end it right there; we have bigger fish to fry so I do not want to continue harpooning on the subject, but in reverse order... I will say that I am a speaker such as found when God speaks through me, but somewhat different from your average motivational speaker, such as those who host seminars related to self-empowerment workshops and such. I am different on a non-professional and professional, ministry and non-ministry scale, as you will come to discover, amen.

"Now in the opening of our truth discussion, I made mention of, 'The Twelve,' does anyone remember! Now who are these twelve men?"

Lieumas asked. "It's a courthouse jury?" One member of the Peeples family stated this, beloved and friends. Now here in lies the old, "answering the question by asking a question in return," card. Some members from the Peeples family who were great grandparents, grandparents, aunts, uncles, nephews, nieces and cousins within the entire family were no strangers to playing cards—parents and children as well; no doubt a great multitude played. "No, they are not a jury of 12 complete strangers being held up in some court room in deliberation or something, or perhaps awaiting a hearing or trial," I said to them.

"Are they a football team?" asked some of the Peeples children. Again, I responded by saying, "No, that causes for, I believe, there to be, 11 men on the playing field at one time during a game so no, that's not the answer either." They all continue with their eager and yet, timid stiff line of questioning! "Well who are they then, uh um, Lieumas, sir? We're waiting..."

I answer their question with an upcoming stiff-arm of my own (wait for it) as seeing I could not resist. Here it comes! "But these devout men in fact knew one another unlike a jury of 12 complete strangers. They knew one another like a football team do, but their reason for winning was not at all in relation to football. These men were a very distinct group of disciples. Jesus Christ discovered these men many, many years ago and then later, Jesus Christ personally made them his apostles, himself. To you, the grandparents and great grandparents, you may very well know this, and this addresses to you two as well, Mr. and Mrs. Peeples.

"The reason I say that I 'run' with them is not to be mistaken as a literal translation. However, it is a metaphorical and spiritual statement, instead. Please, allow me to explain it a little more as to have it make sense or to, present it more clearly to your children and perhaps your children's children as well—a better version of my vision, if you will."

Beloved and friends, here Lieumas explains away... "You see, these group of twelve men were alive during Jesus' time here on planet earth and they have long since been gone. Albeit, even though they are long gone, they have not been long forgotten, by any means. For me however, well I shall remain physically in the present tense of being down here on planet earth with the rest of humanity—at least for right now, and I am okay with that, amen.

"The Twelve remain on planet earth through their presence in the Holy Bible. The reason, for the third time, I say that I 'run' with them come across as twofold. The first fold is because I, too, am an apostle of our Lord and Savior, Jesus Christ, but in the *right now* (enter the stiff-arm) tense of today."

"What is that (cough cough, as if by choking); come again? But there are no living apostles today just bishops...at least that's what I thought, and in some cases, we both were taught," says Mr. Peeples. Now the misses, as she stands there, next to him, shakes her head up and down in agreement with her husband and she adds, "Neither are there any prophets too, but mostly pastor-teachers, and rarely evangelists." He looks over at his wife and then *he*, nods back in agreement as if to solidify their mutual stance concerning the matter. I say to myself in a low-pitched voice, "At least they're on the right track as far as communicative agreement alliances are concerned; perhaps more important views and stances will lineup for them across the board, as well. All they have to do is open their eyes and ears and look and listen for the signs which are all around them."

I continue in my mezzo forte voice with, "Well, let me just say that I used to think this way myself and quite honestly, for a long time, I did not even remember who *I* was let alone, know what an *apostle* was, or a *bishop*, even. Some even suggest that they are one in the same but again, I used to think this way (that they [apostles] no longer existed). This until I was *personally* made aware and given this *special* call to ministry by our Lord and Savior, Jesus Christ, himself, amen. I even began to remember who *I* was, an apostolic/prophetic/evangelistic theologian/instructor to the world through art, and this revelation slowly but surely. Amen! Although, I will have to admit, due to him using me wherever and whenever...sometimes my memory still fades in and out which keeps me thinking along the lines of, well you know, like where did I come from before. Where am I at right now? Where am I going later on; I find that it keeps me dependent on the Lord though; he has all the answers I do not have, amen.

"As an *apostle* i.e. *prince; ambassador; *angel; sent one (in all absolutes); messenger; watchman; one of which, having central Authority regarding Kingdom business—a walking signboard, *runner* who is accompanied by haste, or human agent *sent* by the Lord, himself, to deliver his messages, I am free. I don't pluck from a one stringed instrument, but a five string instead, and I am obligated to do what is asked of me with honor. I personally stand before you all as one given time sensitive material and special information, among those being, to announce to the people of the *King's* swift arrival, therefore, in so doing I feel a need. I feel the urge and the desire to strive to experience all of the missions that God has for me and to help those he has given me to watch over with the utmost respect." Whew, I take a breath before continuing..."...Now we apostles are not superior or, inferior to the brethren but we are commissioned as first and foremost in order of leadership and we are able to facilitate multiple offices *of* said leadership as delegated by the Holy Spirit of our Lord and Savior,

Jesus Christ. He then sends us out and trusts us to perform said mission and or, missions.

"Peeples family please, I invited you here in hopes that you would help me to help some of you, if not all of you. In so doing—praying—you will have helped me in return." "Why sure Lieumas, we're open to that thought," says Mr. Peeples, sarcastically might I mention. On the other hand, Mrs. Peeples, as she sits there, bumps his leg with her own leg as if by making a sweet gesture for him to stop being so cynical. "Thank you Mr. Peeples," I replied.

I continue with, "Here is another point I wish to make however; I am not naïve in knowing that we will have some disagreements and or, indifferences during our truth discussion, but being open to agree to disagree is a pleasant thought. Moreover, I am aware that I will not please everyone here so take what you can from what I present and propose to you and this proposal, from the one who sent me, and leave the rest for the others to grasp. It is because of that level of maturity, our truth discussion will go on peacefully.

"Now, this task of being an apostle includes my physically and spiritually messaging, or attempting to message, as well as my prayerfully watching over my family, friends and beloved. In addition to that, my duties are to watch over the church family and governments as well. This task also involves helping to *usher* those who know not the Lord into his everlasting Kingdom. Consider me to be as a, 'blue flaming, twin bladed sword,' flashing blurs of red, back and forth, guarding the way to the, *tree of life*, an 'earthly guardian' if you will, over *life* from the Lord, and *truth* of doctrine from his word, amen.

"Now my apostleship; bishopric, writership ministry offices were not designed and constructed through self appointment, or handed down through delegation by men of the clergy even. However, again it was a special dispensation personally initiated by God himself, and administrated by our Lord, Jesus Christ—our Savior. You see, I was especially handpicked by my Sovereign *employer*, again *three* times over, who being God, himself, and empowered via my *handler*, also known as the Holy Spirit or, Holy Ghost.

"Now some *do* consider me to be somewhat of a 'rogue' but hey, I admit that I am not your typical apostle; *I am different* and *I do*, do my own thing! However, I do not worry about what the other band members think anymore, I am being the instrument God desires to use for his glory and agenda; everyone else can play what they like. Again however, after much thought I have concluded, so did all the others—apostles—before me. Moreover, for this reason, the clergy recognized me and as a result, honored my calling from the Lord. They followed his counsel and proceeded, along

with the parishioners, as my witnesses for sacred duty. Therefore, after experiencing this, I too, can relate to these 12 apostles in many interesting ways regarding their special and personal call to ministry, as well as their lifestyles, also.

"As I read about their walk with the Lord in the Holy Bible, in an indirect correlation, I find myself walking right along with and in some cases, beside them—this is the second fold, once removed from the first. I apologize if that makes the both of you; to include the rest of your family, feel a bit uncomfortable. I must stand ready to defend, as well as give an account not only in season but out of season, also. So again, may I say to you all...critical thinker?!

"I must say though, I hid this ministry from the public at one time in the past and now feel, through the urging of the Holy Spirit, that I will hide it no more. I have accepted the fact that *in* this generation and *for* this generation, God specially designated me as the personal confirmation of his *covenant* with humanity; among others, he has called, of course humbly speaking, and this to avoid what my own prophetic brother, Elijah, perhaps inadvertently exclaimed. In addition to that, he has specifically chosen me to demonstrate his *righteousness* through Christ Jesus, beloved Peeples family. He has not only given me the keys to the kingdom of heaven utilized in unlocking and unraveling life's mysteries in, as well as, outside of his holy book, but by his *mercy, justice* and *grace*, he has washed me *with*, and stained me *by*, his blood.

"It is because of my faith in him; he has given me the anointing *seal of life* through the Holy Spirit. He has appointed me to be a light to the lost in the heart of a dark world hidden; lead the blind who cannot visualize hope for themselves let alone, humanity; deliver those whose souls are entrapped in self-imprisonment and locked away in the dark and damp self-guilt dungeons of their minds, to freedom. Yes, God has done this. He has done this *to* and *for* me, in order that he would receive glory from it; I am a representation *of* him, I am *not* him. It's true; the truth of these finds is stated in, The Book of the Prophet ISAIAH 42:1-9, KJV.

"Now having stated this, let me reinforce this and make it clear to all of you, this to include the gathering spectators: I am not the light but a light am I. I am not the sun, the greater of the two lights, but the lesser of the two lights, the moon, whose light draws from, as well as, reflect off, the sun's light; I am he. Moreover, just as Luck's charms and Cupid's love arrows suspend in midair, and logic and faith reasons between the two throughout the months of February, March and April every year, both a, flaming nova star of hope, and a showering rain cloud of refreshment, suspend in midair beside me, also; forever.

"Pardon me for my off-putting ramblings—at least for some of you—I just felt the need to establish and solidify the credentials and official duties of my ministries' to you. For I feel the desire to be forthcoming and upfront with you all. I must portray before you, honesty and genuineness as an authentic and official, Apostle of the Lord, instead of being reviewed as someone fostering trickery and deceit—disingenuous—and committing acts of 'young Jacobtry' and 'old Tom Foolery' against you.

"The Holy Bible riddles with these counterfeit apostles of Christ, *'false angels of light,'* really, and the world is full of them as well. Because of this, I am encouraged to defend my apostleship before the world, and to do so before hand; that is to say, before disruptive conclusions draw about me; you see, I am a protector of God's interests. I believe this is fair Mr. and Mrs. Peeples, how about you! Do you think this is fair, the both of you?

"Right now though, after clearing that up, I would like to engage you both from a bit of a different angle now, a more, unique stance, if you will. What is that? Yes, your children and children's children can listen in as well. Who knows right, perhaps they can teach it to their children coming after them; God would surely appreciate that. For some are not even born into this world yet and yet, are still known by God just the same, but well on their way to being born, nonetheless. They too, will need to learn the way of, The Christ, as he indeed is The Way, The Truth and The life, who knows them.

"Now then, the angle or stance from which I will engage you comes from the standpoint of the *Messiah*—which is a Jewish term meaning, *Christ*, in the Greek—Jesus, himself, and some of what he stands for, amen? Now, with good manners and having properly introduced myself, and the angle/stance to which I will discuss the Lord, I have another very important statement to make. Alternatively, shall I say, I have an important question to ask. Here goes nothing, but in every aspect of these next set of words… here goes everything!

"Did you know that Jesus told of many stories in the Holy Bible over two thousand years ago that have relevance in today's society; like, *right now*, even? It is true. Some are allegorical and some are metaphorical. Some are even figuratively, literally as well as historically and genealogically based, too! Some even, are for the sake of imagery, hyperbole and analogy, and for my own sake of artistry, a bit of satire tossed in, as well. However, lend your eyes and ears to this; it is *all truth*, and *truth based*, nonetheless."

Beloved and friends, surprising as it may seem to some, allegorical and the like does not render it false but renders it, *interestingly true*, instead. "In addition, and more interestingly than that, for the first time ever, the Lord has given *me* the opportunity and even more importantly, the privilege to tell of these stories, and to reveal the truth of the messages hidden

behind some of them. I do these things for him through my ministry and throughout my writing. As I have previously stated and or, alluded to early on, it is sort of a new journey for me in the realm of ministry (compared to most) and ministering through writing, as my latest venture attack.

"However, here's the thing! God knows I have the unsettling quirk of a 'perfectionalist,' even so, he told me that I did not have to be experienced, like that of, *the professionals*, but just to have a, willing…heart! He said that criticism would somehow find its mark on my work—both good and bad criticism, to say the least. He encouraged me to be strong though, as he placed the signet ring on my finger, sandals on my feet and the best robe on my back and said just to be myself. He said to deliver the messages anyway as his Spirit goes and clears the path before me, covers me on both sides and protects me from the rear; it is in his nature to do so.

"Perhaps this is God's plan to begin with, you know, my learning to be okay with *imperfections* in an otherwise quote unquote, *perfect* world, my critics too. Perhaps even, his conceptualized way of thinking along with my contextualized style of writing—even in reverse order—will also secure my insecurities and convict my would be critic assassins. I'm just excited to be a part of his plan and thus be given an added platform from which to carry on with his work.

"You see, I don't do this to win a prize, not that there's anything wrong with the potential of winning literary prizes along this journey; I would gladly and humbly accept them all. However, far be it from me to lay claim as a professional writer; I am just, a writer. With me, I am who I am, what you see is what you get; take me as I am, key character flaws and all. Who knows right, I may get better with time; even so, will you still want me then, but in reverse order, like right now?

"You see, even though I'm 'down to earth,' as my roommate, God knows what is inside my heart. He knows because he lives there. Moreover, God knows what is inside my mind for I have the mind of Christ. Therefore, that is what I will strive to do, amen! I will just be myself, remain 'down to earth' and let the Holy Spirit do the rest. Moreover, that is all any of us in the world of Christianity can do quite honestly, amen. For it is in Christ that we fit a higher standard from which to be observed from others. Yes, I will just let the Holy Spirit do the voiceovers this time; God has safely placed him as my encasement.

"Now, humanly speaking, it is easy being ourselves but not easy being someone else, right. Alternatively speaking, it is easy being someone else as opposed to being ourselves, too! Would I be right in both your opinions Mr. and Mrs. Peeples? Even for those who are non-Christians, they tend to experience them both.

"Having said that though, being ourselves gives way to experiencing freedom to enjoy ourselves to say the least, or even tolerate ourselves at best because…well, let's face it; we are supposed to be *free* in Christ, you know, the higher standard. Hey, we have the signet ring to prove it, remember. However, store this in the back of your gray matter for a time or two… there is indeed an *old self* and a *new self* in the mix of life. Quite truthfully, I must add, they are in constant battle with one another and at times, the latter you, will fall back, physically speaking. Spiritually speaking though, the latter you, will never fall back beyond re-cooperation and recovery, the Holy Spirit will see to that if you are inept, perhaps in reverse order, to allow him.

"Now, having cleared that up, I must regress, in reverse order, and regain the traction that I lost by digressing, amen. As a Minister, I do minister in a special way that is indeed familiar and comfortable to me in hopes that they will become as such to you, too. I believe God has wired me this way in order for me to reach out to the masses in both, the Christian and the Secular worldviews, the remnant and the mainstream audiences. He has equipped me this way in order for me to reach out to an overall generation that is in a crisis. He has encouraged me to do this in order that I would reach out to a people that seek to know more of God's truth, but in a special and personal way, amen.

"Mr. and Mrs. Peeples, he has birthed within the core of my heart, an inner being of fire by way of the Holy Ghost! A flame powerful enough to experience all that he would have me to, in order to minister to you in a way by which some of you would come to know of his special, and personal, presence in your lives. He—God—wants you, the populous, to know just how approachable he is. In adding to that claim Mr. and Mrs. Peeples, he wants this approach to him to flow into the lives and hearts of this present generation, and the generation that is to follow also, amen. This is why I strive to maintain myself as a well-oiled machine in order that the mighty breath of the Lord's Spirit can maneuver me from point A to point B, and back again. To this, I ask of you, pray for me.

"Now is it easy for me, you know, experiencing some of the things that I do? The answer to that question, in part, it has gotten a little easier; the answer to that like question, in full, no indeed not! It is not easy for any of us as Christians (non-professional leaders–*laymen*, and professional leaders–*vocational ministers*, alike), but you know what? Going into this I knew that it would not be easy, but I also knew somehow, and understood in someway, that it would be very necessary. That *somehow* and that *someway*, was and still is, the Holy Spirit. In saying that, I have found it to be, he who makes this new life a little bit easier to necessitate. Many do

not believe me but at the same time, many *do* believe me so again I ask, will you pray for me?"

You see beloved, friends, and spectators, sometimes Lieumas has to go through some, *out of the ordinary*, things in his own life in order to be able to have something, to the tune of experience, to minister to you about; you know, something that is perhaps going on, *out of the ordinary*, in your own lives. If he has *not* gone through anything, then how is it possible for him as God's "pet wolf," the Peeples' truth discussion host and a divine messenger of the Lord to reach out to those amongst the masses who *are* going through something in their own lives? Notice I said sometimes...

"Peeples family, the word, *sometimes*, is the operative term our narrator uses here because as God's 'lone prisoner,' and divine minister and angel of the Lord, he has the Holy Spirit feeding him platters of dispensations. This doing is in order that he is able to feed you all plates *from* these platters, and according *to* these dispensations. He does not possess a need to *go through*, but better yet, be equipped to *follow through* sometimes, instead.

"Listen to me, God knows all and God sees everything; because of this, he is able to understand situations in life as he sees them occur, in order to dispense answers thereof to those needing answers—even if they (*the writers*) have not gone through these particular and specific situations for themselves. You will be amazed at what truths or lack thereof, may come out of the mouths of people, in the midst of dialogue. Just as so, you will be amazed at the many places from which God's messages flow, for he is, The Creator, of the heavens and the earth—the entire, universe, even.

"Now this is not limited to just you two who are heading this family, no, uh-uh, this includes your brothers and sisters in the Lord, as well. This is not limited to you all though, but I speak of your non-Christian relatives who are in your *family tree* too, amen? You too, are going, or will go, or have gone through some, *out of the ordinary*, things in your own lives, as well! Please, may I dispense to you these words and do not think that they are being yelled at you. No, honestly, I just want you to see the importance of them as they stand out okay."

LET IT BIRTH CHARACTER IN YOU AND LET IT NOT BREAK YOUR SPIRIT, AMEN? LET IT BECOME A PART OF YOUR GROWTH SPURT IN THE LORD AND LET IT NOT STUNT YOUR GROWTH IN HIM, DO YOU HEAR ME? AMEN!

"There you have it, they have been dispensed; perhaps let me put it into perspective for you. You see, even though difficulties will stand to face me, my difficulties become, *less difficult*, having Jesus Christ walking by my

side. My sorrows become, *joy within my sorrows*, with Jesus Christ living inside my heart. My lack of self-confidence becomes, *me being bold*, in my lack of self-confidence with Jesus Christ ministering to me in my spirit. My havoc regarding this side of life becomes *peace of mind*, within the havoc of this side of life, with Jesus Christ at the helm steering and navigating the ship, and inviting me to have a seat as his copilot, and so on and so forth. The result of this is because of my prayers, and it is because of your prayers for yourselves, *and* for me. Besides, though, having said all of that, *out of the ordinary*, is quite, *the ordinary*, in today's society, you know. Even still, living for God does not mean that we turn our backs on society. We *are* a part of society, the parts that stand out! With this brings negative outsiders but with it comes positive insiders as well, perhaps in reverse order, too! Let us continue praying for one another, amen.

"Listen Mr. Peeples, Jesus Christ absolutely wants the best for you and all who belong to you—in the family sense of the word—because they originally belong to him, too! Mrs. Peeples, he wants you and your family to come back to him and to come to an understanding of him a little more, that is…if you have already returned to him but seek further understanding, of him. Is this passion from God fair in your assessment? He has made a way for that to happen, you know, this idea of returning to him. The idea of personally bringing you to him through *special* and *personal* means has indeed happened. His joy in that is having you find out how this plays out in your own life. Keep looking; keep listening. Keep thinking; keep digging…

"Now as a Minister of our Lord, and through the miraculous discovery of this, newfound love of ministering through writing, that I now have and most probably was born with, to some degree, I have noticed something… I have found myself to indulge in other worldly and also, spiritual endeavors (through reading and researching, including the Holy Bible) in order to achieve self-validation, as well as confirmation from God, of the truths I have come upon, resulting in affirmation. Ironically, I *do* in fact 'remember' having always loved to do this since I was a child (read, research, and even write a little). I give to you first, the spiritual endeavors and later on in another chapter, the worldly endeavors.

"Now then, in the writing of their many books, and through speaking engagements from my peers and colleagues, I find a few of them having differing opinions; some of which are different than my own, which is not wrong intrinsically for each is entitled to their own opinions. However, more or less, I have found a few of them to, how shall I say this—oh! I got it…not very understanding of the way that God may speak to a person, or even another believer in a most critical, personal, special, in-depth and

interesting way; this is where I have come to believe wrongful misjudging occurs. Some examples of these ways are as follows: open visions and closed dreams, short insightful glimpses, gifts of hind-site/foresight, audible communication, feelings of empathy, through other people, intercessory and even in parabolic form (universally), usage for the purpose of examples and teachable moments—sometimes a daunting task—, and through dispensation and divine messaging from, The Holy Bible. Oh, and I cannot forget most importantly enough, prayer, too, just to name a few. Uh-huh…yeah, I think that works!

"You see, God sometimes take the physical aspects of something and later manifest it spiritually. He then, at other times, implements this in reverse order by taking the spiritual aspects of something and later, manifests it in the physical, too! The Holy Bible alludes to this as sometimes being locked (bound) in heaven locked on earth; unlocked (loosed) in heaven unlocked on earth, types of occurrences. Others may have heard it as being said, 'As it is in heaven so shall it be on earth,' and even in reverse order, 'As it be on earth so shall it is in heaven.'

"Some of God's leaders find this strategy illusive. Even so, that is their opinion though. Listen, that's okay with me because I understand how they may feel, you know, being made up mainly, but not all, of the 'orthodoxy ecclesiasticism type' body of believers, and having really never experienced this sort of thing (lucidly or fluently) themselves perhaps. Even so, I love them all the same for they are as much of the *body* as I am; just a little closed minded in their perception, teaching and or, approach to things of a different nature, I suppose, a different 'animal,' altogether, so to speak. Their 'wheelhouse' is in teaching—religious seminarian scholastics—so that is what they are familiar with; it's what they do! More so, by God, I applaud them for what they do in and for the body; we need great Bible teachers and gifted speakers, but of an unorthodox Theological perspective sometimes, when the Spirit allows such an occurrence, to implement the learning and proper application of the word of God. Amen.

"I will say this though, my stomach is a bit strong and 'bad sandwiches,' or 'bad tacos,' do not have that kind of affect on me that I might experience Holy Spiritual motivated things. It just may be that my 'television set' is tuned to a different channel than theirs. I might 'swim' in the opposite streamline (upstream/downstream) or even perhaps, an *electrical current* than what they swim. In other words, my eye vision, work processes and thinking patterns may be out of range or 'out of the box' for some of them.

"You know that old saying, 'The glass may be half-empty for some but half-full for others,' or something like that. Perhaps they bathe under a standard type showerhead while I bathe under a 'liquid avalanche.' Oh, here

is one! It just might be that, 'I march to the beat of a different drummer' or something like that, and at times, a different drummer than he—all beats are not of drum… Tooting one's own horn may be amiss but even to march to the beat of one's own drum may not be such a bad thing.

"Ooh-ooh, I know; how bout this one! Whereas they may enter through the front door, it may be that I was sent to exit around back through the sliding glass door, or even, slip through the side door; depends on the layout of the house I guess. They may be on the outside looking into the window and I may be on the inside looking out through the window; perhaps in reverse order; again, depending on the layout of the house. Well on second thought…not so much.

"Maybe, just maybe, I have 'clearance' therefore accessing the secret chambers of God, in his *throne room*. You see, when they ask the question of, 'Why?' I respond by asking the question of, 'Why not?' It's that sort of thing I'm talking about, yeah, that version. I am not being difficult; I am just being whom God made. It's my vision; it's what *I* do! And if you think, I'm causing waves then learn how to surf! I always wanted to say that. There is no need for me to go on; I believe my point is well worth taking. Do you know what I am saying? You get the idea!

"Now then, unlike you Mr. Peeples, I am not trying to be sarcastic, coy or cynical here, but I have heard several of God's ministers say that, 'bad sandwiches/bad tacos,' sort of thing over the years but even so, I respect them nonetheless. For again, I say to you, they are my peers and my colleagues and I love them all the same. I just hope that some of them would, by God, give applause to us for what *we* do in and for the Body, and perhaps not judge too harshly, God's ministers and or, his children, who are of the *same team* without first giving these same ministers and children of God, the benefit of the doubt. For the very ones who claim that the Sovereignty of God is without limits and or, restrictions are in fact the same ones who, in the same breath, place these same limits and or, restrictions upon a Sovereign God. Let that one sink in for a minute also…

"Besides though, not to mention, wouldn't the Old Testament prophets as well as the New Testament apostles who had these like visions and dreams be accused as having eaten 'bad food,' also. Examples of these would be like for instance 'bad tacos' and 'bad sandwiches' just the same, even leavened bread which, physically and not spiritually speaking, really, isn't quite so bad resting on the palate; but who's taking orders right. I would think not; perhaps I have missed something… Therefore, it is as such, the, *right now* apostles and the, *right now* prophets, experience an *authentic anointing* just the same as the other different ministers of God, even those who were living out these like experiences in the biblical account.

"Listen, I know we are to discern truth and the aspects thereof but this is usually the world point of view stance, not the stance of our fellow Christian brothers and sisters in the Lord. Perhaps I'm being a bit naïve. Anyway, God knows the heart and the intensions thereof. I guess that goes both ways to be fair, you know. Just like a physical body operating at abnormal heightened temperatures, we can agree to disagree about our current condition; our opposing positions, we *are* civilized and belong to the same body of Christ, I am right, right? I mean this fever will subside and all will be well again, if not now on our earthly home then later on in our heavenly abode.

"However, having said that, God explains in his word, the 'art of distribution.' I say this right now because God mentions that there are many *gifts* distributed in his body—The Church—but he only names one source (Holy Spirit) as being the distributor *of* those gifts. To me this says that we all have differing gifts but are of the same spirit as Christians. Therefore, I cannot reduce any of my brothers and sisters in the Lord. For that would be the same as reducing the Holy Spirit, himself, and myself as well. #ImJustSaying. It would resemble that of self-destruction in other words and that is because his *Spirit* and his *gifts* are within us. Considering the Lord's House, forget not that a house divided against its own self cannot stand. Sure, some things in the spiritual family tree have to be shaken loose and the foundation shifted, or readjusted, or arrangements rearranged even, but surely not divided. For if it were so, it (God's House) would not stand.

"Listen, I cater to the Holy Spirit. The Holy Spirit then turns around and caters towards many. What the Holy Spirit gives to me regarding Intel, I turn around and distribute the crux of it to the whole of humanity. What I mean by these two statements is this: I dispense whatever my *handler's* Intel is to me. The message may not be for everyone *within humanity* but it will be for someone *within society* nevertheless. He takes the message I dispense (my part) and transitions the heart for the one (s) to receive it (his part) for we are *partners* in this.

"Listen again, I, being an *apostolic ambassador*, do not make me superior and or, inferior to any of my colleagues in leadership who may be prophets, evangelists, pastor-teachers, or other apostles, even. We all are considered *the leadership* within the church body. Moreover, we all need each other within the body as well—even those outside of leadership are included with us (vocational/layman/body life ministers). We need each other within the church, we all exercise gifts to promote encouragement etc; and as leaders, we promote advancement. Each function which we reside over, or might I say, resides over us helps the body as a whole; it just boils down to jurisdiction, as far as leadership is concerned, and even

beyond that. What I mean by 'beyond that' is this: we all need each other within the church, we all exercise gifts to spread the Gospel message to others in hopes to produce disciples of Christ; in hopes that it sticks.

"Allow me to focus in on the leadership for a brief moment. A great example of this jurisdiction would be found in the Law Enforcement Agencies, again, as far as the leadership is concerned. Allow me to explain: The C.I.A. (Central Intelligence Agency) have jurisdiction on an international level. The FBI (Federal Bureau of Investigations) have jurisdiction at national level. The DPS (Department of Public Safety/ State Troopers) have jurisdiction on the state level. The County Sheriff's Office have jurisdiction on the county level. The Local Police Department have jurisdiction on the city level. They all have differing job titles and descriptions however; they have legal authority to enforce the Laws of the Land nonetheless. They may even operate outside of their perspective jurisdictions in the sense of aiding the other agencies, if special duties call for such actions. Even so, they respectively refrain from, 'coloring outside of the lines,' so to speak.

"The same would be implied—especially where dispensation is concerned—for apostles, prophets, evangelists, pastors, and teachers. The apostles would have 'international jurisdiction,' the prophets having the 'national jurisdiction,' the evangelists having 'regional jurisdiction,' and the pastors and teachers having the 'state and city jurisdictions' (local church/branch locations). Each particular anointing may assist the other as well even though operating in one's own gifting is a vital key to having church structure strengthened. These examples are, in essence of course, for sake of analogy, but with truth attached. I hope I have made myself clear on this matter.

"It is because of this personal and special way, this unique blend, that we have become 'as one' with God, and Jesus Christ—at *new birth*, amen. However, there is much more to the story than just that." "What more is there Mr. Lieumas Leumas...I mean, Mr. Ettesorde?" asked Mrs. Peeples. "Please, just call me Lieumas," I stated. I continue with, "The *more* is that we do not let these special communications, or lacks thereof, with God through the Holy Spirit, curve our benevolence for others and toward one another as Christians. We must show humility not malevolence. We should display humbleness in the eyes of humanity and in the eyes of God. He is the Creator of the universe and everything in it. We do not have to be weak in the eyes of humanity but showing meekness is not so bad.

"I feel hard pressed to do so Mr. and Mrs. Peeples, and your offspring too; therefore, I feel I must explain even further. Please listen carefully, God has blessed me to experience the special and personable way Christ

Jesus communicates with me. You should understand that God has blessed some of you as well. In addition to that, others of you God will bless to experience the way Christ communicates with you also, for it is special in and of itself, amen. No matter how he does his communicating, to the masses, to you and I as individuals, let me just add that to know that his presence is involved in our lives at all, is most exhilarating and it is the most important."

"So the point is not how he does it but rather that he does it at all am I right?" asked Mrs. Peeples. "Amen indeed, and you *are* correct indeed, Mrs. Peeples," I said. "I also understand you to mean that as Christians, it makes us no different from one another, in terms of greatness, in the eyes of our peers, colleagues, and especially our Lord and Savior—Jesus Christ; is that also correct?" asked Mr. Peeples. I continue with, "That is correct Mr. Peeples; believe me when I say that we all go through the same pitfalls that many of our peers and colleagues go through. To be honest, Jesus even understands this because he went through many hardships himself, too! He faced more outlandish (for that particular lifetime) types of suffering than we could *ever* possibly imagine. He faced more persecution than what we (even in this current lifetime) could *never* possibly imagine, and I mean to say that with all of my mind, heart, body, soul and spirit.

"Now, having said all of that I would like to begin, or shall I say, I would like to continue our truth discussion in all humbleness and with humility, by stating to you this first obvious truth among the many, many truths that will follow behind it, amen! I want to gradually coast into this truth before we tackle the heart and soul—core—of this discussion, story and its timeless message. I want to talk about the importance of having food and water in the desert for a while and may I add that in doing so, I will express a little poetry from my poetic journal throughout our truth discussion okay. This is for the sake of the children in your huge family and for you two, as well—all who love poetry, as I did when I was a lad, amen! Oh, by the way, did you all pack your red and black swimsuits, and your blue and yellow swim trunks?"

There are Two Options of Eternity?

Jesus is the Christ; he is the Author of life
His words are with power, cuts like a double-edged knife
The word infiltrates the bone, penetrates through the marrow
God's love is unconditional even hardening the heart of Pharaoh.

Watch closely and pay attention
His words come alive as you hear it
Jesus inspired the words and works of the Holy Bible
This doing is to encourage and revive your spirit
His truths can be trusted, for he is reliable!

Jesus took food from his hopeless disciples
In the form of fish and in the form of bread
He blessed it then broke it before their very eyes
Causing a miracle of hope for them all, instead.

The crowds were all seeking and hungry that day
To which he personally fed out in that desert field
Today this miracle of hope still lives
Long after that faithful day God, revealed.

Today this special Miracle from God name, Jesus
Is still feeding us and the crowd
Feeding crowds for which he died and rose
He right now lives for us all, out loud!

Now beloved and friends, it is a bit of a shift they are going to go through in regards to subject matter and content, throughout the truth discussion that Mr. Ettesorde and the Peeples family is having. You may even face information overload at times that is, if you haven't already. However, please take some time to digest the food properly by processing this information, as they, the Peeples family, should, amen!

At this time, follow along with me as I follow along with Lieumas as we get started, and trust me, we will get through it okay. It will be as like a beautiful tapestry composed of many diverse and colorful thread patterns, and unique parts woven together perfectly, like a quilt. However though, at the end of the day, formulating as one harmonious blanket piece, just as it began. May I say to you all that this is the goal here, amen? Lieumas will now resume his place in their truth discussion. Let us all listen in on their dialogue, and the interesting narratives that follow accordingly.

"Now Peeples family," Lieumas says, "I believe that having food in the desert is so very important and that it is extremely vital to the physical body to sustain itself in *life*. I believe most would agree with that statement do you all, as well." "Well if you're asking a question Mr. Ettesorde, yes I guess so," says Mrs. Peeples. She then goes on to say, "You are pretty hard to gauge sometimes, that is why I asked."

I give to her a pleasant look and a meaningful smile, then I proceed with and I quote, "I also believe that having water in the desert is equally, if not *more*, important to have the physical body survive in the hot climate, and dry terrain, as well. Again, most would agree there too, right? Mr. Peeples? Sir, Mr. Peeples? Would you agree with that statement or are you, as well, confused as to my questioning techniques?"

"Yes, I agree Lieumas," says Mr. Peeples. I continue with, "But going two, three, or even more weeks at a time without food, well, one could still survive perhaps a little while longer before starvation takes its toll and results in a slow demise, no argument there. However, going seven to eight days at a time in the desert without water alone is a different story, and that different story comes with a different ending altogether—and a quick one, might I add. That alternate ending my friends, sadly to say, is *death*."

At this point, beloved and friends, the children and especially, the children's children, shrink back in their places on the couches as some of the mothers and fathers shriek of fear. As they cup their hands over the ears of the smaller children, they put on faces of seemingly horrific proportions—Mr. and Mrs. Peeples, too! With a slight bit of hesitant reluctance, Lieumas, at this point presses on through with the truth discussion anyway, as he continues in what he were saying.

"Now, I know that for some of you, that tragic word, *death*, and even

this subject matter in general, is a bit touchy and a difficult pill to swallow at times, and rightfully so. Nevertheless my beloved Peeples family, even in that regard, it is a sure reality nonetheless; the Holy Bible even speaks of death. However, another word opposite of death that may lift your spirit does exist as well. It is a sure reality just the same. This word is *life*. Is this better Peeples family?"

Now as it stands beloved and friends, at this point Mr. and Mrs. Peeples display a sigh of relief while taking off the cups along side their ears. In addition to those two, the other adults take the cups off the children's ears in this huge family, as well. Everyone is mellowing out again. Lieumas continues by saying his next series of words and believe me; it is priceless; at least in my own measure! I must also inform you, it is not one of those, "long story made short," type deals either. Let us place and weigh it on the scales together and see how it leans, and what takes place.

Now these next series of words are strategic in his quest to get the Peeples family to understand at close range, the realistic value of hope for survival in an otherwise unsuccessful world of survival, without hope. This scenario is to potentially play out, even though as like a made for T.V. Soap Opera, the mellow may turn into the mellow dramatic, once more. Even so, he takes his "chances." *Besides…* Lieumas thinks to himself *…surely they have seen worse off in movies.* "These two words of, *death* and *life*, interestingly enough are also words in which the same Holy Bible speaks of throughout its many pages as well," he convinces them by verbally stating.

"Picture this if you will, Mr. and Mrs. Peeples, and all of your extended families too, please bear with me for just a moment. You are traveling through the hot desert terrain and the dry weather is chapping your lips something terrible. Because you have not any water left from your, once full, now empty, canteen bottle, you shriek, cringe and bite your fingernails down to the nubs. You have searched for an oasis of *refreshment* or at best, a mirage of *hope*, but…

"You shake the canteen, rigorously look through the opening of its top, down into a, what seems to be, an endless black hole. You then, frantically might I add, turn the bottle upside down with a wish, a hope and a prayer. You shake it a little more vigorously this time, and all you can squeeze from the spout is a single tiny droplet of water. Prayer answered, perhaps. You now, strategically might I add, contemplate the careful execution of quenching your thirst; here goes nothing, but in every aspect of the attempt, here goes everything!

"The droplet of water hangs on the edge of the lid which dangles for a, what seems to be an hour like, minute. In a desperate attempt to moisten your lips from it, the sparkling droplet drops past your lips without even as much

as a touch *to* your lips. You pause at this point in life, all the while in disbelief. As if by slow motion, in your mind, you play back the scene of your eyes of desperation following the clear blue droplet as it is found spiraling downward, and which then hits the very dry ground, you are standing on becoming desert, itself, and therefore having it never touching your lips as you planned.

"At this point, it seems as though you are facing near death as death, itself, smiles at you forebodingly. You fall to your knees in anguish but hoping as you look up into the clear blue sky, for a drop of refreshing white rain to miraculously, pour out of the scarce white and gray clouds disguised as backup, at least one droplet; 'C'mon, give me something!,' you manage to squeeze out. Your throat is dry and your tongue is parched. If that wasn't bad enough, you have not slept for quite a few days now but instead, your daunting eyes lock on the bright yellow stars of heaven as though they seek this unattainable slumber. You are so tired, and, so tired of reaching for this illusive sleep, that your stomach feels quite nauseous, and your head screams that it aches something terrible. Even so, you attempt to eat some food hoping to gain strength from it, but slowly though, (for fear that you may vomit) as you pull off your backpack while attempting to empty its contents.

"Now you discover that the empty food sack that attaches to your back by means of a tiny single strap is no longer heavy as before due to the horrific fact of its now, food scarcity. Due to mind fatigue, you have forgotten when was the last time you ate anything at all while at the same time, realizing that you may have taken a bite or two earlier, or perhaps wild animals, may have eaten the last of your food; you're dazed and confused. Even so, the backpack now becomes as light as an eagle's feather. It is as light as it was before you placed large amounts of food in it and now your stomach, in its queasiness, growls from hunger pains even more so because of it. Your heart begins to whimper that it aches.

"That empty canteen bottle and that empty food sack is a sign of what is to come, and sadly my friends, what is to come…is not good. Are you with me so far? Mr. Peeples? Sir, Mr. Peeples? Are you with me so far? You are shaking your head as if by saying no, I presume. How about you Mrs. Peeples, are you with me so far? Ma'am you are shaking your head and saying yes, while seemingly confused still. It's quite okay though, I will explain further to the both of you, including your offspring as well. That is why I am here. Please, I ask of you, do not be alarmed?

"You see, as an ex-military soldier, in another place and time, I can say that I have indeed spent some time out in the field and to some degree, the desert climate as well. Although my body was not weak because we had plenty of food and water out there, I cannot say that I have truly experienced, firsthand knowledge, that which I have deduced in my

previous statements. However, for the sake of this important illustration as well as research, I will explain the other side when one becomes, or may become weak for lack of food and water—provisions—for an extensive period. This especially while spending time alone in the white desert sand.

"Now I must say with all due respect to the film industry, it is not anything like the desert races in Morocco, the television hit, Survivor, or the T.V. series, Naked And Afraid, either. I must warn you also, to prepare yourselves, as the deducing from this angle may become a little less comfortable to bear as well, more so than the previous; but it may be a deduction, which is still to scale, nonetheless. Again, do not be alarmed but do be aware. Oh yeah, and in case you are wondering, yes, my *employer* allows me to see in the clear, even without the sunglasses, perhaps in reverse order. I just choose to wear them, and for good reason.

"You see, in the daytime, the blistering gold colored sun beats down upon the weakened body, disheartening eyes included. During the black of night though, one would think that it gets better because it is no longer hot! However, what they fail to realize is that the night brings with it, *cold* temperatures pressing against the still, weakened body. It is even weaker now because of the elapsed time in hours, and in *nights* that went by from an even earlier exposure to the outside elements, to include unseen sand and dust particles, and flying debris (eye protection at night) in the previous *days* gone by. This is causing the mind to ponder the thought of giving up and suggesting to the hand of just throwing in the white towel and or, waving the white flag of surrender. The brain is scanning right about now, these following words but then eventually the heart will receive the signal and cry them out, through its mouth!"

"My God, some food and water, and rest would sure be wonderful right now! I need to build up my strength to carry on. There are huge black ravens (caw caw), gray and white buzzards and gray and white vultures circling above me and I think I do not have much time left. I thought I was in good enough shape to survive these current conditions on my own, but I now realize that I am not. I feel like giving up and just throwing in the white towel; I feel like waving the white flag of surrender. That would certainly be better than this! I am so tired… I am so weary while I trudge, and my immune system is becoming quite vulnerable.

"I have no more water left in my canteen bottle and I have not any food left in my backpack. My identity is in grave condition and my name is, Despair. My heart is in pain, my mind is restless as the yellow and black hyenas, and the gray wolves too, are beginning to howl. It frightens me to know what may come for me… I wish twin were here. I'm frightened, by what may, become of me…"

Beloved and friends, I think it is safe to say that this severe outcome as told by Lieumas, concerning Despair, would indeed become a travesty but nonetheless accurate. Now I do not mean to say "safely," that in the sense of sadly witnessing the heart giving up, and the mind suggesting to the hand of just throwing in the white towel is a good thing. However, joyfully speaking, some hearts *would* give up and minds suggest to the hand to wave the white flag and their body just surrender; but what I mean is in the sense that there would not be a whole lot of time left, you know, for the mind and heart to survive. I mention this because to survive the outside elements of the desert and its dreary conditions, which would be taking advantage of the body all on its own, is quite treacherous, to say the least. On the other hand though, *would* having a white towel to cast, and or, having a white flag to wave, more than likely be…leading the mind to experience the heart, and again but in reverse order, as both are being led *to* salvation?

"Now birds are quite a peculiar and lovely species Mr. and Mrs. Peeples, but some types of birds, although peculiar and lovely, are quite dangerous—especially for the weaker species of animals to include other birds even. The ravens are black; they are beautiful in color, but are indeed symbols of doom. As far as for the gray and white buzzards and gray and white vultures are concerned, well let me just say that they can indeed smell death approaching in the air, and they…are…coming! Based on the evidence of their stalking circular flight patterns, there is knowledge of destruction, and that the end is near, or even that the expiration date has come already. It is very true indeed! Despair, will continue by saying these following words:"

"O God, again I cry out to you for help! I cry out by faith this time! If only you would have mercy on me and send someone to come along and rescue me. If only you would extend your grace towards my direction and send someone to snatch me from the jaws of *death*, itself, after having searched for me day and night because you, in your infinite wisdom, knew that I was lost out here on my own, eeekk! I feel like you are at war with me, God. Perhaps it may be that I am actually, at war with you, even.

"Wait! What is that in the background so far away and yet, so close up? It looks to be a huge black wall cloud hanging there, in the balance, stalking me with its intensely electrifying eyes of lightning. The bottom of it has the remnants of a swirling tail, as like if nephilim or even archangels with an enormous spoon are stirring it like a beverage. This tail like image, and there are many of them, which I witness across the sky, is spiraling downward toward the earth's landscape. Sparks from the stones are ricocheting off each other and the earth, and are projecting from its tails! They are tossing up and raining down causing hail like damage and

brushfires all around, like smoke and brimstone or some other catastrophic disastrous thing! Woe is me, for I cannot survive its wrath; lo and behold, it is coming right towards me! My luck just ran out, 'for the love of God,' help." "Peeples family, something over and abundantly striking, and more so, miraculously happens as Despair will cry out these words:"

"Behold my God! At a distance, I see a man as his coming is on his white steed and with its bonny physique, pulling behind it a gold chariot with bronze wheels spinning and skipping over the earth like twin tornadoes. He is moving rather swiftly across the desert floor escaping, himself, the jaws of death, itself, and it is not a mirage! It is a miracle!" "Now the sand and dirt kicks up behind his horse's hooves as the windstorm gusts seem to be producing a hurricane in his wake, beloved Peeples family." ...*This is amazing!* "Despair will think this to self before spewing these words out of its mouth like so: "This is amazing!" "Despair will then continue with these words:"

"Above him, I see *white doves*, black falcons and white and black eagles, chasing the *black ravens*, gray and white buzzards and gray and white vultures away, and then circling back around and encompassing him. The brown horses that he brings along with his winged transparent troops riding atop their backs are frightening the black and yellow hyenas and the gray wolves away, too! Also, and I see with him attached to the right and left sides of his thighs are what seem to be, what looks to be... food and water!

"Yes! LORD, he is coming into focus now, and I can clearly hear the white stallion's hooves beating against the floor of the hot desert sand. Sounding louder and louder and even, louder than before, simultaneously in twin with his own heartbeat, he, upon it, moves closer and closer to me." "At this point in life and or, death, Peeples family, Despair will clearly hear, with confidence more so now, the loud, *Clickety clack-thump thump! Clickety clack-thump thump!! Clickety clack-thump thump!!!* There is even more rejoicing from him. Despair will continue with these words:"

"Yes, he has found me, and love, new life, liberty and salvation have indeed come for me. He looks like a knight in white shining armor with four added distinct colors from, bottom to top, of bronze, silver, gold and sapphire that is racing against the backdrop painted the color of night, and all of this is in order to rescue me? As he leans over the side of his white horse in full gallop towards me ready to give me a brand new identity, even as I gasp, I will wave the white flag of surrender; I will cast the white towel at his feet. I will stand to my feet. Yes, I must stand to my *feet* ready to receive him and his providence. Even so, if I am *unable* to stand due to my weakness, I will surely lift my *hands* to him, instead.

"Indeed, with the food and water that he brings, Faith, Hope and Love integrated with Peace, Strength and Rejuvenation and Rest will become my new names! He even has a chestnut brown horse and a gold chariot for me too! He even has a third and fourth horse along with their chariots; perhaps there are others who are *still lost* out here somewhere in the dry desert and needs rescuing besides me?"

"Despair will continue rejoicing with these words:" "His eyes are like fiery red laser beams perfectly fixed upon me as he reaches for me with his outstretched arms. He has a rainbow colored name badge affixed to his white robe! For the life of me, I cannot seem to make out what it says though; is he friend or is he foe? Am I right, or could I have been wrong all this time! Will this be the *death* of me, or the *new* sustaining *life* of me? Wait, his silhouette is in full view now! Oh gracious me! I think it reads..."

"It is because of these two very important components of food and water that the human body can operate successfully in the world, let alone, the desert, Peeples family. You see, God designed us with a uniqueness in mind, did you know that? It is so true. Now when I use the term *us* in this context, I speak of all nationalities, and ethnic backgrounds, amen. I speak of all the *human race* to be exact, and God created all of us— Humanity. Yes, God, through Jesus Christ, created all people. What makes you different from me in outward appearance is the *paint color* and *brush texture*; as far as the inward appearance is concerned...well, that's another story not so far removed from this one. Even so, God could have turned his back on a blank canvas but instead, he chose to create.

"God designed us to not only ingest food and water in their physical form in order to have life and to sustain life through its rigorous physical journey, which includes vigorous exercise—as human beings. However, what I want us to realize is this Mr. and Mrs. Peeples and please, listen carefully. Here it is; God also designed us to ingest these substances in their spiritual form just as much, and for preparing us for the spiritual beings that we are to become—which is a bit more important for the journey. It is more important because spirituality is important and has its rewards for, not only this life, but the next life as well—it is not temporal but rather, it has an eternal promise attached to it!

"Now, he has put this structural and strategic plan in place all by himself did you know that. Do your children know that? Do their children perhaps know that as well? Do your extended families know this? Again, it is true indeed. He did this in order for us to be able to remain strong for both, the physical journey, and the spiritual journey, of life eternal. It is a solid plan that we all have the opportunity to engage in as *free* human beings, and it is what God, through Christ Jesus, in his infinite love and wisdom, designed."

Now beloved and friends, when Lieumas says *free* human beings, he does not mean free from a type of "Sin bondage" *we were*, and *we all are* born into, although that particular choice of freedom may come later, and through faith no less. We will get to that a little bit farther up the road perhaps. However, when he says *free*, he means *freewill* or, *free choice* for lack of a better term or sake thereof, to choose between two options of eternity. Having said that let us approach the word, *option*, for a moment. What does the word mean? Well, it simply means the following: *a choice of, or in, a particular avenue, by which an action takes place*. This may be a good and or, fair way to exist for the sake of eternity, right—freedom of choice to implement a particular lifestyle, forever. Just think along those lines for a moment.

Now for the second word, we have, well…what do you know, *eternity*, how bout that! What does this word mean for us? This word means the following: *the condition or state of being in existence for a seemingly or very long period, or an endless timeframe*. This may even be better and or, fairer for the sake of choice, right—an endless timeframe from which to exist. Again, just think along those lines for a moment.

Now the simplicity of these two words are not simple at all, especially to those who would toss around the third word which is, *determinism*, and which means: *the belief that virtually everything, (this to include every human act), is caused by something*. It is also thought to have its *basis* rooted in something as well, and that there is no authentic *freewill* or *free choice* from which those actions are caused or based. Let us face the facts for a moment; robots may or, may not be (depending on the person), a good way for us to exist for goodness sake, right—a robotic non-freewill/free choice way of life. You know the drill…just think along those lines for a moment.

"Now then, in getting back to the idiom solidarity of *spiritual journey*, and yes, I will elaborate on the optional spiritual or lack thereof, journey a little later… Yes, this spiritual journey, God gives to us after we obtain spiritual life from him—Jesus Christ. Now, why is this important? You may be asking yourself that very same question indeed and the conceptive answer lies contextually within, The Holy Bible, itself, often called, Gods word. Now Mr. and Mrs. Peeples, along with your offspring clinging to your backs for dear *life* so as to avoid experiencing a horrific exposure to *death*, and some others just for recreational purposes I suppose, for heavens sake, let us all swim deeper into the aqua green seaways of what is to become a biblical reality check for, eternity!"

God's Love Ingredients in a Book

God is you without feelings are you without love
The Holy Bible, not tradition, writes that "you" created us
But other philosophers think and evolutionary books
Conclude that we were "just" created.

Surely the thought of being created in general
Was sparked by some kind of emotion from someone
I would like to think that it was someone's love
I would hope that this was the love potion
Sent from someone up above.

Perhaps I will read more of your book
In order to find out what is true
For it seems to have quite a bit of ingredients in it
It has ingredients surrounding the thought of love
An emotional thought of a love even
A love so far and yet so close
A love you sent from, you.

For you are the Lord of Hosts
Your book claims to know my heart
And the hearts of all men as well
It is two books united as one book
However, to some that may be hard to sell.

I said I would read it and to a degree I have
I've made good on this promise to you

I believe so far, of what I have seen and read
My hope is that my mind and heart
Will stay true to it, too!

Now may I ask what, The Holy Bible, beloved is? Friends, this question poses to you as well. Can anyone answer me? Well, God's Holy Bible, and I will touch on it lightly, is an actual book. It is an object of holiness, which rightfully means just that, book, or, holy books. It is a series of holy books bound together to make up the one, *Holy Book*, in other words.

The Holy Bible considers being of sacred texts within a canonical collection—hence the word, *holy*, which means, *completely* or others may dub, *whole*. It entirely fills with and yet, is non-exhaustive of, God's love ingredients did you know that, for God himself is Love, amen.

"Now, Peeples family, please allow me to break it down even further. Although some people may refer to it as two different books which were written, namely the Old Testament and the New Testament, it is in fact one unique book which is actually composed of 66 different books (73 books in Christian Catholicism) and which were penned by 40 different authors over time and throughout these 66 books. Some other religious churches, like for instance the, *Ethiopian Orthodox Church*, have eighty-one books in their canon.

"Other religions may divide the Holy Bible into various books interspersed within its canonical collections also, such as the case within Judaism. For now though, I will speak on the one holy book, or, Holy Bible as the term goes *for* Christians, which for the most part, might I add, is *not* a shared technical term between the Jews and the Christian religions.

"The Jewish Holy Bible is called the *Tanakh or Tanach*. This word represents the three parts of the Tanakh, which are as follows: Torah (teachings-law), Nevi'im (prophets), and K'tuvim or Hagiographa (holy writings). Now then, as I have said, for now, I will speak on the one holy book and yet I digress; in essence, of course, not so much as they are uniquely one in spirit and in truth. Therefore I will utilize too, both, the teachings from both divisions of this one holy book of God by the Judaic and Christian 'religions,' or lack thereof ('relationship' book, Christianity considers) for this particular writing, and marry the two—Holy Bible and Tanakh. I will do this because these many books collected together are to form the one complete, or whole, book as I have alluded to.

"Are you confused Peeples family? Do not over think it or even under process it. In so doing, you may become even more confused in the process. It requires thoughtful balance. Let us take our time and talk a bit further

about this holy book, shall we. It involves much careful planning and deserves much intimate study; paying attention to detail is a vital key component to this.

"Now what is so unique about this one holy book of God, The Holy Bible, is the fact that all 40 authors from both divisions of said book (Bible-Tanakh), are unanimously saying the same things about the one true God within the overall, 66 books. Again, this book and its blueprint are of unique design. You see, this, Holy Bible, is not just a book; its sacred texts, are a *pulse*; and this because they are God breathed. The structure is in the form of three characteristics of one God, called the, *Holy Trinity*, and they are what makes up, The Holy Bible. Now don't get me wrong, Christians do not worship three Gods however; one God having three distinct characteristics is whom we worship; but more on that later.

"What is so mind blowing and you are welcome to agree, is that some of these special authors are even doing this miraculous feat without the assistance of the other authors' involvement (some studied books previously recorded by others). This event is due to the non-existence, for some of them, at least in their own mind, of being unaware of the others at a particular or same time, in history. We call them contemporaries of the same authors spoken about in the present tense.

"What I mean by the previous statement is that these recordings were mostly written down in different periods and or, of the same period, but experienced by these different (in many ways) authors from the same one true God nonetheless. In other words, the authors had many different versions of the same vision but having the same one truth nonetheless. Interesting is it not? This confirms the non-existent time barriers for God. For God, himself, created time and God, himself, is able to transcend time. He still does transcend time and he does it even in today's day and age.

"Now again, God is the *'transcend ere'* of all time; not us. Although it is said that, time heals all wounds, 'It...Is...Finished!' Memories are a blessing and some memories, a blessing in disguise. However, if we habitually look back on our pain, we may open time all over again... Relax, breathe a little and allow the Holy Spirit to comfort you during those times of transgression, even right now. More so, it is sure to build character in you.

"Now, and let me be clear on this as this is a bit of a shift in tempo, I really enjoy different types of sciences but I do not want to confuse the biblical *timepiece* that we are discussing right now with a type of dysfunctional scientific ideology. I mean to say that some scientists' look for ways to discredit and or, disprove God's existence by proving that he is in fact, non-existent; by this dispute, they disprove his love, also. I know

they are just searching for 'truth' but they are confused and it is destructive to those who hear such things.

"However, for the same reasons of popular opinion and or, hard facts, I know there are some scientists' who also research to give credit *to*, and prove God's existence, and marry science into the equation, perhaps in reverse order although, a *right relationship* with God holds the precedent. In my opinion though, this maneuver is constructive and instructive to those who hear it; this dispute in turn, prove God's love. Listen, we must approach science not despite, but in light of theology, even in reverse order of viewing theology in line with science. I will travel down that wormhole in-depth at another time. For right now though, I will just run atop the surface leaping over the dysfunctional type scientific rabbit holes for a while as I briefly travel down a wormhole or two to satisfy my hunger for curiosity. Peeples family, are you all, good with that.

"I remember a while back at about three or four years ago, I was visiting a dear friend of like mind and we began a discussion about truth and the spiritual things of God; kind of like, we are doing right now Mr. and Mrs. Peeples. The things I remember from our discussion and the surrounding circumstances, and even the surrounding scenery from that period, subconsciously, are now coming into fulfillment on the very paper that has been in my heart all this time. Aside from that though, it is now making a second appearance in my psyche, even as we speak!

"Wait a minute… It is as though I am now writing it before me; and that you, the Peeples family, will come to read the contents after its future production. The title of this piece, I believe will be, 'FIVE + TWO = PERFECTION,' with its subtitle being, 'Does Luck Hold The Key To Life Or Does Love Have It?' The book I hope releases some time in the near future, even. Yeah, I kind of like that!"

"Can we be a part of your story Mr. Ettesorde; can all of the Peeples family be involved?" says a member of their beloved family. "That is a great question," I replied. I continue with, "Why yes you can, all of you! I will write you all in, as though you were already there from the beginning all along; how is that Mr. and Mrs. Peeples, would you and your family like that idea!

"Tell you what; I will do you one even better than that! Yes, I will even go back in my voice recordings of our truth discussion (s) where we started and just write you all in. I will even continue where I left off, yep, right up to this very point, like, right now! As we finish each day, I will even fill in, for the spectators gathered around us, your feedback, after hours, so that they will not miss any of the valuable content we have previously discussed here. How is that? In other words, I will be speaking in the first, second,

and third person (s), kind of, as my *employer* sometimes does when he is communicating from within his word. You know Peeples family; I was thinking…perhaps you have always been there, in my story."

"That sounds great Lieumas!" says the family member who initiated the question to begin with. Lieumas feels a sense of comfort settling in as this person was formal in saying his name before and now, presents an informal ending to his name. It is okay though, he wants this family and himself to build a relationship of trust, a rapport if you will. "Right you are Mr. Narrator; I prefer them to be a bit relaxed."

Beloved and friends, it was like, déjà vu or something, you know, the spiritual conversation between Lieumas and his dear friend. Now the word *déjà vu* is a French word for the English term, *already seen*. It went kind of like this, as Lieumas resumes in the truth discussion again with the Peeples family, and all of the spectators who are gathering around, and explains it in his own words.

"Now the things I remember, Mr. and Mrs. Peeples, from our discussion and the surrounding circumstances, and even the surrounding scenery from that period, subconsciously, are now coming into fulfillment on the very paper that has been in my heart all this time. Aside from that though, it is now making a second appearance in my psyche, even as we speak! It was as if I have seen this, perhaps been here, thought this, or perhaps even said these things before and it just lapsed over my train of thought!

"Now these things are formulating onto the page like, right now, before my very own eyes. They are formulating without me ever even thinking about writing these words down, right now, on paper from a premeditated standpoint. At times of recording, these words even now, I write down in real time as my fingers are now dancing across the surface of my laptop as though I am playing the piano, but without being a pianist.

"Now, may I say to you, that I know from a functional scientific standpoint, that we all are subject to receiving loads of information since our early childhood (three years of age) on a daily basis, and even more so now than ever before, especially with all these hi-tech and social media businesses going around these days. With that being said though, subconsciously, we as a people are reminded of the information that is stored in our memory bank; gray matter—brain—from time to time. Granted, I do believe that but somehow this was different. This is how I know the apostles and the prophets, and even some of the saints of God wrote what God wanted them to communicate. Aside from that, they wrote it even at the proper time he wanted them to write it.

"Now, might I add, it gets a little bit more complex than just stored information rearing its pretty and at other times, not so pretty head, but

I'll save that topical logic for another time and place, perhaps? Spiritually speaking though, for right now, I think, as well as believe, that God—by his Spirit—will drop a thought into one's own mind and heart in a mere moment. I believe that since he *controls time*, he is there working behind the scenes during any duration *of time*. And what looks to us—humanity—like we've been there or done that at some point or another *in time* and are now remembering these things thereof *on time*; it may be that God is actually quickening our spirit to actually receive these 'memories' *at this time*. This doing, as he dispenses this information to us for various reasons as well as, in various seasons; *as time* catches up to itself.

"You see, their—biblical characters—words were, as these—my own—words are, prewritten, and as the Holy Spirit guided them, while, or as they wrote the words in real time even; I, myself, included. Words prewritten by the finger of God and by his Spirit working effortlessly behind the scenes through them at that particular time in space must have been a very awesome experience. Wait a minute, get this Mr. and Mrs. Peeples and the rest of your family as well, as I will state it once more, the finger of God (as like in, The Book of Daniel), has prewritten it. And in so doing, this same action by his Spirit working behind the scenes through me even now, right now, is manifesting and therefore, I can totally agree with his wonderful display of Awesomeness!

"Again, I state these words to you and I quote: 'This confirms the non-existent time barriers for God. For God, himself, created time and God, himself, is able to transcend time. He still does transcend time and he does it even in today's day and age.' It is because of the fact that God lives outside of time; he is not limited by time, little Peeples children. His perfection is time and soon and very soon, we will come to discover that, through this book, coupled with his book. Amen. Indeed his timing was perfect.

"In the long and short of it, this one book of, The Holy Bible, is composed of 66 different books splitting the difference from an Old Testament point of view and a New Testament point of view, but ultimately, having the same points of view between the two books, nonetheless. This often ends in heated discussions and or, debates among the many different church branches and religious leaders, philosophers, and others—people in general. Now this one argument, out of many arguments to say the least, is in regards to there being two distinct books having absolutely *nothing* (stumbling block), and or, absolutely *everything* (stepping stone), to do with the other.

"However, I have found through my ministerial studies, as so many others have through their ministerial studies, that they *do* have something

to do with the other indeed for they both share a commonality. It does not end there, to take it a step further…it has been discovered that these two points of view are in ratio, thirty-nine for Old Testament and twenty-seven for New Testament. This equals 66 books comprised, blended or immersed into the one *Holy Book*—Bible, Tanakh.

"Now then, the most interesting fact is that this one book has many stories and truths filtering down into one message from them all—66 books. Now all 66 books, and with its 40 authors, have a unified message for the times past, the times present, and the times future and the message itself is for all of us—diversification is not an issue here, due to the many translation ministries' out there, thank God for them. Again, it is for all of humanity past, present, and future; God's heart did not miss a beat! There are those whom find this hard to believe. I believe that for them, it is just difficult to understand; perhaps they are over thinking it or even, under processing it. This is where the opportunity for exercising one's faith comes into play; you know what I mean.

"Okay so this ultimate truth, which follows, concludes the fact that the Old Testament and the New Testament *compliment* each other as opposed to *contradicting* each other. For it was God, himself, who told me one Sunday afternoon these very important and unique words: 'Bridge it.' Allow *us* to elaborate. During this particular dispensation, when the Lord called me into the ministry back in 2007, I heard the voice of God say to me, 'Bridge it.' Peeples family, this is true!"

The Holy Spirit followed suit by causing Mr. Ettesorde to understand, through *divine* interpretation, to "bridge the gap." Now some of you—in your own minds—maybe are asking the question of, "What gap are you referring to Lieumas?" Beloved and friends, there is a gap in the relationship between God and Man and the "bridge" situated over the gap itself is the God-Man, himself, Jesus Christ!

"As I have already mentioned, there is also an attitude in the hearts of men these days that says that the Old Testament and the New Testament are *two* distinct books having nothing to do with the other. However, in order to bridge the gap between the two books, one must cross over the one bridge itself or perhaps, better stated, he, himself, first. Once this crossover is manifest, then one may come to *realize* and thus *appreciate* the intelligible design and complementation of the two books coming together joint-fully, through Jesus Christ, as one whole book—complete.

"Peeples family listen, 'they' may do this in regards to there being, and 'their' having two distinct points of view coming together in a harmonious way as one unified book *of* God with one point of view *from* God. This one point of view *of* and *from* God is indeed truth. It is a rich point of view

instead of poor contradicting points of view from two 'contrasting' views, which causes a rift in God's extensive message to humanity—and which by the way, this rift as you will, is false."Let us brush up briefly in our learning of the Holy Trinity, which sadly is another argumentative topic between church and religious leaders, can we do that. Yes, the Holy Trinity (triune, tri-unity) I mentioned early on to you is deity. This word, *deity*, which means, *one*, in a monotheistic way, and which can be found in the likeness of the Father, the Son and the Holy Spirit, which again, make up the *three* characteristics and *three* functions of *one* God—*deity*, is forever.

"*Monotheism* means, *the belief of one God*. This, quite interestingly, makes up the belief system in not only Christianity, but also in two other 'major' religions, as well. These two religions include Jewish–Judaism and Muslim–Islam. However, although the three of them have a monotheistic view of God, they have three distinct takes on the overall religious points of view concerning their morals, teachings, and well, ultimately, their take on the truth of God's salvation in the form of, *way of life, religion* and *relationship*: Islam, Judaism and Christianity. This salvation, which is the core of any religion—salvation or, 'right standing' with God, or, a god, at best, or least; depending on the 'god' one is aiming to please, is that which humanity thrives on pleasing."

Beloved and friends, be mindful of this by the way, when Mr. Ettesorde speaks of the two other religions besides Christianity (Jewish-Judaism, Muslim-Islam) as being "major," I do not believe he means this in the sense that they are *truth* intrinsically, but that they are major in the *size* of their followers. More so than that, I agree also with him that it is in this one, Holy Bible, which speaks of all three of the characteristics of one God. It is a very powerful book that we can take advantage of by reading and studying its pulsating texts and the powerful contents thereof. By feeding on it, and drinking from it in a Godly manner, we can find blessings upon blessings illustrating this oneness found in the three. Please, allow us to elaborate on this further before moving forward and digging deeper into this tale, the heart and soul of our story, and its timeless message, amen.

"Peeples family, I am thanking you in advance for allowing me to rendezvous with you all but I feel as though a percentage of you will lean your heads forward and then downward. You will draw your eyes closer to the black and white pages that are before you with your heads slightly cocked to the right or perhaps, to the left. You will do this as if you seem interested in what I am speaking about, but not so much as you let out a massive yawn and elongated stretch. At this point in life, you are slightly confused still, probably because you do not understand it, in its entirety.

"However, be careful because this is when Satan seizes the opportunistic

time to enter the thought patterns of your minds and attempt to snatch what you *did* hear from your very hearts. Again, I thank you for allowing me the time to introduce the Gospel message to you nonetheless. I will not give up on you because my faith in God says to me that, you all, and I, will have another go at it. Yes, *you* and *I* will have another *chance* to talk, amen.

"As for some of you others, I am also thanking you in advance because I feel as though a percentage of you will lean your heads downward and then forward. You, too, will draw your eyes closer to the black and white pages with your heads slightly cocked to the left, or perhaps, to the right. You will do this as if you seem interested in what I am speaking. To be frank, you *do* understand it perhaps a little more, but are quite eager to know even more still...

"This is when Satan realizes that his permitted attempt at snatching from your hearts that which you have heard in your minds is a bit more complicated for him. You are indeed very interested at this point, as you seem a bit intrigued by the simple, yet complex words displayed here on the page and in God's holy word even. As blessings arrive, you all begin to learn more and more and as you do so, you find that you are excelling in bountiful ways, congratulations!

"Then there are some other percentages of you, later in the season, Peeples family, which have never heard of but now have, or even understood Christianity at all, but now do so, a little. Up until this point in your lives, you have never truly been interested in any of it, but you are now. For you, the wheels in your slightly darkened minds are beginning to turn more and more quickly as you listen in with your eyes and hearts.

"The once dimmed light there, in your minds, begins to spark sporadically or intermittently—at irregular intervals—to the sound of an electric buzz or two here and there. Water slowly drips from a rusty colored pipe in the background causing an echoing sound throughout its gray walls." "Why it gotta be all rusty and stuff?" asks a hip swag family member draped in green and black, and this questioning originating from the spectators' camp. "Because it makes for a great and colorful visual," I answer. I continue with, "As the dim light in your mind glows a little bit brighter, I am ecstatic by what is formulating before my very own eyes, in you. My hope though, is to help you fully engage your mind's generator to full capacity through the writing and preaching of God's Gospel Message, which really is, The *Good News* of God.

"It is at this point in life that you have experienced a type of death. Something positive from this experience takes form and thus the lighting of the 'bulb' in your gray matter becomes increasingly sharper and transitions from fluorescent yellow to like, translucent crystal or something. And if

this wasn't enough, the traveling of blue electricity begins traveling up your spinal cord, and then in beeline fashion, it starts making its way to your red muscle glowing ever so brightly, and bringing with it increased purple blessings also. Thank you Jesus for allowing us more time to spend with one another. Thank God, he has given us an equal opportunity to have another go at it. God, your grace and mercy have allowed there, through kind acts of *love*, to be a chance for us to catch up. We are orange with excitement and pink with joy.

"As for others of you, you however, *are* indeed very interested at this point, as you are very familiar with Christianity, and have been so for quite some time. You are avid collectors and joyful readers of the works thereof, and are eager to know more of what drives you in the first place. Your minds and hearts have been enlightened a little bit more by the Lord and through his holy word even, but the black problematic road course of this life tends to drag you into another state...a less developed state of mind, to be exact, as a roaring lion on the prowl awaits its attack!

"You are confused as though you are navigating on the F-1 racetrack in Austin Texas, as a fan not a driver and thus you fold like a deck of cards in a high-end casino on the Las Vegas strip because some are challenging your faith and your heart cannot handle it. Yes, you have taken on 'the house' and 'the house' sadly...is taking, you. For you I say, stay strong and start depending on God more so now than you have in the past despite persecutions, amen. He is trustworthy and true and will allow you a way of escape from your would be attackers. Moreover, I pray he will send others to help you navigate the road course that has been set up for you since before time began—one-on-one if need be.

"Unique is here and there are yet a percentage of you who welcome what is heard here and look forward to seeing the rest of what has been written here! Joy sets in as you soak it up like a sponge sopping up water off the table; the table of God's holy word even. However, something drastic takes shape...

"Worn out due to the pressures of this life you turn toward the seeking of money and misguided wealth to get ahead instead of trusting what the *Word* says *to* you, and believing what the *word* says, *about* you. You soon realize that you cannot get ahead because you find that after taking one-step forward, you end up taking three steps back. When you do take two more steps, forward, the math in your head does not add up and you find yourself going nowhere fast because you are right back, or stand just short of where you stood and started to begin with. Your faith in your green colored money and gold, silver and bronze colored wealth has failed you.

"Now don't misunderstand me...it's okay to 'dream big' however, in

order to acquire something *worth* having you must strive to put in the man hours to achieve it, amen. Even so, I am excited to be able to share a part of this teaching experience and learning curve with you that I may gently guide your backs, back to the proper multiple colored nomenclature of faith. Moreover, I mean that in all four respects. That is why I am here… I will now proceed with this tale and our story; I will continue with God's Message…

"You see Mr. Peeples, feeding on God's Word in the form of his Son, Jesus Christ, and drinking from God's Word in the form of his power, the Holy Spirit, Mrs. Peeples, notice it is not necessary to sustain physical health for the human body, even in terms of God's holy word in the form of, The Holy Bible. Although supernatural healing from God through his Word and from within the root of his word does occur, and quite often might I add, do not get me wrong when I say to you that God's Word and God's word alone does not always sustain you, health wise—physically— our bodies and the health factors thereof are only temporary. As difficult as it may seem, sometimes the answer to prayer is yes and at other times, the answer to prayer is no. This should not constitute our giving up on our faith, or even losing all hope, no matter the circumstances or situations. Both of these terms, faith and hope, should remain as having a strong presence in our vocabulary concerning the power and sovereignty of a loving God. Keep in mind though, I encourage you to pray for healing and exercise your faith in God, in the right now season, for this healing. Go ahead, reach out and touch his garment train. Keep hope ahead of you and stay active in your faith!

"I say that because if it *is* God's will to heal you as a Christian, or even as a non-Christian, physically then believe he will do so. He has that Authority and the right because again and please notice the distinction, 'The word of God, alone, is the power of God, alone.' In keeping with that truth, 'The Word of God, alone, is the Power of God's word, alone.' Amen!

"Listen, what I am saying to you is that the multiple colored nomenclature of faith goes beyond the physical, well into the eternal; it is multifaceted like a mirror and or, prism. You know, prisms are glass objects producing a marvelous array of colors when the sun hits it. I like to think of it this way: *The eyes of God are like prisms giving off multiple rays of light, through the Son.* The Holy Bible is indeed very complex this way, which in my opinion gives it its shine. It gives it its reflective beauty; if we look into it closely enough, we can actually see our own *reflection's,* reflection in it! Time, and looking back at it allows reminiscent joys to set in because it is there that some of the good times, which outweigh the bad, makes to be the focal point of our family's fabric; go on, have a look inside. Listen to the smiles and cherish those laughs…

"Right now though, this topic of physical health and healing, overall, is not my angle, in-depth and or, at large. However, I do find it quite important to mention to you that the many teachings, in the form of God's word, the Holy Bible, can lead to a healthy lifestyle for those of us *inside*, as well as for those of us *outside* the Body of Christ, amen. Moreover, the latter will ultimately need to gain exposure of life from God, after having experienced a type of selfless death to…well, his or herself.

"Of course, many within your seemingly endless family could easily argue my points and I am not one to debate over these types of things, at least not right now; I'll leave that for the absolute gifted apologists'. Although, as a critical and biblical thinker, I will state my explanatory personal opinion in this matter as I believe it is an important one and they in fact, do matter. Besides, I did bring it up therefore; a fair explanation is in order, amen. Here is my angle in-depth but still, not at large for God's word and his Word exhausts not…

"You see, for the sake of imagery and metaphoric speaking, those of us who are *in* Christ (sheep) have an inner power from the Holy Spirit that satisfies the appetite of the Spirit of God through, not only the reading, but also in the acting out, of his word (green pastureland). Now those of us who are *not* in Christ but are still *closely related* to sheep (goats) may still read and learn how to live morally from God's word. But although it may produce healthy living and 'feel good' sensations externally, without the inner power of the Holy Spirit functioning *within* the heart of a person, it is seen as useless, or as one might put it: vain; vanity—emptiness.

"Now this may temporarily satisfy the appetite for the goat as it reads, and even acts out what has been read (in the green pastureland), but this has no internal satisfaction for the appetite of the Holy Spirit because he doesn't live in them but rather, he lives near them (goat, non-Christian). He lives in the sheep (Christian) instead Mr. and Mrs. Peeples. Please allow your children to come in closer so they can hear this…but that's why, interestingly enough, I'm of the personal opinion that it's both, God's Word—Jesus Christ/Holy Spirit, and God's word—Holy Bible, that is ultimately designed to feed and water our eternal spirits. This action manifests while traveling through the hot desert bed of our surrounding physical world—all of it.

"Now Mr. and Mrs. Peeples, these two natures of God encourage us as Christians to find comfort and peace in our spiritual world in the midst of trying circumstances that we may face from time to time in our physical world, amen? Here, we can find hope; here, we can find rest. In addition to that, we find them again, and repeatedly, and repeatedly again in his word.

"Moreover, this gears toward those of us who *are* in Christ Jesus as

opposed to those of us who *aren't*. However, your time is coming; perhaps it is here already as the dynamics of his Spiritual whirlwind is constantly in rotation. It is constantly in rotation circling around the minds of humanity overall awaiting an opening through their heart chambers.

"Let us face the facts shall we, we as Christians must believe God's word is true shouldn't we. Otherwise, why would we read it seeking out answers to fulfill the Holy Spirit's appetite for, and desire of, peace, comfort and rest for, and within us? You see Peeples family; this truly does give us fulfillment in both, physical and spiritual things. It is a great feeling no doubt but goes beyond your typical 'feel good sensations.' Yes, it is a great feeling to be able to *call* upon the name of the Lord, Jesus Christ, and *rely* on his Spirit to aid and guide us in life, and in the reading and studying and acting out, of his Holy Bible, which is his word.

"Now regardless of sporadic hunger pains, I do not mean to alarm you all. I am not suggesting in any manner or way, shape, or form, that by not taking complete and full advantage of these fulfilling opportunities of reading and studying, and acting out or even engaging the Holy Spirit on a regular basis of 'twenty four-seven,' will bring with it your demise of total decay and destruction. I am not advocating *condemnation* to believing Christians neither. No, I am just saying that in immense lacking of these rewarding attributes, it may stunt your growth in the Lord. Trust when I tell you that God himself taught me different; he taught me better.

"You see, these statutes and guidelines from within, The Holy Bible and coupled with prayer and devotion, are put in place by God in order that you, and even I, myself may grow from being babes in Christ while feeding on 'milk' from the word, to maturing Christians in Christ while feeding on 'meat' from the word; notice the distinction. In other words, the Holy Bible is there for us to find nourishment, and nutrients, proteins, etc., for healthy growing spurts in our Christian lives, amen. It is important for us to feast lest we become starved, malnourished, stale and stagnated, and more vulnerable in our stance against evil, and the temptations thereof. We sometimes become dry and insensitive to the things of God; we lack in drive and energy sometimes and may become bored altogether because of this false sense of a mundane Christian lifestyle. This can cause us to participate habitually in actions that are damning to us without repentance and or, to others whom are close to us as our actions illuminate a false sense of hope through outside observation. Too much of this vain lifestyle may cause God to intervene…or not, intervene; both are forms of discipline with one disciplinary action more permanent than the other is. However, be mindful that God doest discipline those of which he loves.

"We must be willing to eat of it ourselves or at best, eat of it as we

feed on the word from our spiritual leaders set apart by God for this task of feeding his flock, amen. I believe, for some of them, that the more we, as spiritual leaders feed them—God's flock—, the more they will want to eat. Perhaps they may want to snack on the word—Holy Bible—themselves at times and from within the privacy of their own homes, even. They may even have an urge to tap into the reservoir, that is the Holy Spirit, and counter the dryness found within them through the Word (Jesus Christ) through prayer.

"The same thing we learn of physical babies born into this world. I mean think about it, by comparison, they, just like you and I, have to feed *on*, or be fed *by* our parents or guardians (those set apart for such deeds) starting with the milk. Mrs. Peeples, then after the infant stage advances to the adolescent and adult stages, feed on nutrients, proteins, and meat and vegetables and such—fiber too! They do this in order that their young can have an opportunity to grow up healthy and strong, full of drive and vigor. In this way, a stronger stance can be taken as they take on the rigorous hurdles in life to include disease and the like—opposition as they grow older. Remember what I stated or perhaps alluded to earlier: *The Holy Bible is God's Love ingredients. God is Love, amen.*

"The logic of this many can appreciate I'm sure. Without denying it, we have each experienced it in our own lives would you not agree? I mean to put it quite simply; we have to crawl before we can walk, amen. Moreover, we have to walk before we can run too, amen. Now we can run in place, which is to say that we are going nowhere fast in our faith walk or, we can run and make tracks in our faith walk, which is to say that we are indeed going somewhere, but at a steady pace, amen. The question is this and I quote, 'Which running techniques are we willing to endure?' Amen!

"Listen, although God has given us the capacity to think, God knows the limitations in our thinking abilities concerning his all too powerful word, Grandpa Peeples. Therefore, he lowers it down a notch in order that we may gain access to a sense of understanding, to some degree, of what he is talking about, hence the analogies, metaphors, imagery, etc. amidst the historical and analytical truths within his word that we can relate. However, esoterically speaking, some truths within are veiled and 'enigma-tized,' and for good reason… Aside from that though, the promises of God should refresh our hope in him after all, God's word is higher than the name of God; it is his bond. Any upstanding citizen knows that this says a lot about a person more or less, about him or her, for a man and or, woman's word is his and or, her bond, am I right; everything else, tangibly, is an added bonus associated with the spoken and or, written seal of agreement, and for the purpose of momentum. Well God is no different in this regard. His word

and bond is one of a higher distinction, degree or magnitude but definitely no different in terms of spiritual, moral and ethical standings.

"Now I spoke of those who have escaped the ultimate 'death trap' of the desert through Christ, but that is not all dear ones. Ultimately designed by God it is also both, his Word (Holy Spirit), and his word (Holy Bible), that feeds and waters the *still lost* spirits currently trapped within the desert of their own souls as well. They exclude not, especially for those who are 'still lost' but are sincerely seeking light, life and refreshment which spawns about faith, hope and love with the greatest of these being, well, you know…"

Beloved and friends, Grandma Peeples sheds a tear as she displays her concern for the *still lost* souls out there and who are even amongst her own family. It seems as though Lieumas has struck a nerve as he watched the muscles in her 'growing old gracefully face' sink lower and lower. However, inwardly he feels as though he has actually struck accord with Grandma Peeples as well, as the muscles in his own 'luminous face' begins to lift up higher and higher! Even so, he consoles her with words of compassion in the sense that her facial expression would be found in reverse order.

He understands her concern for, *family*. He is even brought back to his childhood memories concerning his own grandma and the droves of platters upon platters, pots, pans, plates and saucers displaying food. Oh, and not to mention the baked goods she would always have waiting on the kitchen table when he and his family would visit. Here he is comforting and consoling surrounding the situations and circumstances concerning Grandma Peeples, but in his own words and through his voice recordings of their truth discussion for spectators, after hours…

Pushing The Record Button: "Are you alright Mrs. Peeples? Grandma Peeples are you okay?" I said once more. She looks at me, sighs, and says softly these words… "Yes, I'm fine, but some of my children's children are not." She continues with these words also: "Some of my children's children are fine but some of my own children are not." Somehow, I understood her sorrow and could relate to her woes. However, it also gave me yet another opportunity to give her hope and to remind her of the power of God's *Right Arm*—Jesus Christ—and his role in salvation for the *still lost* souls giving them life!

"With endurance aiding you, you and some of the others in your family would have to travail. You will have to do this like all of us—travail through the downside of truth in order to travel, like some of us, to the upside of truth." I continue pressing on. She continues pressing on with me…

"Nevertheless, the difference in this scenario, as opposed to the previous scenario in terms of sojourning is this very important fact: If the *still lost* souls never take the initial first step of faith in Christ Jesus through his word and his Spirit, they will resume in a place of danger. Ignoring God's message directly and even indirectly through the preachers, messengers and faithful witnesses God *presents* and at other times, *sends*, to lead them back home to God, himself, is a sad state from which to exist. This is true.

"This is so because they will never obtain eternal spiritual life that true Christians have obtained by these same means. These *still lost* souls will instead suffer *spiritual death eternal*, which is the other optional *spiritual journey* I spoke of very early on in the previous chapter, II, of this book. It is the opposite of *spiritual life eternal*.

"Now, even though the *still lost* souls who read the Holy Bible may believe some of what they are reading, it may be that they are reading the discourse from a different ideology and a different kind of zeal, but having mixed in with it, a self-righteous attitude instead of a Christ righteous attitude. However, we can still classify this as being vain and empty even though they may be truly good-hearted people in their everyday lives. Just to be fair, quite honestly, though, the Bible teaches that those still lost souls do not really understand the deep spiritual aspects within the word of God; for them, the lines are blurred.

"There is indeed a bigger picture here, and sadly, they are missing it. They are looking at the three trees standing in front of them instead of viewing the forest in the background at large. This is where the assistance from God's Spirit can come into play."

"Wow, that's a bit harsh!" says someone from the Peeples family seated somewhere in the background. "And interestingly enough, some of you may even agree wholeheartedly with my pungent, but necessary and true statement," I continued saying. "I do!" another one from the Peeples tribe shout but this time, the sound came from someone seated in the middle ground. I continue yet again and say, "Wait for it...okay, now!" "I'm way ahead of y'all," says this last one. "There goes the upside in the foreground!" It is true; I did say this. However, does this unfolding situation poke holes in my tree to forest scenario? Peeples family, no it does not, not in the least.

"Even so Peeples family; bear with me for just a moment. Think about this now as I have mentioned or alluded to already... If only the *still lost*, generation would *earnestly* seek after God's truth through his Spirit with an open mind—and from within the white, black, and red pages of the Holy Bible even, they, too, would find fulfillment in both, physical and spiritual things. They may even enjoy researching other religions and works thereof

through literature and the like. They may enjoy it to some degree but not for the sake of worshipping said religions or denouncing Christianity as some people do who engage in such activity. In fact, quite the contrary may happen instead. Like for instance, they just may enjoy researching for the sake of affirmation (through learning) more about the truth of God, Jesus Christ, Holy Spirit and his book (Holy Bible), which to me trumps all other books and religious points of view regarding religious tradition or even Christian ideology. Albeit, true Christian ideology…we find that the Holy Bible forms the foundational basis for, in structuring. It gives it its structured analysis in other words.

"Let me say this though, I am *not* '100 % knowing' in all things pertaining to the Holy Bible for that would make me perfect, to which I am not. However, Mr. and Mrs. Peeples, I will say this in all humbleness and with genuine humility; I *am* about '100 % accurate' in the truth of the Holy Bible, to which I empathize with, study on and regularly teach from its pages. Nevertheless, I digress. They may do so and thus adhere to this *one truth* out of the 'many other truths' floating around out there in space, by faith; this is the upside.

"Now this also goes for anybody, no matter the background, gender, social status or skin color, amen. No matter the traditions of religion either, for no one is exempt from the love of God, amen. Absolutely no one on the face of the earth is exempt from the Savior's reach because he loves all of us with an everlasting emotion. His proof is in our opportunity, even in reverse order; our opportunity is in his proof.

"Remember this, God created all of humanity and shows no partiality *towards* humanity I mean why he would do that would make no sense to me. He would not do that. Listen to me; think on this now, for it would make no sense at all Peeples family because Jesus Christ validates this love from God. Listen, God's desire is that all of humanity experience salvation. Having said that though, the decisive factor is this, and again do not think that I am yelling at you, I am just making a bold point in order that it stands out:

HE WANTS ALL OF HUMANITY—WHOM HE CREATED—SAVED BY WAY OF HIS SON—JESUS CHRIST.

"There, I said it! Although contrary to popular belief, it is indeed the whole truth. Please, let us be clear on this, as a church leader I strive in judging no man *outside* of the church, I leave that Judgment to God; I judge *within* the church. Nevertheless, I am free, just like anyone else in church leadership, to express through observation, my true concerns while exercising careful

discernment toward those who *are* outside the church, am I not. Okay, okay, okay, let me put it another way, I'm careful to *not judge* any outside of the church I leave that judgment to God. I am however, encouraged by him to *discern* and make known my assessments and just determination. This goes for all parties, and on all fronts within and outside the church, and yet…I have enough restraint to, forgive.

"After all, we as human beings, are not out there alone in this world, for God is still with us. We are all in this world together, and we are all searching for salvation—in one form or another. We are all searching for the truth of our existence, right. We are all searching out the exciting truth of existence minced with heartache and pain of our actions in and of itself, period—and Peeples family that is okay. It is okay because we cannot distance ourselves from pain, it exists in the world to which we live, oh but joyfulness doeth come in the morning does it not; indeed, it does! We also cannot distance ourselves from the world's viewpoint and its actions carried out thereof; we would have to leave this earth altogether.

"Mr. and Mrs. Peeples, listen to me, some of us try to crack the code of our existence and even, our actions through the reading and studying of other books and or, other religions, practices, sciences and philosophies even, without ever cracking open the book of God, itself. Personally, I feel as though I may know why that is in one obvious and particular instance. I believe the ultimate reason why so many people do not take God's way out is the 'fall from grace' in regards to humanity and this, due to Adam and Eve syndrome. However, here's the thing, if you want to understand yourself, or people in general a little more then look to the Holy Bible, it has many interesting things to say about us.

"You see, since then—the beginning stages of our existence—, Man always has to feel as though he has to put his own work into salvation; to defy God's wishes for us and to place blame on another instead of admitting when we are wrong. Man feels he has to do this as opposed to the work that God has *already* put in for us to receive salvation. As a result, Man still feels as though something is missing without placing his own useless—vain—two cents worth into the successes of God's work. That is just how Man thinks at surface level therefore, that is how Man reacts at same said level."

"But hey, at least there is zeal to know the truth!" says Mr. Peeples. I reply with, "Hey, I respect that and I respect them for even searching at all, amen? I just want to help *narrow* their *search* for the truth in order to help *broaden* their *research* in the truth. I just want them to come to the realization that we as humanity do not need to do anything to help God *save our souls*. We just have to believe, by faith, what he has

already accomplished for us; to not only obtain salvation, but to sustain salvation also. I believe this is fair do you as well?" Mr. Peeples shrug his shoulders as he looks at Luminous as though he wants to understand him but somehow does not see the logic of what he is saying. Mr. Ettesorde explains more in detail a little later on…

…**Later On Arrives:** "Now I can honestly say that it has helped me to know more of God even when researching and even 'divinely stumbling' upon other religious works and or, other points of view concerning different types of religion. For me it brings to light more of God's truth in his word—at least in my own opinion, to which I believe, is an accurate one. Hey, I'm just being honest here. For others though, they have gone as far as at least trying to read and or, crack the biblical code, and as a result; some either ran farther away from it or found true salvation by exploring it farther in; now that my friends are some of the signs of duality from the *Pen* and the *Sword* at play here."

Grandma Peeples agrees with Lieumas at this point beloved and friends as she has witnessed this throughout her own life and ministry, even in her teenage years and even young adult age. He continues with, "In some respects, it has even affirmed what I already knew about God through the original confirmations I received from him and through his Spirit during my spiritual journey. I will write more about some of these things, too, a little further upstream in the following chapter, amen. So let us all keep swimming; we are swimming farther out into the blue yonder so stay with me, okay?"

Lieumas Speaks Into The Recorder Microphone: "As I make careful observation, I find that some of the Peeples children, to include some of their offspring as well, are mimicking me. They are found motioning with their arms, the act of swimming. After witnessing this, *how poetic…*I think to myself, *how poetic indeed…* I led the way as I dipped beneath the waves. The Peeples family followed suit and dove beneath the waves as well. They trust enough to go forward, or in this case, downward, with me. My hope though, is that they will come to trust God upon resurfacing and breaking the plane reclaiming fresh new air *as I did* some time ago. Only time will inevitably tell. This audio document is verbally signed by me, *Lieumas Leumas Ettesorde*."

Now beloved and friends, I want you to remember something before leaving this chapter that is so very important okay. I want you to remember that God's grace is free. Yes, God's grace is free because he paid the ultimate price by giving up his one and only Son to die on a cross for us. Moreover, Jesus paid the ultimate price by accepting his Father's punishment by dying up on that cross for us, amen. I believe Mr. Ettesorde will describe these

things in more accurate detail as we move farther along, as if he *hasn't* been all along right, at least for some of you.

"So you see Mr. Peeples, as we approach this milestone beneath the waters, we discover that God's grace, is free! Without any discrimination to anyone who is willing to receive it, he, or she, *can* now! The reason for this is that ultimate price margin that was initiated and set about by God the Father and fulfilled through implementation by Jesus, his Son. Yes, we see that to any of them now, God's grace is indeed free! That is not all Mrs. Peeples get this, activation came by the power of the Holy Spirit as well, the Holy Ghost! This is amazing is it not!

"Yes, now we can see that this makes up the three functions of, The One True God, himself that I've been telling you about in this very chapter. To the Peeples children and your children as well, may I say to you that as the mind and heart of the *still lost* souls—aided by the Holy Spirit—begins to open up regarding these things of Jesus Christ, it gives the Spirit of God room enough to enter into? It is the truth… It really is the God's honest truth!

"Peeples families, all of you, pardons I ask of you for asking you this but, aren't I confidently being the only one salvation bestows upon or are any of you a *still lost* soul; are you saved in other words? Are you searching for a foundation of acceptance? It may very well be that some of you do not even realize that you're still lost—if in fact you are…*still lost*.

"However, let me expand on the second question, as this may be a more appropriate question, or broader line of questioning, for you all. Are you searching? What I mean by that is are you looking for fulfillment from the things the world offers? Are you feeling empty deep down inside your soul because you have come to the realization that what the world offers is not filling you up to capacity? Do not be surprised by my words but, it's okay…it is designed not to.

"How about these next set of questions: Do you desire more from people, places or things that you cannot seem to fulfill on your own—let alone they cannot seem to fulfill for you? Again, it is okay that this vacuum exists; no one knows and can fill your needs like Jesus. Has the world let you down somehow or perhaps in some strange way? Do you feel as though you may have let yourself, and or, your family members down? Have you let your mother, your father or your children down; have you let your spouse down? Have they somehow let you down? The reciprocal experiences by which we live day in and day out are inevitable; it is an intelligent design fabricated by one of whom which we may opportunistically cry out for joy amidst the sorrows.

"Are you without a mother or a father, or a spouse; have they abandoned

you? Have some of you even been abused by your family member (s), parent (s), children, spouse or friends in some abusive, sexual and or, otherwise degrading way? Listen, may I say to you that it is not your fault; may I say to you that God still hears the cries and that visions of fresh water made manifest soon awaits you.

"Have you lost your parent (s), spouse, child, children, siblings, or even relatives in death perhaps (to include abortion) and find it hard to recover from these experiences of great loss? Listen, with compassion let me say this; it is the circle of life. Death happens just as life happens. Sometimes the surrounding circumstances are synonymous with current situations and sometimes, 'wrong place wrong time' events play out. The earth continues to rotate regardless of the way life and death occur (unexpectedly and expectedly; prematurely and ripened). God knows the end from beginning though, and everywhere in between; there is no surprises with him; take comfort in knowing he is there for and with you, through it all. Tragedy can cause some to fear tragedy itself, and tragedy can cause some others to have reverent fear for God amidst tragedy.

"How about this, do you feel as though you may have let God down in some unforgivable way? Do you feel as though you are not the same person you started out as and are in desperate need to find yourself again? Are you trying to figure out just where you belong in this world? Perhaps you are thinking to yourself the question of, *Why am I here; what purpose do I serve...?* Well, the age old answer to an age-old question of, 'Why am I here; what purpose do I serve?' is, to worship and serve the Living God. This brings glory to his name. Once committing to this truth, through a personal relationship with Jesus Christ, one can and may experience a Holy Spirit led life of fulfillment walking alongside contentment.

"Here are even more questions to consider: Are you perhaps a War Veteran, or even a wounded War Veteran, finding it difficult to cope with life while still on active duty? Are you a War Veteran, or wounded War Veteran; perhaps finding it difficult to cope with life while having an in-active duty status? Do you know of any who may be in this category? Many of you, who are suffering from 'wounds of the mind' (PTSD), please know that you are not alone; God is with you. God wants to share his life and Son with you; he wants to continue his relationship with others of you whom are saved, and as you begin and or, forward the process of healing.

"How about this one: Do some of you perhaps even wake up the next morning with thoughts of feeling empty, and guilty and even ashamed from the habitual excess of partying the night before dear ones? You know deep down inside your heart, that is not who you really are. Nevertheless, you did it anyway, and continue to do it for the sake of impressing your

colleagues and or, your peers; you do it to impress your friends... Do you feel this way? How about *you*, do you feel this same emotion of looking into the mirror the following morning hung over and thus conclude with the thought of your reflection hating the reflection that is staring back at it?

"Do you feel hungry and thirsty for more of the truth? Do you perhaps feel hungry and thirsty for truth in and of itself? Are you trying to find yourself?" "I am," says a young Peeples family member. "Finding yourself includes a conscience effort of searching for Jesus; together you and he will set out on a wondrous journey of your self discovery. With him walking by your side and living inside your heart and mind, you will rediscover who you have been all along.

"Are you down and out or down and out because you may know of someone, or some others, who are down and out? Are you just plain down? Are you just plain out? Are you perhaps sports superstars like for instance...a football player who spiritually or morally fumbled the ball in the 'game of life' and this, due to a missed block opportunity and an inadvertent stiff-arm in reverse? Well I have *Good News* for you; God says you can recover the ball you dropped; he will block and cover for you now.

"Are you in the middle of an abusive relationship, like right now? If so, it is time to get out of it. Allow for Jesus and his, ministers of the New Covenant, to help you with Godly advice. Are you angry? If you are angry, may I ask the reason why you have such anger? Is it because of negative influences in and or, around your life perhaps brought about by evil and chaos? In his word, even Jesus asked the question of **'What question ye with them?' —MARK 9:16, KJV**

"Are you an excessive drinker or perhaps an alcoholic or heavy tobacco user, even (possibly due to stress on the job or, stress in general) and find it difficult to let go of these things, which may be ruining the internals of your body? *Allow* the Holy Spirit within your *temple* to counter the imbalance of these dangers. Do you feel like you do not belong and or, have a desire to belong or even fit in somewhere in society possibly through gang affiliation, even, and being in war against rival gangs? Listen, God is willing to adopt you into his own family and the war itself, will be not a physical one but, a spiritual one instead.

"Do you suffer from insecurities, or plagued by severe cases of unhealthy melancholy or even an inner phobia; are you tired and or, perhaps suicidal? Wait a moment do not fall on your sword just yet, there is a hope you need to know about. Do not stand on the edge of the ledge self-loathing and contemplating the inevitable—at least in your own mind, of leaping downward into the abyss. Instead, look at the next ledge in front of you and challenge it by leaping to its edge.

"Channel your emotions and make history through mindful and heartfelt art; I believe you have a lot to say as well as, display. Personalize and nurture each song lyric, keystroke, string pluck, paintbrush stroke, book chapter etc., individually, as you would each special child amongst your very own children. They are each uniquely different from the other but the end-result and overall genetic makeup structure manifests cohesively.

"Are you addicted to pornography? Are you involved in same sex affiliation or other unhealthy relationships such as fornication—sexual relations outside of wedlock (marriage)? Are you addicted to drugs? Are you proud and arrogant thinking that you are okay without God's guidance and truth? Are you well? Do you think you are, when in fact you are sick instead? Is your heart heavy and missing God's presence in your life that was evident before but vague now?" "Sometimes I feel this way," says another young Peeples family member.

"Do you even believe in God and the testimony of his Word, and from, his word? Do you think there are many ways to God or have to jump through flaming hoops, or even undergo a '12 step program' to meeting him? Perhaps you trust in the many man made idols instead of trusting in God's one and only Son; is that it? Do you find that before being open to truth, that you got along with others and since becoming open to this truth, your relationship with others became estranged somehow? Are you prejudiced against others differing in skin color than you, your arrogant mind being a carrier of hatred in your heart toward others? Do you feel this way while proclaiming belief in God? He created all of us you know. Let that one sink in for a minute… Are you perhaps a victim of racism and the like (creed, religion, financial/social status etc.)?

"Do you find yourself going in and out of jail on a constant basis and perhaps may even face possible prison time? Do you begin to think about the things of God and your family while being locked up for months and even years at a time? When you do become free again, you can care less about the things of God; you can care less about your family. For those locked up, most times the *true test* comes upon release, not always while you are on the inside, for God and family still loves and wants what is best for you. I know this to be true because employment held me captive there once, within its walls many years ago, and I witnessed the perpetual pull of repeat offenders and their repetitive visiting family members. However, having stated that, do remember this; although the pull for some may be perpetual, inevitable is in a class of its own; a class you do not have to attend because hope is not there to teach it.

"Are you suffering? Are you lonely? Are you at war, you know, at war with God? You may not even realize that you are at war with him but you are.

You are that is…if you have not received his Son, the, 'Victorious Warlord,' himself. Are you without hope and refreshment? More importantly…are you seeking? Above all, are you *willing* to *humble* yourself and *admit* to God that you were wrong and *need* his *help*—his salvation, his life. Are you willing to love him as he loved, and loves you first by his shed blood on the cross, for the sake of your own judgment, yet and still?

"There are so many more questions that society can ask. More so than that, numerous scenarios virtually plays out in our lives everyday and in our personal everyday lives. Thank you all for allowing me the time to ask you these deep and personal questions.

"Listen, God told me to tell you something. He did, he says to tell you, the entire Peeples family, and perhaps you can run it by others that may be coming up after you in the future generations and who are not here in this truth discussion meeting we are having right now. He told me that he misses you and that you should talk to him. No, seriously, 'Talk to me.' He said for me to tell you this. He is inviting you to talk to him and pour out your heart to him. He—the Holy Spirit—said, 'Do not be afraid of the answer just ask me.' He said, 'We should talk.' He says, 'I miss you.' It is true; he said all of these things.

"Talk to him and tell him that you need him and that you want his help. Your life is a shipwreck; tell him that you understand that. Tell him that your life is going nowhere fast and that you recognize it. Tell him that you have a heavy heart most days and would prefer a light heart all the days for the rest of your life, and even when the day itself, *seem* heavy.

"Tell him that your heart and mind is confused with all this religion, and types thereof, going around these days and that you need him to *centralize* his truth in your mind and heart, himself. Tell him that you are ready. 'Talk to me,' he says. My, oh my God is so good! Oh, I want to thank God for his knowing the true minds and hearts of humanity. Yes, Jesus can fix it; God can fix anything.

"He sheds tears for you did you know that." "I would like to believe this is true Mr. Lieumas; I really would like to," says another young Peeples family member while an adult Peeples family member shakes her head in agreement with what the young Peeples family member just stated. "It's true," I said. I continue by saying, "The reason I know it is true is that I shed them for you too! I shed them for you even though I know you not—at least some of you I know not. Nevertheless, his Spirit lives in me and he knows all of you…

"However, here's the thing! I am no different from all of you in the fact that I am not perfect. For others of you in the Peeples family, I *am* quite different in the fact that I have a person living on the inside of me. To the

Peeples children who cannot fully comprehend this 'living on the inside of me,' statement, no, he is not a monster, and neither am I, but quite the opposite instead. He is one who *is* perfect; yes, that's enough for me, and I am good with that; I will take it.

"Peeples family, his Holy Spirit is just that powerful and he has the ingredients of his love laid out on paper in black and white, and in some cases, red ink, as well. It is even listed in the obvious gray areas of life, off paper, where it may be confusing for some to distinguish and navigate a righteous and moral living, black and white standard. However, the beauty is in the fact that it lays out at all, and it is right in front of you as well as I, but bringing with it the Holy Spirit's power to discern through these gray areas of life too, amen! Just so you know; there are three special delivery packages that are soon to arrive, one black, the other white and yet another so very colorful indeed, all of which may assist you in seeing a little bit better in the coming chapters ahead."

An Open Mind and an Open Heart Brings Faith

My mind was closed to the facts of God
He then opened my eyes to see
His majestic presence was alluring to me
Although his beauty others did not see.

They whipped him and scorned him
However, I said nothing to defend him
I need a second chance to redeem even me
I will trust him and put my faith in him
My heart is open and his Spirit lives within me!

I've been redeemed but not by my own hand
It was through his right hand of Jesus
That redemption came to me
Right now, I possess the land
For the kingdom of God is upon me
The kingdom of God is at hand, child
The entrance into the kingdom is free!

Draw back the shades allow the light to shine through
To the windows of your soul
Turn to Jesus, our blessed hope
For he is more valuable than riches and gold!

Beloved and friends, Lieumas Leumas Ettesorde, feels that it is now time for him to open up a little more about his Savior. He feels a sense

of internal combustion on the rise. He is ready and willing, and wants to release this power into the atmosphere hoping it would hover over the entire Peeples family and thus, land on all of them. However, logically thinking, he hopes, by faith, it would eventually enter most, if not all of them, the spectators as well. Let us all listen in with our lives.

"Now Peeples family let me spend valuable time in saying these next set of words to any of you who may be searching for some form of truth. I do not want to waste any valuable time in *not* following through with this next important statement, amen. For any of you, who may be searching for some form of truth? Please, hear my words:

IT IS OKAY TO BE OPEN AND HONEST ABOUT THESE THINGS; YOU ARE NOT ALONE IN THIS.

"There, I said it! Please hear my heart in this. I, too, was blind to having faith in Jesus Christ and the power from his Spirit at one point in my own life. It is true! You want to know something else. I could not even open my own eyes to see, that apart from God opening my eyes for me, I would remain blind. This, also, is true. He also blessed me in furthering my mind to think; true again!

"He did these marvelous things through my freely putting my faith in him and his magnificent work of, and on the cross. He did it through the death of Christ Jesus for the forgiveness of my sins. Then, 'as if,' that wasn't good enough, he topped it all off because I believed in the bodily resurrection of Christ Jesus even after he was buried, and which, surprisingly might I add, came through the Holy Spirit no less—resurrection. My heart was fully opened and I received this same resurrected power!

"Now I know from a worldly viewpoint—in essence—it may sound a bit strange and uninviting to some but I, myself, accepted this whole truth through my mindset nevertheless. In other words, I accepted it through an open mind frame of thinking as opposed to a closed mind frame of thinking. Sure, I had heard about Jesus Christ before but even so, I did not pursue him at the time of my hearing of him. Sure, I believed Jesus Christ existed some many years ago again, through hearsay and even *head* knowledge, but through firsthand *heart* knowledge, or lack thereof, I had no inclination to trust him through my being receptive in the right now!

"However, having said all of that, my mind never was completely closed off to the interest of Jesus Christ either. I just thought that God was enough for me. To be honest with you all, I thought that he—God—was good enough for the rest of humanity too, for that matter. Unlike others, my heart was not completely black and indifferent to the ways of Christ

either, but to think and to feel as though I did not need him in my life would amount to this same blackness and accommodating indifferences just the same. It (not needing Christ Jesus) would prove to be false to me; it turned out to be foreign to me. I mean boy was I ever wrong in not seeing his genuine love for me.

"You see, thinking back on it, although I didn't 'cut my teeth' on ministry and my dad was not a pastor of a church or anything, I often felt very close to God throughout my life I mean, as a kid I used to save part of my seat for him at the dinner table for crying aloud. That is proof enough that I was in awe of him and I guess Jesus Christ was perhaps…oh my, was he just an afterthought? I suppose in my mind he was… May I say again to you that I was wrong, as he, this, 'so-called urban legend of the past;' this, 'far-fetched myth of a man from yester-year,' this, 'truly inspiring earthly teacher,' at best, existing some 2,000 + years ago personally met me in the, right now? In addition to him showing me that he truly is alive, we—Jesus and I—began a truth discussion of our own.

"Mr. Peeples, Mrs. Peeples, Peeples family as a whole, I want you to know something that is so very valuable to your soul and that is…I received it all in my heart by faith. In other words, I was willing to invite Jesus Christ to extract the dross in my *old heart* and to replace the emptiness of my soul with his *new heart*. You know what; I believed he did just that! You know what else; I know that he did just that! You see, even the demons know who Jesus is (through head knowledge) and they *accept* him for what he is capable of *because* of who he is, therefore they tremble and flee at his presence. They do not *receive* him for all of his Sovereign attributes though; the rebellion etched in their hearts decided their fate, a long, long time ago. Now apply this or better stated, associate this to the *original sin nature* of the human psyche and the human heart…see what I mean.

"Boy did he ever draw me unto himself by his Spirit! Just as the Holy Bible teaches of those whom are far away from God; they are drawn in; the old, 'hook in the trout's jaw,' sort of thing and then, so commences the reeling in of the big catch! Be thou as it may, some trout do put up a good fight though before being pulled into the boat. Thank God, I was not one of them; I fell for him hook, line and sinker. More over, I'm signed, sealed and delivered!

"Yes, I *accepted* and *received* not only God's mercy, but also his grace, and you know what else? You can too! Yes, consider my boasting not of myself but in what the Lord has done in and through me; perhaps you're next! Having said that though, I guess the next thoughts and questions, for some of you, towards me would be, 'How did he really come to terms with choosing Jesus Christ. Also, at what starting point did this decision for

him occur. I mean be real with us, man. How were you so drawn, as you say?' Am I not right in my assessment? Would you not like to know how?

"Hey, that is a very good train of thought put into a question for perhaps sometime in your future. I will give a detailed answer to this in books ahead or teachings to follow, God willing. However, while putting it mildly, for now, I *do* want you to know this: Out of the previous list of questions I asked of you earlier while we were in chapter III, I too, did in fact face some of my own trials and tribulations, and even, some of the same circumstances and situations that I asked of you.

"The Spirit of God urged me in my thought process and nudged me at my heart's core. Because of this, I chose to respond. Now I've not mentioned any painstaking circumstances in my writing of this particular piece but again, I will do so someday in person, and through other books and teachings as well. Perhaps I will do it rather sooner than later, even. I would really like that.

"In the meantime though, please ponder upon the previous questions I stated in chapter III with an open mind. Moreover, please be willing to dilate your heart for God in the process of your pondering. For you can have an open mind of keeping a closed mind to things on your own, but having an open and dilated heart comes by freely being willing to express your faith in things not otherwise thought of, or seen from, or even heard about, in the reasoning of your own mind.

"Does it sound confusing to you? Well allow me to explain. To put it quite simply, for the most part, you cannot see a person's faith, save for traditional outward garments sometimes and this too, may be a little far fetched hence the term, sometimes, simply by just looking at him or her. You can, however, certainly see these same persons act on their faith by simply witnessing them partake in certain situations regarding their proclaimed faith, or lack thereof, for the most part, and this even while displaying traditional outward garments, for man judges outwardly while God looks inwardly.

"Okay I will simplify it a bit further for you. By this, I mean that you cannot see what is in a person's mind as a stand-alone occurrence—unless someone possesses that certain gift of discernment from the Spirit. However, you can certainly see, through the outward behaviors and even, inward expressions—actions—of a person's heart, what is in his or her mind. I hope I am making myself clear so as not to further confuse anybody; with that being said, I will continue...

"Can the same be of your faith and my faith also—in terms of the mind and the heart? I believe that it can. I do not want to run too far ahead of myself so we will get to more 'faith speak' a little further along as we

graze over these next few sentences that we have left here on faith. Yes, just as it is with the close relatives such as sheep and goats grazing the same green pastureland and reaping *some* of the benefits thereof, we will indulge ourselves becoming full with more 'faith speak,' amen?

"Meanwhile, let me first finish up here by stating the obvious though, and I believe it will challenge some of you in your thinking. That is one of my main objectives when writing and ministering the word of God, the, 'I made you think? and then, think!' factor. I believe that it is good for you and anyone else in the Peeples family who are freely willing to have their minds and hearts s t r e t c h e d beyond normal limits. Are you ready for it? Here it is:

GOD GRACIOUSLY GIVES YOU, AND I, THE CHOICE OF EXERCISING OUR FAITH, FREELY!

"There, again, I said it and it is true. You see, he—God—gives every one of us the freedom of choice to have faith in something or another." "Whatever do you mean?" asked Uncle Peeples. "Okay, I will magnify it for you, sir," I said. I continue with, "You see, in the previous chapter, III, I mentioned that I would touch on some of these things regarding other religious works and the points of view they hold to, and so I will make good on it right now in the next few sentences of the following paragraphs, amen.

"First let me say to you all, God has given each of us (Christians) a measure of faith which is written in our *new hearts* concerning the true things of God as mentioned early on in chapter I of this book stemming from, The Epistle of Paul the Apostle to the EPHESIANS, 4:7, KJV. Please I encourage you all to read beyond that point as well. It is a *part* of him, in all of us equaling the *fullness* of him, in all things.

"Now the flip side of that coin we find in, The Epistle of Paul the Apostle to the ROMANS, 1:19, KJV, and I again encourage you all to read further beyond that point as well. This passage is where God states that humanity, albeit knowing right from wrong, has a sense of the truth of who he is instinctively (embedded), and that it is even seen throughout his creation. This truth is revealed, but commonly ignored by those freely willing to, not see it. I emphasize the point that it—conscience awareness of God—has been embedded in their hearts (instinctively), but leaving behind a gaping hole piercing through what has been written by God in their minds (illogically) perhaps in reverse order, might I add.

"However either way, it is in their minds that they choose to go wayward and think differently than what he originally placed within the heart of Man because of this gaping hole. This is why I make such statements as,

'God graciously gives you, and I, the choice of exercising our faith, freely!' I understand to a certain degree that what that statement means may astound you but it is true—he has indeed done this. However, be warned that while he is patient, he *does* turn Man over to a reprobate mind after Man continuously reject him—this also is true.

"Now in its broad complexities, we *do* have a basic narrowing down of various types of religions people live by. Some groups and or, organizations may even discard the term, 'religions' altogether and thus familiarize and or, disguise themselves as being, 'philosophies' or 'practices,' instead. Having said that though, and in the context of God, some philosophies, practices', and even sciences are great *resources* to have in and of themselves all the while acknowledging God-Jesus as the *Source*, please do not get me wrong; God is in control of all of it do you understand? Was that a no, you do not?

"Ok so to explain a little further, where they go, *astray*—those who are engaged in these helpful resources—are in their *substitution* of these helpful resources in *exchange* for the depleting of *authentic* Christian theology and Christ like values. An action of theirs, in the mindset of them, may seem legit, but all the while causing them to be 'stand-alone' entities outside the context of God. However, I do believe I will stick with the term, 'religions' only to bring about less confusion when writing and discussing this piece. While they may *hold to* a system of beliefs at present, my hope is that they may not, *hold on to* them, forever.

"Now, in stepping forward but in reverse order backward, to the place of freewill/free choice beliefs, that is why many other *religions*, if you will, have freely put their *faith* in their own religion. They have done this apart from having faith in the Son of God—Jesus Christ. Surely, some of these religions may know, or even have heard that there *was*, or even, *is* such a person as the *Son of God* byway of Jesus Christ, but even so, they may have no interest in putting their trust or faith in him, just yet—optimistically and faithfully speaking.

"Some may want to search out others avenues first, of the reality of truth as well and some may even reduce him to being merely human— spiritual teacher (high priest) or prophet, with a lower case p—and thus zealously adhere to God's word as it teaches us to, *put not our trust in mere humans*. They have it twisted and wrong though, and their interpretation or lack thereof, of The Holy Bible or lack thereof (books on philosophy, self-help and or, other structures premised from these practices), has utterly shipwrecked them. Perhaps their so-called leaders have taught them this as well—put not your trust in mere humans.

"Even so, there is a, but, somewhere in this heresy and it is missing. Wait a minute! I do believe I have found it: *but* Jesus *was not*, and Jesus

is not merely human! Jesus *was then*, and he *is now*, for reality and for teachings sake both, fully Man (Human) and fully God (Divine).

"It is because of this strange and unpredictable, uncanny and un-understandable way, the world's mixed up confusions about life and death, and how this whole thing really works are, I find that there are what some would call, Atheism. The term, *Atheist*, means, *somebody or somebody (s), who does not believe in a God or deities*. The term derives from the Greek word, atheos. This word, *atheos*, means, *without god or gods*. Do you understand?

"Now then, please forgive me for sounding so abruptly blasphemous and or, volatile, for that is not my intention to carryout this disdain behavioral posture; that is not who I am. However, I must concur with what the Holy Bible's narratives of his own people are in ISAIAH, the first chapter and say that, for this injured corruptible mind and sick ravished heart of a reason, through the fall of humanity—to which I once was a part of—, I have found justification for what follows. Yes, I have found that they—Atheists'—have freely placed their faith in their own thought of a non-existent God. I have found, through research of my own, that they trust only in themselves or at best…no one or no thing. Sadly, the takeaway from Atheism: They have no hope! They also perhaps associate with other strange avenues of trust factors as well. These trust factors are such as those that may have its finds rooted in the evolution theory!

"The Evolutionists' believes that we were created through means of Biology, by evolving from some type of algaecide seaweed and or, other organisms, such as those stemming from lemurs and other animal types, such as those found in apes/monkeys, and then evolving—overtime—into what is now called, human beings—hence the term, *evolutionism*. This so-called evolving process again, is said to be stemming from various life forms of plants and animals to include algae, seaweed, lemurs, apes, monkeys and the like. This belief may be most associated with, 'The Big Bang Theory.' Now in my honest opinion, if there *was* such an occurrence as, 'The Big Bang,' I am willing to bet, minus the betting chips and evolutionary process of course, that GOD 'lit' the fuse that ignited it. Mistakenly, the takeaway from Evolutionism: They have no Theological values and or, concept of a higher intelligence for creation, just vain Scientifics attempting to, theoretically push through the barriers for creation.

"Now as I have said, I have found, or perhaps a better way of stating it would be, began to establish, through my own efforts of research, that there are many of these religions, to include others that are set against God's truth—in some aspects or another. In addition to that, they having the idea of being set against the truth of *what*, or a better term would be,

who, Jesus testifies of being. Believe me when I say that this is only the tip of the religious iceberg. Here are just a few of them. Might I add that the research on my own is not entirely based on absolutes due to the non-existent study of each for lack of time, though it is mildly brief! Moreover, it is in essence inconclusive yet, ongoing with enough traces of substantial evidence of each to support my initiative without theoretical strongholds.

"I hope to continue studying and research gathering to further my writings, teachings and sermons and to think deep, and dig a little deeper into the various complexities; there is always room for growth and yet, I will keep my faith in God's center despite these various complexities. This too, will include me following this thread through other various religions as well as these particular religions that I will name right now; and why am I doing this? I am doing this because in this season, and in the many seasons to follow, it is the *right now* time for transitioning!

"Be thou as it may, we must journey from Religion to Relationship. It is time for us to stray away from religious Legalism in the church and thus migrate to relational Liberalism in Christ! Yes, we must begin, not only reaching for but also, conquering this objective; we shall rise up in this generation becoming strong in the Lord! We will stand united as one from the two, marching forward from Suppression to Expression, from Pessimisms to Optimisms, from Parody to Praise, from Treason to Truth, from Tragedy to Triumph! If it must begin with us then so shall it be, even in reverse order; if it must end with us then so shall it be! In every generation, God has marched to the drumbeat of his cause. So shall it continue in this generation, with us marching right along with him?!?!

"Peeples family, respectfully, here are some of these other religions, and stand-alone philosophies and practices: Scientologists' are a type of religion, which freely put their faith in themselves and their own works of success thereof. Whether found in success and or, failure, they make their own way through knowledge or better stated, pave the way for themselves through stages *of* knowledge. They, in their own hearts, and minds, believe that they are at the helm controlling his or her spirit's destiny. Vainly, the takeaway from Scientology: a type of mind/heart over matter—self-love; self-empowerment.

"Another religion is Hinduism, which is a major religion and the third largest religion in the world (or way of life), as it states itself as being, and possibly the oldest form of religion there is—worldwide even. Its roots and traditions we find in South Asia but it is a diversified ambiance of many different religions or philosophies, which makes it quite complex in nature. They characterize by having a belief in reincarnation and of both, gods and goddesses. In the long and short of it, they, those practicing

Hinduism—freely place their faith in 'Mother Earth,' in the statues of gods, and devote to one *god* while are accepting of many *gods*. Idolatrously, the takeaway from Hinduism: a type of escape from the pain and suffering of this world through the continuum of birth and rebirth through means of *reincarnation*.

"Another type of religion believed to have their ties of faith bound up in the forces of nature as like Hinduism, as this is celebrated and or, worshipped—forces of nature—is the Druids—Neo Druidism. This one Celtic practice, among many other Celtic practices, and *ghostly* takeaway from Druidism is, *necromancy*. This is a term identified as *having communication with the dead in order to predict the future*. Druidism in the Americas and or, the lingering traditions thereof still exists today, but may be concentrated elsewhere in other parts of the country, and some other countries as well, that have closer ties to this particular faith.

"We also find that Muslims—those of the Islamic faith—, freely put their faith in Allah (God), and emulate the prophet, Mohamed, in daily life and actions thereof. This prophet, who according to this faith is the last prophet chosen by God to administer, and or, deliver the divine message of Islam through the Qur'an (Islamic holy book), also pronounced, Koran. In their belief system, this is the only book existing as the unadulterated or unaltered revealed word (s) of God. It is the second largest religion in the world but considers being the fastest growing religion in the world as well.

"Now the *devout* takeaway from the Islamic faith is to surrender to Allah and adhere to (Sharia) Islamic Law. From what I have witnessed, there are pockets of these (not as a whole) extremist groups and terrorists belonging to this particular faith and or, religion that convey *religious world rule* and force conversion unto others. They proceed to also establish *governmental world rule* and domination (even amongst their own religion and the peaceful practitioners thereof) for the sake of Allah through relentless Islamic jihad, and that all *must* surrender to Allah…or else, period! This hostile maneuver from them reflects a take away of their own—dictatorship. They exercise no freewill/choice and do not express love toward others, but display a type of superiority over others and portray tenacious courage inwardly of themselves; their honor is for the prophet, Mohamed, to which they take the blaspheming of his name very seriously, and their reason for living is the devout surrender and worship of, Allah. Here are the words spoken and written from God (Jesus) concerning their ancestor, Ishmael:"

And he will be a wild man; his hand *will be* against every man, and every man's hand against him; and he shall dwell in the presence of all his brethren. —GENESIS 16:12, KJV

"Are you thinking; are you digging? I, through research of my own, also find that those of the Israelite/Israeli-Hebrew-Jewish faith or Judaism, which is the religion of the Jews, have its basis in only 'one half' of the Holy Bible (Old Testament) and included, is that of the Talmud. The Talmud is the collection of ancient Jewish writings that forms the basis of Jewish Religious Law. It consists of the early Scriptural interpretations— Mishnah—and the later commentaries on them—Gemara. Also, to add a bit of a side note, they, Hebrews-Israeli-Jews-have a half-brother commonality shared kinship to the Arabs-Egyptians-Muslims through their mutual ancestral father, Abraham (pronounced Ibrahim in Arabic).

"Abraham (Hebrew) was the father of Isaac (Hebrew) through his first wife, Sarah (Hebrew), and he was also the father of Ishmael (Hebrew-Egyptian) through his second wife, Hagar (Egyptian). Again, the Egyptian handmaiden-servant to Sarah, Hagar, was the mother of Isaac's half brother, Ishmael; both sibling seeds were of Abraham. This explains why both, Muslims and Jews share closely related ties to the Abrahamic religion as well as deep devotion to, [YHWH]-Jew, [Allah]-Muslim; (both names for [GOD]). Their relative ties, indifferences, even tolerances, and confirmations of these finds are found to be in existence in the completed Holy Bible—Old Testament, New Testament—record and some of which, although different variations surrounding the story apply, are believed to exist in the Qur'an as well. Are you thinking; are you digging? Do you recognize the parallel of the Holy Bible's words and the actions of the world in which we live in today, right now! These two half-brothers have been at odds for a very long time, they and their offspring. The reality is that one half seems to be at odds with the, entire world.

"Now the Pentateuch—first five books (traditionally written by the prophet, Moses) of the Holy Bible is what many Jewish religious followers deem necessary, and is most important to them; in other words it is their way of life. In Judaism, which by the way is a seemingly large religious faith in the United States, God is the creator of everything and the source of all goodness, to which he is. Please understand me. But the disconnect for them—Jews practicing orthodox Judaism—is that they freely put their trust in God (YAHWEH or YHWH) for everything apart from Jesus Christ being the most crucial factor in the spiritual equation. The takeaway, *stubbornly*, from Judaism is as follows: a type of self-enslavement; live life by the letter of the law; morality, self-righteousness through good works.

"Another religion is Shamanism, which is a religion, believed to stem from the northern part of Asia, but its practice is in other parts of other countries as well. When studying this form of religion I have discovered that Shamans believe to be able to intercede—mediate—between that

of humanity and that of powerful spirits—both being of good and evil spirits. Through researching this religion, I find that they put their faith in their own selves through their own, 'higher thinking,' as the term, *Shaman*, associates with, 'one who knows' as they are said to emulate magical powers. They are believed to be assisted by these benevolent and or, malevolent spirits as well as act as escorts (mediums) to the 'other side' of life and or, death. They also believe in animal spirit guides and have a fascination with spirits beings of both, animals and humans. Their beliefs are complex but the *mystical* narratives and 'far out' takeaway from Shamanism: astrology, star power, astral travel, horoscopes.

"And so on and so forth, I, through my own studies and research, though brief, but with enough supporting evidence, find that many other aspects of religion such as Buddhism are most popular among many. Buddhism or Buddhist—from which we associate the term Buddha—is a philosophy based on the teaching that worldly temptations; desires can be over powered or prevented by being 'awakened' and or experiencing a type of enlightenment. The *self-disciplined* takeaway from Buddhism however, is this: conquer sin through intellectual means and or, having the willpower of intellect to guide their lives.

"Jehovah's Witnesses are those of whom we associate with having a Trinitarian disbelief—those who do not believe in the Trinity or, Triune essence of the Father, the Son and the Holy Spirit. They believe in working hard to please Jehovah because by doing so, maybe, just maybe, they will succeed enough to enter heaven, or paradise on earth, at best and it will gain them this prize of abode wherewith. They also, do not believe that Jesus is God.

"Mormonism traditionally, have a belief in polygamy but modern day worshippers are thought to discard polygamy altogether. This type of religion of the Mormons is thought to be one, which follow and strive in achieving the Ten Commandments and Christ's earthly teachings. They *believe* they *are* successful in this charge of keeping with the Ten Commandments as well, might I add. These are just to name a few of the ongoing religious circles out there but one must not be naïve as to how many others that are said to exist.

"There are other forms of the occult practices, some of which are of a darker perilous parallel such as the dark arts of Wicca—warlock-witchcraft existing in the world, too. Other 'evil forms' of divination, and so many other 'practices' or 'religions' or 'philosophies' even, practiced apart from God's own testimony of a proper religion, which really is no religion at all but a *relationship*, is what the masses seek after. Moreover, it is sought after freely I presume. It does not satisfy completely so the search continues,

but having mixed in with it a false sense of truth attached to this reasoning regarding fulfillment, this might I add.

"Did you notice that the religions, philosophies, practices and sciences I just mentioned have something in common though? What is it? It is the fact that unlike the 'religion' of Christianity, which by the way is the leading largest religion in the world, they all exclude from them, the basis for Jesus Christ (Son of God, Lordship)—for whom Christianity was founded—, and for whom salvation comes through. In addition to that, they include the necessary means to *do the work* as opposed to the *work already established* through Jesus Christ. We can safely say that he, Jesus, literally put the 'Christ' in Christianity. Where is my basis to support this? The absolute evidence is there and it *is* conclusive, as I have previously stated, *he* has met me personally; *he* continues to meet with me and teach me.

"In their opinions though—alternative man made religions—, Jesus Christ has *no* part in these other religions; at least not as the *central figure* and *ultimate redeemer* that he is. I mean I am sure he is mentioned in some of these other religious accounts and possibly in some of their philosophy records and religious books, even. However, he may not be mentioned in the context of Lord and Savior, but perhaps just the opposite, in reverse order. Perhaps he is mentioned as an *inferior* human being to that of a more *superior* human being—a prophet or a teacher and not, *The Prophet* or *The Teacher*, in other words. However, it is a relationship that God is after, not religion; it is internal not external. The hopeful takeaway from Christianity is as follows: We are not to do the work for ourselves but instead, walk in the work that he—Christ Jesus—has already done for us."

For by grace are ye saved through faith; and that not of yourselves: *it is* the gift of God: Not of works, lest any man should boast. For we are his workmanship, created in Christ Je'-sus unto good works, which God hath before ordained that we should walk in them. —EPHESIANS 2:8-10, KJV

"Freely choose to accept the message of his Son's death on the cross for *your* forgiveness of sins; freely choose to receive new life from his Son's resurrection through the Holy Spirit from the grave in exchange for *your* old life. Recipients of this can rest from all that God has done for us through his Son, Jesus Christ to which we can add nothing more to, take away nothing less, from. Moreover, as an apostolic/prophetic Christian leader and theologian/apologetic defender of the faith, for the evangelistic cause of Christ and Christianity, and for the betterment of humanity, too, may I say to you that I am not any of these things without God. However,

I am of God and I am not ashamed to say so. The message I bring, it is what he desires and seeks from his creation *of* humanity, a relationship. This is true, amen.

"When he sees his creation worshipping themselves and or, idols, even worshipping him as God with the *exclusion* of his Son (Jesus), instead of worshipping him *through* his Son, Jesus, it grieves him. It saddens his heart. Again, I state to you that he—God—gives every one of us the freedom of choice to have faith in something or another. God would hope that it was he though because after all, his truth embeds in our *hearts* instinctively. *Remember...*

"Just imagine if you created something so beautiful just to have that creation turn around, spit in your face, and pull out your beard or hair even. Imagine if it—your creation—did not want you around or even to be a part of its life and watching it grow and experience your love. Imagine if you will...you having your very own creation not believe in that which you spoke and wrote of it, in the pages of your journal or diary even— *Holy Bible*—you left behind for it so that some day your creation could share experiences of your love and life lessons with its own offspring— generation after generation.

"Some may say, 'Well, but I haven't the divinity to create as God has done so, so it's irrelevant to me.' May I ask of you that you think in terms of your own precious children God blessed you *to* create or perhaps, the love of your life that God created specifically and magnificently *for* you? Now, run back through my previous lines of messaging...

"So then, let me explain this again and forgive me for being so repetitive in my talks and discussions with you. However, I feel a need to explain in simple terms something to those of you in the entire Peeples family, especially your young children, who may not have heard or even read in the teachings and writings of the Holy Bible. Here it is! God has indeed made it so that everyone born into this world has an instinctive conscience of his— God's—existence. Again, it is true. He has placed within Man, himself, a sense of an awareness of God, himself—a homing device but with a short in its circuit, a beacon (if you will) but with the light burned out.

"Even so, Man freely will, or freely will not, accept God's illogical—at least in their own minds—and truthful explanation of God, himself, and his works thereof. Even more so, God will not force his love on any of us, either. In addition to that, and in so doing, he will not force the mindset of the acceptance of the cross regarding his one and only Son, Jesus Christ, on any of us, as well. In addition, yet again, and in doing so, he will not force the receiving of his Holy Spirit into the hearts of Man, on any of us as well. What he *will* do however is twist the strands of the rope; he will

nudge and prod you with the goads to enable you to make a life or death decision. This is a bold decision that has to be made; this decision will dictate your eternal abode wherewith.

"To me this sounds a lot like true love. You know the old cliché and forgive me for misquoting if it turns out that I have, 'If you love, someone let him or her go and if the person returns to you then it was indeed true love to, begin with.' Think about that for a moment also in regards to God's love for us—*his creation.*

"Now, again, I am not here *to* pass judgment on anyone let alone, force my faith on their opposing views regarding their own personal teaching of a particular religion, philosophy, practice, science; I love and respect you all—for we are all humans. I *am* here though, to twist the strands of the rope, nudge your heart and prod your mind in order that you make a bold decision. I am here to present to you what I have personally found to be *truth*, and the beauty thereof; for this is what I am called and chosen to do. As I have said early on, I did not always know this truth, even though I will say that I always *did* have a heart and awe for God, like the Jews, and Muslims, do not get me wrong. I may have not followed the other religious mindsets but even so, I was *still lost* and simply by having followed my own sinful nature, the nature I was born with; the nature all other religions and its worshippers—to include even the Jews and Muslims—are born with. My brother, Paul, was a devout Jew and persecutor of Christians. He even witnessed the murderous stoning of them before his eyes were opened to the truth of Jesus Christ and God forgave him.

"Do you follow what I am saying Grandpa Peeples and the rest of you? Moreover, it is because of freewill to exercise a free choice to decide as to what, or in whom to put our faith in, that we can come to such conclusions in our lives thanks to God's mercy and his grace. Some people, and of different cultures might I add, even follow through on their preexistent faith due to a long line of tradition, or heritage from their ancestors—to them it seems only right; it's all they know and have been exposed to. Sadly, however, their minds are closed in their search for truth and as a result, their hearts are closed, too. Please, I mean to say that with all of my mind, heart, and body, soul and spirit—the essence of *my being* from *our Creator.* This, Condition of Tradition, saddens that—saddens me. It truly does weigh heavily on my mind... It truly weighs heavily on my heart, too!

"Here's a thought put into a statement Mr. and Mrs. Peeples and your family as well: 'You hear about Jesus Christ after never having seen him physically.' Now opening up to this thought process, will most of you be willing to have an open heart just the same? Even though the reasoning

of this in one's own mind is incredibly far fetched, would you still even consider this? Wait; do not follow up with an answer just yet.

"Interestingly enough, some people in your family still can't comprehend this and therefore, will not be willing to have an open heart regarding the existence and miracles, and most importantly, the salvation that comes by having faith in him—Jesus Christ—so don't be reluctant in raising your hands, even if they don't raise theirs. Similarly, I must trust that most people in your family tree will *indeed* be interested and that fills me with joy. Okay, you can answer now... However in doing so, please forgive my manner of prudence in the matter.

"Now God does not want us as a human race that he created, to be lost forever, but God *does* want us to believe on *the one he has sent* as being, *The Sent One from God*, and he wants us to do this freely. In addition, by freely putting our measure and embedding of faith in what God accomplishes through the, *One He Sent*, we have eternal life. We will indeed find out just what miraculous accomplishments the *Sent One* achieved even more so a little later on, within the heart and soul of this story and its timeless message. This tale, dear Peeples family, tailors to you; that, I can promise you. It contours to fit you as clothing does; that, I can assure you. Amen!

"Aunt Peeples, in getting back to my main point I originally started with in the opening of chapter, II, of this book, your spirit, after becoming born again, will need, or shall I say, will desire, to feed and water itself to sustain a healthy spiritual lifestyle for you. This special process, of progress, does so even while your body is in its temporal physical form, while sojourning or journeying to its eternal spiritual form. We all have the opportunity through our freedom in Christ Jesus, to take full advantage of this search for truth or not to search for truth." "And these two words, 'or not,' to search for truth are geared toward non-Christians who choose not to engage Jesus Christ?" asked Aunt Peeples. "Yes, it is as you say Aunt Peeples," I replied.

"And we as Christians, are also given opportunities through our freedom in Christ Jesus, to take full advantage of our personal relationship with God by eating *of* his word (Holy Bible), and drinking *from* his Holy Spirit?" asked Mr. Peeples. "Mr. Lieumas how long will it last?" asked Aunt Peeples. "Aunt Peeples, his word and his Spirit that is true and pure enough to eat and drink from, instead of indulging in the impure things of the world, which attempts to taint truth in all its temporary form, is *forever*. The truth lives on but evil attempts to distort it with false dualities, interestingly enough...in threes."

I continue with, "Mr. Peeples you are correct in your analysis, sir. God is full of grace! Moreover, this, grace of his spills over *unto* us and *into* us

also, his mercy as well; and we shall benefit from them both." "It sounds a bit complicated," says Uncle Peeples. I reply with, "I know sir, but bear with me. Please, and in the process of your gracious bearing, I ask that you all please, hear this word from the Lord just as he writes it!"

Wait beloved and friends, and so it begins or shall I say, continues... Now the transitioning back and forth from Lieumas' analytical mind into his creative and abstract mind is in the beginning stages of "kicking in" and, or in reverse order, "kicking out" as he imagines himself someday standing before hundreds, if not thousands of people, delivering some of the very teachings he is now writing about... He is truly in a state of exhilaration about it as his red muscle is full with joy! More over, his gray matter is liberated with vibrancy! By God's grace, the feeling of emotion coming over him sends chills up his spine and goose bumps about his skin because more fragments of memory stored in his gray matter is coming together like puzzle pieces. Can you feel it in your red muscle, too?

Now then, teachings are on deck and are about to release into the atmosphere as thoughts of him in an auditorium filled with people hearing, "what thus saith the Lord," come into play. Just then, a small hand goes up. He can barely see it in the back corner of the auditorium.

"Yes, what is it little Peeples child?" says Lieumas, and this after removing his eyeglasses, wiping the lenses and places them back unto his eyes. He continues with these words: "May I help you, or is it a question you have for me dear?" "May I please be excused to go to the water fountain and get a drink?" the little Peeples child says. Mr. Lieumas replies with these words, "Why yes, you may do so but please hurry back in ten minutes. My hope is to point out more of this truth, and that you would glean more understanding from its contents before moving on to the heart and soul of our story, and its timeless message. We still have quite a bit to cover and not to mention, uncover, beloved, and I do not want you to miss any of it, amen? Keep in mind that we will all have an opportunity, as a group, to be excused as our 30 minute break is vastly approaching and will begin shortly."

Ten minutes later, the little one returns. Just as so, so does the package delivery handler "guy" that their instructor made mention of earlier, excitement from the auditorium perhaps? Inside the packaging rests binoculars, telescopes and kaleidoscopes for the children as well. Lieumas then points out the following Scripture verses that you see just up ahead while using your white binoculars, and I must say that the timing is right on. He begins to instruct the Peeples family by using these following Scripture verses in the next chapter, V. Please if you will, adjust your black telescopes, peek inside your colorful kaleidoscopes children, and stay tuned!

It Is Written

Did God write a book about himself?
Or was it merely a book written about me
God "did" in fact write a book about himself
In the name of Jesus who advocates for me.

I want to think and I want to learn more
I want to absorb all that God ever did wrote
For it would benefit you and me in the end
For it would clear up many things in one note.

It teaches me so many things but most importantly
It teaches me about God's Son instinctively!

The Holy Bible is one book we could never escape or hide from
As we read its pages, it reads us right back
No other book is quite like that one
Not even one book could ever come close to it, beloved
Compared to this one book, friends, all others lack.

These words of mine are written in stone
And these are words that I will never take back
I owe my life to God and to, God alone
I owe it in the name of Jesus who sits on his throne!

He took my stripes across his own back
He took on my pain minced with his pain
He took on silence, which remained fully intact.

Jesus took on the struggles of us all
As he went into that desert field
He did this in order that we follow his lead
To the Holy Spirit we so shall yield.

"Mr. and Mrs. Peeples, I want you to examine God's word with me, no really, I do! Break out your excavation tools, your chisels, hammers and brushes, and let us get to work. Moreover, I want you both to *ponder* what is written inside its holy grounds once we break through the dirt and the mire and lightly blow the dust off its cover, shedding new light on the texts. I am going to pitch a verse to you, amen. The rest of you in the entire Peeples family can join in as well. I will attempt to explain away, through teaching, some of its hidden knowledge and wisdom. Are the both of you ready? Great, let us get started. Hear this word from the Lord as he writes it:"

But he answered and said, It is written, Man shall not live by bread alone, but by every word that proceedeth out of the mouth of God. — MATTHEW 4:4, KJV

Now beloved and friends, let us begin with where we left off in the last chapter, IV, concerning the teachings of Lieumas Leumas Ettesorde. Let me say to you that although this verse is brief, it packs with a ton of knowledge and wisdom because of its surrounding context. Yes, the *grammar analysis*, among many other techniques used, of a surrounding context, to include lexicons even, is one of the important criteria for our understanding the text and the explanation in his teaching. This is true in the learning of any particular Bible lesson, amen.

Beloved, I want you to take notice of these words in the verse that Lieumas threw out there for Mr. and Mrs. Peeples. I want you to notice how they are situated in the text, dear friends. Look for the differences in both, the spiritual and physical atmospheres, amen…

…Are you finished looking? Did you notice that the more important emphasis—ultimately—was/is secondly placed upon the spiritual concept of what Jesus is saying to Satan here and not on the physical context of what he spoke first? Although, the physicality of our words, we should not take lightly due to the necessary role it plays in our lives, we will examine them here, first. Let us follow Lieumas a bit further in as he attempts to unpack the truth of what I am saying dear ones, amen.

Keep in mind that the Peeples' and their families are still swimming

beyond the blue liquid just beneath the aqua green waters. Not to worry though, if they get tired…coming up to the surface for air and treading water for a time will have to suffice. Now then, just as I promised, here Lieumas resumes his place of teaching and he does so in his own words.

"Now these following words in MATTHEW 4:4, Peeples family, when isolated from the rest of the text in the entire verse itself, reads like this: **'Man shall not live by bread alone,' (KJV)**. Now, having been isolated from the rest of the text, we find that it equals a physical context here— the act of Man eating that of physical bread in order to satisfy his and her hunger. Why is this so? It is *physical* because that is what Satan was implying to Jesus that he (Jesus) should do by turning physical stones into physical bread in order to live through his hunger, and to do this by his (Jesus') own divine power, no less.

"You see, Cousin Peeples, Satan's scheme was to successfully get Jesus to see things his way (Satan) in order for him (Jesus) to have any kind of a chance of surviving the physical desert environment surrounding him (Jesus). Moreover, to do this on his (Jesus') own strength or lack thereof no less (due to Jesus' weakness *because* of hunger and fasting), was excitingly tantalizing to Satan because he knew that Jesus' condition might have been a desperate one. Question, why was this important to Satan dear Niece Peeples? You know, that is a great answer! As it was indeed important to Satan because he knew, that Jesus had the power to do this on…well, his own despite his (Jesus') weakness.

"Satan knew that Jesus was the Son of God so this wasn't the issue. However, he figured he would give it a shot anyway—duping Jesus into sinning—; there is no harm in trying for defeat right; so far yet, not so good… You see, by defeating him—Jesus—, this would be a 'feather in Satan's ball cap,' if he were wearing one; this was the issue. Therefore, for Jesus to, not perform this miraculous feat of turning the stones into bread in order to satisfy his own hunger—his appetite—and feed himself would be to no surprise for those aware. On the other hand, for those unaware of Jesus' divinity, well, they might be perplexed as to why he would not and this, due to their shallow thinking. However, to perform this miracle with no mention of a spiritual remedy or dependence upon God for survival, because, again, this would be on his (Jesus') own no less, was a temptation brought about by Satan, who decided to 'play ball' anyway.

"Listen closely Peeples children, for Jesus to *lean on his own understanding*—of course this attempt brought about by Satan—would be drastic regarding hope for humanity, amen. For Jesus to give into sin and become sinful as opposed to being sinless—as Jesus *was*—would defeat the whole purpose of God's plan for our salvation. Jesus, despite

his divinity, needed to experience the fullness of humanity; this to include temptation, and this to include knowing and obeying Bible Scripture too, let us not forget that. You see, Bible Scripture is one of our spiritual weapons, besides prayer and resistance, against Satan and his dominions, which, if you notice, is why Jesus used Scripture, prayer and resistance, himself in order to counter Satan. Again, it was a successful attempt but at the hands of a failed execution. What I mean by that statement rests in the fact that Jesus was not willing to succumb to the temptation, itself. Sure, the temptation, itself, did in fact present itself to Jesus, but Jesus would give into it not. Therefore again, it was a failed attempt by Satan.

"Even though he was tired, alone and vulnerable out in that desert field for 40 days and nights, Jesus dared not to fall into Temptation's trap because it would place Jesus at a huge disadvantage *under* Satan while at the same time, would place Satan at a huge advantage *over* Jesus. This is quite interesting right, Nephew Peeples? Would I be right Uncle and Aunt Peeples?

"Now as we apply this teaching in reverse order to our own lives we find that as we experience Christ more fully we, too, can resist earthly desires and or, physical temptations brought about by Satan ourselves. We can actually *lean not on our own understanding*, but on the understanding of God's wisdom instead, the wisdom of God through his word and Spirit, through prayer and resistance. Let me show you all what I mean. Follow me a bit further into the second part of the same verse as we isolate these following words in the following paragraph.

"When isolating these following words: **'...but by every word that proceedeth out of the mouth of God.' (KJV)**, from the rest of the entire verse itself, we notice that it equals a *spiritual* concept here. Why is this so? Now laying aside the chisels, hammers and brushes for a brief moment, with binoculars, kaleidoscopes and telescopes in hand, let us scholastically take a closer look at it. That is correct, it is spiritual; that is what Jesus was really implying to us that he needed. Spirituality not only survives the physical desert environment, but also to survive the desert environment on this level with of course God's help through prayer, resistance and his word, as the ultimate remedy, is the revelation we are after. Again hence the statement: **'...but by every word that proceedeth out of the mouth of God.' (KJV)**

"Now, outside of God's self manifestation through Jesus Christ, we know that God was not a physical being having a physical mouth, but a spirit being is he. This further makes the statement a spiritual one. As a side note, by this we learn that God is indeed very poetic, amen! However, in keeping with the lesson at hand, the one right here in front of us, simply

by freely putting his own faith and dependence upon God, for survival, well...Satan's attempt at a successful temptation of Christ, fails.

"Yes, even at his weakest moment—due to hunger and weariness—Jesus would not give into sin. Jesus won that particular round *over* Satan and well...Satan failed at that round, *under* Jesus. Yes, he failed at it miserably due to the successful discernment *of* Jesus. Imagine that truth as no imagination at all; imagine this truth as being what it truly is...real! This also is quite interesting is it not?

"You see, beloved Peeples family here is the bottom line, God is showing us *truth* because he knows that we are faced with the same exact circumstances and temptations in life that Jesus faced as a human. God is making known to us that through our *Adversary*, Satan, and his one and only Son—our *Advocate*—Jesus, that the physical realm of who we are, and that what we face on an everyday basis as human beings is indeed, real. Moreover, God is showing us that what we do concerning human efforts, or works to find life through salvation, or even sustain ourselves in life apart from dependence upon God through prayer, resistance and his word, as human beings, is a real decision some of us choose to make.

"Even so, all of that knowledge and wisdom God is showing us right now, without taking positive action in these truths thereof, does not amount to a hill of beans—no pun intended. It doesn't amount to a hill of beans that is...without we, the people, entering into the spiritual realm of who we are to become as disciples of Christ, and ultimately, as Christians through faith in Christ, as well. Being a disciple is simply training, studying and learning about a particular thing. Peeples family, becoming more than that is accepting that which we have trained for, studied and learned. In addition to that, may I mention also, that the very fruits of progress are in, not only the receiving, but also the acting out what we have trained for, studied and learned concerning these righteous acts, and good works according to the Holy Spirit? As Christians, yes I would say that this is important as well.

"To sum it all up, the truth of this find is in our full dependence (discipleship training, acceptance, receiving) upon God, himself, for our survival. This, of course ultimately obtains through salvation. Moreover, the truth of this find is in our fruitful service as Christians through our good deeds (works). These good deeds are what we can partake in after initial salvation is attained, as well as during our journey to Ultimate Salvation, which our eternal heavenly, is *home* and our dwelling place, is *rest*. Amen.

"The fact that we as human beings can finally relate to God through what Jesus had to suffer in the desert is *food* for our mind and soul. It is *drink* for our heart and spirit. Indeed, we are going to take full advantage

of it throughout the reading of this tale, and God's message, blended within this book that I, and my co-Author, the Holy Ghost, has written. The reason I say this, is that here we find Jesus advocating for us as his representation, *of us* in the form of humanity before Satan.

"Now I could expound on these explicit truths from God's word, in regards to the whole of humanity's desires, power and pride (the flesh, the world and the Devil), concerning this entire section of Scripture, found in MATTHEW 4:1-11, KJV, but honestly though, it would take another book—to which I may write in the near to far future. Again, I must say that right now though, presently speaking, it is indeed getting interesting is it not. Here is more of God's knowledge and wisdom as seen from a different section of Scripture. Wait a minute though, before we continue on, who would like the honor of blowing the dust off this jewel? Hear this word from the Lord as he writes it:"

Je'-sus answered and said unto her, If thou knewest the gift of God, and who it is that saith to thee, Give me to drink; thou wouldest have asked of him, and he would have given thee living water. —JOHN 4:10, KJV

"Okay, let us tackle this one my beloved Peeples family. Strategically placed, did you notice how the atmospheric pressure and emphasis is upon him, Jesus himself, and the Holy Spirit, himself, within the grammar analysis? Please allow me to unpack this section of Scripture as well; follow along with me. That is awesome, Niece Peeples." Beloved and friends, Niece Peeples is highly motivated right now as she stands to her feet and pumps her fists. I believe she's catching on, some of *you*, too!

"Now when isolated from the rest of the words in the verse itself, we find that it reads as follows: **'If thou knewest the gift of God, and who it is that saith to thee, Give me to drink;' (KJV)**. Now, while suspended in isolation with open and closed quotes floating beside the text, we have this connotation. Jesus is implying here, to the woman at the physical water well (after her attempt to refresh herself and possibly others who were awaiting her return, with physical water) that the gift of refreshment from God and his grace in this find, is in fact, the hope diamond standing right in front of her. This jewel is in fact, him—Jesus—hence the words, **'…and who it is that saith to thee,' (KJV)**.

"Now then, to add just a bit of a side note, it is from this lesson from God that we ourselves must take with us, this knowledge: the Spiritual water well found in him is the true-life sustainer. His *living water*, originated spiritually, instead of being found physically at the tangible water well.

This is the same well, which was left behind by the woman's ancestor, Jacob (a mortal specimen), hundreds of years before the incarnation of Christ, but it is also in relation to us; it is relevant to us today.

"Peeples family listen to this, here we have a classic case of, *Condition of Tradition* I spoke of earlier in chapter IV. I say this because the context here speaks of her questioning Jesus' water as opposed to Jacob's water that she is so used to drinking from because of *customary belief.* However, Jesus is alluding to her the fact that she should come to know *him*—Jesus, and be filled with his Holy Spirit—Power; she should break the chains that bind through customary belief, so should we. Wow! Let us continue on pressing through this powerful teaching in the following paragraphs my beloved Peeples family.

"The words, **'...and he would have given thee living water,' (KJV)**, and while suspended in isolation we notice the truths of this exposition coming into focus as the Holy Trinity makes an underlining appearance. We conclude that it equals the overall Holy Spirit being given—or in this case—offered from God the Father, to the woman through the *resurrection* of his Son, Jesus Christ, amen. Now the results of this come in the form of ultimate refreshment, and comfort in the company of chaos and tragedy, and this promise from continuous living water found in the Holy Spirit, and this *hope* concludes with *eternal life!*

"This is a better option presented by Jesus to this woman. It's better because instead of physical water found through ourselves or in this case, herself, from a physical water well, which again is only temporal for our physical bodies...she could get refreshed over and over again spiritually, and which is not temporal but eternal instead, for our souls—perpetual. If only she would ask for him by faith, she would then receive the luxuries thereof, us too. Hope abounds, amen!"

Beloved and friends, just then, out of the corner of his eye, Lieumas notices the youngster who asked to step outside the auditorium for a drink of water back in chapter IV. The little Peeples child smiles at Lieumas as his eyes are saying to him after looking into the kaleidoscope: *Clever...I get it!* He then follows through in action by actually stating it verbally. "Clever...I get it!" he says. "God gave you that smile to hold on to young lad," Lieumas says to him. He concludes with, "Let neither a *man* nor a *woman* take it from you."

By this time more of the Peeples' in the class as well as many other spectators throughout their family, and extended families even, in the auditorium surrounding the class while it is in session, become encouraged at this point and thus they began to sit up in their chairs and take notice, and notes. People are even lining the hallways as they exit the confines of their

own classes to which they have been conducting themselves. They begin to focus in on what Mr. Lieumas is teaching all of them; some have even went as far as to place orders and a rush delivery on their own binoculars, kaleidoscopes and telescopes. He now has become motivated to continue as well. "Thank you Jesus," he says in a low tone beneath his own breath. The young Peeples woman in the front row smiles also as she repeats these same words, and in like fashion. "Thank you Jesus," she says. Lieumas continues pressing through… She continues pressing through with him…

You see friends, knowing Jesus Christ, and the experience of the Holy Spirit, is just the beginning of a great relationship with God. Moreover, beloved knowing the truth about Jesus and his Spirit, and knowing Bible Scripture, and then living by them accordingly, aides us more and more in our relationship turned companionship through prayer. Listen beloved and friends, all of these truths aides us more and more with ever increasing strength, in resisting the Devil's attacks.

These important proteins, vitamins and nutrients, milk and meat, fiber and energy are important. They are of the Bread of Life (Jesus Christ), and the Godhead's holy word (Holy Bible), and his Living Water (Holy Spirit) also known as The Holy Trinity. Keep in mind that these were laid out back in chapter III, by Lieumas. They are just some of what the Peeples family will come to discover today, or in the weeks, months and years ahead.

In adding to that, I would like to second Lieumas' motion by saying to you that as you read, study, and learn further details of this book and its many teachings, your blessings shall follow suit indeed. Its overall focus will be in the sum of compassion, praise and worship, character, role-play, personality, poetry, warning, admonition, inspiration encouragement, faith and faith in action.

Now what my delivery needs, I know this may sound a bit overwhelming to some of you and overbearing to others of you, is family integration. I truly believe the ultimate key leadership elements outlined in the *heart, soul* and *spirit*, the overall *body* of this book's tale and storyline, and its timeless message comes in the form of instruction, prophesy, evangelism, and shepherding; teaching—*family integration*. This is the only way, I believe, and that Lieumas knows how, to deliver it—at least in this particular piece; it uniquely blends as like the Brazilian Martial Art of Capoeira.

My hope in all of this, and Lieumas' as well, I Am quite sure, is to bring about these things successfully for your reading pleasure and entertainment, as well as your instructional enlightenment as you study more of God's word (Holy Bible) on your own. In Lieumas' discussion on truth, and in this book, you will continually find, as well as having already found, pockets of motivation and inspiration, and even imagination, from

beginning to end for your spiritual satisfaction, and lively innovation. Some parts are even seen as fun, laced with humor. Please, I encourage you to investigate the "blueprint" who is to become, Isaac.

This book is one I hope you will come to embrace for many days, as well as many years to come. My sincere hope is that it travels throughout your family, as well as extended families' timeline, and sprouts fruit within your whole *Family Tree*. As it sits upon your bookcases amongst the rest of your priceless artifacts and prized literary collections, or in your personal and or, public library collections, study halls and classrooms even, I hope it feels right at home. It is a special piece dear to my heart, written in a personal, yet with simplistic and plain format, but packed with colorful brightness and fierce boldness, equaling, Intrepid Courage.

Its many pages filling the cup's brim with phantom like intrigue and unpredictability, and mystery, suspense, too; not to mention, knowledge and wisdom nonetheless is a tall drink of something worth discovering. Perhaps freshly squeezed lemonade or ice tea in the backyard on a bench swing beneath a thousand year old Oak tree will suffice, or perhaps drifting in an aluminum boat amidst the Bald Cypress trees covered in moss on the black still waters. It is sort of like a, 'N'awlins' Creole gumbo, 'yeh kneaux!' Well perhaps in this particular lingo some of you do not know depending on where you are from in the world. It has a core message though, that we will surely uncover, but it will take a few more turns of the pages upon us getting there. It is indeed a white pearl *within* the white pearl though, a translucent blue, diamond in the rough, so to speak.

In its star line-up, Lieumas gives to us a unique full on glimpse to an even more unique full on cast of characters. These characters are to include Lieumas, himself, and with a surprise guest appearance from a "Hall of Faith Alumni" from, The Epistle to the HEBREWS, as well, to be introduced later. However, with all the characters involved, Mr. Ettesorde presents us with the main star character and centerpiece who being a, Divine Nova Star of Hope and Tranquil Rain Cloud of Refreshment, and Loving Work of Art from God—Christ Jesus, himself. He is indeed a true "peace" of art, very colorful and bold, indeed. We will read and study more of their integrated piece but I must warn you all to strap in your orange seatbelts because we are going for a "rollercoaster" of a ride. Yes, but first we have a special and personal encounter with a, blast from the past!

Fish and Bread... Not Pizza

A spell catches my attention as I beam into your eyes
Just so, I know within my heart that I belong there
The sky is dark but the moon is light
The stars that are your eyes shine ever so bright
I know within my heart that I belong there.

As my siblings and cousins, fall asleep in motion
I look into the sky and feel a sense of, explosion
Within my heart, a beat of the drum; a ting of the snare
Truly, I know from within my soul that I belong there.

God you are the Author and the Finisher of my faith
You gave me a glimpse and a slight bit of taste
Even in my youth, I could feel your hold so strong
You made me realize my sins through things I was shown
So very long ago, you even to me, made it known
That I knew with you in my heart, I belonged there.

It has been a long time coming, as far as my childhood days of growing up well into adulthood are concerned, but I do remember growing up in Louisiana in our immediate family of five people nevertheless. It was an interesting time in my life and I enjoyed it quite so. My family was small in number and in it included my dad, my mom, and my two older sisters. We lived in a small rural village called Toomey and which was situated about 6 miles west of a small country town called Vinton. The funny thing was that if traveling by Interstate along Highway-10, you could possibly miss it with a blink of an eye or elongated yawn. If you took two blinks of an eye and added an extension to your yawn, you could probably miss them both in passing.

You see, the rural village in which I lived was indeed a bit small; my parents migrated here from L.C., an acronym for the city in which they lived previously. The upside though, was that it also rested about 10 or 15 miles west, just outside the small city of my birthplace, Sulpher, as well as the major city of Lake Charles (L.C.), both of which are also in the state of Louisiana and known to some as, "the entrance into Cajun country." It was named for a place where *Cajuns* and *Creoles—Acadians—*were said to have settled long ago, this to include another famed place of residency, New Orleans. These Creole and Cajun people were byproducts of a multiple mixed bag type race of people to include the, somewhat of a melting pot of numerous other cultures of people blending from other parts of the country beyond the sea. *Bienvenue à Louisiana—*, which translated, means, *Welcome to Louisiana.*

Now I, being the youngest and the only boy, was an added blessing to my parents. I mean to say this in addition to my three older sisters of course, for they were blessings too! Hence the word, *added.* However, may I say to you that the reason for their—my parents—joy and excitement may have had something to do with the fact that they had three other children before me and the three of them, were all girls?

Some of you are probably calculating the math in your heads right about now and rightfully so, as I previously mentioned that I belong to a family of five and yet…I speak about a family of six. For this reason, I feel that I must explain to you that one of my sisters—the firstborn of us all—is now in heaven. She was indeed here on planet earth for a limited time before my birth. She was a *special* human being given to my parents for a brief and limited, but important time.

My mother told me about her tender heart, soft-spoken words and very humble spirit throughout her beginnings up to age three. From that conversation, I, myself, drew up the conclusion that she had to be a very special child indeed and that God must have taken her back to be with him in order to protect her from the evil world, which was to come. However though, before taking her back to spend eternity with him up in heaven, she would complete her mission of teaching most of those closest to her the value of life—including me.

Growing up I found myself always thinking of her. Although I never knew her personally, I, being just a young lad and all back then, often visited her pictures around our house, and even while visiting my grandma's house in Lake Charles. It was as if I were drawn to these photos somehow but without fully understanding why. I took one of her photos for myself many years ago when I became a young adult, and now I fully understand why. I especially understand why since I began my writing career. For this reason,

I most surely concluded and through confirmation as well as affirmation, that she not only affected my own life but that her brief journey here on planet earth had to have made quite an impact on other lives also, and in a personal way.

Now, I do not remember too much before the age of 3 to 5. But I will say that during, and after the age of three to five, the fog clears in my mind, and my childhood memories begin to kick in like a shot of adrenaline would do for the heart just after, or even while riding a rollercoaster favorite—perhaps for the first time. However though, some instances that I do remember a little later on, and quite enjoyed might I add, are the times in which my dad would say to my mom that we were going to go out for pizza. He would say this in a non-traditional type of way. "Hey honey, y'all wanna take a ride and get some pizza?" I would catch him saying this, as I would be eavesdropping like a *chameleon* on the wall blending in with my natural surroundings.

I do not really know where my sisters would be at the time, but anyway here's the thing! I was not eavesdropping as one might think. Moreover, I was not a chameleon on the wall either. Rather, I would be a small innocent child operating in a stealth mode like mentality just as if a chameleon would do, in order that the others would not detect my presence. Fair enough you think!

As I walked from my bedroom doorway through the threshold, I turn left and then make another quick left through the short hallway into the living room of our home. My ears perk up while they pick up the sound waves of dad's voice regarding pizza like radar detection. Allow me to explain how this would play out...no, seriously, we have plenty of time.

You see, I would be in my bedroom, and beings that I didn't have any brothers of my own I would be playing with my toy soldiers all by myself while expanding my mind through imagination. Did I neglect to mention to you my, *by God's grace*, sense of artistic creativity? How about my imaginative and innovative persona, did I mention that? Oh, I did not! Sorry for that, how rude of me, you may only know the, other side. Even so, after all, I am from the south—namely Louisiana—where manners are a way of life, or at least it used to be that way... Perhaps it still is that way so again, I apologize.

Now I want to guard myself in saying these next several sentences and that is because in these times, using your imagination you are born with from God, threats are in attack mode. Today young girls and young boys at grade school level and in some parts of the country—even stateside— cannot freely use their imagination while playing outside at recess for fear of being profiled as an imminent threat. They are also limited to playing

on heavy-duty playground equipment roughhousing it for sake of injury. Moreover, they cannot play as if they are "make believe" superheroes and the like, saving the world and doing these using fake imaginary weapons without the threat of police interception, school suspension or even becoming expelled from school altogether.

My heart goes out to them because God's heart goes out to them. I know how the imagination of a child can run away from them at times because, well…I was a child, myself and so were you; so were "they" lest some of them forget. Now I do understand that also in these days, bullying, school and park shootings, and even mass shootings are escalating and this from all ages. I am very sensitive to that fact; the fact that times have surely changed; I am saddened by this. However, I must say that during these inevitable times of change we have to draw the line at some point, right. We can use balanced and sound judgment as responsible adults and children, even though we are amongst irresponsible adults and children, to say the least, right; be not surprised for they, too, are in our midst. I mean this is not just coffee shop, talk anymore, I *am* right aren't I.

We have found that in these current times of change through social media networking and new groundbreaking technology—which can be a good thing (networking) or bad thing (privacy breaches) to name a few things on either side of good and bad—it, coffee shop talk, goes beyond itself! In these days, openly discussing these things is up front and in your face, personal. I know that God's heart is looking at these incidents across his land too! He showed me a visionary glimpse through his eyes concerning these things regarding children and their imaginations a whole day in advance. Before I even heard the stories brewing like coffee on the local talk radio show, God made known to me this occurrence, amen.

I, too, had a creative imagination as a child (in some cases I still do) and acted out these same imaginations (in some cases I still do). Albeit, back then it was safe and there were no threats rallied against me and or, my playmates (classmates) engaging in these same types of behaviors regarding these types of games and activities. Even at recess time we were, *all in*, as we acted out, "the good versus the bad, the black 10-gallon hat versus the white 10-gallon hat," type of scenarios. Those were indeed fun times you know, the anticipation of the ringing of the school bell right before recess; then we are off to the races like thoroughbreds and quarter horses, right, and then from there, on to the city park situated right next to the town library!

Now that I have finished my soapbox rant, follow me into the distant past if you will, if you dare! We are stepping back in time to my place of childhood and we are entering my bedroom for a moment. Now, it may

come off as a bit messy in there but hey cut me some slack would you, I am not perfect; I was a kid! Moreover, I am still not perfect and I am an adult! Although, I have to admit, I am a whole lot tidier. Besides, we will not be in there too long. Relax a little; you look tense. Just trust me and I will walk you through it. We might have to step over a few things when we get there though!

Are you relaxed now? Are you ready to accompany me as we go down this road? I can assure you; God is with us. Awesome, we are off to the races then! Grab hold of my belt loop and let us go back in time through the portal of that, "time wind tunnel thingamajig," I just dreamt up! C'mon now, off we go!

You see, I would be in my bedroom playing with my toys mom picked up for me at a nearby family supermarket, let us say, Kroger, shall we, some time before. Some toys were in the image of "Cowboys and Indians" situated right there up on the top shelf. Some toys were in the form of DC Comics and Marvel Comics, comic books, "Superheroes versus Super villains," like for instance, and these Superheroes are my favorites in this order: The Dynamic Duo—Batman and Robin—, Superman, The Incredible Hulk, The Amazing Spiderman and The Wonder Twins, the little monkey, too! Wait oh yeah, and the X-Men, with my favorite characters being of Wolverine and Gambit, even in reverse order. They are over there on the lower shelf.

Some toys would even be in the form of stuffed animals. Hey now, I had a soft side too you know? Well, humble side; I admit to it. That is my stuffed animals over there sitting, and resting on my twin beds. I had a meek side; how's that!

Lastly, for this story's sake, some toys would even be in the form of toy soldiers; yeah, that would be my bolder side, try that one on for size. As if ants or something, there would come in groups and platoons, about fifty-one hundred green Army men. They would be found posing for battle on the backs of surfboards as though they are riding the waves in a "mad scientist" attempt to storm the beachhead or something.

That is I, myself, over in the wild blue yonder taking my other toys out of the red and black toy-box with one black shoe on my sock and not the other one, and with white tube socks on my feet—green stripe edition. Oh yeah…the black shoe of course, has its white shoelaces untied—this dress code is typical of kids huh? Sometimes, as with teenagers for this 80's time era, multiple colored blocked shoelaces well, even without the shoelaces was considered fresh and cool!

I also delved into the world of comic books, in general, and even the Worldwide Wrestling Federation movement, aha!, more boldness. However,

some from the south would say, "rassling" movement! I collected several of these magazines over the years but in the future tense of the right now, they lose themselves away inside my dresser drawers so that is the reason why you cannot see them.

As a kid, I was even into horror film characters as well like for instance, and these were my favorites in this order: Werewolf, Count Dracula, Frankenstein, and I thought Zombies were "pretty cool" too! Ok, hahaha, sorry for the pun. However, I must admit though, Michael Jackson's Thriller was the best depiction of this!

Now, I would take the bedcovers off one of my twin beds to enhance the stage. This would take place after transferring my beloved stuffed animals onto the other twin bed. My twin beds were originally bunk beds but dad, and or, mom, would separate them and situate them side by side, instead of stacking or, doubling them up every now and again—for a *change* of scenery I suppose. I was cool with that though, because it broke up the monotony of having them set in a particular position for long periods. I guess it made my room look different on occasion and accommodated my imagination although; bunk beds and twin beds *are* one in the same, right—"twin bunk beds" *would* make sense, I think.

Anyway, I would ball the bed covers and mattress sheets up, then as like, God's process of creation or something, shape them, and mold them until the satisfaction of a mountain came to life with clefts, and valleys and all kinds of hills and stuff! The stage is now set *and it was good*... I would then airlift my team from the beachhead and tuck my toy army soldiers into the cracks and crevices of the mountainside and mountaintops, as though the fighting men were hiding in wait for the enemy in every nook and cranny while fully camouflaged. You know the *drill* right—no pun intended?

Acting this out, it is somewhat just like a chameleon would do in order to defend from its prey, or even offend its prey, you know, if the circumstances are in reverse order, or, "the other shoe was on the other foot." Keep in mind though, that this was indeed "wartime," but in the world of, make believe. Some of them were indeed instigators of war and casualties of war also, so keep that in mind, too! Moreover, some were indeed prisoners of war also; let that resonate in your mind as well.

"Rat-a-tat-tat!" echoed the toy M-16. "Sergeant I'm hit!" yelled one toy soldier. His battle buddy radios for back up from the medical team. The medics arrive and examine him while the many witnesses from my baseball card collection look on. As they line up against the brown wall paneling and white sheetrock along the side of my bedroom wall my mom stapled them to, the players on the cards interact with me. Strange thing

how their eyes seemed to follow everything that was going on inside that bedroom of mine as the players' faces on the baseball cards seemed to be from all angles, watching with their eyes, my every move. This was strangely intense and not to mention, down right creepy indeed...

...White sheetrock though, brown wall paneling, really! I think to myself as I step forward into the right now future present tense of today, how nostalgic! Well, you get the idea of kid chaos at playtime right? Ahhh, so refreshing are the memories... It is as refreshing as when the cool blue water, streams betwixt the toes on a beautiful summer day, alongside your wife or husband on a white sandy beach after strolling the boardwalk. Yeah, it's kinda like that!

Meanwhile...back at the king's ranch... After daydreaming about the summer day beach stroll...uh-oh, unexpectedly, it dawns on me (as like my future granddaughter, would do on her predicted birth date and yet, miss the mark entirely) that I have left you there, back in the past inside my bedroom all alone. "Oh no," (as like my future step granddaughter, would pick-up using these words in her vocabulary), this cannot be! I must return there with you before you become uncomfortable because your acute presence is aware of my brief absence!

With Trumpets Sounding: Have no fear! The mighty Lum, uh um...I mean, I am on my way back! "Hang tight" I am almost there! I can almost see you now even though my eyes are squinting from the wind in the wind tunnel time portal thingy that I am traveling in...

...Well I'm back and get this, you haven't a clue that I was ever gone in the first place as you are found waist deep, but head first, inside the top opening of my toy-box train, which is in the form of a giant red and black caboose. Yes, that's right, *a* giant red and black caboose and not *the* giant black and red locomotive engine that all the other kids are so eager to get into, much less get their hands on. Let me explain.

Even though I am an *apostle*, chosen by the Lord as his *forerunner* and *fanfare*, sometimes I feel as though the Lord, as his toy soldier (P.O.W. status) is displaying me and I am learning to deal with that. I am okay with that. On the other hand though, and sometimes what I am not so okay with is that, well, that my "toy counterparts" are neglecting me, you know, my human associates and just the same, spiritual constituents. I, at times, feel as though I am forced to stand in the corner of my room as if I am (M.I.A. status) in timeout or something. Yeah I know I know, I know what you are thinking, "But you shouldn't let that bother you." Listen, I don't let it bother me for the most part that's why I mention the word, *sometimes*; even so, I am still, "half-human" even though I'm a new creation.

Up-close we are highly regarded but far-off lowly discarded at the same

time, like recycled garbage. On the other hand, this outlook for some may be in reverse order. One man's trash is another man's treasure. In adding to that, one woman's, fragrant parfum is another woman's, foul stench. Therefore, being the "engine" and then treated as the "caboose" with little to no *fanfare* is right on *schedule*—one of two puns intended. Moreover, we are *not* prisoners of war; we are *not* missing in action, either. We are "free" and we are "here," some of us are even hiding in plain sight. We are humble and wear humility as our covering also, thanks to Jesus Christ! Not to mention though, sometimes *rainbows* do suspend in midair over landfills and such too, you know.

And so…that being said, continuing on, at about an hour later, I have grown tired of playing in my room for the time being. So I, along with you, commence to putting my toys away. We put the lid back on top of my toy-box caboose and you take hold of my belt loop once again as I proceed to lead you out through the wind tunnel of time.

At this point, we make our way out of my bedroom. As we step over the threshold from my bedroom doorway, we turn left and then make another quick left through the short hallway into the living room of my home. "Hey honey, y'all wanna take a ride and get some pizza?" says my dad. Now, time has caught up with itself via the 360-degree trip back to the pizza story. Let us move forward to see how this ends.

I often felt as though my dad was talking to me alone regarding these sojourning missions of, *fulfilling hunger pains*, that would creep up every now and again in the pit of my stomach. I perhaps felt that our dad was talking to me alone because I knew the spot in question was to be a very popular eat in pizza joint, and that pizza joint was *my* favorite. Notice that I put the emphasis on my. Next, we would all go and get ready for the evening ceremony by freshening up a bit and putting on our, "going out for dinner's best," clothes.

Now, as we all loaded into the custom family van about two hours later, we sometimes would make pit stops along the way to the local restaurant. We would pick up a multitude of relatives that we invited to come along with us. Some relatives of ours consisted of our cousins, aunts and uncles—a huge crowd of people. Often times though, they would be at our house already visiting us as we all so often did as children, as a family. Even well into our teens, we did this. For none of us live too far away from the others at any given time.

I mentioned the words, *custom* and *van*, but keep in mind that this was the mid 70's to about the mid 80's, and custom vans, not minivans, or Astro vans, but again, custom vans, were all the rage. It was not until the 90's that the minivans and Astro vans became most popular with the masses,

and with good reason—I'm sure we all owned quite a few of these beauties ourselves in our latter years; I know I did. Are you with me so far? Amen.

Now the type of custom van my dad had at that particular time in history was the fully loaded Ford model, the Ford Econoline. Let me inform you of how the immaculacy, for that era, churned out. Keep in mind though, I am no "car salesman," but I believe that I can conjure something up to give you a bit of imagery, you know, kind of, as a car salesperson would do. Here goes nothing but in every aspect of the sell, here goes everything!

It came off the assembly line's conveyor belt with a two-tone blue and white exterior paint color scheme. As far as the inside regarding the van's color scheme, it was beige and dark gray vinyl and tweed, and came loaded with a fully functional sink. It had a closet and a wrap around rear couch seat, as well. Oh, did I fail to mention that it also came with a rear mini dinning table, which doubled as a full fold out bed for all the sleepyheads? Well it did and that was just the interior!

The other eye trappings of the custom van—and now we're back to the exterior—came with the look of stock 15 or perhaps, 16 inch white rims wearing wide raised face white lettering brand name tires spelling out the words, BF Goodrich, and spinning in rapid succession on the hot black asphalt surface of the yellow striped highway pavement. Yeah, these shoes and socks were a great fit. In addition to that, check this out; it had a sound like thunder, which roared from its twin dual exhaust mufflers and tailpipes at points of ignition, idling, and acceleration—quite arguably, the "Trinity of wrench heads," to say the least. Uh um, continuing... Laced with aluminum running boards as well, each side of the van—both left side and right side—came with these bad boys.

It also had, in its build stature and pose, a killer stance with the front end tapering off just slightly lower than the rear end, nice! It had a mean front fascia wearing an upper and lower spoiler kit set-up, too—white in color. Now to add a little bit of a, "side exhaust note," it doubled as a great place to play *Hide-N-Seek* with my sisters and our cousins. Oops, um, sorry dad, for keeping that part of our lives regarding your van hidden but it was just plain awesome! In addition to that, I must admit that I was a tad bit, okay...overly proud of, having that custom van catching some shuteye in our driveway carport/garage for the evenings. Oh yea I almost forgot to mention that the windows were tinted dark brown, too! *Méfiez-vous main tenant* (Watch it now)!

Nevertheless, even after all those years of being overly proud to be associated with being a part of that custom van in all its glory, and even now considering my priorities in life, I have come to the realization that my love for God outweighs any custom van that may have been an eye trap

for me. The same saying goes for any "eye-popping" custom hot rod today as well, to include 4-door sedans, 2-door coupes, hardtops, removable hardtops and soft-ragtop convertibles, too. Now I still appreciate these luxury cars, American muscle cars, super cars, hot rods, classy classic cars and pretty much anything else resembling these, especially while visualizing the nostalgic picture of orange and brown October-November leaves swirling briskly about the dew-covered road after the mist burns off. This astonishing scene as the Potenza Bridgestone tires blow past them, but I appreciate them on a bit of a different ground level now, a different scale if you will—pun intended.

You see to me, he—God—is plain awesome and other people, places and things come in second and third as priorities in my life. I now know that by me putting God first over all things, and my life in general, I know that all other things God takes care of because of his promise to me. Moreover, I know that they are of great care by his will. Now that, my friends, is okay by me. I am man enough to admit, as well as accept that fact, amen.

No matter what God allows for me, *content* is who I have become and *contentment* is what I will continue striving to maintain, beloved. I will continue in this journey *of* life while aided by the Holy Spirit, *in* my life. Yes, the "idols" that were once controlling my life are now sitting "idle" and they are not controlling my life anymore. They are collecting major dust situated up on a store shelf somewhere in a family supermarket of oblivion, perhaps with an enormous white price tag dangling in front the faces of others, like carrots to horses. It's their modus operandi. However, I am here to say that the same enormous price tag that *I* see is red. I will not allow them to take me in under their wing any longer. I must not give into them anymore! Christ has paid the enormous price tag for my freedom and this same freedom for everyone else, as well, and I accept that now; I would hope that everyone else did. Yes! Amen!

This is my hope for you, too. *Yes, I'm talking to you*. This is God's desire for you, as well, for he will not share his praise with carved idols. The same goes that he will not give his glory to anyone else. It is true, for he says so in, The Book of the Prophet ISAIAH 42:8, KJV. The idols may rear their ugly heads for a brief moment in order to tempt me but the binding marionette strings have been severed from my torso all together, therefore, I'm no longer a puppet on a string; of this I Am is certain.

I *am* the LORD: that *is* my name: and my glory will I not give to another, neither my praise to graven images. —ISAIAH 42:8, KJV

"Hey there Uncle Casey and Aunt Frieda," I politely spoke out. "What's up Cousin Casey Jr.? What's up Cousin Erin?" I obnoxiously blurted out these words as I pinched my cousin, Jeff, in the biceps of his arms. Now keep in mind that Cousin Jeff was a young body builder and me…well, not so much.

Yeah, that is about how wired up I was as a kid at times, but it was all in good fun and nothing short of that. Uncle Casey was a tall slender man in build and he stood about 6 foot and 2 inches in height. His complexion was a light brown and his black hair was a cut lower than most—especially for that era in time. On the other hand, my Aunt Frieda was a bit shorter and thicker with a height of about 5 foot and 7 inches. She had a nice warm smile every time we all would meet up for family occasions. Her complexion was a bit darker than my uncle's was though. They were a great match to say the least. Perhaps this was by God's design.

Other relatives, we met with greetings and salutations upon their entering the sliding doorway of the van, too. While we all laughed and poked fun at one another as it proceeded in the direction of the restaurant, the rest of our family continued socializing as the music streamed from the eight-track player from the radio blaring drums and snare, and exited through the Pioneer speakers mounted throughout the Ford Econoline. I am sure your childhood past sounds a bit similar to mine right. Singing to the tunes of popular music on eight tracks while we cruised around town in the blue-lit night sky on a mission to go and get a bite to eat as a family, to include relatives was such a cool experience. It was very cool indeed.

Now, you may have had different names of family members perhaps, and you may have had different vehicles to cruise around town in, but the same memories nonetheless seem a bit familiar to you. You cannot deny that fact. You may even be among those lucky few who were in route to go see a drive-in movie no doubt. Imagine being able to view a movie and have a view of the night sky at the same time. Being outside on a beautiful blue-lit night with the yellow stars sparkling and looking as though they are the eyes of God's angels winking at you—perhaps God's own eyes—was surely a catching and not to mention spell bounding scene; this as you beam back up at them, winking in return. In my humble opinion, that is not *luck* at all. To me that is God's grace, his showcase of *love*.

Now, while the horse playing between my cousins and I were going on, I can remember thinking to myself that I could not wait to spot that glowing red roof. I could not wait to sink my pearly whites into the piping hot yellow cheese, and red pepperoni pizza that I would be *introduced to* and later that evening, *engaged to*. Then I would envision myself, perhaps while unaware at that point, of the melted cheese, which draws

back hanging in the balance midway between my mouth and the slice of pizza, itself. It would hang there, as like a power line would, uncertain of itself as well; you know, unaware of the immense power that it contains; after all, spiritually and metaphorically speaking, life can be experienced as a balancing act, you know...with the choices of either walking on tightropes, or running atop *power lines*. I would then use my index finger to break the melted cheese. Later that night, the same *electrifying imagery* would manifest into a *marriage of* sure reality. Oh yes, the pizza was just that good!

It was soon to be sizzling hot from the huge deep dark metal pan (those old worn out pans and black skillets are the best), it rested upon for so many years, all so it seemed, through impatience no less. Finally, it would be pulled fresh out of the oven with the white aroma fumes floating in the air like a prized cartoon animation. I would then surprisingly find myself un-seemingly floating in the air following these same white aroma fumes. With my eyes closed, I would be found effortlessly drifting about aimlessly in the air doing the worm, also like a cartoon animation. Charged just knowing that it would be just that good was my mood! Of course, the pizza joint was well liked and enjoyed by many other members of our family as well, but I felt as though the restaurant staff catered to me on a more *personal* level, you know what I mean?

Now, I do not really know what the others were thinking about at this particular time in our individual and separate lives and quite frankly, at this point I did not care. Nevertheless, for me, in my own mind, this imagination of *special* treatment came from the young woman standing behind the soon to be, present counter. Of course we cannot forget about the pretty hostess who would be seating us all shortly upon our entrance through the front twin doors marked with the red, or perhaps green colored words, Entrance, and Exit, of the restaurant.

Yes indeed...aha, the awesome smell of pizza! Get a whiff of that! Yes, that my friends, is what I cared for; make no mistake about it! I'm just kidding... A very soft-spoken, *Right this way,* she would soon be speaking to our family of several, and she would speak this while pointing us to a tablecloth covered in red and white checkerboard print. Boys will be boys right?

Anyhow, I am sure most all boys can relate to this segment in this story even if their favorite food place was somewhere different other than fast foods dives and dine-in pizza joints. It would not matter to the male gender if the main course were fries, burger and a soft drink, although I prefer Root Beer and or, Coke. It would not discourage us if it were in a fine dine-in facility, or a simple but crowded mall food court, even. We

would not care as long as the food is there, hahaha! However though, in this isolated case, it was pizza.

I believe God wired us boys that way, and even some girls, too. I do not mean loving pizza by itself mind you, but instead, thinking that we are the center of attention in the midst of a crowded room *while* loving pizza! Now that is living! On the other hand, is it? A very soft spoken, "Right this way," she says to us.

Toward the end of the night though and after the jukebox songs were beginning to weigh heavily on me, my tummy became full of pizza. You know the feeling of; *ugh, I am so stuffed and I feel miserable, and my tummy is full of pizza*, yea that sort of thing. And since this slow satisfaction of pizza inhalation took place in the, *right now*, my hope was that we would be lucky enough to have fragments of pizza leftovers to perhaps nibble on later the following afternoon—you know, when we're hungry all over again. This is commonplace amongst us human folk, especially those of us folks who frequent restaurants.

Now my desire, although full, would be that someone would please signal for the server to get our table a well-deserved "doggy bag." *Oh, let the remaining pizza leftovers be housed in a to-go-box to perhaps nibble on later the following day*, I thought to myself, and then methodically stated these same words underneath my breath hoping that my dad would hear my mumbling it... "Oh, let the remaining pizza leftovers be housed in a to-go-box to perhaps nibble on later the following day."

Yes! A hand from our table goes up and the server makes her way over to us in beeline fashion... "Sure, I'll get that doggy bag for you, coming right up," she says. She would soon delegate the task of retrieving this alluring to-go-box detail to the counter help. She would then, bring the doggy bag back to us with a warm smile upon her face; at last; finally, the moment I've been waiting for!

By the way, that pizza joint is still in existence today after all these many years and with all the bells and whistles to boot. Yes, you guessed right, you are thinking of, ye old...Pizza Hut! Yeah, that's the one. Maybe your own Personal Pan favorite pizza joint is satisfying to you and to you alone, also. I confess to you that it is still my favorite, too! Even if it is perhaps different from yours, we all have our own distinct tastes in pizza, which is satisfying to us.

Think about it, it's kind of that way with life too, for us human folk... Unlike pizza dough, there is indeed only one distinct taste for life itself, whether we are satisfied with it...or not. By the way, did you all catch my punch line; hey, *you there*, did you catch my joke? I said, "Unlike pizza dough," instead of saying, Unlike pizza though, hehehe! Perhaps it's a

knead to dough basis engineered to stretch past the stiff upper lips and stuffy noses.

Now as the evening would wind down to a close, I, and the rest of the family, would slowly make our way to the Exit marked door of the restaurant. Us kids would pile up in the back of the custom family van, convert couch to fold out bed like special twin agents in a kid spy movie or something, and then head back to our perspective housing locations. Yes, we would prepare to head back to a place of; "before the restaurant, tour enters our gray matter." Yeah, that place! There was not much of any horse playing going on this time around in the van though, but idle conversation instead and that my friends, thanks to our full bellies.

Shortly thereafter, it is lights out for every one of the kids curled up in the Ford Econoline, save for myself. *What if something goes wrong during the drive, someone has to stay awake and render aid...* I would think these words to the universe as I witnessed the bright white star guardians of the blood orange moon above, this moon, which seemed to be floating in the blackish blue balance of oblivion held up by nothing. At this point, I thought about my family, and their safety while traveling the highways and byways.

Now, while softly speaking these words to me, myself and I, methodically, I truly and sincerely felt it genuine in my mind, heart, body, soul and spirit that God was out there somewhere in the universe eavesdropping; at least that was my hope. Laying there pondering life, I hoped that God would hear my words of loving concern echoing within the deep chambers buried within my heart. "What if something goes wrong during the drive, someone has to stay awake and render aid."

As a natural born guardian; protector of those around me, I guess God was secretly preparing my heart at an early age. Somehow, it was as though I already knew, I belonged there. Again, at least in my own mind it feels that way; it felt that way in my own heart, too! I now know that, the Holy Spirit was there too—you know, traveling upon those highways and byways with me back then as well. In fact, he was there with us all in that Ford Econoline custom van as he guided us back home to safety. Off to sleep went the other kids in our family...and eventually, I right along with them. For at this point I, too, felt safe in the midst of God and his holy angels, his guardians. Have a pleasant goodnight Zzz... Zzz... Zzz...

Thanks dad, for feeding the multitude pizza. Thanks mom, for supporting dad in the idea of feeding us pizza, as well. Most importantly first, I want to say thank you Father God in heaven. Thank you, my God, for always allowing them to have the resources to do so, even at times when they did not have a whole lot of money to spare. You took what little

they did have though, and by your grace, you multiplied it many times over. I truly appreciate it even after all these many years. It was not by coincidental luck that we experienced these miracles in our lives but it was by your compassionate love that this was made possible. I am sure the rest of our family and relatives feel the same excessively, my Lord. This, too, is my hope.

Beloved, this tale; message, this story is not all about pizza though, but it is more in relation to God, our heavenly Father and his Son, our Savior, and King. As Lieumas alluded to us early on and as I have mentioned, he is the main star who goes by the name of Jesus—the Christ. Well, I am certain Lieumas would be honored in demonstrating and illustrating to you more of who he—Jesus—is but first allow me to explain some more things to you from your, as well as my, Holy Bible. In so doing, Mr. Lieumas—Luminous, as his friends refer to him—will transition for us at times. He then, takes over altogether and enlightens us, amen?

Now I do not want to escalate your hunger for pizza, not that there is anything wrong with that! However, I would prefer that you hunger for something else far more valuable than pizza that will satisfy your appetites. I prefer that you hunger for what else is baking in the oven up ahead in the following chapters awaiting birth. Yeah, now that is what my hope is, for you all.

Turn in Your Bibles

All you need is one book; all you need is one
There are so many characters in this one book
However, even more so, there is only the One!

We can learn so many "special" things
From God through his book
We can learn so many "personal" things
It truly deserves a, second look.

I thank God for leaving it behind
Just for you and for me, in the essence of time
For its purpose is that we could all absorb
With a signature directly from Jesus Christ, our Lord.

Turn in your Holy Bibles with me to, The Gospel According to MATTHEW, chapter 14 out of the KJV, beloved and friends. Would you do that with me? Now I want you to know that tradition has it that this biblical account was recorded at about 60–65 A.D. In addition to that, its recording is produced by Matthew, the Apostle, as it is at the heart of Lieumas' tale to us, bound up in God's message for humanity, which together, again, is a collaborative work for all people. It is a work for both, Jew and Gentile alike, for together this integrated piece is…Their Story!

For those of you who are *not* familiar with this particular man of God, let me just begin by explaining to you that Matthew was a *tax collector* by way of his occupational profession. Moreover, he became a trusted friend and a true follower of Jesus Christ. Now although some of the traditional renderings conclude that Matthew *was* the original author of this book that bears his name, other biblical scholars' claim that he *was not* the original author. In your own personal studies, I would encourage you to explore the biography account of

Matthew and thus draw upon your own conclusions, amen. I, myself, believe that he *was* the author until it has proven to me to be otherwise, amen.

Now, this title of, Tax Collector, was not a well-liked profession by the commoners throughout the many towns and villages and frankly, it is not a well-liked profession by many in today's time as well. Something about the control of one's, *own money* being in the powerful hands of another to control can be quite humbling indeed, and yet, here we have this biblical account at the same time, all aspects of it, the good, the bad and the ugly. However, aside from all that, later, Matthew, whose name means, *Gift of the Lord*, would become one of the *Twelve* disciples and later, *apostles* spoken about in this most intriguing biblical message, and real life story intertwined in Lieumas' tale.

The Holy Bible also explains and teaches us that Jesus approached him one day and suddenly recruited and took him on as one of his disciples. Now this must have been a fascinating time for Matthew (recruitment by the Lord), some would imagine. He followed Jesus without hesitation. Jesus had quite the influence over some people you know. One word from him, for some, was all it took, for them to become his follower. Trust me; I know this all too well. That time in 2007, when I met him *face to face* was definitely a time I doubt that I will ever forget. I followed him almost immediately too! Well, almost, is putting it quite mildly. I began to follow Jesus without hesitation; this much I do know.

Keep this in mind though, Matthew, although Jewish, had a universal appeal in his writings of Jesus, the Messiah—Christ. His aim was to convince the Jewish people that this "Jesus" was, and is indeed, their promised Messiah. The Jewish people knew one would come (according to what the inspired prophets hundreds of years ago promised) who would rescue them from their Roman oppressors and in doing so, set-up a new kingdom. What they did not know, or perhaps recognize however, was that this same one would suffer physically, socially, and be killed. Then again, one should ponder the notion of this: how could he do these great and marvelous things of rescuing them and then, die or even more tragically, be killed or executed; yet, it is what the Bible says. I imagine that in their minds, they would render this tactic unsettling and purpose defeated altogether, so much for hope, right.

Matthew used his words carefully when explaining truth to the Jews I mean, he used terms like, *Son of David*, and *Messiah*, which would allude to the Old Testament writings of the Holy Bible that the Jewish people were so used to reading. Matthew wrote specifically to the Jews in their own time. However, in its universal appeal, this same claim convinces, or intends to convince, the non-Jewish audience of something they have

missed along the way. The missed revelation we have here, is of this same Jesus as their promised Christ—even today, amen. I can attest to that same claim and I am sure, Lieumas, can as well. I say this right now because as he mentioned earlier in chapter III of this book, God told him to, "Bridge it," also. Please, allow me to explain.

In using Matthew's Gospel writings, God's aim was to bridge the Old Testament with the New Testament as this, Matthew, would indeed become an apostle of, not only the Son of Man—Jesus, but Jesus—the Son of David and the Son of God—still, Jesus. That is just for starters though; I mean the whole of the book, The Gospel According to MATTHEW, has clues of the linkage between the Old Testament and New Testament. However, most of the Jews in that day and time as with most of them in this day and time overlook some of the prophecies of the Holy Bible concerning Jesus, the promised Messiah; our promised Messiah; their promised Messiah.

Listen; contrary to popular belief, I can personally say that God is not through with the Jews. Yes, he still views them as his beloved. Moreover, he still has a unique plan for them waiting to be revealed, as they indeed still are the *apple of his eye*. However, in knowing that fact please, I state that you become aware of this fact as well, God is not through with the Gentiles either as they are just as much his as are the Jews; God shows no partiality, we do. It started out with ones set apart rejecting, but ended with expansive others accepting, just as so, it will end with the latter but begin again, with the former. Therefore, his plan for them, too (Gentiles), will carry out shortly. We (all who trust in him) belong to the Savior; the Messiah; the Christ—Anointed One. In due, season, his plans for both Jew and Gentile will unfold as they continue to unfold, even right now!

"Okay so, Peeples family, starting with verse 13 out of the KJV of the Holy Bible and working our way through to verse 21, we are going to begin embarking on a conscious journey filled with physical, spiritual and emotional truth. Yes, we are to begin embarking on an odyssey, if you will. We are setting ourselves up to undergo a peregrination, so to speak, filled with relevant truth as we speak about the miracle of Jesus feeding a multitude of over five thousand, yes, that's right; five thousand people.

"...*Wow, imagine that!* You are all probably thinking this to yourselves. Then on top of that, you are all probably following up mentally with the words: ...*This is what we all have been waiting for!* However, I have to say wait just a moment, not so fast. Please allow me more time to set this up for you, amen. The bad news, well...the not so good news, is that we are not quite to the gratifying apogee yet; there is still, 'the build-up.' However, the better news is that we will soon get to the culmination of things, 'the climax.' I promise.

"Now, to put you in the mood of what is going on here, I want you take these truths and bottle them up in your heart of hearts. I want you to feel what I feel and know what I know. Amen. I want you to see what I see from Jesus, the God of creation itself, himself. Yes, I want you to internalize this day as though you were there *with* them—myself, Jesus and his crew of twelve along with the crowds of people—this is of course if you haven't made plans to do so already.

"I mean listen, I know not of your personal reading style and the depths thereof. I know nothing of the sort may I say to you. You see, the depth of reading style for an individual varies in many different kinds of ways, like pizza combinations; like complexities of life even. Perhaps it is similar to mine…or perhaps, it is not similar to mine, right?

"However, if it is not your typical reading style then what is prohibiting you from allowing this reading style to be a first for you in its grasp? What is keeping you from experiencing all that God has to offer to *you* from this story, and believe me it is a lot? Well it is certainly not me, and it is certainly not you dear Peeples family. You asked of me to write you into this story and well…

"Now, please go ahead and start preparing for mental insertions of yourselves within the remaining black and white pages as we move further along straddling the gray fence-line too, throughout the reading of this colorful book, and the truth discussions found within. Feel free to begin preparing yourselves, to immerse yourselves inside the text, as I implore you to explore this account with me in between the verses as well, and this in order to finalize a way of escaping self-containment. Just hold on to my belt loops while I take you inside, as if I was our narrator, or a curator at a fancy art museum or some other exclusive establishment, okay.

"Yes, I did say hold on to my belt loops. Grab hold as if we are traveling back into our trusty narrator's red and black toy-box caboose, discovering the many more gifts that lay hidden in there, amen? As you grab hold please, allow the others to grab hold of *yours* and we will make like a chain link convoy. Continuing onward, let us work our way in.

"The truth of God is the ultimate establishment though as I, myself, was there *supernaturally* as the heavens opened and Jesus took me in Spirit one evening in order that I might grasp a portion of this truth, while attaching the rest of it to Scripture. It was my assignment from the Lord that day as he was preparing my mind for the, right now, discussion we are having and preparing my heart for the, right now, writing of this book. This sounds a bit surprising to you right now, huh. I was a bit surprised by it the first few times that it happened to me also. I mean, 'This Bible stuff is really, real!' I said to myself aloud. Nowadays, I find that it's

pretty commonplace for me though, just as it was for some of the earlier apostles and prophets, and even the saints written about in days gone by. I am sure too, that I am not the only one outside of the biblical account that this has happened to over the many generational gaps and I say that in all humbleness, and with genuine humility, amen.

"Now I have met a few of these saints in my day that share my experiences. However, at the same time, experiencing these things is a bit overwhelming for some people, as they do not believe it is possible. I believe I am stated as having made mention of this in chapter I of this book; perhaps I may have been speaking on Lieumas' behalf or perhaps again, in reverse order. Either way, I can truly say that I have met them as well. But it *is* possible (I stress the word is), and the Bible says so in, the book of, THE ACTS of the Apostles, as well as in, The Book of JOEL, who was a prophet also, and whose name means, *The Lord is God.*

"You can check this out yourselves Mr. and Mrs. Peeples, for it is the truth and I am a living witness *to* this truth. Hey, as I have alluded to before, its finds are among some of them written about in the many pages and chapters throughout the Holy Bible no less. I will properly introduce more of my apostolic and prophetic, as well as my ecclesiastical brothers to you a little later on.

"Getting back to our previous train of thought though, and investigating the mysterious red and black toy-box caboose even further, yes, I found myself supernaturally traveling inside the boat that day on the lake with Jesus and the other disciples, Grandma Peeples. Grandpa Peeples listen to this, so as not to exhaust this transfiguration for good, later on while in the Ghost, I also experienced the same crowds of people more vividly. I experienced them gathering and approaching all around us as well, just as we began docking the boat that day.

"Now the waters were a bit calm and almost black in appearance, with small ripples approaching and bouncing off the bank of the lake like cue balls banking off the side cushion walls on red or green felt pool tables; you know, after shark one has taken his bite! I could see beneath my feet, the grayish beige wooden deck of the boat as I carefully took a step over the small bench seat in an attempt to exit the boat safely without falling into the lake and attempting to walk on water as my brother, Peter, did. I could hear the crowds murmuring words but I was unable to make out any full sentences at this particular time in my *spiritual* experiential history.

"Beloved Peeples' of God, hear this fascinating description of what my own brown eyes, through God's multiple colored lenses, did see: As the darkness fell from the beautifully blue and white painted backdrop, which highlighted the skyline's orange-red sunset like an equally beautifully and colorfully stitched

tapestry quilt blanketing the daylight, I am in awe. Continuing on, and then transforming itself into the smoky gray and pink-blue dusk filled nightlight, something begins to take shape and crystallize. Somehow, I could feel the intensity of the Holy Ghost as my body grew ever so weakened.

"I awoke suddenly out of the Spirit in a cold sweat shortly thereafter with a frown fixed upon my face. Then I suddenly awoke and sat up in a cold sweat with a frown fixed upon my face shortly thereafter! This frown fixture was symbolizing and describing to me that the *spiritual* dream I just endured, was over, and then...over but in reverse order. My own reflection described to me that it *was* over, but was it indeed, you know, over.

"No, it would not be the end because by the grace of God, I would later return to the scene—in my thoughts no doubt. Yes, I returned to the present but will never forget the Supernatural Spiritual Realm Shift just as I experienced it that day in real time. I mean it felt so real, and I am not the least bit embarrassed to say that it was...REAL!

"Now it still happens today, and quite often, I might add, thanks to the power of the Holy Spirit in my life guiding and instructing me on a daily basis, amen. He—The Holy Ghost—is the *one* running the show in the life of a Christian you know? It is imperative for you to know that *he* truly is the one running the show... You must realize this; let me explain to you all why this is.

"You see, the Holy Ghost is Power! Need I say more? He is the one who fuels and refuels me with the compassion, and the passion, to do what I do in the ministry he has given me. Out of the Holy Trinity, he very well may often be the least talked about, the least preached about and therefore, because of the previous two, the least respected. Could he be the least humanity experiences as well, even those whom are Christians and carry the DNA of, The Holy Spirit?

"However, in his defense, this *special* ministry of sharing him with you on a more *personal* level is what drives me. It drives me because I choose to allow him access into my everyday living experiences dear Peeples family; he is the one who operates here, right now! Because of the knowledge he has given me to share with you all, perhaps you may come to discover experiencing him on a deeper level as well. He sees something in you. He sees something in all of you; what you do with what he sees is up to, well, you.

"Listen to me, God...Is...Real! Jesus Christ...Is...Real! The Holy Spirit...Is...Real! I know this because he and I hold Real conversations, everyday. We hold real conversations concerning some of the things going on in my own life and in the lives of others as well. These conversations are what drive me.

"Now may I ask what drives you to do what it is that you do for the Lord dear Grandma Peeples? Excuse me, what about you, Niece Peeples, what drives you dear, is it also the Holy Spirit? I would be very interested in hearing the answer to that some day, especially if you already know, and especially when you find out if in fact, you do not already know, fair enough. We will have more time to share with one another someday, God willing. I am looking forward to meeting you all again, face to face."

Anyway, without further ado, let us begin in chapter 14, and starting with verse 13, as Jesus has just received some terrible news about the death of his beloved friend, cousin, and messenger nominated by God, himself. He—John—was chosen by God to do his bidding by being the forerunner *of* and fanfare *for* Jesus Christ for the *Good News*. Yes, I speak of John the Baptist...I speak of John the Baptist. Listen, we will get to more of John the Baptist, a little later on, as this story unfolds okay. First things first though, Jesus is about to show us himself through his own mind, heart, and yes, his word; he holds the precedent.

Jesus is about to show us how he is able to interact with a multitude of people to include us—you and I—and those disciples too, Matthew and Lieumas included. Yes, those of us who seem to *hang* on every word from Jesus' mouth, just like the melted yellow cheese when you, too, take a bite from a large deep dish pan pizza from your favorite pizza joint is the experience we will have; well, kind of. In other words, it will be just that good and so I bid you, *bon-appetit*—happy eating...

Are you ready to experience Jesus in perhaps a completely different plane, more than what you possibly have in the past beloved, and friends? "Are you ready to experience him in a completely different vibe than what you are used to hearing and feeling, Peeples family?" Our hope is that you are all ready indeed, as it will be a refreshing approach to what is already considered beautiful.

By God's grace, and in all humbleness and with genuine humility may I say something to you? May I say to you that as a *minister of sorts*, this is who I am and I am ready to deliver for you? "Now when he says 'deliver,' he does not mean pizza. Let us dig in and remember this...internalize the verses, cool?" "Cool," says Nephew Peeples. I reply with, "Cool!"

Beloved and friends, I hope you are hungry and ready to receive—in many ways. I believe you have been patient with us long enough as we are zeroing in on the *hub* of this dynamic tale mixed with truth, and its real life message and story of events. Yes! Amen! Take it away Lieumas; you have the floor my friend...

"Jesus is a miracle worker would you not agree? Most would agree, stemming from the Holy Bible references." "Yes, I agree Lieumas. I agree,"

says Grandma Peeples. "Thanks Grandma Peeples," I replied to her. "In addition to that, dear ones, by this story on paper within the framework of the Holy Bible, we *know* that he is a miracle worker. Moreover, by our own personal story in relevant times, we *know* that he is a miracle worker, off paper as well.

"I say 'off paper as well' because the truth of the matter is, we are all being made witnesses to these miracles in our own lives, right?" "Yes Mr. Lieumas," says Cousin Peeples. "Thanks to you also, Cousin Peeples," I replied. "Follow me in if you will, as I take us back to the glory days of Elementary School in our furthering exploration of the *dreaded* Math class with your teacher, Mr. or perhaps Mrs., you fill in the blank…"

School Bell Ringing:

"Okay class, settle down and please be seated it is time for us to have a quick review of our lesson. Yesterday on paper we discovered that five apples + two oranges = seven fruit as its sum total. When we multiply this number, 7, by 2, we come up with an answer of fourteen, which is in its numerical term identified as number, 14.

"Now class, today in real time we actually have the apples and oranges displayed right now in front of us, here on this table so that we can see the truth of this for ourselves; please, do not peel the oranges little Johnny; thank you. If someone told this to us before we began learning the 'art of Arithmetic and Math,' we would still be in a stage of doubt. However, the subjects of both, Math and Arithmetic, has been around for a very long time and now, it is important that we learn these two so that we can process things properly and thus progress throughout life. Believe me; we are going to need it down the road.

"Remember when your parents gave you flash cards to practice your Math and Multiplications Timetables. Surely, they had to run through it with you several times and even use real apples and oranges so that you could get a visual of what was truly going on here, right. Over time, some of us eventually got it. Sadly, though, over time some of us eventually did not. Let us remedy that situation this year class, shall we?"

"Now then, how about this scenario from perhaps your Sunday School days:"

School Bell Ringing:

"Okay class, settle down and please be seated we have a quick review. Yesterday on paper, we discovered that this 'special' man, Jesus, multiplied 5 loaves of bread and 2 fishes to feed over 5,000 people. Think about those

numbers for a total of 60 seconds, would you do that for me right now. I mean the ratio of those numbers is indeed quite staggering, and unheard of, and yet...he did it, how about that! What someone had given to this 'special' man as a miniscule portion of food later turns out to be a mega-sized miracle of food—at least on paper...

"I ask you now class, what Mathematical method did this man use to accomplish this miraculous feat? Uh umm, excuse me little Johnny, please return to your seat! Thank you. Therefore, class, as I was saying... How was he able to come to those astronomical numbers, personally? Does anybody have the answer? Does anyone know? That is right class; he used the method of Multiplication after having used the method of Addition.

"Can he manifest himself right now, in real time and perhaps show us so that in this way, we can see for ourselves and thus believe? On the other hand, do we trust, by faith the things we have discussed from his word, which are sitting on our desks and desktop screens right in front of us, even though we cannot see he, himself, perform it physically? Will we choose to believe in the first way? Will we choose to believe the second way? Does it even matter which way we choose? Either way, as we process this experiment properly, we are going to need to believe and trust him to progress throughout life, well into the next one, the next life that is."

"Therefore, Peeples family, you see, even back then God was preparing our hearts for the learning of numbers and words during the school week. He did this so that even during Sunday school, as we read in our Holy Bibles of this *miracle* of super sized proportion, we would not be completely lost. For this reasoning, that God knows how important numbers and words are, and how they work too, is awesome to say the least. For he created numbers and words, and he created us to think and to speak. Let us engage in interaction between the four."

However, the same saying goes for these relevant times in our own lives also. I say that because what we give to God as a miniscule portion of, or in, our own lives can be made two, three, or even one hundred times more abundant than it originally was before we placed it in the hands of this *special* man, Jesus. Yes! Amen! Beloved and friends, this is the point I am making here.

Now it—miracles—may not appear right before our very eyes like those that they do for some. However, miracles may instead, come from other places also, and as God deems necessary. God orchestrates this in ways such as, *inner drive* or *inner determination* for example, as well as, through other people, too! Even so, that is not all; for his available abundance of resources is plentiful and without limits, amen?

"Now keep in mind all of you in the Peeples family, this concept works well with our time, talent, and treasures—you know, our resources from God in other words. Stick with me here as this is one of those 'head scratchers' and I am certain that I do not want to lose anyone. This is going to be good as we are only just scratching the surface and peeling back the layers of fruit—no pun intended."

Beloved and friends, let us watch this story and miracle unfold on paper, and then later in relevant times of today. Let us watch the dynamics of what Lieumas brings forth for us. After all, God's word is not only historical and revelatory, but it's lateral also in its, poetic appeal. Let us begin examining the verses of Scripture in this next chapter, shall we? This is going to be good...

At this point, Mrs. Peeples is doing the backstroke atop the surface of the blue water. Niece Peeples, in an attempt to "one-up" her, is floating on her back along top the blue waters. With arms and hands interlocked behind her head of black hair, and shooting water into the air from her mouth like a water fountain, I believe the odds are in her favor.

The others in the Peeples family are still swimming. They all meet up in the middle of the "KJV Ocean," and dive underneath the aqua green waves even further in an attempt to engage the beautiful white pearl. Wait a minute! I believe they may have found something just beyond their reach, but in reverse order, *shimmering* in the darkness, and settling there, *glistening*, just beneath their reach!

CHAPTER VIII

A Special and Personal Look Behind Truth

Look inside these lenses of mind
Notice the hardness and dross
Reflect on the inside of your heart today
While noticing that heat makes it soft.

Remove the pain that is inside your hurts
By allowing Christ to pick up where you left off
He will guide you and protect you
For better or for worse, he loves you
And he will shield you from those who scoff.

God desires a personal relationship with you
Will you trust him in all of his ways dear friends?
As he takes you in flight to the upper room
As he takes you in flight to his loft, in the end
When you hear the sound of a sonic boom!

Again, will you trust him in all of his ways dear friends?
As you soar up in the sky leaving behind all sin
By so doing, you are sure this race to win
In so doing, you have survived the lions den.

You need him, seek him, he desires to show compassion
His love is one of no comparison
For his love is an everlasting taste

Take your cares and start casting
Toward his everlasting grace.

"Let us take a *special* and *personal* look behind the truth of these on going verses beloved Peeples family. Yes, it is time for us to insert ourselves inside, and immerse ourselves within the texts, amen. I believe it is time for the texts to come alive in our minds and hearts, amen.

"Mr. and Mrs. Peeples, I trust it is time for us to live in the moment, the right now moment! You know, it is time for us to become, one with the Word Peeples children, amen. I said that it is time that we become one with the word, Niece and Nephew Peeples, shall we.

"Beloved Uncle and Aunt Peeples, it is time for us to role-play, what do you think? Grab hold to my belt loops once again, and follow me inside these upcoming verses. Are you willing to do that with me, all of you, the entire Peeples family and your extended families too?

"Spectators, you all are also cordially invited to come along as well. God shows no partiality; we do. Yes, Cousin Peeples this means you as well; you *are* a part of the Peeples family right. Follow me in as we make our way behind these verses, and even making our way in between these verses too! Now even I have to say...finally! Let us explore this white pearl that you all found in, The Gospel According to MATTHEW 14:13-16, KJV."

Dun!-Dun!!-Duunn!!!

¹³When Je'-sus heard *of it*, he departed thence by ship into a desert place apart: and when the people had heard *thereof*, they followed him on foot out of the cities. KJV

Please be aware, the Holy Bible does not provide a vivid backdrop or detailed back-story for verse 13, and the ones to follow, that I am aware. However, what I am aware of is this, beloved and friends, this dynamic tale from him, Lieumas, and this miraculous message from God, has produced an essence of beauty. In its collaborative piece drawn from, Their Story, I think it is one of epic size proportion.

Now the spirit of Lieumas, coupled with God, *is* Spirit, and he has developed an integrated hybrid piece drawn from his own "creative imaginative template," and the truth of God's own testimony about Jesus, the template for our—humanity—faith, hope and love. It may not be considered authoritative to some, but instead, a sacrilege to all things holy. Having said this, Mr. Ettesorde believes otherwise; he believes some

will indeed embrace this as he, himself, has. Taken within context we can presume imagination while consuming, truth. Having said that, taken out of context, we can assume theories, however it is better to consume, truth.

You see, after much prayer, the Holy Ghost assured him that he is, in no way, *taking from*, or *adding to*, the integrity of God's beating heart, his word; his Holy Bible, amen. He also reassured Lieumas that his interactivity *within him* is contributing to this story and timeless message *within this book*, Five + Two = Perfection and promotes further understanding of some of the contents found *within God's own book*, The Holy Bible, as well. It is down to earth. It is *heaven, on earth.*

Moreover, because of this reassurance and reinforcement from him (Spirit of God), he (Lieumas), is become reenergized. He will indeed demonstrate and deliver its, *personal universal appeal*, in the form of a *special artwork*, as instructed. It is Spiritual Art. He translates for me the words after which they translate to him from the Lord: "After all, it was I who gave you this personal and special gift in order that you would translate its beauty to others. It is I who encouraged you when I spoke unto you in my own words, 'Beautify,' my Law."

Having said that, imagine if you will, being there that faithful day and hearing as Mr. Lieumas Leumas Ettesorde, imagined himself hearing these words, and also living out some of its *real time; right now* experiences, in its entirety. Beloved and friends, here is "Luminous" as he tells his intertwining version of this tale to not only the Peeples family, but to us all…

"Wait for me! Wait, wait; wait for me," she yells out to her husband from inside their lovely home, which was situated in a nearby small neighborhood village. "You mustn't forsake me and the children, my beloved husband." She bends down to finish tying her left sandal so she could protect her feet from the rough roadways they would all face later as they pursue this holy man sent from God name, Jesus.

She finishes the lacing of her sandals now; then, as she rises to her feet, she begins to adjust the waistline of her very colorful garment. She tugs on it and pulls on it from left to right. Finally, after a few tugs and a few pulls, it adjusts according to her specifications. She is pleased. She is graceful.

With excitement piercing his heart first, and then this same excitement transforming itself into outward body movements, second…her husband impatiently hurries her along even more so, while being patient at the same time. With his white sneakers, Nike, brand already laced and in like color of said sneakers (white), the husband stands to his feet after saying these words: "Okay dear, I will wait for you and our four little ones." He then begins to roam through the house inspecting the bolt locks on all the

doors leading to the outside of their house. Moreover, he checks to see if the thermostat is properly set, as the wife would ensure this upon their leaving for the day.

Next, he begins ensuring that all the rooms are empty of the children and that their bedroom windows are secure, as well. It all sounds way too familiar huh! I mean this is typical of the average father, right. Of course, this was a sign to the others that their departure would soon take place. His words to his wife earlier that morning were to the tune of this: "Hey honey, y'all wanna take a walk and go see Jesus?"

Standing at about 6 foot and 9 inches tall, her husband had a build like a doorframe, but filling the frame like a door, itself, due to his being 320 lbs. and all. It is amazing to me that he could even squeeze through the threshold of the doorframe of their humble little home. The house was a modest one situated on a descent-sized (a few acres) lot of land within a tiny neighborhood village. Trees of green, brown, and even gray were surrounding it as if to hide the house from the rest of the world and yet along, the surrounding villages, towns and cities that rested just miles away.

Now before *their* lacing of sandals and sneakers occur, and upon *his* last minute security checks of doors and windows that would take place later, and not to mention *her* double checking the thermostat, the wife entered the kitchen earlier that morning to finish preparing lunch for the afternoon, a daily task. She turns toward the kitchen window and draws back the electric blue curtains a little more. She does this to increase her view of the clear blue sky above and not to mention, catch a whiff of this breeze of fresh air. However, she does this hoping to also; increase her view of the rolling white clouds. These majestic clouds, which seem to be flowing, like white and pinkish blue cotton candy from a carnival or county fair. Not only that but also, to view the children as they play in the back yard amidst the green, gray, and brown trees as the bright orange sun beams through the branches.

The family cat, *Freedom*, zigzags between her feet. She then rubs up against her leg while the purring of her insides begins to *rev* up like a small turbo engine *rpm's* or something. She *shoos* her away and then warns her little black kitty about the safety or, lack thereof, of roaming around the kitchen while mom is at work preparing breakfast, lunch, snacks and dinner.

Just as she raises the window a little bit higher to yell for the children, she sees something not so uncommon in her neck of the woods but yet, unexpected nonetheless. She witnesses a gray squirrel being chased by another of its family; a brown chipmunk she presumes. These two rodents

are found racing in front of her face as one scurry up the trunk of a nearby Pine tree and loses the other before finally settling atop one of its many branches. She being slightly startled, "Woo," but quickly recovering, "Okayyy…" She ponders this scene in gestures and with speech! "…They are two of a kind but having 'in reverse order' lifestyles, hmm…sounds like some of the characters portrayed in Genesis from the Holy Bible…"

Snapping out of it, she hurries along the children while she ties a knot in her purple, *her favorite color*, headscarf—purple symbolizes royalty. Now she ties the headscarf tightly in order to keep the high winds from blowing it off her head while she and the rest of her family traveled through the towns and wilderness. Sometimes due to powerful windstorms, the winds would kick up a notch or two, or even three!

Aside from that though, like most women, she also inherits gifts in the area of multitasking. Yep, she was very colorful in her schedule throughout the day. I believe God wired them that way, too! Now I do not mean that in terms of minding the children and performing daily routines in the home in and of themselves mind you, but doing these *personal* things while having the *special* ability of multitasking *while* doing these things simultaneously is what I am referring to—even outside the home. Now that is living… On the other hand, is it?

Making her way to the refrigerator and placing her gentle hands on the door handle, she opens it and pulls out the lunch ingredients and begins immediately preparing the items before her. She does this after making a beeline to the food prep area, I believe they call it an island, situated in the middle of their kitchen and making sure it was sanitary for food preparation. She did not want her family coming down with any illnesses. It all sounds way too familiar huh! I mean this is typical of a mother's nurturing care.

She had long natural extremely curly chestnut brown hair with a slight hue of red in it. The hairstyle was cut in a classy and yet, edgy fashion. Now she was a tad bit smaller than her husband was. Oh yeah, and she had a warm smile and bubbly attitude most every time you would see her. Not too much bothered her as she regularly placed her faith in the God of heaven and of the earth, and all that is in it, and that was a good thing. She was short, full figured, and athletic; she is a stunning figure of beauty—both inside and out.

She often "popped" her chewing gum and walked with a skip in her step too as she hummed, and while she would be visiting the family supermarket in town. At other times though, she would often hide and jump out at an unsuspecting passerby making their way through the house, or perhaps in public places even; this, in an attempt to scare the "heebie-jeebies" out of

them! She would do this while her stunning hazel-green eyes hysterically cheered her on.

Wait a minute let us go back in reverse order; is that even possible! Is "heebie-jeebies" even a word, or, words? Err anyway, that was her intent. It's funny stuff though; one would have to admit. Is "err," even a word...? At times even, she would encounter a brief case of the, "blonde moments," in her most of the time, "brunette moments," and which seem to dominate her daily life—the brunette moments.

Now then, let us informally introduce their small child whose nickname is *June*, shall we? Yes, you heard right, *June*, is his nickname. Wait, before I go on any further, let me make mention that God *knew* our name before our parents did, and he even *knows* our nickname before our parents and or, friends dubbed us with said nicknames. Okay, having made peace with that, I will continue...

This was his nickname because his dad was a Sr. and thought it would be cool to name his one and only son after him too, just as he was named after his own father making June's dad the II, and June himself, the III, you know a, "chip off the old block," sort of thing. Sometimes he would even refer to June as the "chip" and himself, the "block." June loved the idea of that but often thought that given the circumstances of having a one and only son of his own, that he would give him his own unique name and brand new identity. Perhaps it was God's idea you know, at least that is the "Q" I was given.

Now despite the difference in name, he would still be a type of shoot growing out of the stump—"a new branch producing fruit from the old root," sort of thing! Eventually June would go on to have a one and only son for his self. Moreover, his son would have two sisters, too; imagine that...

Continuing on, June, whose skin being of the color, mahogany, had a little friend name Lydnis whose skin color was that of, peach. This name was given to her from her parents, although it sounded Russian or something. However, it was not in relation to Russia at all. Instead, she was white-part Irish American and part German American and she had a little Cajun mixture in her blood, too! Yep, *go bhfuil an ceart!* This, which translates in the Irish dialect: *that's right!* June however, was black-African American descent, not to mention, portraying historical Jewish elements in his legal name, but also having Creole and French Indian (some mentioned he having, trace elements of Native American-Cheyenne but who's keeping census, right) in his blood as well, "huh yuh yuh yuh, aayeee...!"

Now then, her—Lydnis—nickname was *July*, which actually pronounces like the American traditional name of Youly, or perhaps spelled, Julie, in other parts of the country. Her friends knew June and she

liked each other, a lot, so they gave her this nickname in fun with a bit of a twist in its pronunciation; you know, to mark off the calendar months of the year. These months being as such: March, April, May, *June*, *July*, well... you get the idea as the two of them do exist and suspend in midair side by side and all. She did not like it at first but over time, she began to adapt to it. She actually grew to love it and she held on to it not for *one* season, *two* seasons, *three* seasons, but for *four* seasons. Just think of what the *"fifth"* season will bring being it would be in its 360-365 degree turnaround and all. Perhaps it will bring about more of the same excitement; maybe, just maybe...it will bring about a sense of exhilarating newness! After all, God created change; therefore, change is inevitable; change is good. We are always changing and even expecting changes, in some form or another.

Anyway, the two of them chuckle and poke fun at each other while playing "Hide-N-Seek." This was a very popular game around the neighborhood village and amongst the small children even. This fun game, and many other games, they would play with the other children from the "5000" block of *Matityahu St.* of their inner village neighborhood, to include those from the "4000" block of *Matthaios Sts.* within the surrounding outer villages, towns and cities as well; perhaps it is *universal*. It was, and still is, a fun and exciting game for children of all ages to play I am sure. Perhaps that is why it is in uppercase letters, right! Anyway, continuing...

The other children from both, the 5000 block small neighborhood village *nearby*, and the 4000 block regional areas *far away*, and who were of many different races-colors and ethnic backgrounds consisted of *Heather*, from U.S.A., *Cannon*, *Brandy*, *Tammy*, *Lucy*, *Sandy*, *Boctu*, from Egypt. Unfortunately, for *Sandy*, her twin brother, *Sanders* returned to be with the Lord at an early age; by God's grace, their mother found comfort in the Scriptures. Also among them were, *Jack* and *Jack's* cousin, *Cousin Roy*—they all called him that even though he was not any of the other children's biological cousin. Cousin Roy's older sister, *Sissy*, was among those playing games, too!

In addition to that, there was *Aiombi*, who was from West Africa, *Pashca*, from the Middle East, *Sabortorre'* whom was of Cuban American descent and many others who shared in playing these fun games as well, like for instance, *Sue-Soo*—who was from Japan, *Zack*, *Einswald*—who was Jewish, *Chummy*—who uniquely blends of African American (black) and Caucasian (white). In addition to them three times over, there was *Fireball* and *Shoop*, oh yeah, and *Ditr*, too! Finally yet importantly, was there among the group, a Chinese girl by the name of *She-yun shoon-she*— yes, all one name; she was an *exchange* student.

Oh yeah, I almost forgot about the other half of the two sets of twins

who ran in their circle; I cannot forget Jack's twin sister, *Jacky*, who was also there playing among them along with June's three older sisters. Moreover, their relatives as well as July's two older brothers played, and their relatives too! They all were ranged between the ages of about 7 to 11 years with a few stragglers aging at 12 and 13 years old and they seemed to be having fun as they so often did while playing together.

Even in their diverse and multicultural backgrounds; despite some of their adult parents, within these groups of children, no one felt superior or even inferior among the others. I mean why they would, even they knew that God personally and specially, created them all, and with purpose too. God sees something in everyone; how we choose to display, or not display what he sees in us is our responsibility; it is a choice we all must make.

Now the name, Ditr, was a unique nickname given by family members and the name stuck with his friends. It was a nickname pronounced as an acronym: D.I.T.R. also known as, "Diamond In The Rough." He was named for this because of his well-behaved mannerism and personality, but having mixed in with it, an undesirable attitude which sometimes masked his natural charm. Do any of you know of a person or perhaps persons even, like that? Does anyone know...? Crickets are sounding in the background... Does anyone...know?

"Tag Sandy you're it next time but first we need a timeout for a water break and maybe a cool cup or Popsicle!" an exhausted June shouts. The family dogs, *Teddy*, the gray observant Schnauzer, and *Daisy-Mae*, the beige spoiled Shih-Tzu, run behind them all, barking and having a good time, too; the squirrel and chipmunk even seem to be cashing in on all the fun! Sometimes *Buggie*, the chocolate brown Chi-weenie dog and K-9 escape artist, would come out from hiding wherever, in order to catch up to, or in this case, catch up with, all the fun as well, this of course, if his time wasn't spent escaping the confines of his home.

Now as for Freedom, again, the family black cool cat, well...she would just hang loose in the green grass outside sometimes. Having said that though, most of the time she would be sitting on the sidelines from *inside* the house and watching all the fun going on *outside* the house from the kitchen sliding glass door. She would be doing this while lying in wait for anyone to exit and or, enter, through the door so that she could throw out a jab or two to the unsuspecting passerby with her paw; you know, kind of, as a professional boxer would do. Although black, she was no shadow-boxer. Instead, like Apostle Paul, she made her punches count!

Now as they gathered around the water faucet, Cousin Roy motions to June and the others to come in closer within the huddle. He then says that the next time they all meet up it will be for a friendly game of "cops and

robbers." Most all of the children agree with this game and begin plotting and planning for the next neighborhood gathering. However, Chummy and Sue-Soo both petition for a, get this, "friendlier" game of "super friends and dark villains," to play instead, but not before two more friends suggested the games, "red light green light 123," "Simon says," "mother may I," "freeze-tag," "duck-duck-goose," or even, "eye-spy," sometimes rendered "I-spy" instead. And there you have it, so went the casting of lots in order to come to a formal decision of which "game" they all would play next time. Now it did not take long for the results to come in or for the casting of lots to formulate. Even so, onward with the current game of "*Hide-N-Seek*" they play.

After taking a swig from the nearby green rubber water hose attached to the side of the house, and after the hose passes through Zack's hands, June wipes his mouth with the blue (his favorite color) sleeved shirt of his forearm, turns the tap to the off position and lays the hose aside—blue symbolizes loyalty. With the water now turned off, he knows he will have to roll it—hose—back up later though, for his dad, and after they all have stopped playing. Suddenly, June hears a familiar and almost silent voice coming from the kitchen window...

"My mom is calling July and me to come inside 'guys,' and she seems excited about something!" June politely ends his dialogue by saying. They, June and July, begin singing songs as they both scurry along toward the inside of the house while the others fan out like black and white Ninjas and begin returning to their perspective homes. "Mary-had-a-little-lamb-little-lamb-little-lamb-Mary-had-a-little-lamb-eeyi-eeyi-ohh..."

Now, June was a little bit shy, hence the "sunglasses for eyes," compassionate, soft spoken and reserved at times, too. However, aside from that he was often a little analytical interpreting tike at other times, as well. June would grow up retaining these character traits using the left cerebral hemisphere side of his brain and often be criticized as one having a "curse" of, O.C.D. or A.D.H.D., of the mind. June would *see* it different though perhaps in reverse order, you know, like dyslexia. He owes it all to being "blessed." His moderate curly to mild wavy black locks, fall colored eyes (those lucky enough to see them) and crooked, yet subtle smile often would light up a mild to dark room upon his entering it.

As for July, well, let us just say that in reverse order, she was a bit the opposite of him and she was not too shy about much of anything! Nevertheless, she too, could light up a mild to dark room upon her entering it, just the same. Moreover, she was a good discerner too, especially when it involved assembling things. Just imagine if they enter that same room together; one *analyzing* and *mending*, like a "life coach" for God, while the

other one *discerning* and *assembling*, "like an administrative assistant" for God. Well...given a substantial amount of time in the "work place" of God (heavenly Kingdom), they could *peace* together a room full of *brokenness* in one or two sessions. Oh, imagine the possibilities... In another time and place, one was a hopeful interrogator and the other, a helpful negotiator; one, a Range Rover, Porsche and Mustang fan, the other, Cadillac, Corvette and Camaro; well, you get the idea.

She had the cutest smile. Her eyes were the color of springtime, too. She was the prettiest little kid you ever did see though, with her short hairstyle and all. The two of them begin gathering up items for the trip after receiving the exciting news of going to see Jesus. Remember his— June's—mom hurrying them along from her kitchen window as she yelled some exciting news just a few paragraphs reverse ordered. For all the children heard of him and some even already knew who he was. Yes even by the time they were of appropriate age—old enough to utter names, know the difference between right and wrong and enjoy the vast eating of solid food—his name was mentioned in their midst.

By this time, epoch has caught up with itself as June's mom has already pulled the lunch from the oven and his dad makes a final sweep of the house. His Nike sneakers already laced, he is satisfied and ready to lead his family outside but first making sure the misses is all dolled up, and laced up as well. June's three older siblings are ready to go too, so they exited the house and waited for mom and dad in the small courtyard out front. Suddenly, June hears another familiar voice but this time...it is not his mom, and it is not so silent, either...

"Wait a moment June," July says. "You can't just pursue to carry your lunch in your hands without it being of a covering and protected somehow. Instead, you can place your lunch inside this little red and white checkered sack I took from my own mom's kitchen just hours before. Here take it," she says. "Take it so that it will be hidden from the outside elements without it being hidden from thou sight! Here, go on now, take it," she says once more.

In doing this, July shows her precious concern for the lad, and she even ties a knot in the sack after placing the lunch inside of it. June smiles at her as if by showing a bit of gratitude for her actions. "Thanks July," he says. "Thanks for thinking about me and my safety; boy am I lucky. As always, you are a great deal of help to me. I am lucky indeed."

June blurts out loudly, "Hey, I have an idea!" He continues with, "Look at this long grayish black stick I found! I found it while combing the ground for 'roly polys' and chameleons and all sorts of other bugs and stuff, too! It kind of looks like a shepherd's staff does it not. I always wanted to be a Shepherd by the time I grew up." "EW, BUGS?" asked July, "Who are

you, really?" "Yeah July, I want to find a pet chameleon and add it to my animal collection; you know, kind of like that old guy from the Zoo, Adam, would do. Will you help me? I even picked out a name for it. I wanna name it *Camo*, you know, short for camouflage. What do you think?" She looks at him with a blank stare with crickets sounding in the nearby background… perhaps the crickets are over hearing the conversation in fear. July hates crickets! "Besides, July," said June. He continues with, "I'm the same guy you met many, many moons ago, remember?"

"Suit your own self," July says to June. She then adds, "You can find all the bugs you want to find, save for crickets, and even give those critters homes and names too, but you can count me out of it deary, I don't wanna be dreaming about any of those bugs later tonight. Besides, you heard that old saying, haven't you; 'do not let the bed bugs bite,' remember?!?! The 'wander twins,' Jack and Jacky, might be able to accommodate you I mean they are into that kind of stuff. They think that it's fun but child…to me, that's gross. Anywho…!"

She continues with, "But yeah the stick you found *does* resemble that of a shepherd's staff remarkably so, June. It is somewhat weird though but at the same time, 'kinda cool,' too! As far as the bug thing goes, you know I am only kidding with you, right. I can help you locate them; I just won't help you touch them, especially crickets; you know I cringe at the thought of, crickets!"

July ends her dialog by saying, "A Shepherd when you grow up June? I did not see that one coming but okayyy…I guess I can roll with it! After all, I do remember you from many, many moons ago and I look forward to having many more of our past memories to share in the future. Besides, I may even assist you in your shepherding duties; I marvel at the thought!"

Now the *grayish black stick* (shepherd's staff) in question was lying off to the side of the dirt road in a seemingly small patch of seemingly very *green grass* beside their house. It was peculiarly lying, seemingly, amidst a single four-leafed *green clover*, which stood softly planted beside an old *brown tree stump*, which boldly stood embedded in the *grayish brownish red earth* beside a single *red rose*—also softly planted. How seemingly odd for a barren *gray landscape* one would think. Nevertheless, hey anything is possible with *perfect* conditions right.

Uh um…anyway, June continues his dialogue by saying these next set of words: "I'll just put my sack lunch on the end of this here stick and rest it upon my shoulders. Yeah, I'll just do that so I won't become tired and weary of lugging my lunch around shuffling it from hand to hand. How's that for an idea July?" "Yes, a great idea indeed June," she says while signaling a thumb up gesture and serving up a wink and a smile. Poor

June's analytical skills did not come in handy at this point. I mean after that last trick she played on him he could not determine if she was just fooling around with him this time or if in fact, she was serious.

Is that a stroke of genius or what Mr. Peeples? Is that living Mrs. Peeples? It may be close perhaps, but not quite, what I have in mind; there is quite a bit more to come our way. Here are how these next series of events play out beloved and friends:

"I have faith that the hook like end of it will hold my lunch sack in place and keep it from backsliding off," June goes on further to say. If I may interject here once more, keep in mind that this small boy, June, carries with him a total of *five loaves* of *barley bread* and *two fishes* as his little lunch during this soon to be tedious trip to go see Jesus. This was some of the lunch ingredients his mom prepared in the kitchen of her home that faithful day. For the trip, she gently wrapped some of these ingredients, which dad stored in the cold-box to preserve freshness, and later pulled the rest from the hotbox. Okay let us continue, amen.

June makes a bold move at this point. He thinks outside of the parameters at this stage of the game. He feels he's about to mobilize outside of his comfort zone and enter into un-chartered territory. It's a territory, which involves using the right cerebral hemisphere side of his brain. He hesitates while pondering his next move. He thinks a bit more carefully while the wheels in his mind are slowly but even so, methodically, spinning... Yes, grayish blue smoke pours from his ears, spirals upwards and dissipates as like visions sent from the Lord; colorful creativity is on the brink as the wheels speed up in their rotation!

Suddenly, slightly suspended above his head in midair, a light bulb flashes yellow outlined in black, yet radiant, tick marks, and then dissipates as though visions sent from the Lord again, but not before two shades of the colors red and green burst into the all-encompassing atmosphere. He politely steps over the single green four-leafed clover and gently picks up the single red rose. This is the same rose, which seemingly stood out amidst the seemingly very green grass patch and old brown tree stump embedded in the grayish brownish red earth—the barren gray landscape. He then, quite bashfully might I add, removes his sunglasses and presents the rose to July. *At last, a new beginning...*he thinks to himself before regurgitating out of his mouth these very same words. "At last, a new beginning," he says.

All July could do at this point was smile into his eyes of the color, fall, with her springtime, colored eyes as her face turned blush red, almost the same color as he, and the rose pedals. "Err," puppy love I presume—no pun intended Teddy and Daisy... "Uh um!" says June's older sister. She, too, began to smile along with his younger sister, who was older than he,

but younger than, the other two sisters. "Come along now," his eldest sister, says to the four of them—June, July and the other two girls. She politely ends her dialog by saying, "Dad and mom are coming through the front door."

Now shut and latched, the open doorway of their humble brown and green house is secure. They are secure along with the windows. They, too (windows), were just as with the same that went unto the back door with it now being secured and all, also; thermostat? Check! The parents, and their four children, along with July, intermingle with the moving crowd— some of which are relatives of theirs and the neighborhood children they played with just a short while ago. They all begin socializing as they fall into place flowing and blending in with the others from the surrounding villages, towns and cities as like the *shimmering* waters do, as they flow and blend into the blue Ocean from the surrounding *glistening* rivers and such. GOD, you are so amazing the way you designed the waters to flow like that; the way you designed the Universe to synchronize as it does, everything playing overlapping and complimentary roles, even as we sleep!

Sandy and her family, as well as the "wander twins," Jack and Jacky, are among those from the multitude going to see Jesus as well. "There he goes! There he goes!" some of the people from the crowd yell out at the top of their lungs. They yell out as they speak of Jesus in anticipation, and with excitement, but mixed with heartache at the same time.

"What could bring about these mixed feelings of emotions Lieumas?" Well for starters, Mr. Peeples, some of them were indeed very sick and it was beginning to take its toll on them. They were indeed tired but even so, they were eager to catch up to Jesus' boat, yes? They were willing to do this all because of what they had heard about him. He was a healer they had heard, and sometimes, the right hearsay goes a long, long way; you know what I mean. "Yes, for we have heard and seen him do many miracles and healings indeed," says some of the others from the multitude of people.

I made out this next voice to be coming from *Tomasz*, who was an Italian man, and a far off neighbor from the 4000 block of the surrounding city. Tomasz—whose hair was black and with eyebrows to match—was one of the city's many blacksmiths' and he always seemed to be chewing on a brown Cuban cigar even while working to forge out tools, weapons, or horseshoes even…you know, for the city folk and all. I often found that a bit odd (cigar) because he was working around fire and heat 12 hours out of the day, you know. Never quite figured that one out but anyway, maybe it's just me. Listen to what he says, "Can he make sight of us *Bill* and if so, will he cometh nigh to us?" Bill answers back with these words: "Yes! He can see us and maybe he'll come nearer to us Tomasz."

Now Bill was Jewish-mix (Samaritan) and a carpenter by trade. He had homes in both, the far out, 4000 block, and the nearby, 5000 block. Bill's best friend is *R.J. Yobi*, who is a locksmith by trade. Like the king and priest, Melchizedek, his ethnic background is untraceable and therefore we knew nothing of his pedigree, his dwelling place either. I guess it didn't matter though. After all, God created all people and he knew races would integrate but chose to create us anyway; perhaps to integrate, and learn of each other through pure love...—God shows no partiality; we do.

Now again, R.J. was a considered a locksmith by trade because interestingly enough, he holds many "keys." Too many hearts and minds within the town he lives in, and even out yonder in the "wild blue," are locked up or locked away. His seed used to pick locks back in the day but now, uses his many "skills" a certain *someone* handed down to him some time ago, to perhaps open these locks in a more efficient way. We still do not know who that certain *someone* is. Sometimes we, in the town, we wish we had keys to his—R.J.'s—pinkish brown lips but to no avail, his lips are *sealed*. Some of the others including a younger Acadian French Indian man name *Enuj* asked themselves and their neighbors quite a few questions mixed with pleasing comments concerning Jesus.

Now Enuj was a wordsmith by trade and often taught the villagers, Speech. He was a language translator and trained in Linguistics, as well. Yeah, some of the townswomen thought Enuj was somewhat nice with the words even though his broken English was sometimes difficult for some of the townsfolk to understand, let alone, grasp. At times, he talked a little muffled, and fast too! A bit ironic some of the townsmen thought, and often said—that is how we knew they were thinking it I mean, not everything did our Master divinely whisper in our ear for the sake of knowledge; we were encouraged by him to think on our own, as well.

Anyway, the crowd grew very excited more and more by the minute although again, some were indeed sick. "For we need him and have a dire need of assistance that only he can impart to us," says one villager. "And mine ears have heard that he is quite fond of little children too!" This, coming from townsfolk. "It's something about their level of faith or something, Tom," said another city slicker—"Tom" was short for Tomasz.

Now little June's ears perked up at that moment like that of a little puppy dog's ears. You know what I'm talking about right. "Like for instance, when a puppy dog is sensing that his master is nearby before even seeing his master's presence at the door of his kennel, and after his master has been away from home a few hours Mr. Lieumas?" says a little Peeples child. Why yes little Peeples child, it was sort of like that. Yep, June knew that he

could surely muster what little faith he had received from God's measure if it meant that it would entertain Jesus.

Because of his excitement and not paying attention, as he so often did, to the gray gravel-filled dirt road in front, and beneath him, June slightly tripped on a small brown smooth stone while walking; it seemed to have come from a nearby dried up brook. He successfully recovered his little sack lunch before it hit the dirt road though, along with the other four smooth stones he placed in his left pocket; he tucked the one he tripped on deep into his right pants pocket. He would later use this special stone in the seat of his trusty slingshot his mom bought for him at the supermarket, for target practice. Although it was a successful save on his part, dust from his sandals *did*, kick up a little bit, as it surrounded the sack his lunch wore. The dust bowl rather reminded me of a famous cartoon character associated with the snack, peanuts. *Pig Pen*, I presume.

Now July, again whose eyes the color of springtime and to which this clever scene did not escape, witnesses it while laughing uncontrollably. She says jokingly, "June you're so silly and filled with such folly!" June replies to her, "Just think if I were to have fallen, or perhaps dropped my lunch completely! Without the sack you gave to me to put it in, my food would have been defiled already. Surely, it would have filth all over it by now, July. Boy I am so lucky!"

She then returns to him a little smile of her own as she felt she had accomplished something of significance through this sure confirmation from God. Suddenly! She gets it now and by this her cheeks again turned a slight hint of red just like the rose pedals from the single red rose she acquired from June earlier that day. July says these words slightly beneath her breath but loud enough so that June could still hear its beauty: "It wasn't by luck at all but by God's grace did this take place."

"Could he be *the one* we are expecting as mentioned in the days of old?" June's mom says. "He very well could be," says his dad. "He very well could be..." "Quite dutifully so," said Enuj, "Quite dutifully so." June's dad looks at Enuj with a blank stare upon his face while shaking his head from right to left, as if he seemed annoyed by the echo of crickets or something... #SMH...

Nevertheless, they all of course asked each other these questions, along with the rest of the multitude, because of all the rumors that had been floating around concerning Jesus. Moreover, not to mention the compassion he so often demonstrated privately, as well as publicly too, was intriguing to them all, as well. Surely, they were all eager to know these things more in-depth. Surely, they would all soon find out. Watch as the miracles unfold

in, and in between, and then, behind these next set of verses… It's now Jesus' move!

¹⁴And Je'-sus went forth, and saw a great multitude, and was moved with compassion toward them, and he healed their sick. KJV

"Look at this great multitude of people my friends. They look to be without guidance from a shepherd." Jesus says this to Matthew, Phillip, and of course me, as I, myself stood there envisioning these things taking place. We all three look at each other along with the other apostles, and then our eyes gaze upon all the crowds of people that our Master was referring to.

Now these guys, my apostolic brothers; these disciples are not only a strong band of bothers, but also a special brand of people. At this time, I would like to introduce them to you in order that you would become even more familiar with them in your own personal studies, of and throughout, the Holy Bible. I must say though, they were indeed very interesting characters—each in their own right. Besides, I said that I would properly introduce them to you and well, here they are…

Now early on I mentioned what Matthew's name represented or better yet, what his name stood for. Again, and if you have forgotten, it means, *Gift of the Lord*. Now many names are divine in nature and are important to God, and as you will come to find in and throughout your biblical studies, perhaps you already have. You will find that many of the meanings have intriguing names behind and or, in front of them. It makes for quite an interesting read if I must say so, myself.

As you have already met me, and now know the significance of *my* name, I will now introduce some of the others to you all… First, we have Peter, which means, *Rock* or, *Stone*. Jesus gave this new name to Peter shortly after meeting him. Peter, whose real or birth name was Simon— which incidentally means, *Pebble*—would eventually grow up and thus transform from being a *weak pebble*, to becoming a *strong rock* for the Lord. Peter was sometimes called Cephas, which means Peter; both names mean, *Rock* or, *Stone*. He failed many times while following Jesus but followed him nonetheless. He even followed him in crucifixion—at a much later point than Jesus—where he himself, was crucified upside down to symbolize his devout love, honor, and unworthiness to be crucified identical in position (right side up) to his Master and friend, Jesus.

We have Andrew standing slightly to the left of him—Peter. The name, Andrew, means, *Man*; he, my friends, is Peter's brother. He is the one who actually found and brought Simon Peter to meet Jesus after having met him his self, first. One can confidently say that Andrew was often eager and

excited about introducing others to Jesus. Yes, he is quite the evangelist if I must say so myself, quite the evangelist indeed.

Next in line, we have James, and then John, who are brothers themselves; both of them are said to have scourging attitudes at times. The two of them often identified with others as being the, "sons of thunder!" I can rather relate as I tend to over analyze and or, under process things and as a result, blow stuff out of proportion sometimes and down right make a mess out of things, myself. I have learned to apologize for my actions in a timely fashion as opposed to prolonging it though, as I did in the past and this, thanks to my *handler*.

Bartholomew and then Thomas next, follow Phillip. Now of course we have Matthew standing in front at center, for which this book and chapter, and even these verses bear his name in writing. No longer was he to be despised as a Tax collector but accepted because he bear witness to Jesus; this is seen in his in-depth writing style and record keepings of Jesus. James is next and then we have Thaddaeus waiting in the *wings*. Lastly, we have the remaining two apostles who make up, "The Twelve," that I *run* with. They are Simon, *not Peter*, and Judas Iscariot. He—Judas—would be replaced soon by someone waiting in the *wind*. They are the ones who are standing in the very back.

Oh what is that Mr. Peeples? What about the professional boxer that was earlier mentioned, Paul, you asked. Oh well, Paul, the Apostle not Boxer and the other disciples' paths have not crossed yet. It would be years later before this event is to occur dear one, and not to mention, I, myself will have learned a lot about Saul, and whose name was later changed to Paul, as well. I will have learned a lot from Paul because my own *personal* apostolic experience will resemble his in a *special* way, my *unique* spiritual pedigree, as well. Thanks Mrs. Peeples for your inquisitive mind, and intuitiveness nonetheless.

"How did he know it was really me inquiring?" said Mrs. Peeples to Mr. Peeples. He—Mr. Peeples—shrugs his shoulders signaling an, I don't know gesture. Lieumas follows up with, "I could read your body language Mrs. Peeples, which is how I knew dear." He then displays a sinister (uncommonly) type minister of a grin and continues... Now, having properly introduced my brothers to you, with the exception of our, *soon to be brother*, Paul, of course, I will carry on with this story and its timeless message.

Dude...I thought to myself and then verbally stated it aloud! There are too many people to count, an excessive amount. They look like white sand along the seashore, or even bright yellow stars in the black night sky, too many to count, like dust of the earth! I thought these things and then I

verbally announced them too, embarrassingly enough, out loud. Even so, my right side flushed face full of red, and the nervous pit of my stomach and left side of my face full of green, did not get the better of me due to the reality of what it was that brought about my overall rose-colored face to begin with. That would be the magnificently outrageous numbers. I stood there, by the thought of it being very resurging nonetheless as Peter, and the others looked at me astonishingly because of my bold outburst. Even so, with his multiple colored eyes, Jesus looks at me intently but softly at the same time; he gets it.

"Because they have come seeking from me, and I feel compassion for them," Jesus says, "I will tend to them like I was their Shepherd, and help them. Yes, I will guide them since they seem to have no one shepherding them. No one else will take on this responsibility, right now, so I must do it myself, I do not mind. That is why I am here my friends…that is why *I AM* is here; now follow me!" he says. Again, he repeats these words as he looks at all of us intently, but softly at the same time.

Keep in mind that we could feel the seriousness of Jesus' soul at that very moment. Judging by the look on his face though, we understood that he meant every word of it. He had such an amazing character and not to mention, such a deep passion for these people; *me voici; voila Je suis la.* (Here I am; I am here.)

Now as far as his demeanor was concerned, well, let us just say that the stare of his multiple colored eyes could very well burn a hole through your cloak or tunic, even in its softness. Yes, just as the bright orange sun positioned in direct line of a magnifying glass could burn a hole through a piece of white paper, brown leaf, red rose or green clover even, so was the stare of Jesus' eyes upon your very soul. He was radiant and thus your wearing sunglasses would not remedy his glow. Imagine what an even bigger hole his eyes could burn in your cloak or tunic if he became even the slight bit angered or determined even. Perhaps he would go from a peripheral multiple in color to a tunnel vision red! He may even break out the whip and start overturning tables and chairs! He was our Leader though, so we all followed behind him nonetheless.

We all agreed with what Jesus had said, and then I turned to Matthew saying, "Get ready brother, because I feel as though this will be a day that we will see more of what Jesus can accomplish." I continued by saying, "Yes, this will be a day overshadowed with excitement! This surely will be a day to remember for many years to come. In addition to that, 'Matt,' since your talent is in notating all the details of what is before your very eyes because of your tax profession, brother, it is possible that you will even record these very moments someday for the sake of the Jews. And not

now might I add, but instead, when you're able to reflect back on it in your latter years." Peter and John look on. Moreover, with their faces fixed with slightly crooked grins, they both nod their heads looking to be in agreement with me. Matthew and the others agree with me also. Hmm, *imagine* that...

Now Peter, although he was not the first disciple picked, was indeed one of the first disciples *chosen* by Jesus and was depicted as the leader of the disciples from that special day forward and beyond. I say, "From that special day forward and beyond," because some time later, Jesus would ask his disciples and then Peter, whom the masses of people thought he (Jesus) was. Peter would then state, through revelation from God and not humans, that Jesus is the *Son of God*. He was correct in his assessment thanks to this revelation asserted in Peter's thalamus by God, The Father. He, verbally stating so, also, carried out this assertion in Peter's heart. Peter had a very strong stance in his approach to things, but often spoke at times without thinking it through first; this was not one of these times though.

Now, sometimes this action of Peter's, (in the sense of speaking ahead of thinking), would sneak up to bite him in the gluteus maximus. He was a great leader though, no doubt about that, and he gave up devoting fulltime to his commercial fishing business to follow Jesus. His brother, Andrew was his partner in business as well, and he too, dropped the family fishing enterprise and followed suit after Jesus.

Peter, James and John, who considers being the closest to Jesus out of the group of *twelve*, did not affect my closeness to them. I mean why it would is absurd, even I was comprehensive in believing the truth that they were more mature in their understanding of certain things about Jesus than the rest of our group at this point, especially me. To believe that everyone else's understandings of Jesus are wrong with the exception of those in "their own little group" is quite the turn off to both God, and fellow believers. Anyway, back to what I was stating, yes I believe Paul the apostle would later mention that the three of them classify as the "three pillars" of the church.

Before going forward with you, my beloved, friends, and Peeples family, I want you to realize this very important fact: Jesus had a strong influence over some people. Even to this day, his influence is strong; I believe I mentioned this earlier. However, let me say that, in a stark contrast to that, many people also rejected Jesus just the same; allow me to explain... You see, his *dreamt up beautiful* appearance, as a king, for many people, did not assimilate with the reality of his, *not so beautiful*, appearance as a king, for many people as well. However, in saying that let me say this, although, for quite a few others, his inner beauty indeed shined through.

Do some of you ever feel that way, you know, thinking that you are not as beautiful on the outside, or perfect as the next person therefore you are afraid of rejection and repentance from other people, as they turn away from you. Perhaps some of you may even feel as though you are *too* beautiful and perfect, but are still afraid of failure because in the back of your mind you have nowhere else to go but down; and this, after having reached the pinnacle of yourself—perhaps you've forgotten of your inner beauty. Some may feel this way because of outside pressure and others may feel this way, because of ever-increasing, age.

Do some of you become the victim of a hate crime or perhaps in reverse order, are in fact, the one pushing the hate crime, and this because of some of these deep burdened feelings buried within yourself? Well that is just the tip of the "emotional iceberg." Many angles and diverse situations deter us. It re-routes us from the "real way" God desires us to be.

"What 'real way' is that Lieumas?" Well Mr. and Mrs. Peeples, that is to become a positive influence to others no matter how perfect or imperfect we are; no matter how beautiful or not so beautiful, in the eyes of others, we are, both, outside and inside. He understands humanity and can help with our human nature you know? For there are no more excuses for feeling any of those things once we know that our beauty or lack thereof, in the eyes of others, and our imperfections, lay beautifully and perfectly hidden in Christ.

His Spirit seals us as Christians and thus we are protected and safe. Even non-Christians are a thing of relevant beauty because God created all of Humanity. However, it is "in" the internal being of Christians that holds eternal beauty at a "royal purple" standard—a "true blue" beauty beyond measure because of the Holy Spirit taking up residence inside their heart, inside our heart.

Listen; lastly let me say this, the beauty within us seeps out through our pores. It contours to the bone structure and crystallizes into what is to become, our skin. Although the skin is beautiful no matter what color, texture and or, tone it is on the outside, there is indeed a deeper and inner beauty resting just beyond the pores that we need to get back to, why…? Because we need to be reminded of this: "Art is who God is. Works of Art is what we are."

Anyway, back to my previous train of thought. For the many who followed him, the same, or even more, can be said about the number count of the many that rejected him—even his own people, the Jews. Therefore, it would be to no surprise that probably a lot less people followed him than

those of the people who *did* follow him. Do you follow me? He was not a high and lofty king, but instead, he was a lowly and poor king. He was not your average high maintenance personified king that the *world* so often looks for. He was your less than average king that not too many people *in* this world look for let alone, look up to.

You see, in today's times, it seems as though the masses gravitate toward politicians, dignitaries and so-called kings, princes and presidents—leaders in general having this high maintenance personification. Even some queens, and princesses' having power, and pride, and a mannerism flowing with a strong sense of arrogance along side these so called dignitaries and kings, and princes, fit the build for a huge fanfare. People knowingly, or perhaps, unknowingly, gravitate toward those who show no personal interest in his or her own followers. Now keep in mind, I do not mean this as a measure across the board for either party so please don't get me wrong or take what I'm saying out of context. Nevertheless, this is definitely true to some degree for those in either party.

Peeples families listen to me; nowadays it is as if it is no longer, "we the people," but "they the people." Perhaps another way of saying it is, "we're not the people," but "they're the people." Therefore, it is not that the government works for us rather; it is in reverse order, we who work for the government, all so it seems.

"Hey now, that is our 'heads of state' you are speaking of Mr. Ettesorde!" I understand that and that is why I speak out. It is not from the motivation of a negative standpoint. It is motivation stemming from my love for them; besides, I said that it was not measured across the board did I not, amen? The same saying goes for the biblical days as well. Even in the Holy Bible it asks us to pray for them—government. For it is God who created this governmental body and statute, and its institutional foundational structure, bleeding down from federal, to state, to local levels; God also gave us the right to vote for these leaders in office just the same—excuse my selection of words, no pun intended, watering down may be another way of stating it.

It is true though, that he loves them, too. He loves all of his people on both sides of "the law" and everywhere else in between, and we all make society work—those who "serve to protect" and those who "protect through serving," amen. We all could make society "work better" of course but we have to "work together." Peace with each other has to come through having peace with God first, peace with God based on having a relationship with his Son, Jesus Christ. I believe that at this point, more parts of her becomes excited about God again.

Sure violence is on the rise throughout this country as well as in other countries. Because of this, we often face crimes on and from both sides, and things do not always seem fair in our justice and judicial systems. In the meantime, though, because we have pockets of unlawful resistances set against imposing misguided enforcement, even in reverse order, we have to be honest with the scales of life. We all must weigh each individual circumstance in its proper context and try to place ourselves in the shoes of others standing on the opposite end—either end.

This turnabout of and or, in fair play, is drawn from in order to come to an honest plea or just retribution for the crimes committed and or, lack thereof. Even envious Cain who slew his innocent brother, Abel, was marked by God with safety from would be vigilantes. God deals with sin and he deals in his own timing and own way. Let us make sure God is the one doing the dealing here and not us.

Now then, so as not to lose ourselves in translation and be off topic, again, during the biblical account when he physically walked the earth, Jesus was humble and lowly though, and he wore humility as his covering. He brought with the nature of his, a personable interest in those who followed him—and even those who did not follow him. Overall, Jesus *was* not an earthly king but a heavenly King *is* he. This is Matthew's angle, to which he preached to the Jews about Jesus.

This is the type of king to look for. Yes, it takes a special kind of people to gravitate towards that type of a king. For he is the "narrow road" that leads to *Life*, as opposed to the "wide road" that leads to *Destruction*, undergoing *repentance* instead of maintaining *rejection*. Of course, many people do not even know the full meaning of this statement, but our hope is that more and more people will come to realize it as being what it really is, Truth.

As they learn more and more about him, and as they learn more about his worldwide free offer of grace, to which I am geared up for in teaching people more about on several key platforms and in several venues, amen, I am certain that truth will prevail in the lives of these people. You know, I must say that I am excited to share more of this truth with you in the near future the more I think about it, as there is plenty to preach, instruct and write about. Yes, for the word of God in all of its perfection, exhausts not. However, for right now, we will continue on right here, amen.

First a quiet moment, then all of a sudden I hear the soft-spoken words of, "Come here my child." I looked to my right and then I looked to my left. I see no one… That is when I noticed where the voice came from. I stop; I look; I listen as I slowly rotate my head around my shoulder at a 180-degree turn. The voice came from behind me about 12 feet away from where I was standing.

Jesus smiles at one of the little boys. He bends down and puts his hand upon the forehead of the child and felt the child's temperature decrease as it changed from hot to mild, and then from mild to normal. "You are healed my child," he says as the boy's mother sigh in relief. "Thank you Jesus!" she says with tears of joy in her eyes. This went on for most of the day and with many other single families, and multiple family units as well. Jesus kept going forth healing many illnesses, and administering many teachings amongst the multitude of people. Now as evening fell, we noticed that the crowds began to grow weary and hungry...

"...Dad," a small child says. The dad answers back with these words, "Yes, what is it my son?" The small child responds in a soft whisper, "I'm hungry." "Me too!" another child echoes in the midst of the backdrop sunset surrounding a single brush tree he stood hiding behind while they played "Hide-N-Seek." Obviously, he was not concerned about being caught anymore; he was just hungry.

The wind picks up a bit and the dust swirls around and around causing a small non-threatening whirlwind. Tumbleweed of brownish gray rolls past and skips right over a single red rose softly planted in the grayish brownish red earth, amidst a very small patch of green grass on the side of the gray gravel dirt road, resting beside a brown tree stump with a green clover standing next to it. June's mom holds on tight to her purple headscarf while she tightens her eyes, which helps in shielding them from the dust particles; she was not wearing sunglasses.

"Look, look at that whirlwind Sandy!" excitingly, July yells out. "Wow!" says Sandy as she points to it and with both hands, cups her mouth in astonishment. Both the two girls chuckle and giggle at what their eyes, wearing designer shades and costume sunglasses, did see. This event went on while Shoop, Zack, Tammy and some of the others race towards it as though they are meteorologists' and storm chasers' in training for that era.

The dad mentions to the mother of the little child who was hungry to get ready to head back to the main land for fear that daylight would end soon, and that nighttime would follow in daylight's wake darkening the wilderness. However, the mom says she thinks it is best to wait on Jesus, although she feels strongly about following her husband's lead, as he *is* the father of their children, and not to mention, head of the household. *Besides...* She thinks to herself and follows with the thought of *...darkness is a very dangerous time and eyesight "is" limited.*

Even so, slightly torn between leaving and going, she respects the dad's decisions made in the past and she will respect her husband even more so, and even in this present hour. She then first, follows through in her words. "I have respected your decisions made in the past my dear husband," she

145

speaks out. "Therefore, I will respect them all the more so, even in this present hour," she ends her dialogue by saying. Secondly, she follows through by confirmation in her actions soon after.

The dad, at this point, looks at her curly long black hair waving in the breeze. He brushes his fingers against her beautiful uxorial olive-brown and toned skin about her sheer covered arms, this same woman who wears the graceful eyelashes fixed upon her semi exposed dark brown eyes resting beneath her lavender veil. He says back to his wife these words: "Because you love, respect, and support me in all that I do, I will return this same honor back to you. Yes, we will wait upon the Lord. For I know it is the righteous thing to do. I spoke first without thinking it through my darling. Surely the stories about Jesus are true."

Oh, the dynamics of God's Spirit at work in a Marriage between a Husband, his Wife, and the Lord is amazing especially when balance, respect, submission and most importantly, unconditional love, they both give to each other results in, True Biblical Love—a compatible love, even. For her, he is the one she has been *searching for* all of her life. For him, she is the one he has been *waiting for*, all of his life. It is indeed amazing and it is indeed priceless, Mr. and Mrs. Peeples. Stress is limited followed by a daily helping of grace sprinkled with a dash of peace, beloved and friends.

Spectators, on a New York salad, she is his Ranch Dressing. In Louisiana cuisine, he is her Cayenne Pepper. In money, they are like two sides of the same coin, a Penny or Dime, even; he is her Head and she is his, Sanctuary. In the hot of summer, he is her Ice and in the cold of winter, she is his, Fire! The love they both share cascades over the mountains naturally, like Mineral Water; its cohesiveness compares to that of Lemon Lime refreshments.

You see, the both of them need each other in order to make their family unit work in harmony; the honest communication betwixt the two is important this way. *Why* is it important? The answer is because there are no power struggles in their relationship. The hand, belly and leg *restraints* are off in "conditional traditions" of love but, the heart still anchors to the soul in "unconditional practices" of this same love. This, my beloved beings, is what makes it important; maybe the two who have become one in Holy Matrimony, can send this unconditional love across the Globe like as would a cap full of harmless dye dropped in the fish tank permeates the entirety *of* the fish tank, so shall its potential be about in the world; just a thought! Perhaps, and without knowing, she has been just *under his nose* the entire time and he has been right in *front of her face*, just the same.

We too, were hungry as well though, because we, apostles, had not acquired any time to eat, neither. Yes, we were hungry and thirsty—at

least I was thirsty. Aside from that though, we were in a hurry to get away from the hustle and bustle of life and ministry, and not to mention, we needed some time to process our thoughts about John the Baptist. Do you remember him? That is one reason why we went away from the crowds to begin with.

The evening air-cools down the barren landscape as the howls of wolves sing to the levitating moon. "Chirp chirp," went the crickets and the owls and screech owls began to hoot! As the sun begins to rather quickly, yet, slowly settle down on the wilderness during the two great lights' shift change, the whole animal kingdom is as if they are on stand-by holding their breaths during this, phenomenal event taking, earth reshaping at God's command, occurrence manifests. The sun politely greets the moon in passing as one gives way to rise and the other bows out gracefully.

The chameleons and some of the other species of God's creation rest their bodies atop the cool gray and brown rocks, just as they have done earlier that morning, when the sun punched the time clock and the moon traveled home to the other side of the world after he punched time just moments earlier. The animals have done this but in reverse order this time, as they sought out warmth on the same rocks from the previous cold night. Uh oh, spoiler alert!—at least before the predators seek them out as prey in a real life game of hide-n-seek.

Suddenly, out of the corner of my eye I see what looks to be an ostrich of significant height sprinting across the landscape on, "stilts for legs," or something as though an even bigger creature of the wild, was chasing it. Then I notice some of the children saying that they saw a dragon, dinosaur, winged horse, unicorn and then a phoenix too! "Wait a minute," I say to myself in a low decibel, as I shake my head from side to side as if snapping out of it! "Those things aren't in existence, must be the desert atmosphere playing mind games of hallucinations." Although, I *did* hear some of the parents whispering, muttering and giggling as they sat around the grounds with their kids, telling fairytales and ghost stories around the orange campfire. "Perhaps the children are playing make believe," I concluded…?

…Still stunned however! I realize after watching for about five minutes or more that nothing was in pursuit of the ostrich. *How strange…* I think this to myself and follow with the thought of …*how odd indeed.* Dusk befalls us as the other apostles' moods change and through affinity, mine as well. Here is how the next events play out. It is now, our move!

[15]And when it was evening, his disciples came to him, saying, This is a desert place, and the time is now past; send the multitude away, that they may go into the villages, and buy themselves victuals. KJV

[16]But Je'-sus said unto them, They need not depart; give ye them to eat. KJV

"Oh no," I unexpectedly said aloud! "Surly Jesus," another brother of ours says. Still in our kindred spirit-affinity zone, we continue simultaneously with, "You do not expect us to go and buy up enough food for all these people right? I mean look at how much they are in number!" The crowds begin to inquire of food and I, myself, do not know what to do in this particular instance let alone the other disciples in our group. We all look to our leader, Jesus. Then we shift our eyes over unto Peter's direction as well as James and John, being they were within the "*inner circle*" within the group of all of us other members.

At this point, Jesus gives off a smile, and Peter shrugs his shoulders as we all look back over at Jesus. I stand there surprised by the public agreement of this outrageous number by some of the other brothers of mine. It was very reassuring I thought to myself but is this a test? *What is happening? What just happened...?* I think this to myself. I continue pondering the idea of this being an actual test in the back of my mind. Besides all of that, "The time is now past!" we all say to Jesus.

Next, our brother, Philip, added to the conversation by saying something astoundingly weird—or at least to me it sounded, you know...weird. He said something to the effect of us not having enough money or something for all these people to eat but he said it using Old English styled language, I presume; I wish Enuj were here. Wait Peeples family, I remember now! Confirmation comes as our other brother, John, would later record Philip saying these very words in the book of, The Gospel According to JOHN, chapter 6, KJV, and in verse 7. The verse reads:

"Phil'-ip answered him, Two hundred pennyworth of bread is not sufficient for them, that every one of them may take a little." KJV

In other words, what we all agree in saying, and what Philip means is that we did not have enough money to buy enough food in order that all five thousand plus people would be able to eat. Our brother Judas, who was in charge of the money treasury, shakes his head up and down in agreement—more so eagerly than the rest of us. The eagerness of our brother Judas', soon to be annoying attitude followed by the revelation of his excessive eagerness, played out later in his disloyalty.

I then lean back against the scratchy gray bark of a nearby Sycamore fig tree and scratch my back. I scratch my head too, (not using the tree of course), in disarray all the while pondering to myself, *what next...?* Surely, it is Jesus' move again!

More Faith Speak

Faith is what keeps me going
Faith is what keeps me wanting
It has a hold so powerful that I cannot resist
Somehow knowing that, I must insist!

I hope for, but cannot see it
I long for, and desire to feel it.

Faith is a gift from God to me
Moreover, his gift is to you, as well
Without this, gift from God, our Father
We are bound to a place called hell!

Heaven is a better place to spend eternity
A place that truly exists
And with it brings comfort and serenity
With it, comes serendipity and bliss?

However, this was no surprise accident
This was the planned will of God
For faith is what keeps me wanting
And faith, is what keeps me going.

Now beloved, let us take a quick timeout here. Friends, I ask of you, think about this for a moment, if you will… It would be next to impossible to supply the people with food, no? Well why not; because the fact of the matter is…in this finite world, what you see is what you get! Therefore, it would *not* be next to impossible, but in fact, impossible, all by itself!

Listen; in this, "world point of view," your luck may just run out. The cards you are dealt in life have to be played out according to what is in front of your face right? It is the luck of the draw perhaps, yes. Luck of the draw, you are thinking, maybe? At least that is the way it is when playing a friendly card game, or that is the way it was back in the day when shooting marbles in Middle School at recess time. Even during the casting of lots as was done in the biblical account, what was the result often played out in the lives of many—for some, even this was short lived due to God's Sovereign will.

However, might I remind you that this is no card game? May I remind you that this, my beloved, my friends, that this is no marble or the casting of lots game either, amen! Sure, in the, "world point of view," our luck may just run out. However, even in this *world*, it is reassuring to know that God's love will *not* run out, ever.

So again, I must ask you, "The cards you are dealt in life have to be played out according to what is in front of your face right?" Wrong! It is not that way concerning Jesus, beloved; this we would later find out. Moreover, it is not that way where our faith in God is concerned either my friends, amen! There is a supernatural life beyond this natural life of ours and Lieumas is about to explain this to the entire Peeples family, and believe me, it is a lot of them.

"You see Mr. and Mrs. Peeples, and all of you other Peeples', the Holy Bible teaches us in, The Book of the Prophet ISAIAH 55:8,9, KJV that God's ways are higher than our ways, and that God's thoughts are much higher than our thoughts. This means all of us and not just some of us. This means Christian and non-Christian, both Jew and Gentile alike. This means the entire human race; no one is exempt here. Here it is as he writes:"

"For my thoughts *are* not your thoughts, neither *are* your ways my ways, saith the LORD. For *as* the heavens are higher than the earth, so are my ways higher than your ways, and my thoughts than your thoughts." KJV

"Therefore, you see, the mind of God is far more superior to our minds, and the mind of God advances farther than, our minds; this, in part, is because of *dispensation*. After all, it was he—Jesus—who created our minds in the first place, which is the other part of this equation. He is from heaven and we are of the earth—as he, himself so utterly states it. Surely, he would not create us humans to be smarter or more advanced than he is now would he? In that, you are right of course. He would not because that would put us humans on the same plane as him. That just cannot be." "If it were so, you know, us being on the same level as God and all, then God

wouldn't be God at all, right Lieumas, sir?" says Niece Peeples. "Right you are Niece Peeples," I reply to her.

"Satan tried to go that route and just look at where it got him. Again, he—God—is from above and we—humans—are from below. He is the Potter and we are the clay, but we are clay in the Potter's hands. We, have 'no right'...well, technically speaking, because of freewill/choice, we *do* have the right and or, privilege, well...freedom, better stated, but even so, it doesn't *make* it right, negatively questioning God on his decisions as a human race that he created, amen! Even so, he is the Authority Figure here; we are not; I found this to be true by just asking one of the biblical patriarchs, Job...

"Again, we may have the freedom to question him but we have no power, through our freedom in questioning to change what he created. Nevertheless, it is what some of us do anyway. We negatively question God on his decisions concerning us all the while assuming, he will change our situation and circumstances because of it. Even those of us who are as Christians, do these things. Listen carefully, God knows this is what we are subject to do as Christians, but he leaves us with his word and his Spirit in order to keep us grounded in the faith as we act out our freewill/choice, he also knows what is best for us; even if it pains us or not.

"Now then, just because we are subject to do it does not necessarily mean that someone or even some people force us to do it from a dictator type, or ruler-ship standpoint. After all, we are free—*new birth* Christians, right? He leaves us with his mercy and grace, and he leaves us with his love. Besides, he admires it when we are completely honest with him in our low points of *valley dwelling* and believe me there are plenty of those sinkholes looming around.

"When we are sincerely seeking answers from him though, without disrespecting him, I believe his heart reaches out to us even more so." "Why do you believe this to be Mr. Ettesorde?" Beloved and friends, this comment is coming from Uncle Peeples. Lieumas continues by answering with, "His heart reaches out to us because we engage him with positive questions regarding the negative circumstances we may find ourselves in or even what others are facing. Yes, we do this instead of engaging him with negative questions, regarding negative circumstances; thus, we rise from the valley to sit above on the mountaintop dwelling there for a season, and enjoying a pleasant bird's eye view as if from on top of the world; trust me there are plenty of those high cliffs hanging around just the same.

"He is a wonderful Father to his children, but be mindful of this: He is a stern one, also. In saying that however, his patience is in fact, patient with us. Yes, I think it is safe to say that he is fair, and he is just, amen. You

see, we as Christians bound by sin are no more; we are free. Now it *is* true having said that however, although we *are* entirely free from the 'bondage' of sin, we *are not* entirely free from the 'act' of sin.

"You see, the temptation of *sin* will shove and force itself upon us like a bully at any given time. Even so, we have the freedom of choice and because of this freedom of choice, we may choose to act on it, or not. The Holy Spirit is our *helper* in these tough situations in order that we may reject the bully. Therefore, I need you to trust when I say that God will surely manage our behavior and that is what we need— management from the Holy Spirit. He is surely looking out for our best interest and knows what we can and or, cannot handle. He even blesses us with an opportunity of escape when tempted.

"The Lord even told me the other day as the sky was made to open, and as we were in conversation one to another that he wants us, *humanity*, to talk to him. Imagine that if you will. He, the Holy Spirit, actually wants a relationship with us—all of us.

"Let me ask you these personal questions if I may. When was the last time you enjoyed spending time alone with your creator and maker—God? When was the last time you…talked to him? May these words inspire and encourage you to arrange to follow up on some, *alone time* with him. He would really enjoy it so…it is true. He is a great conversationalist!

"Now, getting back to our previous story and its timeless message, we see that it was obvious that the disciples were merely thinking in terms of limitations and not using their faith. When using our faith properly, I have come to learn that we will come to trust the Lord in any given situation because we know that he is Sovereign. In addition to this, by that inclination we know that his thoughts and ways are indeed not the same as our thoughts and ways. He can do anything he wants to do except lie. It is not in his nature to lie. Now, on the other hand, as far as we humans and 'super human agents' are concerned, well, we cannot do everything, amen! Moreover, some of us are very good at lying too. Hey, I'm just being honest here. Pardon the pun.

"Okay then, let us talk further about the word, faith, for a minute, amen. I said that I would and I do not want to leave behind any cliffhangers, in the sense of wildly guesses, before closing out this chapter in our lives, let alone this book. First of all what is its meaning? We can find out the biblical meaning of the word, faith in, The Epistle to the HEBREWS 11:1, KJV, where it states:

'Now faith is the substance of things hoped for, the evidence of things not seen.' KJV

"In other words Mr. and Mrs. Peeples, the word, *faith*, means: *to have a belief or trust in something, or some one of true significance, even without seeing the results from that person or that thing, first hand.* Amen. Even though you have not seen the evidence, you know that they are good for what they stand for because of what you have heard about them, or heard about it—in terms of things. You ever felt that way about something or someone. Of course, I have. Allow me to explain...

"You see, just as my physical eyesight sees that chair in the corner of the waiting room of that doctor's office without actually seeing the physical sight of someone actually sitting in it, I know beyond any doubt that it would indeed hold me up." "We can use these two chairs we are now sitting in also as an illustration, Lieumas?" Mr. Peeples asked. "Of course you two can Mr. Peeples," I answered.

"Getting back though, I know this chair would do its job because of what I have heard about chairs in general, throughout their—chairs— history. In addition to this, it is because of that historical fact, and that of my own mental capacity of thinking and reasoning, that it would hold me up, too—it solidifies. Moreover, because I know this Grandpa Peeples, I can confidently sit in that chair with out the fear of it ever falling or collapsing from underneath me causing me to injure myself. Therefore, I put my faith in that chair to hold me up or support me. Does this make sense?

"Another example of faith we see is in the case of a car you are driving from point A to point B. I do not mean for you, Peeples children, only the adults who are legally capable of operating a motor vehicle, okay. Now you do not really know for sure if you will make it to point B from point A on time because you have not arrived at your destination yet. However, in your heart of hearts and in the very depths of your mind you have confident assurance that you *will* make it there before ever leaving point A. At least in your own mind and heart you believe that. You leave in that car of yours without ever thinking twice about the chances of something or even someone hindering your correct arrival time to your destination—or your arrival to your destination...at all.

"Secondly, how do we activate our faith? Well, the answer to that very important question lies in the reasoning of believing who God is as our heavenly Father and support system, which is number one. In addition to that, it is also in believing what he promises he will do, which is to bring us to our destination of heaven through faith in Jesus Christ, and this according to his own timing; this is number two. We would then act on these two truths accordingly just as we have done with sitting in that chair or in the driving of that car, amen.

"You see, we must strive to be doers of the word and not hearers of the word only, in other words. Listen, we must strive to sit in that chair safely, by faith. Moreover, we must strive to travel the distance between two points of existence safely, and to do this by faith as well, even if we set about traveling from two polar opposites having our sights fixed on the same zero (0) center. Most importantly, we must strive to trust God at his word in our minds, and receive his Word into our hearts and we must do this by, faith.

"When we begin to believe who God says he is, and believe in what God promises he will do for his children who loves him and answers by his name, and whom he calls according to his purpose, then we will surely see those promises from him materialize before our very eyes. We will begin to understand spiritual things more clearly and more so, because of our faith, amen. We will surely see this because of our faith, and our faith in action of both, number one, and number two as mentioned previously.

"The results of this should end by us Christians knowing that God is *different* than we are and that God is indeed as *real* as we are. Furthermore, the results of this should end by us Christians knowing that God will hold us up by his strength, and last but not least, us knowing that God is our support system in our journey here on planet earth. Sometimes he may drive or even call us to the brink and or, edge, but as soon as we are about to fall off the cliff into the sinkhole he catches us in perfect timing, amen. This struggle and strife makes for a teachable moment; it is a lesson to be learned.

"To know that God keeps his promises is to know God, himself. We should be confident in believing that we will make it from point A to point B, on time even. We will make it to our end destination, which is heaven after our earthly journey is over according to his will and his timing, amen. That chair and our cars will indeed fail us at any given time but God will not fail us, at all. This I am also certain of."

Now in adding to what Mr. Ettesorde is saying, when activating our faith, we should do so with excitement and expectancy before the Lord, amen! We should also make a habit of thanking God in advance for the promises that he will bestow upon us as his very own children—his offspring—even if it takes a little while for God to react. What is that, and why set about going through all of this? Well the answer is because this builds our faith. God delights in fulfilling his promises to us and he even spoke to me about it some time ago, in reverse order. Hear this word from the Lord:

"Samuel, stay Active in your Faith." —Holy Ghost

The finger of God before my very eyes wrote these special and personal words while I was in the Spirit one evening. The words then slowly began dissipating as if by light gray smoke pouring out from a chimney during the winter season would do; the words spiraled in an upwards direction before disappearing well into oblivion. Because of this revelation from God, I strive to remain just as I Am instructs me to, and I pass these "savings" onto *you*, this to include even others. I do this for the benefit of the people; I do this for the freedom of us; I do this for the sake of humanity.

"So you see Grandma Peeples, we must remember that our Father knows best and that his will must be in accordance with our trust issues, or shall I say in reverse order that our trust issues must be in accordance with his will. Even so, his Spirit is in tune with our needs when we are at a loss for words during an attempt to pray and therefore, he is able to empathize on our behalf. This is important to note because the relationship between Jesus Christ and us is on going long after initial salvation accomplishes in our lives. It is true.

"Do you remember in the introduction of this book? I believe it is in chapter V, where Jesus speaks to Satan... He says to Satan that we are to feed on every word of God and not on bread alone. That is to say, that we must give up our earthly desires for spiritual manifestations. We must carry our cross for the sake of the flesh. It is also another way of how we can build our faith in him and ward off the Devil's attacks, because of our full dependence on God, and not of ourselves, it builds character in us. I just wanted to reiterate that because the *prince of the power of the air* said to me one day that he was going to beat us, the *church*, up. Yes, he—the Devil—is real also.

"However, may I remind you of something? Dear brothers and sisters in the Lord...we already have the Victory in Christ Jesus! Sometimes we may stumble and fall in the *battle* but at the end of the day, we shall stand victorious after the *war* is over, amen! In hindsight, we may miss the mark or just plain over shoot it at times in our lives. Ultimately, though, in long division, I see a vision of victorious light glistening at the end of the corridor and my hope is that you are seeing the same 'light' I am seeing. What is that? Even if you are standing at the opposite, end of that same corridor looking at that same 'light' would it classify as being the same. Why yes, it means the *Light* is positioned right where it should be...right in the center of our lives!

"Listen closely; Satan knows that he cannot eternally kill, steal, or destroy us because we *are* Jesus' Church. However, he also knows that he can make an assertive attempt in temporarily crippling us spiritually by bullying and irritating us as Christians. It is at this point in our daily

dependence on the Lord that we begin to quench the Holy Spirit. We do this by constantly falling into the speed trap of his—Satan's—deception. This is so, especially if we are always allowing him the luxury of trapping us and thus follow through in the acts of sinful deeds, to include animosity within the family unit, and not to mention, church family. It is dependence on the Lord but in reverse order; let us slow down, upon approaching the yield sign, amen; the Lord has the right of way.

"Listen, temptation is not a sin in and of itself. Having said that though, do understand this: the acts carried out due to suggestions from Temptation, are what will eventually harm us; by this, our leaves will wither. To avoid walking into a trap can be a tiresome journey everyday but a tiresome journey we must strive to take on daily, as we keep our minds and hearts affixed on Jesus, or at best, refocus on him after having lost focus, amen. It is not that we fail as Christians, but that we slipped on the banana peel the enemies of our souls leave behind in our pathway to paradise, Life; forever be mindful of that.

"You see, God wants us to soar like eagles to heaven but Satan wants us to waddle like limpkins on our way to heaven. What do you want? Either way, as *true Christians*, we are going to get to heaven regardless. However, to what method or condition will we get there, amen!

"Listen again, the Word of the Lord came to me one night in a vision. This is what I saw before dissipation takes place: I saw what looked to be an eagle's feather lying on the ground but no evidence of an eagle, dead or injured, I could find. I looked and looked but to no avail…

"Beloved Christian Peeples listen, I took from what the Holy Spirit showed me as the heavens were opened, and I concluded that we might take hits from the *evil one*, but by God's grace, we shall keep soaring, amen? The fiery darts may ruffle our feathers on the surface but underneath; it will not pierce or puncture our bodies, or our hearts, for we have on the body of armor issued from God himself! Therefore, the question is this, my fellow Christians of the Peeples family: Will you soar like the eagle or will you limp like the limpkin?"

Beloved, friends, spectators, if you have not guessed it by now, both are beautiful species of birds by our Creator—the eagle, and the limpkin, and the distinction between them both is of strength and weakness—allegorically, figuratively and or, metaphorically speaking. Now having said that, it is indeed a learning experience we can share in daily as we spend time with him. His blessings are new and fresh every morning and when I say *him* and *his*, I mean God. Let all of us say, "Thank you Jesus, because there is Victory in Power through the Holy Spirit in the Church!" Again, I just want to say, "Thank You Jesus!"

Now, getting back to his disciples and this story beloved, let us keep in mind that they, too, were learning as they went along as well, Lieumas also. Therefore, because of this we, ourselves, can find no fault in their reactions to Jesus lest finds in us are as hypocrites, ourselves—myself included. I say that because we should face the facts, we have all been there and done that. I mean we can all be honest here. We have all faced these circumstances in our lives at one point or another, right. Surely, I am not perfect, and neither are any of you out there, amen?

Moving forward, in keeping with the tracks we are making along with them, the disciples came to Jesus with the impression that they did not have enough food to feed the multitude, right; "impossible" was their claim. However, in reverse order, Jesus spoke with possibilities, as if they *would* have enough food to feed the multitude. Why do you think this is? The answer to that question is because Jesus had faith of his own, and he put it *where* it belonged. In other words, it is because of Jesus' faith in his Father. You see, as Jesus teaches us of how he had faith in his own Father, we can learn to mimic Jesus with this same type of behavior regarding our faith in him—Jesus—and in his Father also. Amen!

Okay so the disciples were with Jesus long enough to realize his true character, which is to say, his true nature. In addition to that, they were with him long enough to realize to what degree he would dispense this true character and nature within himself, in terms of miracles and faith in his Father. Again, they doubted at this point and did not trust, through the faith that Jesus so often demonstrated for them, and even gave examples of, to them. Here is Lieumas, again explaining to the Peeples family, his spiritual and biblical endeavors.

"I want to encourage you today, all of you. Yes, I honestly want you all out there to begin to believe on God from this day forward—mark it in your calendars, amen. I am not being facetious here; I'm being serious here, I want to encourage you to begin to thank God in advance and with expectancy, and with excitement for those things you do not yet see. I need you to become passionate as I am about this, amen dear ones, dear Peeples family.

"Let us move forward and witness what Jesus is so good at doing." "What would that be Luminous?" asked Nephew Peeples. "Well Nephew Peeples," I began answering, "That would be his illustrating, and demonstrating to us, his righteousness, his faith, and his miracles." My answer ended there as I began with this new statement: "Let us continue by looking at verse 17, and the rest of the remaining verses up to verse 21 taken from the KJV of our Holy Bibles. Again, hold on to my belt loop and follow me inside. Then, while we are on the inside, follow me as we go behind the verses and in between them too, amen?"

[17]And they say unto him, We have here but five loaves, and two fishes. KJV

"This previous verse, 17, spoken by us after Peter's brother, Andrew, spoke up about a young boy having in his possession, five loaves of bread and two fishes is where we are in the message. Continuing on, our brother, Andrew, was still in doubt about the scarcity of the little boy's food. Yes, the same little child we have come to know and love as *June*, is the same little boy we are eventually revisiting.

"June, along with his father and his mother and his three older siblings, and of course we cannot forget his little companion, July, who was chuckling while they poked fun at each other, were the same people (emphasis on the little boy), who had brought the five loaves of barley bread and two fishes for his lunch. How about that, you can imagine the look on June's face as this man named Jesus spoke these next set of words. Listen and hear what Jesus said. Notice the *authority* and *confidence*, and *faith* that he exercises in his delivery:"

[18]He said, Bring them hither to me. KJV

"So, Andrew politely took little June's sack lunch containing the five loaves of bread and two fishes out of his hand, and brought them to Jesus. July and the other children look on. As this was going on, the other disciples and I began to direct the crowds over toward where Jesus was standing.

"The crowds to include men, women, and children all looked at Jesus as they were anticipating something great to happen as in days gone by, little June too! After all, they heard of Jesus and the miracles that seemed to attach to him like lent attaches itself to some of our clothing—especially clothing that is black. Therefore, Peter, Matthew, and I, began positioning some of the crowds to the grassy area in groups of about fifty or a hundred and with our hands, we began motioning for them to quiet down; for some of them were overwhelmed and eager by this time.

"The crowds of people continue on in their whispering, and murmuring, Brother John," I brazenly spoke out. "Shh ladies and gentleman," I then said in a low, but high-pitched tone. I continue with these words: "May we please have your attention for just a moment? Make yourselves comfortable. Our Leader, Jesus, has just informed us that we are to encourage you all to stay for a little while longer. He actually asked of us that we bring you hither to this grassy area you now find yourselves sitting in so please again, make yourselves as comfortable as you can."

"We know you are all hungry," said the disciple whom Jesus loved.

He ended his speech by asking them to have patience. "We know that the time is getting late, but I and the others ask that you bear with us. Please, we ask for your patience in this matter, Jesus will address you soon." "The crowds of people interestingly, and without hesitation, suddenly began to quiet down at this point. I, myself am glad they did for fear that John would have a, *son of thunder*, like episode, you know; you catch my drift.

"Now interestingly enough though, John considers being the disciple whom Jesus loved. He was very close to Jesus as all of us were. However, his relationship with our Master was very different from ours in the fact that his mind was more aware and his heart was more open to, 'All Things Jesus,' for he too, was also a prophet. Jesus, also, trusted John with his whole heart, and even allowed John to lean against his bosom to hear something of important discretion during supper one time. This was shortly before Jesus' death; it would come to be known as, *The Last Supper*. He even confided in John on several more occasions apart from us, too.

"John also understood the LOVE of Jesus in a more profound type of way than the rest of us disciples—his, Jesus' apostles. He even went on to write about some of these very important occurrences and key elements on the love and life of Jesus Christ also, and his work seemed to have a unique flavor all its own—more so than the rest of us. He did this when he was much older and more mature in his age though. Jesus, during a most important transition in his own life, even commissioned John later on to take on the role as his—Jesus'—own mother's son. Moreover, Jesus commissioned his mother to be as John's own mother confirming him as her son, as well.

"Even in that present day a little earlier concerning the healings and teachings from Jesus, some within the crowds had faith the size of a mustard seed, which in this context, can be a good thing. I knew something miraculous was about to occur although our brother, Thomas, *the twin*, did not believe it to be so. He was a very doubtful disciple at times even more so than a lot of us others were. He was the type of person who wanted proof in the things he had heard about, and he wanted proof by way of seeing it as it occurs or, occurred. Even so, *I believed*, and I could feel it too! Peeples family, get ready, here it comes!"

[19]And he commanded the multitude to sit down on the grass, and took the five loaves, and the two fishes, and looking up to heaven, he blessed, and brake, and gave the loaves to *his* disciples, and the disciples to the multitude. KJV
[20]And they did all eat, and were filled: and they took up of the fragments that remained twelve baskets full. KJV

"Sit down before me," said Jesus to the crowds. "As he took the five loaves and two fishes into his hands, he looked up toward the heavens." "Mom what is he doing that for?" A young lad sitting in the lap of his mother poses this question. "By God's grace, I somehow knew in the back of my *mind* and at the bottom of my *heart* that she would tell her son that our Master was about to pray to his Father in heaven and give thanks, and that it was a good traditional practice. Shortly thereafter I hear the words:" "My son, Jesus is about to pray to God and thank him for the food and this also is a good traditional practice for us; one we should always follow."

"After praying, *snap*, was the sound that echoed throughout the wilderness. Yes, it was the snap heard around the world, so to speak." "What was that snapping sound Mr. Lieumas, sir?" "Well beloved Peeples child, it was the bread in Jesus' hands. You see, Jesus *broke bread* after praying to his Father and then passed the bread on to *us* to give to the people." "Here take this Peter, James and John. Here is some for you, too, Lieumas and you as well, Matthew," Jesus said. "He continued passing out the bread, to include the fishes, to all of *us*—his disciples.

"Lovingly, not luckily, we began distributing the bread and fish to the multitudes. I gave a piece of this bread to Chummy and Shoop. I gave another piece of this very same bread to Bill and Fireball along with some fish that I handed to July. It just kept on coming! It was amazing how the food just kept on coming. 'The food just keeps on coming to us, my brothers; it is amazing!' I said to Jesus and the rest of my brothers—*the apostles*."

"Oh thank you Jesus! For you are worthy, and by this we know that you are the Prophet we have been expecting!" Some in the crowds exclaimed this as they feasted on the food beloved and friends, spectators, too! "Yes, indeed, and indeed some were ready to take him by force and make him their King at that very moment. However, Jesus knew better for his time for that had not yet come...

"The crowds of people to include, June and his parents, and their relatives too, were also among those who feasted on the food that faithful day. However, that is not all Peeples family because also included among them who also feasted were the 'wander twins,' Jack and Jacky. In addition to them, there was the city blacksmith who went by the name of Tomasz, the Italian; do you remember him. Sissy, and of course, June's siblings were there, too! Yes, they, and so many more, socialized and ate with cheerful expressions on their faces; even Enuj, the Acadian French Indian, was also there, both the nearby 5000, and far off 4000 blocks within the neighborhood village, surrounding towns and cities seemed to have spilled over and cohesively overlapped and intertwined, settling there for a time.

"As for the rest of the apostles, including Thomas (twin), and myself, well let us just say that it was surely a marvelous sight for us all to see! Yes, it was a sight of grace and beauty seen even beyond the marvelous difficulty of tears, which flowed from my very eyes. It was like witnessing something beautiful from behind the thin veil of a beautiful white and blue-green waterfall itself, as I caught the momentous cascades in all of its beautiful glory.

"To think that we wasted all that valuable time doubting Jesus when in fact, we should have been supportive of him instead. Surely you have all heard the expression, 'could of would of should of,' right! Yeah, I know what you mean because I have heard this same expression quoted myself.

"Even so, Thomas' doubtful feelings did in fact rub off on us at times, and at other times, this episode was in reverse order. However, that is no excuse for the times in which we, ourselves, catch *doubt* by its tail and hold on for dear life, amen! We, in our humility, should not blame others but instead, we should blame ourselves for our own faults more often than we do. It is true. I believe that this was a low point for us that day, but a necessary one, quite so."

Beloved, that is true indeed for Lieumas and his brothers. However, the fact remains that Jesus is so full of mercy, grace, and compassion that he understood everyone's shortcomings that day when it came to faith because it is an ongoing process. They had faith to believe in their Teacher that day. Nevertheless, the doubting of him performing a miracle of hope hindered them just the same. For that brief moment in time, just as it is for many Christians today, hindrance comes and it springs about like a weed, most frequently. I mean that in the sense that so many of us as Christians believe in our Lord and Savior, Jesus Christ, but we tend to doubt his marvelous works in our lives at times; we *believe* in him but do not *trust* him at certain times. We will have to work on uprooting those unwanted weeds among the wanted plants beloved, for we have to learn how to decreasingly obstruct our progress in the Lord. Not only should we *believe* in Jesus but we ought to *trust* him also.

However, the highlight of that day was in the fact that astonishment came over June because of how long his little sack lunch still lives on! "You see Mr. and Mrs. Peeples, that one act of Jesus' righteousness, for June, gave him extra confidence in this, Jesus Christ. Yes, that one act of righteousness from Jesus gave him—June—more faith in the One True God, himself.

"By this one act of selflessness on his own part, June realized that he could surely do all things through Christ who strengthens him, and that with God all things are indeed possible. He knew he had heard that

somewhere in the teachings from Jesus and now it manifested before his very own eyes." As too, was the thought process of June's own father beloved and friends, as he was also astounded at how his own son's little sack lunch was in a mighty way, able to be used by God through his—God's—own Son, Jesus Christ. Let us look at the last verse…

[21]And they that had eaten were about five thousand men, beside women and children. KJV

"Do you see what I mean Peeples family? All five thousand men, besides women and children ate from only five loaves of bread and two fishes, and it was not by luck that they did so but by love. How great is that? Now later that evening, Jesus sent us and the crowds away as he, himself, went further up the hillside to pray; but it was necessary. He wanted time spent alone Mr. Peeples. Mrs. Peeples, Jesus deserves this time spent alone; can we blame him.

"Hey you there, Grandpa, and Grandma Peeples too; all of you in this family please listen to me carefully. This indeed was an awesome display of Jesus' righteousness, and his faith. My God, what an amazing miracle this was. An amazing God produced it! Hold on to your hats, there is still more that will transpire. I cannot wait to illustrate to you through literature, and share with you more of what I have seen from my *employer*, and how I experienced it through my *handler*, amen! Can you. However, before we get to that, like Jesus, let us all prepare our hearts to pray."

Time Out for Prayer

We thank you, oh Father in heaven
For your direct line to us, through prayer
We use this tool to communicate with you
Although sometimes our faces draw a blank, stare.

For the Holy Spirit knows our moans and our groans
He knows our distresses and our desires without fail
He even prays for us when we do not have the words
His counsel is good for our spirit and the soul as well.

Dire, desires a need to be filled
A need she swallows up in time
No one of earthly dwellings can fill this void
Except the Ghost, which speaks from Holy, sublimes?

When it seems all others fail he's there
For God is in tune with what the Spirit says
He agrees with his groaning on our behalf
More so, to all who are listening he says, we will prevail!

He encourages us to all progress forward in life
God inspires us and gives us gracious insight
Jesus is the Way, the Truth, and the Life
Even when total darkness surrounds us
Jesus is the true and purest Light!

For all who are listening please, bow your heads with me at this time as we go to prayer inside the *throne room* of God, and stand before our heavenly Father. Yes, let us relax our minds for a brief, yet delicate moment, friends. Let us prepare our hearts as we focus in on Jesus Christ and the *power* from his Spirit, beloved. It is *in his name* that we pray, and it is *by his power* that we stay, also, for he is *our sustaining prayer.* After our prayer, we will then pick up where we left off in this most intriguing tale, and timeless message.

The premise of this book and the story within it, are indeed inspired by, and based on, the spoken and written word of God. This, to which I also hope you are holding not in your hands only, but in your hearts as well, beloved. Grab hold of your spouses and the hands of your children as we pray, friends. In addition to that, let us activate our own faith in God and his Son, Jesus Christ, as we begin to move into the next phase of this book…

With Heads Bowed: Father God, we come before you on this day, and bringing with us a certain passion for knowing your truth. We ask Lord God, that you would open our eyes, enlighten our minds and open our hearts. We need you to open our ears as well, in order for us to hear your blessed words this day from these passages within your Holy Bible. Help us to understand, and help us to unravel the mystery that is behind these powerful words that are coming from you.

We ask Lord God, that you come hither to us in this moment. Oh yes, Lord, for we have a strong feeling that there is more to this story and its timeless message than what our eyes may have told us. More so than that, as we looked upon the surface with knowledge from you, my Lord, we know in our heart, this is not all there is. Lord, for your wisdom has its own role to play, as well. Your wisdom far exceeds that of imagination even though, it is *you*, who has given us this delicate tool for exploration in the realm of ideas. Your wisdom unveils truth. We are now ready to receive *more* wisdom from your Holy Ghost, as we prepare our spiritual eyes to look *beneath* the surface and to look *upon* this truth.

Come forth in this hour O God! For you are one God and God alone. Yes, will you show us more of yourself that we become blessed, and thus bless others in return? We thank you in advance, and with expectancy, Lord. With excitement pumping through our veins, we thank you for allowing us to see more of what we could not see before. We see things at a more advanced degree than before and with that being said, it is so joyous to be able to experience these amazing revelations so clearly!

Father God, by dispelling and spreading this message to others, and by conveying this message to others that they may know more about you than they did the moment before, we say, thank you. We know this will

help them and thus bring glory and honor *to you*. We ask this that the others who know you not, draw near by the *power* of your Holy Spirit, O God. We pray that they may come to find you and thus rest in you. We pray that they, too, will open the gray door at which you stand, calling their names as you knock!

From you I have learned this important truth: "Not only do I speak of those who *know you*, but I speak of those who *do not yet know you*, as well." Bless us more and more as you reveal to us of your truth, and as we delve further and further into this timeless, timely, and relevant message. We pray this Father God, in Jesus' name. This prayer is by the *power* of your Holy Spirit within us my Lord, and my King, and according to your will, my God. Yes, Lord, We thank you, Father. Amen.

From Pride to Betrayal

Happy Birthday from you, my darling child
The offspring of my lover
For your dance is conducted with much delight
Its intrigue is like no other.

A dance as if no other is born
It speaks taboo just like the night
The twirling, swirling, high kicks, leg sweeps
It is such a beautiful sight!

I made an oath to honor my word
Dishonoring it would bring embarrassment you see
Although my wrong is not my right
Even so, it would still be disturbing to me.

To repent and not honor thee, my child
The gracious dancer, and to not see
It would break my heart and grieve my spirit
To ignore it and just let things be.

For your wish is surely my command
My humility is made hidden, like hermits in sand
Due to my pride and my wealth, my child
As you wish, for John's head I will demand!

As you wish, I will bring to you this beguile
As you wish, I will bring death to this man
My child.

Beloved, let us go back over these verses from chapter 14 shall we? They are very important and deserve intimate study. This, we will soon find out as we begin taking another look...perhaps a more, closer look. Notice that the wind direction of the Holy Spirit has shifted in the story at this point. The ministry of the *Holy Ghost* is quite versatile that way, as he tends to do the, well you know, directional shift thingy, from time to time. Please though, not to worry yourself, in *his* divergence concerning truth, it will indeed result in *our* coming into a convergence of truth that *you* might understand it fully. Now a little more teaching and instruction has come our way as we move farther along, amen. I ask that you all please bear with *us* a little while longer.

Now here we have in verse 13, Matthew writing about the beheading of John the Baptist. Remember, as the above poem alludes to, this event took place earlier upon the insistence of King Herod's "child interest," *damsel* on his birthday—some writings render her his, niece or stepdaughter. Let us talk about John the Baptist, for a brief moment.

Now John, like Lieumas, was *not* a member of the Original "12," but he was surely an original and just as important (just like Lieumas) as they all were. I make this known because he was indeed a messenger of God also, just as Lieumas is a messenger of God, right now! Nevertheless, I do want you to become a little bit more familiar with him and in the actions that ultimately led up to his untimely yet, timely death before moving in a direction forward with you all, amen?

Beloved, in keeping with his strong biblical character, John the Baptist was again, not only a prophet of God, but he was also the *forerunner* for Jesus Christ, as was talked about early on in this story. You see, as a *forerunner*, or *messenger*, his assignment was to announce to the people, the arrival of the coming king. His mission was to go before, or shall one say, *run* ahead of the king and thus prepare the road for him—tell others, through his preaching and teaching, of the king's future arrival—hence the term, *messenger*. By completing this task, the people would have prior notice—knowledge—, and thus prepare their hearts for that very *special* and very *personal* visitation from the king sent through the messenger *by* this king. Let us talk about his personality, his appetite and dress attire for a brief moment.

Okay so John spent most of his time out in the desert field and his unique clothing style showed for it. He wore unusual clothes of camel's hair. His waistline was fitted with a leather belt used for securing this unique garment. Moreover, this distinct garment was worn for protection against the desert wind and sand storms that so often occurred. Any other type of clothing and belt made with different materials and textiles would not work well in the desert wilderness.

Friends, you see, camels' hair, uniquely designed to resist the high winds mixed with sand and dust found in the barren wilderness, is crucial to survival for the camel. Therefore, why not John, wouldn't you say? Leather, too, was a strong textile and could resist practically anywhere, the climate weather of rain, drought, and snow or shine as well.

John even ate locust and wild honey in order to satisfy his hunger. It was strange food to say the least, but not unfamiliar. Keep in mind that proper food in the desert was quite scarce so he had to make due *somehow*, amen. Although it was strange to some spectators, locust was indeed ordained by God as being a proper food for eating nonetheless. This makes it familiar. By the biblical assessment of this truth, we conclude that John the Baptist was no doubt a desert preacher *sent* by God to announce to the Judeans, and surrounding regions, the King's (Jesus') future arrival, and he was a unique desert preacher at that.

Let us talk about his message and his unique style of preaching for a moment, beloved. His message was one of repentance and obedience to God, which has evidence through the, Rite of Baptism, and we would hope…a lifestyle change for the one, or ones whom he preached. Now the Rite of Baptism or the ritual thereof, was an outward sign of your authenticity of an inward change in behavior. He was not too shy to confront others with boldness in his voice, either. Moreover, when I say others, I mean just that! He did not hold back his brazen "judgmental" aggression of sinful and hypocritical people. Nor did he "bite his tongue" for them.

Included in his onslaught were religious leaders, and political leaders as well, the man was "straight up!" Even the commoners he preached *to* and the messages they received *from*, God's Spirit through John the Baptist, were victims—not in the traditional sense. No one was safe from the aggressive preaching style of John the Baptist. Not a one was safe, that is, unless he or she came across to him as being one who actually showed an outward change of behavior *through*, the Rite of Baptism. Even so, if detected otherwise, you classify as brood of snake, and believe me, that would not be fun… However, in saying that, would its classification be superficial? You know, becoming *righteous* through the Rite of Baptism. Now that is living (superficial outward change), or is it?

Although, Jewish himself, he still had very little power in the Jewish religious circles, and political arenas. Nevertheless, in God's eyes, he still was a man of authority though, that is why God used him for his purpose. By God's grace, this authoritative stance taken by John the Baptist was in God's own way, and John's way (through a solid partnership with God) of getting the Jewish people, and outer regions to move in the right direction forward, toward God.

That is not all beloved and friends, spectators, too. It also was an authoritative stance that probably made others campaign against him, in order to get him to move in their so-called right direction forward, even though in reverse order, it was a step in the wrong direction backward. Ultimately, this aggressive and authoritative stance in the eyes of King Herod, Herodias, and her daughter cost John the Baptist, not only his life, but his very head; how humiliating. As Lieumas stated though, it was the reason why they—disciples—and Jesus went away from the crowds in the first place; you know, to grieve a little, and to be alone.

Although his life was lost, his mission and message was indeed complete in his wake, even today, right now through the Holy Bible. You see, he (John) accomplished the task assigned to him by God, himself. This brings me to another point, and that other point is this:

WHATEVER TASK GOD HAS ASSIGNED TO US, MAY WE ALL STRIVE IN FOLLOWING AFTER IT.

Again, I am not yelling but emphasizing so it stands out, notice the context in which I speak, also the period at the end instead of an exclamation point. Listen, no matter what, if God assigned us to a task, God is there for us and he will see us through it. If we are willing, he will see it through to completion even if it brings with it, our demise. Beloved and friends, for he did not promise this Christian life to be one of no struggles or strife, amen. Love never said it would be easy. In fact, he said quite the opposite. This makes for a great challenge, and an even greater, triumph. God receives glorification *for* it, and he deserves recognition *from* it just the same. Let us move in the right direction forward with Lieumas and perhaps, the Peeples family as well.

"Now John the Baptist, called out the king and condemned him and Herodias, the former wife (divorcee) of the king's half-brother, Philip, for immoral and unlawful behavior (under Jewish Law) Mr. and Mrs. Peeples." "Behold, for it is illegal for you to engage in marriage to her, King Herod!" "Imagine if you will as I did, hearing those words from John. Now imagine hearing these next set of words from him:"

"This cannot go on, for this is not right before God! I condemn you for this heinous act of marrying under illegal pretenses!" "John was courageous enough to say this because again, this was not standard practice under Jewish Law. I would imagine he would be yelling this at the top of his lungs to the couple. I say this Mr. Peeples, because of his—John's—boldness in his verbal message delivery towards sin and immorality in general, let alone this personal interference—divinely inspired—of the king's immoral relationship.

"The bottom line is that John went with the fact that it was indeed illegal, under Jewish Law, for King Herod to do this, and it was an immoral act, too! Of course, this bold accusation angered the king's mistress, Herodias, and she became enraged. I am certain that by this point she wanted to hush this preacher of the desert and man of God, for the last time!

"I envision myself staying clear of the cross hairs, as I lay hidden in a dark corner of the king's courtyard. I likened myself unto an obscure chameleon on the wall as I blended in with my natural surroundings so as not to undergo detection. I noticed she was enraged enough to possibly order 'the hit' on John the Baptist—an execution if you will—but, there was a catch that prevented her from making this evil plot a success. Nevertheless, he was an itch she had to scratch." "A catch?" asked one of the Peeples children. "That's right, a catch," I replied.

"She was powerless and indeed needed approval for this, 'snuff job' of John. However, the king respected John, and you know this king, Herod, even liked talking *to* John, although his preaching at times disturbed him." "Really?" asked another Peoples family member. "Is that even possible?" he continues. "Wow," say other members of their family, almost in unison. I can tell intrigue had set in by this plot against John the Baptist. They were intrigued indeed, as if they were watching a relevant mobster type movie or something, as they sat on the edge of their seats cringing and biting their fingernails or…what was left of them.

"Nonetheless," I continue saying, "King Herod knew that John, the Baptist, was a good and holy man of God. This was a position, which established not only John's credentials, but also John's protection from harms way, as well. This protection of John, which was crucial, or at least, held as being crucial, one would think, was so very important for his survival, but…

"At least in my own mind I thought that way, and with this, I saw of no need to scurry off making my way toward him and warning him of this eminent danger. However, this action from John the Baptizer in turn, catapulted the daughter (traditionally rendered, Salome) of Herodias into an enraged reaction along with her mother, who initiated the plot. Yes, this caused hate and she acted out this hate crime by requesting the placement of John's head on a platter. This platter, presented to her mother no less, was the ultimate goal here. For this was her mother's chance at revenge, and by *god*, she was going to take it! She finally would be able to reach that itch that had bothered her for so long I imagine. For this reach, would be through her daughter.

"And so comes, or perhaps in reverse order, (goes) the inevitable and deadly influenced plot of a mother and daughter slaughter team geared

up for indulging in unrighteous deeds toward another person, or persons, even—second hand—, as this would affect all who were close to John the Baptist—even Jesus; even us disciples. This move of affect was to include even John, the fourth named Apostle, for he was his mentor and John, his disciple; yes, this disciple, John, the soon to be apostle, was an understudy to John the Baptist before leaving to join Jesus' twelve-man team. It is an evil relationship in terms of one pleasing the other without concern for the third party, and this third party again being, John the Baptist of course. It would become an evil relationship intertwined with anger and hate, and pride. The plot thickens beloved Peeples family…oh my, how the plot thickens!

"Again, imagine if you will, hearing as I did, these words, and undergoing these experiences:" "I want the head of John the Baptist on a platter!" Salome, the daughter of Herodias says impatiently, and with intensity and excitement in her voice. "Although still a chameleon on the wall, I cringed at this point while still obscurely hidden in the cold damp quarters of the king's castle within his fortress. At this point, the orange and blue fire still cracks in the fireplace like dry brown leaves roasting due to the summertime heat from the sun. Its flickering light sheds a centimeter of light on my face while the casting of a shadow along the back wall accommodates the flickering and shields me for a moment. I must admit to you though, that it is making me a little bit more nervous for fear, they will see me.

"Yes, fear strikes at my core and thus manipulates me. I am afraid that I would be introduced to death and that I would share John's potential fate *of* death. Why, do you ask? My answer to you is because the same light from the fire, which shields me, also…enlarges my silhouette along the back wall! Yikes! Patiently I wait without moving a muscle, or making a sound though… Patience has become my best friend. Yes, *long-suffering* has become one of the many *fruits* of my salvation, beloved Peeples family.

"As for King Herod, well, he had no choice—at least in his own mind—but to carry out the heinous crime of murder, especially after suggesting to her (his wife's daughter) that she could have anything she wanted, even up to half of the kingdom. Imagine that, up to half of the kingdom, wow! Now that is a lot of real estate; who would not want this. Wait; be careful what you wish! It is not always cracked up to be what you expected it would be, sometimes what you are left with, is a rotten egg.

"It was because of that very delightful dance she put on for the king, and of course, for the leading citizens of Galilee, that her wish was his command. Again, imagine that, one dance for the life of a man, the head of a holy man, at that. For John the Baptist, the potential death has hiked up

in status; for me (chameleon) however, it is in reverse order. The fire along the back wall has dwindled down a bit leaving potential to linger alone, unaccompanied by death..."

Now beloved and friends, we can see through the dull dark eyes of the king, his wife and the daughter, and the sharp bright ink of our writers. Yes, we can see through the structured penmanship of our beloved, Matthew, and truth discussion host, Lieumas, that Jesus of course felt saddened about John the Baptist, who was again, his messenger, his cousin, and his friend. Therefore, this further explains one of the reasons why Jesus went off by himself to that remote area to be alone as his disciples; apostles followed behind him that faithful day in the wilderness.

However, it is not unusual—at least for some people—but in fact quite usual to think this way because even Jesus had feelings, amen. Jesus expressed sincere feelings for his people. Jesus had feelings back then, and he has feelings right now, today for his people; he has feelings for his beloved. He had feelings for John the Baptist, back then...and he has feelings for you and me, right now, even today. It is true!

This may be a little uneasy for some people to fathom you know? To rationalize someone telling you that Jesus *had*, and even still *has*, feelings for the human race are beyond comprehension for some. This notion, let alone for some people personally, commonly ignores as well. They often say things to mock Jesus. Most often enough, some of the comments that are said go to the tune of things like this:

"You said Jesus, yeah right as if he could relate to the circumstances that many of us go through on a daily basis right? I mean after all, the 'man' who we call 'Jesus' supposedly lived some two thousand plus years ago right? How could he still have feelings for us today in this present time! That would insinuate that this man, Jesus Christ, is alive even right now! For that cannot be, it is impossible to live that long! It is impossible for *someone* to rise from the dead, even! Further, more, it is impossible for *anyone* to rise from the dead, for that matter! To that, I say whatever man! I mean that, to me, makes no sense at all! It's just plain bogus and absurd, it's...unrealistic, the 'Holy Bible,' too! Furthermore let me say this, how dare you insult my intelligence; my pride!"

Well, to them I say that there indeed *is* an answer to that, I will remind myself, and you of course, of that answer a little later on as we go along. In the meantime, though, let us continue with what is going on in the "right now" moment, amen. We will also trust the Holy Spirit to bring us back and forth through historical planes because again as I stated earlier, his ministry builds on that premise, amen.

Now the Holy Bible teaches that the multitudes heard about where

Jesus was going and they followed on foot byway of land from many surrounding villages throughout the area. Do you see what is happening here? I want you to feel what is happening here. Yes, embrace these steps taken on by Christ Jesus, himself, as explained by Lieumas.

"The crowds of people knew about how miraculous Jesus was and thus began a foot chase—so to speak—over the hills towards him." "I know he is a miracle worker," says one member from the crowd. "Let us go to meet him. If only I could talk with him face to face and he grants me a service of *healing*, then I would be so gracious as to follow his every lead. C'mon, let us go to him shall we!" "I, myself, was overwhelmed by now of how much they revered him; I was overwhelmed but not at all, surprised."

"Hurry along for we are almost near to him!" "This, they would have been caught saying over and over, and over again as their words rang in my ears just like that of an alarm clock along with an awaiting pot of coffee, and sweet bread too, set to awaken me out of my slumber! It is true though, Peeples family. Jesus healed crowds of people back then, and Jesus heals crowds of people right now—even today. Some people sought, and even seen the face of the Lord back then and some people seek, and even see the face of the Lord right now—even today."

Beloved and friends, hear this word from the Lord, God, concerning this in, The Book of JUDGES 6:22:23, KJV, which states:

"And when Gid'-e-on perceived that he *was* an angel of the LORD, Gid'-e-on said, Alas O Lord GOD! for because I have seen an angel of the LORD face to face. And the LORD said unto him, Peace *be* unto thee; fear not: thou shalt not die." KJV

In addition to that, we can find this teaching in, The Book of the Prophet ISAIAH 55:6:7, KJV, which states:

"Seek ye the LORD while he may be found, call ye upon him while he is near: Let the wicked forsake his way, and the unrighteous man his thoughts: and let him return unto the LORD, and he will have mercy upon him; and to our God, for he will abundantly pardon." KJV

Even so, why would he take the time to oblige them throughout the Holy Bible? Moreover, why does he take the time to oblige us in today's time and even after the possibility of losing a fellow Christian brother or sister, such as the case with John the Baptist? I mean seriously. C'mon, why would Jesus take the time to meet our needs after the circumstance of losing friends and family, or even strangers, or even the loved ones of our

friends for that matter? Is it because of, compassion…? Yes, it is indeed because of that word. It is because he, Jesus, had compassion on them as well; do you not see it?

What does that word mean exactly, and what does it mean for you and I today because let's face it; we all want to know more about the heart of Jesus, right? Of course, we do because we are hungry, and we are thirsty for his knowledge, and his wisdom that only he, can give to us. We are curious for the insight concerning this, curios. I know this in my own heart and mind now. I know this as I follow along and even at times, engage with Lieumas' truth discussion as he walks through the *word*; I know this in my own life now; no longer am I curios but heavenly thanks to Jesus Christ.

"Peeples family, let us understand the meaning of the word, *compassion*, amen? The word, *compassion*, simply means, *sympathy granted to someone or someone's due to unusual or distressing circumstances or situations.* Moreover, it means that we too, can receive the very same compassion from Jesus in our own lives. It is true!

"So, we see that even in that entire midst of losing John the Baptist, again one of the greatest men to have ever lived, and through the act of beheading no doubt, we found out that day that it did not totally consume Jesus. That's it! Eureka! The circumstances did not totally take the attention of Jesus off those many others who needed his help. Yes, Jesus realized that those many others were also in need of him and his acts of compassion that day.

"To know that he, Jesus, still did not shift all of his focus on John the Baptist alludes to the oversized and pulsating heart of Jesus. This find we happen upon as we learned that his compassion for all people, in all nations measures equally and, are without equal; it is perfect. It is priceless, peerless, and incomparable. Yes. Amen.

"Again, he—Jesus—had feelings, amen! He—Jesus—knew he had a mission to fulfill on earth, and he—Jesus—was to fulfill this mission without pride, amen! You see, Jesus still had enough grace to shift his compassion, amen, on the crowd who followed him, and not on John alone, amen! I mean come on; this is John, the Baptist, we speak of, right. However, do not be surprised by my statement just yet because although John the Baptist, considers being the greatest man out of all the men who has ever lived, is a true statement surrounding John, even the most insignificant or least in the kingdom of heaven too, is greater *than* John, the Baptist. That meant them…this means me…and of course…this means even some of you dear Peeples family. Follow me a bit further will you!"

Beloved and friends, I can imagine that some of you are probably saying, "What! Are you kidding me? How do you like the nerve of this

guy?" However, are those words of me? Are they perhaps Lieumas' words, even in reverse order? No, they are the words of Jesus as written in, The Gospel According to MATTHEW 11:11, KJV.

"Verily I say unto you, Among them that are born of women there hath not risen a greater than John the Bap'-tist: notwithstanding he that is least in the kingdom of heaven is greater than he." KJV

This is amazing! Again, what does this mean for you and me? This simply means that John, although a great forerunner and fanfare for the Christ, and who is now in the kingdom of heaven, did not see the completed work of Christ on the cross. This was because he was an Old Testament prophet, and Old Testament prophets spoke of the Lord's coming in all his *glory*, but wasn't around any longer to see its manifestation come to pass.

You see, when addressing the New Testament apostles, *here it is!* We find that they indeed *witnessed* not only the coming of the Lord but also, all his glory (life, death, burial, resurrection, ascension), that which their brothers, the prophets (with the exception of John the Baptist of course, because he met the incarnate Christ, briefly) only *spoke* of through the partially complete, word of God. Even while John was in jail, after hearing about what Jesus was doing, he sent his own disciples to ask if Jesus was indeed the *one* they were waiting for. You see, John did not experience his—Jesus'—death on the cross, and his resurrection from the grave as many of the others did, including me, because John the Baptist was put to death *before* the time of Jesus' own crucifixion. Does it make sense to you all?

Beloved, I will explain even further. You see, after John's time here on earth is spent, others, through their belief in this Christ we know as Jesus, comes into play. John considers being the friend of the Bridegroom, Jesus. Moreover, the day is coming when Jesus will introduce his bride to be. Even in some places within the Holy Bible, we, Christians, compare to that of a, Bride to Christ and he, himself, as a Husband to us. Our brother John could not be his bride, at least before his death, because technically speaking; Christ died and rose from the dead after John's own death.

Now this puts us on the same plane, spiritually, as John the Baptist, does it not? It puts us perhaps a bit higher only (and I emphasize the word only) in the sense that we experienced Christ and his Spirit more fully, his word too! We experience him and his, now complete, written word *more fully* through his completed work on the cross (death burial and resurrection), and experience these recordings thereof, and not by us being "greater" than John the Baptist as a fellow human being and Christ follower. That, if it

were the case, would bring about a sense of prideful arrogance to the table right along side of luck, and we know better than that for we have seen the result of such in our introduction to this book. Yes and amen, beloved, we do not want to eat from that, not so inviting, dinner table and perhaps run the risk of dealing with a potential E'-hud deliverer (Judge) familiar. Boy, some would say his victim was a bit unlucky...

"Dear ones, dear Peeples family, we have seen as much, and we continue to see as much, and experience as much as John the Baptist, why? The answer is because of the anointing from the Holy Spirit residing in us as Believers as was with John from birth through his anointing. Oh my God, indeed you are awesome and no respecter of men. We thank you Father for showing us the way of life. Moreover, we thank you for giving us an opportunity to believe on you, to serve you, and to speak of you, as well."

We love you, Jesus! More than that, we seek to see you face to face knowing that by doing so, our sins pardon. Because of your mercy, grace and righteousness, we will not suffer your justice as seen through your wrath and spiritual death eternal just as the previous above Scriptures point out to us from the books of, JUDGES, 6:22:23 and ISAIAH, 55:6:7, both stemming from the KJV. We ask that you teach us more Holy Spirit. Yes, tell us more...

Here Today Gone Tomorrow

Like glimpses of fog rolling in and vastly disappearing
As like the dew drops dissipating on the grass
Due to the sun that is searing
Therefore, it is with the world we all find ourselves to live in
It's fading and fading and fading away
Before long, it is empty as abandoned buildings.

The time is now no need to wait
Stop trusting in Man's natural opinions
Stop following in ways that are not the truth
Just clinging to Satan's dominions.

Jesus is the Christ who is witnessed by the Father
That he could have more brothers and sisters
That he could have more sons and daughters.

God has gracefully made a way
For us to return to him with proof
However, the powers of darkness are also lingering
And they are trying to keep us, aloof...

Beloved and friends, travel back with me to the current writings of the five thousand who Jesus ministered to as the Holy Bible teaches us that he, Jesus, healed their sick! First, before we go on, I want us to understand that Jesus' actions were an act of *selflessness* and not an act of *selfishness*, do you hear me!, amen. Jesus was genuinely approved by his Father to become righteous, in reverse order, in his baptism here on planet earth. Keep in mind that Jesus *chose* to be baptized by John and

thus this role of unrighteousness would cover him. Moreover, the awful, but necessary suffering that would come along with being unrighteous through this special baptism, Jesus would allow for it having to take place here on sin-ridden planet earth.

Sure, he—Jesus—asked that God would take away from him, this cup of suffering and separation from God. However, he in fact *chose* to go through with it because that is what his Father (the Godhead) wanted. You see, here's the thing! Jesus was not reluctant to die for us but instead, he was reluctant to separate from his Father in the process of dying for us. I believe that this was the most difficult part for Jesus to play in this redemptive plan for humanity...for society...for you...for me. However, that is something we, as humanity, as a society, and as a person/people, struggle with you know—separation of a loved one and or, loved ones.

On the other side of that coin, our struggle with the selfishness that we engage with is possibly because of our own lack of true concern, and sincere love for others, and even ourselves within his church. God's word says to us that we are to love him with all of our being and that we should love our neighbor as our self. We should never "not love" ourselves because this could bring about suicidal tendencies. We can however, "not love" the way we are *handling* ourselves for that particular situation we may find ourselves in; that is a bit of a healthier stance or approach to things considering the, "love myself" versus the, "hate myself" attitude some of us choose to possess. I will get to more of that on a deeper level later on in another series of books.

Allow me to say that even when God teaches us to be on one accord with him, as well as on accord, one to another, we still have a tendency to willingly separate from our own brothers and sister in Christ. Sometimes this is a difficult thing to do. At the same time though, it is also, sometimes very necessary given the proper personal circumstances and or, *special dispensations* brought about from the Lord. Having said that beloved and friends, ultimately, separation from each other as a body should not be entertained due to selfishness, pride, envy, jealousy, hatred and the like. However, like our Creator, I too, have a bit of a jealous streak of my own for my beloved. This is surely something *I* may have to work on. Nevertheless, in the context of vigilance, not so much as it suffices, amen.

Anyway, instead, if there needs to be any form of separation, let it be to promote sorrow and healing. This should bring about guilt, remorse, and the longing to reunite. Let us not burn bridges in the, *right now*, but instead remain approachable at all times you know, just in case we need to walk back "a cross" that bridge *later on* without suffering from too much embarrassment. However, I say that to the least because two-way forgiveness

and acceptance of said forgiveness overrides the sake of embarrassment altogether. Trust me; I *say* as well as having *said*, these things to prepare you for the upcoming sentences, Scriptures, and verses beyond set Scriptures, I have, in the future prepared to past write, for the present.

Listen to me; the powers of darkness are always trying to stir up discord among the brethren, did you know that? It is true. Moreover, those evil powers attempt to do these things by means of causing separation in the *Body of Believers* unto Faith in Jesus Christ. They do these unrighteous deeds through acts of the flesh, which in many ways manifests itself through the spirits of selfishness, pride, envy, jealousy and of course…hatred. The dividing factor we use is sometimes engaged in terms of the natural, and the unnatural, types of instincts. Is this confusing to you? Allow us to explain ourselves…

You see, man is *born* into this world with a natural instinct. In addition to that dear ones, may I add that man is *reborn*, through faith in Christ Jesus, unto life eternal even while in the state of, living in this sin-ridden world? This gives him, or her, an unnatural, or a better term would be, supernatural instinct, after becoming reborn. Is this still confusing to you. If so, please, hold that thought for a minute. Allow "Luminous" to elaborate for us, even more so than I am because this is good stuff. This should not be cast to the side. Moreover, he has the "gift of insight" don't you know, out of the many other gifts he possesses, as this *is* his wheelhouse and all. We will just follow along through the thread he already established, fair enough.

"Now when the term, *natural*, instinct, is used, it reads that way in the sense of, *in the eyes of the world*. That is because the world does not understand the unnatural, or supernatural, things of God. They instead, and through *lack of faith*, understand natural things according to their own reasoning or logic, or self-wisdom—according to their own mind; their own perception of enlightenment. This was touched on a bit briefly in the beginning of this story and message back in chapters I through IV, concerning the, *mind of logic* versus the, *heart of openness*; roughly, its trace elements touches throughout the thread of this entire piece but who is keeping count, right.

"However, moving forward, when the terms, *unnatural* and, *supernatural*, instinct is used, it reads that way in the sense of, *in the eyes of others who have the Spirit of God living in them*. That is because those are the ones who have, or should have, an understanding of unnatural-supernatural things of God because of our *rebirth*, through an open heart. Do you have a better understanding?

"In short, the natural, stays the same to those who do not believe on Jesus Christ, and the, once natural, has now become the, unnatural, to

those who believe on Jesus Christ. However, here is the kicker…the now, unnatural, is the *true sense*, or state of consciousness, in terms of being natural to those who believe. You see, it becomes, supernatural, because of the Holy Ghost living *in* and *through* us as Christians and not just *near* or *around* us as non-Christians who are in fact, in a state of unconsciousness regarding the overall spiritual aspects of God."

Dear ones please hear my heart in this as I speak from the voices that dispenses throughout the writing of this entire book, to include the bold eloquent writing of these next few words, amen. Here they are:

BE NOT LETTING THE THINGS OF THE NATURAL DIVIDE YOUR HEART IN TWO, FROM THE UNNATURAL KINDRED THAT IS YOUR BROTHERS AND SISTERS IN THE FAITH—EVEN UNTO THE LORD JESUS CHRIST. INSTEAD, CONTINUE PROSPERING IN GENUINE MERCY, PEACE AND LOVE FOR GOD, OTHERS, AS WELL AS YOURSELVES, SUPERNATURALLY, AMEN.

There, I said it! As a Minister of the Lord, Jesus Christ, I have seen this type of discord sown between my brothers and my sisters in the Lord. I must admit too, it breaks my heart to see this and to experience this as well, in my own life. I can surely say that I have seen it happen very often. I have seen it both, behind the scenes through God's *Spiritual eyes*. I have seen it up front through mine own eyes, too. I have even seen it through my *third eye*, which is the, Mind of Christ, excessively and often enough!

However, we must keep in mind that Jesus Christ was indeed fully God and fully Man, he was/is, God-Man. May we also be reminded that he is our Leader, and I stress the word is, amen? That is what our hearts proclaim, too. As our Leader, let us follow his lead and stand up for one another as we stand against would be attacks of discord sown among the brethren. For we know who is causing this rip in the colorful fabric of *life* therefore, let us unite in sewing. Moreover, we know that it is harmful *to* us and not helpful *for* us, amen.

Now then, let me touch on another important tactic brought about by Satan's deceptive hand to *you* and the entire Peeples family for a minute. You are welcome to follow along here as well, spectators. What is the bread of aloof? The word, *aloof* means: *keeping distance between some thing (s), and someone (s)*. It is another way of saying, at least in this particular context, having bread with "yeast" of the Pharisees and Sadducees, and their false teachings in it. Now, without going into too much depth, at least in this particular book, unbelievably…I will now touch a bit briefly on these two types of Jewish sects:

The *Pharisees* were members of a strict Jewish sect or group that held the Mosaic Law to a high standard. They saw this Law and its traditions as binding but did not practice what they, themselves, preached. Jesus, on the other hand did not see it this way, and with good reason—in his eyes, this is seen as *religion* coupled with *hypocrisy.*

The *Sadducees*, however, were also Jewish members of a particular group. They held to the interpretations of the Law, but did not believe in the afterlife. They also were an aristocratic party and often sided with the *Romans* to maintain their favorable status. Jesus, on the other hand, was Authoritative in his teachings and followed no one else's teachings except his own and for good reason. In his eyes, this is seen as *religion* coupled with *arrogance.* Jesus' preaching and his teachings were both, fearlessly motivated as well as, original in content, hence the statement after hearing one who preaches with the Spirit of God within them: "His preaching is one of such bold eloquence and pretentious claims; it's conveyed with much passion, clarity and authority."

These Jewish sects and their teachings, and ways, could be used in keeping others at a distance hence the word, *aloof,* from the teachings and moral standards of Jesus Christ, who was indeed Jewish, himself. In short, they both, Pharisees, and Sadducees, were indeed hypocritical and selfish in their teachings, and in their immoral ways as well as with the arrogance of the Romans rubbing off on them, as opposed to Jesus Christ's true teachings and his, moral ways. Their *yeast* does not end within the pages of the Holy Bible, where I walk. It, in fact, has spread from generation to generation, and it is even active in today's generation where I walk, also. It is active in Jewish circles and even in Gentile circles, as well.

Okay so, his—Jesus—unnatural ways, in the eyes of the world, did not make him any less genuine. It just made him stand out more in his genuine acts of selflessness. Therefore, I will say it now in case I have not said it, or you have not heard it before, and I quote… "Let us follow him with truth and honesty at the helm, amen. Let us follow him in love as it bleeds through unto our brothers and sisters in Christ! Let us, aided by the Holy Spirit, overthrow the evil acts of selfishness and the spirit (s) thereof, amen!"

Interestingly enough beloved and friends, spectators too, this will begin to play out through Lieumas and some of the other characters a little further upstream in this book. The things that are now transpiring have taken shape. In addition to that, the things that will continue to transpire will indeed become knowledge very soon. Stay with *us* as we continue to stay with, *them.*

Now, MATTHEW chapter 14 and verse 15 out of the KJV of the Holy Bible, teaches us this, that this particular evening the disciples came to

Jesus and said these words: **"This is a desert place,"** KJV. This word, *desert*, is a name, which by the way indicates a place of desolation or emptiness. It means, *barren or without much trees or vegetation; usually void of desirables but having much sand.* In other words, it is a place without much, life. The verse goes on a bit further by stating:

"...and the time is now past; send the multitude away, that they may go into the villages, and buy themselves victuals." KJV

The time is now past means that the time is getting late. In addition to that, here we have the word, *victuals.* Victuals are another term used for the words, food, groceries, rations and or, food along with supplies. It means *provisions.*

Listen closely my beloved, because I want you to grab hold of this truth. It is about to shape shift direction yet again for a moment, and with good reason! I want you to grasp this, and not let it slip through your fingers like a wet bar of soap. Here is the humorous visual: wet bar of soap flipping through the air in a desperate attempt to be caught by its handler. In its desperation, Dove desires to be caught before gravity takes hold, and landing on the bathtub's porcelain floor within the shower causing it to bruise, but not likely—but with hope nonetheless.

My friends, in losing the humor, let us follow up with some weightiness for a moment. It is very important that you and I understand this section. For this is the very life of God's Spirit transforming the pages into relevancy for us, once again...watch closely! The Holy Bible in-tells to us that towards the evening, the disciples came to him, Jesus, and said these words:

"This is a desert place and the time is now past;" KJV

Stop right there! Now this unique dispensation indicates to us that it was getting late in the day, right? The language and choice of words from God are so poetic and artistic! As we look closely, we can begin to understand, by selective and eloquent word play, that the word, *past*, in the sentence must be indicative to a *past* time in terms of a *future* event as they speak about it at *present*. It is such a beautiful and colorful choice of words here, amen. It is beautiful but at the same time, it is striking word play also, especially for these *current* times nonetheless, amen!

By God, listen to me! The lateral translation from the words above means to say that today, we are living in a world that is also in a state of desolation. Moreover, God is saying to us, through his Spirit, that we are also in the *last hour*, just as Lieumas' brother, Peter stated in the Holy Bible many generations ago. It is indeed getting late my friends because

the time is now *passing*, do you hear me? You see, the world in which we live in today is a *desert* place which is decaying, is it not? It is a world that is indeed fading away because of this fallen state that it is in currently. I mean come on, think about it. "This is a desert place and the time is now past." God is trying to tell us something, right now!

Here is something that I want to bring to our attention, and I want to bring it up now before I, or Mr. Ettesorde, mistakenly forget to bring it up, or mention to the Peeples family later. It will all tie in together no doubt about it. However, we must understand that it must be looked upon in several isolated parts bit by bit, and carefully through the many eyes of God's people that we might dispense it accurately, amen. Remember, in its *divergence* it will result in its *convergence*.

Moreover, just like the huge pink elephant in the room that makes for a feast within the, last hour—a must—, several people and not just one person must eat of it, for fear that, it would take too long for one soul to devour. It must be eaten one bite at a time and starting with different isolated parts of the gray elephant by *different* mouths of God's people in order to expedite the digestive process, amen. I simply cannot contain myself at this time! Here it is!

JESUS SPENT TIME IN THE DESERT BEING TEMPTED BY SATAN IN THE BIBLICAL ACCOUNT, IN A THREEFOLD CORRELATION OF THE WORLD, THE FLESH AND THE DEVIL. NOW HIS SPIRIT IS IN THE DESERT OF THIS WORLD, IN THE DESERT SURROUNDING YOUR SOUL. MOREOVER, HE IS WAITING, RIGHT NOW, TO FEED THE MULTITUDES (US) HIS VERY LIFE (DEATH, BURIAL, RESURRECTION) BECAUSE THAT IS WHAT THE WORLD NEEDS IN ORDER TO SURVIVE THE ATTACK OF THE DEVIL—SATAN. WE MUST CHOOSE TO PARTAKE OF HIS BREAD (FLESH) AND CONSUME HIS BLOOD (CROSS). WE MUST DRINK OF HIS LIFE'S WATER (HOLY SPIRIT)!

Listen to me, he, Jesus, so wants us to feed on his faith, amen! Why, you ask, the answer is because in this world we—a great percentage of humanity—is feeding on, consuming in, and drinking from something else. There are many types of drugs and pharmaceuticals—prescription/non-prescription, over the counter, open shelf— underground (black market), organic and synthetic etc. and there are drug addictions from these drugs and the pushers supporting it and supplying them. We are talking corrupt drug pharmacies, flagrant kingpins, drug lords, and drug cartels feeding us what our flesh thinks and believes it desires.

In this world, there is non-contentment for the things we do not have and or, have access to. This excites the need for thievery and thus results in theft. We are talking armed and unarmed robbery, burglary, assault and battery, and even, murder. When seen and or, experienced through the eyes of certain social classes within the lower, middle and higher brackets, this excites retaliation causing for same race as well as, intersecting race crime. So many times these crimes are swept under the rug or pushed to the back of the file, or perhaps chunked in "file 13" altogether.

However though, this is not the entirety of it, many times the actions of "other" criminals and their victims are happening all around us just the same, but their stories do not surface to the front pages of headline news. I mean let us be honest here some do, but not generally. Then there are the interaction of the law enforcement officials and the alleged perpetrators and well, we know how volatile of a brief moment that has the potential to become; we do not even have to go there. Some are legitimate in their dealings and well, some are not as squeaky clean as they are perceived to be, and I mean that to say that this escalation and such, happens on both sides of the law.

In this world, there is adultery, pornography and other forms of sexual immorality too. These devilish maneuvers are to include, homosexual/bisexual/transsexual relationships and same sex marriages as well, as opposed to heterosexual relationships and biblical marriage between a man and a woman. What is so alarming is not as much as these behavioral lifestyles, which intrinsically, is not pleasing to God but an abomination; yet understandable to the call of the Godly *from* God, and this is due to the nature of fallen humanity. However, it is the blindingly major support systems for this type of lifestyle and behaviors coming from the Christian society, alongside the secular society that makes it alarming.

Sure, we are to embrace others who are worldly as a means to guide them to a better understanding of God and his unchanging word of righteousness through Christ, and this, no matter their lifestyle. Nevertheless, we must be mindful of this, for we are in the world, and even allowed freedom to utilize things of the world, but being careful so as not to become imprisoned and or, enslaved by them. However yet again, here's the thing, but we are not of it therefore we must not engage in, entertain them, and support the world's agenda no matter how unpopular this makes us.

In this world, there is also false teaching and heresy in the pulpits through the distributing of the, *bread of aloof.* Moreover, there, in the pulpits, it seems as though more times than none, we have a teaching concentrated on what God *is for* as opposed to what God *is not for*, what he is against in other words. There should be a balance of the two and the

wrongs should be pointed out just as it is recorded in the Holy Bible and, just as the *rights* are pointed out in the same Holy Bible.

Proceeding forward, in this world, there is animal cruelty. In this world, there are wrongful prison convictions. In this world, there are wars of all types to include, social-civil, political, and religious wars. There are senseless killings, hate crimes, hangings, setting others on fire and beheadings behind such wars also. In this world, there is famine. In this world there is, here it is…SIN! Yes, my friends, I am not informing you of something you do not already know, or perhaps I *am* informing you of a, *Peace of Truth*, that you are aware of, unaware. However, either way, what I am doing is elaborating on something you do know. Moreover, I am even doing these things perhaps while *being* unaware, myself, because it instinctively embeds within the human heart and mind from birth but having at the same time, a void; a hole.

Listen to me some more, it is time to close that void. It is time to seal that hole. It is time to remember God and remember who *God is*. It is time to hear God, and his own testimony of his one and only Son, through his word—Holy Bible. It is time to allow God to remember and hear you.

You see, *Sin* is a disease, (yes, let me make an assertion also that in this world there is sickness and disease) that even the top centers used for safely handling diseases cannot find a cure for much less, contain and keep it stabilized. Do not get me wrong, the Centers for Disease Control and Prevention (CDC), and its peers; World Health Organization (WHO) no doubt has performed an average to above average job over the years. They have done this especially when it concerned cure, containment measurements, and implementation of safe guards issuing the following of proper protocol and information of diseases like HIV (Aids), Influenza, SARS, West Nile fever and the like. Of course, in the future tense of the right now, perhaps others will disagree because of ongoing situations concerning the deaths of loved ones from these diseases.

These deaths mentioned ranging from HIV up to West Nile fever and concerning other various strands of infectious disease like the Ebola virus etc. are quite staggering. However, Sin is the culprit here behind every disease, stemming from the beginning of time associated with the fall in the *Garden of Eden*, and its many deaths are superseding over and above. It is the original candidate as it relates to the *original sin* stemming from the, "back in the Adam and Eve days." Moreover, the world in which we are still living in is indeed fading away because of it.

It is true that God made, and makes no mistakes, when it comes to creation and our individual births whether we are born straight or gay, as I have heard others mention and swear by, but we are the ones who made the mistake of

turning our backs on a Holy God through our ancestors Adam and his wife, Eve. Because of this betrayal, our mistakes are still being made through our soul inheritance, even right now, today. Our mistakes are being made but at the same time, can be undone through faith in Jesus Christ. God did not make the mistake of creating us; we made the mistake of rebelling against God after being created by him. Through his Son, we can choose to fix what has been broken; we can choose him, to make the crooked straight again.

Listen up closely, just as with any surprise crisis, a blitz attack if you will, we as a health society have to learn by trial and error and sometimes we make mistakes. Now having said that statement my fellow homo sapiens (wise men), we must find ways to deal with mistakes and health threats better. In so doing we learn what not to do and then, what to do better as we go along. God has placed certain people in positions of leadership (I encourage them, whoever they are) within the confines of the health organizations to assist for the right now time being in order to sustain our overall health as a humanity, at least until he himself deems it necessary to turn the lights out for good. In addition, this action implements ultimately because the world has exhausted itself through *Original Sin*—which spawned all other sin after it and the enduring trials and tribulations we face during it; God doesn't grade on the curve, it is all sin.

For I speak of what I know, not only through common head knowledge as a mere man, bestowed upon me from the Lord, but also through the knowledge and wisdom of the heart, from God's word—Holy Bible—and yet also, because I've spent some time in the "secret chambers" of the Lord—the, *throne room of God.* Yes, the Holy Spirit has informed me of this as well. It is because of these gifts from the Lord, I make it a point to pay attention with my body, watch closely with my eyes and listen intently with my ears, as bits and pieces of information pass through the endless *oblivious horologic* of time and space, and this to include in real-time, earthly/revelatory/visional, and in dream-state. It covers both realms, spiritual and physical.

It is there, within that *right now* moment that my job is to intercept, analyze, and interpret said information and then piece it together like a puzzle. Is it always easy? The answer is hardly not, often, the challenge comes with, deciphering, filtering, dispensing and or, releasing, and withholding, said information and the times in which to do so. I thank God for the assistance from the Holy Spirit.

Listen, it is getting late my friends and, *the day of the Lord is near!* Yes, Jesus spent 40 days in that desert place and now he is leading us through it—if only we would, Follow His Lead. If only we would, Eat His Bread and His Fishes, we could become immune to the impeding and impending disaster, which will soon come upon this world, as we know it.

Again, the Holy Bible reads that the disciples wanted to send the crowds away so that they could go to the villages and buy food for themselves. The key words are, *they*, and, *themselves*. Beloved, and friends, let me just say to you that you and I need Christ! You see, no matter how perfect we may *think* we are or how imperfect we *know* we really are, perhaps in reverse order, we cannot do this present life thing on our own. I think it is safe to say, and I know that it is safe to say…we cannot buy this food on our own, amen.

You cannot find better *victuals* or provisions than what is *prepared for you*, and then what is *presented before you* or even *offered to you*, and then what is *given to you right* here from his word! It is spiritual food, amen! I must explain this truth! I must explain this truth with a passion burning within my heart. Now that passion was not always there, I can honestly say this to you but behold, for that passion is there, right now!

The disciples went through a passionate transition in their own lives also. Moreover, it was not by *luck* but by *love* that they experienced it. It is true beloved and friends. Let us look elsewhere in the Holy Bible and we will come to understand this a little more…

First, I want you to notice that Jesus' disciples had not the Holy Spirit in them at this particular moment. As far as their flesh is concerned, while unaware perhaps, it is taking over by wanting to turn the crowds away, and even while in the midst of Jesus. I want you to know something that is rarely over looked in the Holy Bible, but overlooked nonetheless, probably more than we know or care to realize. It is not until the day of Pentecost, in the book of, THE ACTS of the Apostles, that the Holy Ghost ignites like a stick of dynamite in a coalmine within the heart of the disciples. Yes, the Holy Spirit of God—driven by the, *Mighty Wind*, from his breath, and, *Tongues of Fire*, from his mouth—activated the disciples into administering faith in action and thus the *birth of the church* manifests.

This miraculous experience came out in their approach to the Gospel when explaining unnatural-supernatural experiences. These same experiences took place before the eyes of the spectators they were boldly preaching to, and in many languages no doubt. I must say, truly fascinating indeed…it is truly fascinating, agreed.

Sure the Holy Spirit visited the disciples at times don't get me wrong, and sure the Lord breathed on them at another time as depicted in the Gospel writings, again, don't get me wrong. However, what I am explaining to you here is this: The Holy Ghost did not take full effect in the apostles until the book of ACTS. Yes, this passion did not engulf them until the book of, THE ACTS of the Apostles. The Holy Spirit came upon them and they received power from on high, amen! Remember, Lieumas experienced this in the privacy of his study, and in his own life also. He experienced it

within a matter of a day even, and then he mysteriously disappeared only to later…just as mysteriously as the former, reappear!

"You see Mr. and Mrs. Peeples, and your entire family too, in the book of, THE ACTS of the Apostles, is where you will notice a distinct difference in our attitude, and in the different tongues concerning Jesus. However, right here in, The Gospel According to MATTHEW, we, the disciples, are saying to Jesus that he should send the crowds away to *buy* food for they, themselves, and that it is getting late! In other words, they do not stand a chance of satisfying their hunger unless they go and *purchase* food according to their own works and perhaps, their own will.

"Teacher we ask that you listen, for we cannot supply them with anything in this desolate place. We have nothing for them; we have absolutely nothing save for a little change I suppose," I said. "However, the disciples, including myself, are not seeing the bigger picture here in the marvelous works of our leader—yes even Jesus. Instead, we doubt him due to the current circumstances surrounding, well…us."

Again, beloved and friends, the disciples are saying the very words that brings with it, *ravens* and *vultures*. There is desolation and there is no hope for them, which equals gloom! Yes, send them to buy up some more food somewhere else, (apart from Christ), which equals doom! I am sure they were expressing somewhat of a sincere compassion for the people, no doubt about it!

Lieumas:
"We were."

Nevertheless, they were willing to throw in the white towel, and in an instant, too! They were willing to allow the crowds of people to just wave the white flag of surrender hanging their heads as they walk away, and give up on eating.

Lieumas:
"We disciples were willing to give up ourselves, but we would soon… *give up*, ourselves. We were indeed overwhelmed at this point."

Again, though, and I must continue going back to it. The disciples do not really understand what is about to take place and neither did me, myself, upon my reading it at first glance… They do not really understand the mind of Christ at this particular moment, and neither did I upon my studying it at first. However, after thinking deep, and then digging deeper, I understood on another level, a more interesting level, to put it mildly.

Jesus Christ is about to show us here in these pages, in these words,

and in these verses, his righteousness yet again... Follow me as we follow Lieumas inside, and then behind these next set of verses! Let us go in between them as we have done throughout the reading of this book. By now, I am convinced you are used to it at this stage of the game, amen. In verse 16, we can see the compassion continuing from Jesus as he feels that it is not necessary for the crowds to depart. Amen, amen, amen! Hear this word from the Lord as he writes it:

"But Je'-sus said unto them, They need not depart; Give ye them to eat." KJV

"In other words, Jesus says to us, his disciples... 'You feed them yourselves. You, my disciples, you feed them yourselves. They do not need to go somewhere else and buy food on their own and according to their own will. *It is free! It is now! For I have purchased it myself!* Sure it's getting late, and sure it's desolate here, but you feed them instead.' Jesus implies this in an attempt to encourage us as followers *of* him to accept his free offer of grace and have faith *in* him.

"However, the disciples and I would soon exclaim to Jesus that we had but only five loaves of bread and two fishes. We do this as if to say to Jesus, 'How can we do it? It is not nearly enough!' On the other hand, we do it as if to say, 'You must be kidding us right now; how this is even possible with this tiny amount of food!' Peeples family, we do not know?"

Yes beloved and friends, this they would soon imply as we watch this play out in verse 17, which reads:

"And they say unto him," speaking of the disciples, **"We have here but five loaves, and two fishes." KJV** Continuing in verse 18, Jesus says these words as recorded: **"He said, Bring them hither to me." KJV**

Again, he is speaking about the five loaves of bread and the two fishes, watch closely in verse 19, where it reads:

"And he commanded the multitude to sit down on the grass, and took the five loaves, and two fishes, and looking up to heaven, he blessed, and brake, and gave the loaves to *his* disciples, and the disciples to the multitude." KJV

Let us move forward with truth my beloved and friends. This truth shall soon liberate us. Indeed, somehow I feel as though it has liberated some of us already.

The Moment of Truth

As the ink dries from a pen's point
The message still continues to flow
It bleeds through the lines of shallow paper
Although, underneath its saturation tells of another story, also.

It's a story of intrigue producing blessings and favor
Favor from God, our Father in heaven
Moreover, blessings from Jesus, our Savior.

Like the waters edgy imagery atop
Giving off a distinct and clear view
It is also the image underneath the water
That surprisingly peaks our interest, too!

It draws us in to reach through its glistening surface
Breaking the plane which to some seems dead
But still alive, of this I am certain.

As we pierce through the shimmering curtain
As we drink from its glistening fountain
I detect a weak heartbeat but with a very strong pulse rate
A pulse beats red just beyond death's gate!

It is really the expressions of life
Beneath the surface that is true
However, these impressions bring to the surface, deeper truths of reality
Which come to life in what is really being said, too?!

Dear beloved, dear friends, God says to us that we must think on the things that he writes. He says that we must ponder the things that he reveals. Why is this so? It is so because his is a divine de'Script'ion where explanation goes beyond first glance. We look beneath the waters of the deep to find what has been hidden there. We stare into the distance, there, as if no bottom exists; we stand above the still waters of his pond, pondering while attempting to catch some of the fish found within the deep waters hidden within the word of God. These still waters, at times will become, suddenly, rushing water swirling from the supernatural churning of the Holy Spirit. This is what makes it serene; this is what makes it dynamic!

Let us examine the heart and soul—the diamond and pearl—of this story and its timeless message. Let us examine the intrinsic duality of this piece a bit more closely than we have been looking thus far just as I have promised, what say you? Let us all focus in on its shimmering light. Here is my version of how I *laissez les bons temps rouler* (let the good times roll), amen! Hear Lieumas (Luminous) as he is about to reveal what beautifully lay hidden beneath the glistening surface as I myself will back him up on it.

Lieumas will do this not of his own accord, but aided by the Holy Spirit instead, the Holy Ghost. Far is it from him to know anything outside of what the Lord's Intel to him in relation to *natural* things, and in revelation of *supernatural* things are, amen? Listen, for it is he who gives him gracious insight into his perfect Spirit and infallible word. Moreover, he who receives the glory from it, amen, is him.

Beloved, it is time for more levels of the instruction phase, amen. Friends, it is all about the *five* loaves of barley bread and *two* fishes right now; but is it really that way, spectators? This is our focus beloved, friends and spectators. Concerning the numbers and the lunch items, is this indeed the main focal point here lying before our very eyes? It may or may not be, to some of you, so please pay attention. It may seem a bit tricky at first but I assure you that it is nothing to be alarmed about, amen? In all humbleness and with genuine humility may I again say to you that according to Mr. Ettesorde, Almighty God, amen, has approved it? He has approved it and the back and forth messaging forward, as well as in reverse order backward, that it contains.

Now it brings Lieumas pure joy, I must say, to be able to translate this instructive portion of *his tale, God's message* and *their story* to you all, amen! "Let us begin by observing some things Peeples family both whom are *in* the church and who are *outside* the church, amen. To the spectators agnostically in limbo, or 'on the fence,' regarding God's word, perhaps you can get in on this as well. Now if you are successfully analyzing, you

notice something do you not. You do notice something, right? You notice there is a peculiar play on words here, correct!

"Concerning the five loaves of bread and the two fishes, we have been speaking about, amen; there is a peculiar play on words here. What is the peculiarity? Right you are. Even so, allow me to unpack some other items for you to shelve in the back of your gray matter (mind), and store within the chambers of your red muscle (heart), that some of you may have missed along the way elsewhere, amen!

"God not only deals in colors, he deals in numbers and the complex combinations of these numbers both, scientifically and spiritually, are endless! Not only that, but in their proper context, numbers have varying interpretations as well; it is exponential! Having said that, I will dispense to you what I have received in this particular season concerning scientific and spiritual numerical wordplay from the Holy Spirit! Be mindful, sometimes the duality of these numbers are productively (complimentary) overlapping and at times even, counter productive (contradicting) in the sense of opposing dualisms.

"Considering this, it was Jesus, and *not* June's mom who chose the number five as a number of significance. You see, June's mom, was consciously aware but intrinsically, unaware of her subconscious (having a mental, through engaging, activity of something without being aware, through consciousness, of the significant role it plays) actions as God was one step ahead of her in preparing lunch that special day, and with good reason. I say that because biblically or spiritually speaking, five has a distinct meaning behind the scientific principles of the number's basic and systematic meaning that we are all used to hearing, as well as knowing about.

"Five, in its operational, methodical and of course, scientific context, actually means the number of completeness did you know that. Did you hear that, amen? Yes, the number five is a systematic way of saying that something is complete; works of completion; having completed works. In other words, Peeples family, as a grace laden underpinning of our fallacies' it is a way of saying that a particular thing is finished, a type of finished work, if you will. Therefore, spiritually speaking, five is the number of *grace*; biblically defined as, *God's unmerited favor and gift to humanity.* I will explain more in-depth as we go along.

"Now, these five loaves of bread were all that the disciples, including myself, would ever need, again, because of the term, *complete*, and by God's *grace*, to which June had found in his sack lunch. Again, these were consciously prepared for him by his mom, and later on (subconsciously), for the multitude; remember! This same food is used

in order to begin feeding the crowds later that same evening, right. Again, five loaves of bread means the number of completeness and or, grace." Beloved and friends, the atmosphere is again quiet as though it is filled with crickets...

"Okay, let me illustrate to you in the physical sense as to make it have more clarity. Listen to me closely Mr. and Mrs. Peeples, as I will now ask you to detach yourselves from the bread for a brief moment, amen! Now that you are isolated from the bread portion, I will ask instead, that you focus on the number *five*, all by it self okay.

"You see, we as human beings created by God, have a total of five fingers right, well speaking technically, four fingers and one thumb? We as human beings created by God, also have five toes, amen? Quite interestingly, almost all amphibians, reptiles, mammals—the group to which we as human beings are said to belong—have five fingers and five toes did you know that? We have five fingers on each hand and we have five toes on each foot, amen? Five fingers on each hand are all we need.

"Think about this now because these extension components needed are for good reason. We need them to do something. What is it? What is your guess? The answer to that my beloved Peeples family is being, to do work with. Will you say it with me? 'It is to do work with, to do work with, and to do work with!' Yes! Amen! While speaking in general, this is what we need to operate at balanced levels.

"Now, think about this... Well, on the other hand—no pun intended—, perhaps it would be better if you did a self-demonstration of this instead. Yes, do these things for me very quickly instead would you, amen! Try, if you will, to grab or grasp hold of something with using all four fingers minus the thumb. What do you think? Is it a bit difficult to do without the use of your thumb?

"Okay so, now try doing the same thing while *using* your thumb. I know after having demonstrated it for me, myself, that it *is* indeed, difficult to do. However, it is a bit easier to do when utilizing all five fingers—thumb included. So it makes more sense to have this fifth extension component, which, again, would be the thumb in order to complete the grasping hold of something, amen? Now again, try it yourselves and you will find that you can obtain less of a strong grip without the thumb and maintain an even stronger grip with the use of the thumb.

"Continuing with the feet, notice that we also have five toes on each foot. By God's grace, five toes are all we need, again to do what! Do you have any guesses?" "I believe the answer is to walk with, Lieumas," says Mrs. Peeples. "That is correct; the answer is to walk with, to walk with, and to walk with! That is outstanding Mrs. Peeples, yes! Amen! Say it

with me, 'It is to walk with, to walk with, and to walk with!' We surely are making great progress!

"Again, another thought on this would be the usage of our big toe, which we use in aiding in the balancing of our bodies while being active in our everyday lives, amen. You see, while speaking in general, without that big toe being attached to our right and left foot, it would seemingly become easier to be knocked off balance by someone or something, or even while just being active in our everyday lives, amen? With the extension component that is our big toe, we find that balance has become a bit easier as we operate in our daily lives.

"So again, because of these two examples regarding our fingers, and toes, we have discovered that in these particular contexts', including the bread for example, the number five is the number of completion; of grace, yes. We do not need six fingers in which to grasp or to do the work with, and we do not need six toes to walk with, amen? We can do these things with only five fingers and five toes just fine, and God thought so too, amen! He even thought it *important* enough, *gracefully* and *completely* enough, to cast five *gifts* of office concerning church leadership—*five fold ministry*—operating in and for the body of Christ interestingly enough, amen!

"Okay, let us get back to the incorporating of the numbers with the lunch items again, in summarization, amen! The number five is the special number that we need because of its symbolism of completion and grace, and five loaves of bread is all you and I will ever need because God said that it is finished. Five loaves of bread was all the disciples and I ever needed from little June's sack lunch also because Jesus will proclaim these same words too, and soon. Are you with me so far? If you are, say yes! Amen!"
"Yes! Amen!" they all say in unison.

"Okay moving on, let us examine the two fishes! All we need is two fishes right? That's it! The number two is the number of witness! Yes, two symbolizes witness, amen! All that was in need of, from June's sack lunch was five loaves of bread, but for a specific reason. However, that was not all that his sack lunch consisted of. What else did June's mom place, in the sack lunch that his friend, July, tied a knot in Mr. Peeples? That is right! The answer is *two fishes*.

"So then, as it seems, when we put the two items, as a whole, together we come up with *one* of the most interesting, if not *the* most interesting number mentioned in all of the Holy Bible!" "What is this unique number, Luminous? Please, we want to know what the number is! We're excited to know!" said Nephew Peeples. "Well in my case, let me take it to a *non-professional* level of meteorological science in our explanation of things concerning this valuable combination, amen! We will get back to the

breakdown of the fishes and their special number shortly so stay close and alert for yourselves, and me.

"Now I want you to picture for me if you will, two different types of air and their flow, amen. One type is in the form of warm moist air, and the other type is in the form of cool dry air. I can tell that most of you already know where I'm going with this… Can you all say divergence meets convergence? Great, here we go then!

"You witness the meeting of these two types of air—warm-moist, cool-dry—as they collide and produce instability in the atmosphere. A centrifugal wind force in reverse order, rotating around and around occurs. There is a shift in wind direction and the speed of the wind increases exuberating velocity. The height of the directional wind tunnel manifests and creates a horizontal gyrating effect in the lower atmosphere. Beloved Peeples family, again picture this, the air, which rises within the updraft, tilts the spinning air from, once horizontal to now, vertical. This produces a sideways to upright motion. The result is a mighty tornado; it is a whirlwind having gale force speed!

"Now as this whirlwind manifests, you then witness the elements in the form of projectiles being sucked inward, spinning around and around upwards, and then dispelling outwards. These flying projectiles and or, debris occur, as the power from the whirlwind grows even more gargantuan and powerful by the minute. Next, you experience a gravitational pull, pulling from outward, and then moving at a rate of speed inward, and finally, formulating a powerful center force, but in reverse order—central force impacting outward. It would be kind of like emulating a turbo blower from within a *hot rod* or *muscle car's* engine compartment as it begins sucking in warm outside air through a tunnel or port, and then creating a powerful inward cool wind force within its engine. The result would be for generating a higher specific horsepower rating due to it keeping the engine at a cool safe level while operating during high rates of speed.

"However, in this tornado scenario, minus the hot rod scenario, the visual remains as one of a gravitational pull, pulling from outward, and then moving at a rate of speed inward, and finally, formulating a powerful center force, but in reverse order—central force impacting outward. The effects of this miraculous miracle in size, power, and grit, are fierce. It is fierce, in which it begins uprooting everything in its path… Mr. and Mrs. Peeples, that very interesting and authoritative biblical whirlwind of two numbers melding together as one mighty tornado of a number, drum roll please… It is the number, **VII**!

"Yes, this is where I would most certainly say that the bridge to the gap is crossed. Here we have two keys in the sense of one of these keys being

the number, *five*, and the other key being the number, *two*. Now then, many people end there because most people would not think deep and then, dig deeper into meshing the two keys together to form *one* final key; they end by just, thinking… They conclude with, that is all there is.

"However, we know better than that do we not? We like to think deep. We like to dig even deeper; we enjoy analyzing and drudging up detail after detail to work puzzles and enigmas, do we not? My friend's wife gets on him and me every single time about our wanting the details to something we think renders paying close and full attention to. Seriously, she is always teasing us about it but that is another story altogether yet, not so far removed from this one!

"Anyway, yes, as I was saying, having a two key combination of a single unified key is what we use to unlock the mystery of this story and its timeless message. This two key combination, and with its one final key component made manifest in the sense that $5 + 2 = 7$, is remarkable; it is *perfection*. The number seven in which we have discovered is the one final key that unlocks the door to the mystery that is *perfection*.

"Now, just idly holding the two keys in your possession is not nearly enough, but it is the usage of the two keys combined, which is the revelation we are after. It would be as like an engine that is running but not moving the hot rod because the tranny gear is disengaged. However, together when they are performed in action, they unlock the *mystery lock* that is perfection; the tranny gear is engaged therefore the engine moves the hot rod. More so, we find that the number 7 equates to not only completion, but also, God's grace with a 'kick!' It equates to a, whole-completion, which is an *anointed perfection* as is its biblical significance. Yes! Amen!

"Now if you are still scratching your heads because you may have heard many different interpretations of the number 7 (one being interpreted as being completion all by itself), let me just say something. Allow me to add this: I, as well as some of you, indeed *have* often heard that the number seven means completion, as its biblical symbolism and I will not dispute anyone over it. However, what I have come to discover, through the Holy Spirit, is that the number, Seven, establishes as one having a more powerful appeal to it, rather than just being simply complete in its meaning—a special and personal dispensation, if you will; perhaps in reverse order. More powerful than just being a completed or finished work of grace, but being a completed or finished work of grace with an added *risen anointed perfection* is once again, the revelation we are after, and I believe we have found it! It lays hidden beneath the still waters of the deep while I sat above the churning white water looking to catch some of its fish.

"Look at these following verses in-depth in, The First Book of Moses,

Called GENESIS, with me, amen! I want to show you, the Peeples family, what I am talking about, amen. I want to show all of you what I have been shown from the Holy Spirit, himself, myself. I'm sure many other ministers and saints of God have been shown this dispensation by him also, throughout many generations in the past; I just see it as being, well…my season to catch these fishes."

GENESIS 2:2:3, KJV
2) And on the seventh day God ended his work which he had made; and he rested on the seventh day from all his work which he had made. 3) And God blessed the seventh day, and sanctified it: because that in it he had rested from all his work which God created and made.

"Notice with me, the words: *seventh, day, ended* and *he, had, made.* These words indicate to us the leading up to the <u>completion</u> phase of the *created work* of God in the world and on the seventh day, rest, right. Indeed interesting at first glance but now, take notice of the words: *seventh, day, rested,* and *blessed* and even *sanctified* in this same passage of Scripture. These words also indicate to us, the <u>anointing</u> phase placed upon God's *completed work* of the world leading up to the seventh day, to which he rested afterwards, amen.

"Therefore, when analyzing Scripture verses set from the beginning of, The First Book of Moses, Called GENESIS, we see that God not only completed his work of two, out of three, distinct realms in the earth, they being of marine (fish) and air (fowl) on one hand. On the other hand, he commissioned the regenerative filling of the two species on the fifth day of creation. Also, notice something else. Take heed that on the sixth day, he also put forth this <u>continuum</u> of creating. He created land species (third realm) of animals, livestock, insects etc. to include Man, and commissioned these species, to include Man, to be regenerative and occupy or fill that to which he completely created by the fourth day.

"Scientifically speaking, four represents the four corners of the universe and created earth—North, South, East and West. The number six represents a type of continuum and symbolization to that of humankind being imperfect, however, made in the image of a perfect God through characteristics of conscience reasoning, creativeness, the many emotions etc. and rule; dominion over the earth, remember this, it is important. God was done creating by the seventh day and rested, but he indeed also blessed (set apart for sacred duty) the seventh day and sanctified it as well, bringing to it, <u>wholeness</u> in its <u>completion.</u> In other words, God not only completed and commissioned the filling of his work from day one

leading up to day seven, but he also anointed and sanctified his work on the seventh day.

"Now the word, *sanctify* means, *to cleanse or set apart for sacred use, to make holy.* Dear ones, the word, *blessed,* define as being, *praiseworthy or having divine favor.* Now please hear me, as this is important, remember; and try to understand this as well it's about to make a little more sense as it couples with the previous call of the important awareness of the number six.

"*Outside* of God's *ordained* work, things are sometimes complete but not whole (6), amen! However, *inside* of God's *divine* work, something that is complete also is always; made perfect in its completion (7), it is perfect, or completely whole. This symbolizes the rich ingredients *of,* and the rich ingredients *for,* the number seven, amen, PERFECTION! Seven is the representation of humanity redeemed and perfected through the only perfect one as seen in Jesus Christ; there is no other way; God foreseen this. One only needs to analyze and examine the Scriptures while being patient, thinking and allowing the Holy Spirit to assist in interpretation. In other words, still waters pondered become rushing waters, experienced. In doing these things, will *sight* become magnified into *insight.* My other brother, John taught me this as he raced our brother, Peter to the empty tomb. Some time in the future, please remind me to perhaps tell you about the experiences of how that whole thing with these two played out; quite interesting indeed."

Listen to me my beloved, my friends and spectators, too! Listen to me with an open heart, and listen closely. Do not allow closed-minded logic to play a role here, amen. I say this because the number seven is also a number interpreted by the world system as having the symbolism of luck; but we know better now, right. Again, I ask of you, open your heart to this story and your mind, to this timeless message. You will be glad you did.

In the word of God, his teachings about love are truly far more in-depth than the naked eye can see. In other words, to see beneath the heart of the surface, of what teaches above the surface of the mind, is a gift from God. It is a gift in a class all by itself, amen and hope *is* there to teach. It is a gift of discernment and interpretation from, not through our eyes as normally seen, but as seen through our blended mind and heart through faith, amen! It is a blended gift of *wisdom* and *knowledge* and even more importantly, it is a gift of *salvation* from God through his Son—Jesus Christ—accompanied by the Holy Spirit, yes! Amen!

To God is the glory given! Hallelujah! Here we have the one key from the two keys, which again, we use in unlocking the door to perfection, and perfection, we find only in the, *perfect 1*—the only one that *is* perfect. In

case you may have missed it, you will not miss it entirely because his name we mentioned repeatedly as it has been throughout the reading of this entire book. He is Jesus, the Messiah; the Anointed one; the Christ! Yes! Amen!

Jesus Christ is the one perfect being ever to have walked on the face of the earth did you know that? Jesus Christ is a product of God's love and perfection, and he is the Key to Life! He is all you need; he is all, I need. He is all the disciples and the crowd needed. Again, five loaves of bread equals a completed grace laden ingredient from which we are to eat. Now, let us revisit the fishes and the special number behind them, amen!

"Why were there, in this story, two fishes? Anyone wants to guess in this beloved Peeples family! No, there are no guesses from anyone? Well, that's okay I will answer it for you. Two fishes equal witness because of the Father and the Son, amen. The fishes, in and of themselves, does not mean witness but the number two, in the context of witness, is the revelation we are after, amen? The Father witnessed Jesus, the Savior. Remember there were clues to this given in the opening poem of chapter XII.

"All of you in the Peeples family listen to me, when the numbers, five and two combine, sure, it equals a perfect numeral seven, which again, in the worldview, construes as chance; the byproduct of *luck*. However, here also, we have perfection, which biblically speaking equals the number seven as well, but construes as grace; the byproduct of *love*. Now if I were a betting man, for whom I am not, I would most certainly place my chips on the biblical worldview and grace-laden message as being the true productive lifestyle, amen! It is eternal not temporal.

"The Father, the Son, and the Holy Spirit are no doubt in my mind, ONE PERFECTION. There is absolutely no doubt in my mind that because of his perfection, it takes the perfection off you and me; I admit, I am good only some of the time however, God is good all of the time. Now some people find this difficult to believe, especially amidst all the suffering in the world—the reality of God and his goodness overshadowing all that is bad—but it is true. Sure the world is poisoned I mean this is no secrete to us, and surely no secret to God. However, be mindful that God is in control and he works everything out for the better of those who love him, and whom he calls according to his purpose. He is not surprised by what is happening in the world right now, he was aware since before he set time into motion. In addition, there is this: for those who are asking the question of why is there so much hate and violence in the world…we have so much hatred and violence because of the world's fallen nature. Just as the bowling ball is set into motion after being released by its *handler*, it too must run its course striking the pins at or better stated, in the end. Some will be left happily standing while sadly for others, they will fall.

"Listen very closely okay. Believe me, by the time we are done here a high percentage of you are going to want to get in on this, amen. Here it is! I am not perfect and you are not perfect; for some…this is a wake-up call I know. Moreover, my brothers, the disciples, were not perfect either, apart from Christ. However, the Holy Trinity and the dynamics thereof are indeed divine in nature; they *are* perfect, all by himself! Again, five loaves of barley bread (barley symbolizes lowly as opposed to being highly in status) and two fishes is what we are working with at this point and we needed to eat from them both. Watch again, what Jesus does with these food items is a *complete* miracle. Watch closely…"

Beloved and friends, allow me to politely interrupt here. Thanks Lieumas. Jesus takes the five loaves of bread and two fishes, looks up toward heaven and asks for God's blessing on the food. Wait a minute! Stop right there! Listen to this; God's blessing was that he broke Jesus Christ into pieces. Hold on, now God did not do this physically but spiritually instead, amen. I say, "spiritually instead," because the Holy Bible clearly teaches us that the bones of Jesus were not broken that day as he hung on the cross. His legs were not broken. Although the two thieves who were hanging on those crosses next to him suffered broken legs themselves, the legs of Jesus who hung in the *center of the two thieves* were not broken. Look at how it presents itself in this next Bible verse:

Then came the soldiers, and brake the legs of the first, and of the other which was crucified with him. But when they came to Je'-sus, and saw that he was dead already, they brake not his legs: —JOHN 19:32:33, KJV

Therefore, we can see that Jesus Christ suffered a broken spirit as well as his torn flesh, and not broken legs, amen. To suffer broken legs meant, by the way, that anyone whose legs were broken while hanging upon the cross, well, it expedited their death sentence. This action expedited their deaths because they were unable to use their legs for the strength and support it would take in the ability of holding themselves up any longer than they anticipated.

Instead, the lungs of the victim hanging on the cross would suffer collapse quicker than normal. Collapse of the lungs would be quicker because of the limited usage of their legs being used to hold one's own self up longer in order to prolong his or her breathing through a supportive posture. Therefore, dear beloved and friends, by this we call it the breaking (spirit-flesh) of the bread, again…why? The answer is because Jesus Christ is the *True Bread* from heaven. He is the *Bread of Life!*

Wait a minute this just in; The Spirit of the Lord just informed me that he would not leave you hanging. Just as the two thieves hanging on those crosses had a choice and only one from the two took advantage of choosing life over death, you too, can make that same choice, or not, just as the other thief who chose not. Here is Jesus himself revealing this miraculous truth of which he is himself. This record is truth indeed, amen. Hear this word from the Lord as he writes:

And Je'-sus said unto them, I am the bread of life: he that cometh to me shall never hunger; and he that believeth on me shall never thirst. —JOHN 6:35, KJV

Therefore, we see that his blood covered body hung on that cross, and while hanging on that cross, his spirit was broken for you and me. His flesh used for bread and his blood used for drinking; his entire body used for our consumption through his death. Again, my beloved, my friends, leaders, you the public and saints of God, his bones were not broken but his spirit was, his flesh too, amen? That is why he cried out in the following verse:

And about the ninth hour Je'-sus cried with a loud voice, saying, E'-li, E'-li, la'-ma sa bach'-tha-ni? that is to say, My God, my God, why hast thou forsaken me? —MATTHEW 27:46, KJV

"Continuing on, the Holy Bible teaches us that Jesus gave some of the bread and fishes to us, his disciples, right. Now Peeples family, let us look more closely at this because we are indeed still piecing this puzzle together. Can you say it with me, yes, amen?

"Let us go back to the fishes but this time, detaching ourselves from the number two surrounding the fishes for a moment. Let us attempt to understand more of what the fishes mean to us symbolically shall we! Any guesses." "Evangelism?" shouts Niece Peeples. "That is correct Niece Peeples; it is just as you say. It is definitely a symbol of evangelism. Do you remember in one of our truth discussion sessions, when Jesus told his disciples that they would be fishers of men? Well it's true, as we read in this next verse of MATTHEW 4:19, KJV."

"And he saith unto them, Follow me, and I will make you fishers of men." KJV

"Again, by this we know that fishes are the symbol of evangelism as told by Jesus that we would be, fishers of men. Therefore, fishing for men was our assignment, amen. Interestingly enough, it was our assignment in

a *two and two* mission, which would suggest that we enter into the, number *two* fish market or, battle arena, once more for witness, amen. Watch how Jesus sends another seventy, to seventy-two, disciples out. He sends them off after by which he commissions them to go forth preaching to cities and towns before Jesus, himself, arrives there. I attached myself, like a twin, to the hip of one of my cohorts; one of these *messenger* disciples as we journeyed forth:"

LUKE 10:1, KJV
After these things the Lord appointed other seventy also, and sent them two and two before his face into every city and place, whither he himself would come. KJV

Beloved and friends, this, I believe, was a system of protection set up for exactly that, protection for these disciples and Lieumas, also. It was protection from the wolves lurking about in order to cause disruption in God's strategic plan for administering the Gospel. This based upon our examination of verse 3 of LUKE chapter 10, KJV. It states:

"Go your ways: behold, I send you forth as lambs among wolves." KJV

Therefore, you see, if attacks from opposing forces threatened the two messengers, well then, the two of them could easily defend themselves against said opposing forces, amen! They could accomplish this feat together as opposed to being alone in facing these wolves. The two could fend off these predators because both of their minds, hearts and physical strength could be used as one.

Again, in summary, we have discovered that we have a witness because of the *two* fishes right. We have a witness found in the Father, and the Son, as well as in the disciples going out evangelizing in pairs of two bound by the visiting Holy Spirit. However, that is not all dear ones, there is more… The two fishes are also, a symbol for meat, yes, meat; did you know that? That is okay; I did not know that at first glance either. That is why, when tapping into the Holy Spirit, studying and researching the Holy Scriptures well, we become hopeful; it becomes refreshing. Yes, it is exhilarating and so very intriguing, and important for our learning, amen.

You see, the five loaves of bread is a symbol of the Lord's spirit and flesh being broken on that old rugged cross and that is all they needed. That is all they needed, completeness and grace (5) found only in him, Jesus Christ. The two fishes on the other hand, which is the *meat* of God's word that you eat from, which is his Holy Bible, is also what we discovered

early on in the opening of chapters I, II, and III, and interestingly enough, myself discovering this, unaware, throughout the writings of this present chapter, XIII, amen!

How awesome is that! Bless you Lord, for every word that comes out of your mouth is that of the Holy Bible, and confirmed, and affirmed by the Holy Spirit. The *truth* to which we must feed on is priceless. Thank you Jesus, for you made this known to us in, and through, your word as you were cooking *fish* of your own with a charcoal fire one faithful morning for future Lieumas, and some of your other disciples, Peter included, in that present day. You also had *bread* of your own with the *fish* that you gave to them in the breakfast you *shared* with them that same faithful morning along the beachhead. It truly is All About You, and we have the opportunity, Lieumas included, to be partakers in this great truth and exciting journey.

Moving right along beloved and friends, yes, and evangelism, which is from the *two fishes*, and also to symbolize a *two and two* system of outreach as they were sent out by Jesus in *two's*, is what we have also discovered. Now, as we put both of these numbers together we get the number **VII** which equates biblically as a symbol of PERFECTION—an anointed completed work of grace sent forth by God through his Son, to live, die and rise again—this also, we have come to discover, amen? I know this might be repetitive but I am only trying to get you to understand dear ones and so, that is all that *was*, and all that *is*, needed, and it is perfect. It is a perfect blessing and a perfect plan from God the Father, and from his Christ, let us all continue onward.

Now, we find that Jesus gave some of the bread and fish to each of the disciples, and then the disciples in turn gave them to the people. What did the disciples do next my dear ones? Friends, what did they do? What did they do? I will tell you what they did… They distributed the, *soon to come*, Gospel to the people! Yes! Amen! Again, they distributed the *would be* Gospel to the crowds of people as Jesus Christ was preparing their hearts and showing his disciples, and them—the crowd—back then, what would come to pass for us as a reality soon, yes even right now, today! Yes! Amen!

Jesus, by way of the Holy Spirit, says to me in this very moment, he says, "You give them food, from me. Give them the bread and the fishes from me. Give them perfection from me, from me, from me. You give them food from me, you feed them." He says these words to me.

Okay, so verse 20 teaches us some interesting things as well. It teaches us this: the *Twelve* even picked up twelve baskets of leftovers for themselves, afterwards. Now the Bible, in reverse order, teaches us that the crowds of people ate as much as they wanted; they did all eat, and were filled, and

going forward again by teaching that they, the *Twelve*, even picked up twelve baskets of leftovers for themselves, afterwards; they took up the fragments that remained twelve baskets full, amen! By this, we can see God's grace pouring through as the crowds ate as much as they wanted, over, and over, and over again, and the disciples were not left without. God's grace is, and God's grace was, and God's grace will continue to go out repeatedly and over again, and that is what is happening here. That is what is happening even right now—today with God's people and his church leaders, as well. Beloved, that is what will be happening in the future in the days to come. It is astounding is it not? Are you excited as I Am!

Hear me beloved, now think this through, why did I say, over, and over, and over again? The reason for my excitement and my joy is that the Holy Bible teaches us that the people all ate as much as they wanted, and the twelve disciples of Jesus Christ picked up twelve baskets of leftovers for themselves. Therefore, you see, Jesus Christ had just that much of himself to give to each one of them that day, and then some. This includes you and me, today also, amen! Some of us just have to *want* it, and others of us just have to want to *give* it, amen?

I am also more excited to have discovered that the relevance behind this revealed truth is that the number *Twelve* (12) is significant as well. Now, let us, all of us calm down for a minute, although I fully understand your excitement from all this fresh learning and insight, I guess you *are* all excited as I am. Now then, I will explain. Let us dissect the natural, to unnatural, to natural again, to supernatural, spiritual meaning of the biblical aspect of the number twelve. Any guesses. It is symbolic of what! The answer is balance; government; order, structure… God's grace is sufficient. Yes! Amen! God is one of structure… He is the government. The government will rest on his shoulders. The Holy Bible teaches us this in, The Book of the Prophet ISAIAH.

Now, God's grace pours out repeatedly because the people had eaten from the five loaves of bread and the two fishes that the disciples had distributed. They received from the hands of their Leader and Master, Jesus, after which was offered to him in miniscule from a little boy's hands passing through the adult man's hands of this disciple commissioned from Jesus, Andrew. His tiny, but powerful, faith in God for the miraculous to occur manifested exponentially.

However, that is not all dear ones. Also, the twelve disciples, including Lieumas, who *ran* with the Twelve and eventually ate from them as well, had *twelve* baskets of leftovers given to them from the *five* loaves of bread and *two* fishes, equaling the number *seven*, who is a depiction— symbolically—of Jesus Christ, himself. It was done so that his disciples;

apostles; messengers would not be without, too, after having fed so many people!

This miracle was manifested because about five thousand men had eaten from the five loaves of bread and two fishes that the disciples, apostles, under shepherds, distributed. If that was not enough, this miracle poured over unto the women and children so that they also ate of this miraculous food, as well. Yes! This is so great and magnificent! God's grace never runs out do you hear me! God's grace is sufficient do you hear me! The eternal kingdom; government rests upon his shoulders, amen.

Jesus Christ's body was broken on that cross (in the form of his spirit, flesh and in death) and he is the bread of heaven. He is the food; he is the food. Jesus is the Bread of Life! He says to go out and make disciples of all men baptizing them in the name of the Father, the Son and the Holy Spirit through what! Yes, the answer is through the regeneration of his word dear ones. Through the washing of pure water, his word, Jesus, the Christ, is Perfection in every way imaginable, and why! It is because he lives!

Jesus' body was broken up on that cross (in the form of his spirit, flesh and in death) for you and I, and that is all that we need. Five loaves of bread and two fishes equals the message of grace and evangelism; it equals the meat of God's word. Five plus two equals seven; Perfection. Jesus Christ is perfect in everyway. May we all *rest* in perfection whose name is Jesus Christ, amen. May we all become *complete* not in ourselves, but in Christ instead, amen? May we all become *perfect* in Christ Jesus, even in our human imperfections and limitations that *we all* have, amen?

Now, forgive me but I have to utilize horology in reverse order, and go back in time a little bit and ask you a question. Have you ever noticed how God's grace never runs out? As I said earlier, it depicts in verse 20, where it says:

"And they did all eat, and were filled: and they took up of the fragments that remained twelve baskets full." KJV

Again have you ever wondered how that plays out in other circumstances in everyday life—even your own life? Oh the beauty of God's multifaceted word, amen. Let me ask you this: Did you think about that during our last few moments? Remember the moment during our brief encounter with the twelve leftover baskets of food. Are you scratching your head perhaps? Well please allow me to explain some other things to you, amen?

When the leadership who sits under God's rule and instruction gives a word, when the leadership teaches from the Holy Bible, when the leadership conveys a message, it means something more; it suggests something more

profoundly rich and deeper. The message is structured in a way for us to ponder because of its depth. Beloved, we must meditate on it; we must weigh it, amen?

God's word alone, my friends, in private time and or, in personal devotion to the Lord, we must weigh, we must ponder, we must meditate on, amen! Just that quick, as like the snapping sound a thumb echoes as it makes contact with the middle finger, like the "snap heard around the world" from Jesus breaking the bread, yes, from one verse we find that God's grace continues to pour out; we continue to eat of it! It perpetuates and flourishes. It shines light throughout the inner to outer bands of our mind, heart, body, soul, and spirit—the essence of our being!

It is true because what you learned in that exact moment from your Bible instructor, and even yourself, through the counsel from the Holy Spirit may come to realization and fruition, in full for you the next week! What you learned in that exact moment, *here it comes*; in a matter of a month, *here it is*; that same verse that you looked at a month prior may have a certain tweak or adjustment in the verse itself. It may have a different meaning fitting the situation, or circumstance that you may find yourself in like, right now! It will seem fitting for that very moment and unlike last month, unlike last week and everywhere else, in between where it did not seem fitting at all, or a partial understanding you were left with, it will fit right into place. Do you follow me?

These results in giving you balance, amen. This spiritual and vibratory twang results in giving you structure in your life, and can lead you to other passages of Scripture as well. Twelve, count them…twelve baskets of leftovers are what is blessing those who indulge in the feasting thereof, this to include the leadership, amen? They will not do without, even after the distribution of God's word; they too, will be replenished from the leftovers. God's grace is beautiful and God, himself, is beautiful. Hear me; hear me! Beloved and friends, you have to hear this truth! Believing this truth is necessary! Like I mentioned earlier, you are definitely going to want to get in on this, if not now then I pray, someday.

Jesus says, "You feed the people; they do not need to go somewhere else." He says, "You do it." Listen to me because the Lord is speaking to some of us as church leaders! He is saying right now in this moment, "Feed my people; feed my flock. You feed them! You do it, by my power, my Spirit." He says, "You feed them by my Spirit of perfection. Do it by my completed word. Yes, you do it in order that they are not left behind in this desolate place and left alone within their desolate souls." Jesus says, "Because of the fact that time is running out and it is getting late, you feed them…but use me to do it! Use my word and my Spirit to do it!"

In Jesus' name Father God, help me in order that I may convey your message accurately and that I may feed your people successfully. Yes, dear Lord, I ask this of you, that you might help me to help them understand this truth and thus partake in eating from it. Bless me in order that I may feed your sheep and that they may learn of you, and that others may learn more of you, and learn more about you. O, I give glory to the living God! I cry out to you! Yes, and help me teach truth so that others who know you not (goats) may come to find you, Lord Jesus, as their *Personal Savior* (sheep) and as their very *Special King* from these words integrated with your words, and your Word. O, I pray this in Jesus' mighty name! Amen.

They need you Lord! Yes, open their hearts Father God to receive this information and message. Moreover, open the mind of others Lord God that they may learn more about you and your grace, for it is sufficient, and you are approachable! God, do not leave them here alone but use us leaders to feed them, and use me, as a *called* apostolic church leader personally *chosen*, and specially *designed*, and directly *sent* from you, to feed, and guide and protect them. Father for it is your love and your compassion that, like a stick of dynamite in a coalmine, ignites within me, within my heart just as it did with my brothers in Acts...

Lord for it is indeed your Spirit that compels me, *write-now*, and encourages me to speak about things of this nature, and to speak of it for your glory! Despite what others may think about me, I have done this at your command and not of my own accord. Oh, I gracefully imply that those others you have called would be inspired to go forth in your name too, Hallelujah! May they also be encouraged to advance in this charge to victory!

"You feed them through us," God says to me. I believe he associates the word *us* with the Holy Trinity found in the Father, the Son, and the Holy Ghost, for they are ONE! The Oneness of *Them* that experience in me because of his Spirit living within me is unfathomable, but true nonetheless.

He lives in some of you, too. He wants to live in others of you, as well. Yes, hear these words from the Lord just as I have received them, and continue to receive them from him, for I did not make this up. "Give me the five loaves that's all I need; my body—the bread. The two fishes for evangelism and meat is what I will use to bless them from the Father. Yes, give me the meat of the word that they may learn through the meat of the word as I present it back to you to distribute, to them."

Some, Lord, may still be on baby's milk as baby Christians. What is it that I am to do about them? "Give them the growth first from the milk of the word. Next, help them progress in the word through the meat." These

are words, the Lord says to me. O, I ask in Jesus' name, that you continue to use me to give them the growth that they need through the milk, and through the meat that they may learn more about your grace. Your mercy and grace is sufficient and it is perfect! For you are Perfection and that is all they need, You, Jesus Christ. Bless them Lord Jesus. Bless them, bless them, bless them, bless them, bless them Lord.

Your words are indeed powerful Lord God. For when we meditate on your word and learn more of you through your Spirit, you distribute more grace upon us O Lord God. You give us balance; you give us structure in our lives. For this, we thank you Lord. We thank you Lord. We thank you Lord. We love you Lord! Amen.

Friends, and spectators, come to Christ because it is getting late and we are in the last hour...we are in the last hour! The Lord says to me these powerful words, "Watch your clock!" This place is desolate and it is true that God will not have you leave unless you are in him and he is in you, but you have to want it. Moreover, your souls are left, desolate without him living in your heart; you have to know this. He loves you so much that his desire for you is to allow him to live in your heart. It is true, and that is why he says to us... "Church leaders, it is of my command but, through your choice that you feed them... So I ask that you do not be afraid and that you feed them indeed."

Beloved, just like that, over five thousand men, women, and children are blessed. Friends, just like that, they receive blessings from the combination of the five loaves of bread, and the two fishes. Spectators, this is the miracle that Jesus presented to God for his blessing to occur, this blessing equating to, **VII**.

Jesus Christ demonstrated do not do it, do not send them away but instead, give me the food. Give me the food and I will show you what to do with it, and so the disciples receive blessings that day, as well. You see, for it all points to Jesus Christ; do you see that? It really does not matter how you divide the garments up at all—pun intended—it still all points to Jesus Christ, the Son of the Living God!

Spectators and friends do not make the mistake of staying here in this desolate place any longer. Do not do that to your soul. Your soul cannot survive in this very dry climate without the proper diet; the balance of food, and water found in God, Jesus Christ, and his Holy Spirit integrated into ONE for our Salvation. It is true... It is true because it is, Truth. Beloved, you very well know this. However, please make a commitment to feast heavily upon the word that you may grow up healthy and strong in the Lord.

Now, although this is a timeless message, it is a message that is timely as it is indeed time sensitive nonetheless. Seek Christ; cling to Christ.

Yes, seek him; seek his face. Seek his grace for he will not turn you away; I promise. Seek his face now so that you can see him face to face in the future.

Please hear me when I say that food and water may not be so easy to come by in the days ahead, and in fact, in some areas of the world, these victuals are not easy to come by, even right now. I will say this though, food and water from Jesus Christ and his word will surely be available, and through prayer even—verbally and mentally—until the very end of days as we know it, and even beyond in the *new world* to come, as we will soon come to know it.

Listen, the world is on the brink of collapse even though there are still powerful occurrences of God's mercy and grace that is pouring out upon *believers* as well as *non-believers*. You can be sure that a minimum of one soul *was* saved today for no day is a lost cause. However, this world is not our home and it will surely implode, it is inevitable and it is biblical, too! Moreover, it is only physical, and temporal, as opposed to the new world to come, which is eternal. The new world to come will be a world of spiritual and eternal beauty from our Great God, Jesus Christ, amen. He promised that it would be nothing like what we have seen in the past, as well as what we see right now, today and you know what! I believe him; eventually, *Twin*, did also.

Listen again, Jesus died upon that cross for you and for me. Three days later, he rose from the dead onto New Life by the mighty power of the Holy Ghost from up above. Again, he has done this for you and for me. Moreover, that same Holy Spirit can now live in you, as he does in others like me. Better yet, he can raise you up to live forever and ever with God, like others and me. Even by that same power, which is the Holy Spirit, this too can happen to you. Listen do not be afraid, for your sins can be done away with. Your sin conscience slate can be wiped clean; is that not incredible! For in the Holy Bible it is written in JOHN 3:16:17, KJV:

"For God so loved the world, that he gave his only begotten Son, that whosoever believeth in him should not perish, but have everlasting life." KJV

"For God sent not his Son into the world to condemn the world; but that the world through him might be saved." KJV

I know he is talking to you in these Scripture verses. I know because he was talking to me when he told me to place my own name in front of this very same verse of JOHN 3:16. So I ask some of you reading the very book

you are holding in your hands right now, Are you believing Jesus to be the only begotten Son of God who died for you? Wait do not answer just yet!

ROMANS 10:9:10, KJV, record these words as well:

"That if thou shalt confess with thy mouth the Lord Je'-sus, and shalt believe in thine heart that God hath raised him from the dead, thou shalt be saved." KJV

"For with the heart man believeth unto righteousness; and with the mouth confession is made unto salvation." KJV

So now, I ask this of you as well: "Do you believe that God raised Jesus from the dead so that he can give you eternal life? Without the risen Lord what we are left with, is death. Death remains who we are because he himself would be dead and we can receive no promises from the dead." O, bless you for confessing Jesus as Lord. Yes, thank you for also believing in your heart that Jesus is alive and well. Thank you for your penance and opening up your hearts because it is not *idly* knowing in your mind or even just *vainly* stating that Jesus is the Son of God, but rather that in your heart you take *action* in receiving him by faith, and with the mouth, earnestly confess him as the Son of God. Again, by this, you have decided to turn away from Sin through repentance and trust him to lead you by faith, amen!

For those who have not yet confessed with your mouth that Jesus is Lord, and believed in your heart that God raised him from the dead, please accept in your mind this truth of the cross by which Jesus died for you. Receive in your heart, by faith, that God raised Jesus from the dead so that you, too, could have life in him, and then trust him as you live sin free! Yes, begin trusting and following Jesus Christ right now, today. Do this because he is the Cure for Original Sin and all other sins spawned after it. Begin trusting unless you remain comfortable with verse 20, of JOHN 3, which states:

"For every one that doeth evil hateth the light, neither cometh to the light, lest his deeds should be reproved." KJV

I will have more on that another time.

Listen I know that this may sound a bit cliché but, it is not by coincidence that you have this book in your possession to help you along in following the Holy Bible written by God through his apostles and prophets. By doing this you have decided to take a step in becoming a *born again* believer or

at best, explore the evidence of who he is more so than before, and this until you become a *born again* believer—I am confident in knowing this will happen. Know that he lives in me and therefore he can live in you, too!

I beseech you brethren; rejoice now that you can rely upon him as the living God that he truly is since attaining salvation. He is the *risen* Savior of the world, and particularly of those who believe in him. Do you hear me; are you listening naysayers? Time is of the essence and it is getting late... Watch your clock; remember!

Do not miss out on this opportunity to eat as much as you want. Listen closely and I will tell you something else... Are you ready? Jesus Christ wants you to ingest him. Yes, he wants you to ingest his word written by God, the Father. He wants you to ingest his food; the bread, the fishes; him; his body, the Righteous One.

The word, *ingest* means, *to take in by mouth*. He says to feed on every word of God. He says eat of me and he says drink of me. My body and my blood I gave for you, he says to us. My flesh and blood is for you to consume, he says to us. Consume my death in the form of my body and my blood as you, yourselves, die to self, which is deemed as *selfishness*. Then drink my Living Water as you receive New Life from my Spirit, and allow him to guide you through his counsel, this is deemed as *selflessness*.

Please do not attach, in reverse order, from his manner of words. Friends, many people turned away from Jesus because of his style of words used in explaining *truth*. Make no mistake about it; Jesus Christ is the *real thing*. He is the real deal, the manna from heaven, the *manna—unexpected blessings and miraculous providence*—from heaven, so eat of him.

Listen; there are many who suggest that they are good enough to survive these current conditions on their own. They mention this because they somehow think that they are obeying the Ten Commandments, but I say to them that they are not, they cannot...it is impossible. Others suggest that they aren't good enough for God's love because society dictates to them that they are worthless. God suggests that we are not worthy but worth it; we are imperfect, just as I stated before as a human race, but Jesus, the *Lamb of God*, is perfect and acts as our scapegoat into heaven; in him, there has been a changing of the guard; with God all things are possible. Let him be that scapegoat for you, and that guard for you, as you ingest him. Do this so that he may clean your hearts out because of it. Yes, let him clean up your insides in order that your outsides may follow suit and become clean as well.

Some of you are thinking, and perhaps even saying, that you have committed horrible and sinful deeds and in no way are you acceptable to God because of it. However, I say to you that you cannot be good enough

for salvation to come to you. Only Jesus Christ was good enough, for he was perfect. He was indeed the perfect sacrifice. Please hear my testimony: "Salvation did not come to me because of how good or perfect I was… no, hear me, salvation came to me because of how good and Perfect Jesus Christ was, and is—even until this day. Now, my many imperfections lay beautifully hidden in his one Perfection because I have put my faith and I have put my trust in him." Now that is living! On the other hand, is it really…you know, living? Finally, I can truly say this… It Truly Is Living!

See, for there is no longer the question of, "Or is it," any more. Will you do the same? Will you eat the *Five Loaves of Bread* and the *Two Fishes* from the Lord? Will you ingest him as the combination of the two miracles (divergence), comes together (convergence), as One Miracle (manna), found in him? Yes, eat as much as you want through the power of the person of the Holy Spirit who lives in you; who wants to live in you. Yes, let it multiply over and repeatedly in your life as much as you want to eat of him.

To the "true leaders" of the Church set apart by God, continue to distribute the Good News—Gospel Message of Jesus Christ and gather up the twelve baskets of leftovers that will be waiting for you when you have finished feeding the flock (s) of God. Because of this, you and I will never be without his Knowledge and Wisdom, amen! Thank you Lord! Thank you Lord! We love you Lord and we bless you Lord, in Jesus' name. In Jesus' name, we thank you. Thank you. Yes! Amen!

For those many of you who, at this point in life, have accepted this truth, and as a result received the Lord, Jesus Christ, by faith, please, more of this Tale, Message and Story await your exploration. There is quite a bit more to uncover. Others of you, who have not done so, please, do continue also, for there is not much left but just bear with Lieumas and myself a little longer. Perhaps before the day is spent, you will be inspired enough to die to self also and as a result, acquire life in Christ, just the same! Oh, by the way, did you all bring your rock climbing gear?

Following the Bread Crumbs

Up ahead I can see it standing out against the grass
It is the size of a mustard seed I cannot go past
I must pick it up for it looks to be dropped there for me
Perhaps to enable me to see what I cannot otherwise see.

I see a way home no doubt, as I store them in my pocket
Follow me from end, to beginning, back to end
As we put the pieces all together
Then store away and lock it.

Lock it in our hearts where it now resides
For we made it with his help
We are surely home again
For we made it with his help
As his Spirit compels us and acts as our guide.

"Now to the entire Peeples family, I am of the personal opinion that there are times in which God, in his Sovereignty, may at times allow certain things to happen in our lives without actually orchestrating or causing it to happen. Sure, it is true that we live in a fallen world right now however; there are times in which God may cause things to happen in our lives as well despite, this present fallen condition that the world finds in itself. Although he may not have orchestrated it firsthand, it may very well be that God allowed it in order for us, in our freedom to choose, to draw nearer to him.

"Even so, some may even use this and freely, further the distance between they themselves, and God perhaps, because they are angered or frightened by the things which God allows or even causes in the first place. However, in hindsight, all things, which God orchestrates, or even allows

apart from orchestrating some of these things he, himself, firsthand, but allowed, by him anyway, he motivates by his *love* for us. You see, *luck* or lack thereof, has nothing to do with it. Allow me to elaborate further as I explain in the following paragraphs.

"Now, climbing a little bit higher on this mountain, there are times in which I also believe that God, through *determinism*, may also cause things to happen in our lives that he does for the same reasons I laid out previously. In addition to that, some may even use this as a failed opportunity to draw close to God. They may instead, continue to separate themselves further and further from him. Now is freewill/choice a major factor in both instances? I believe the answer to that question is, yes, it is.

"You see, God has been in it from the beginning to the end, back to the beginning and back to the end again in reverse order, and everywhere in between. Again, he is not surprised by any of what is going on in the world today. He has allowed some things to happen for the intent to rescue us *from ourselves* and thus run the risk of our suffering eternal separation from him. Moreover, he has caused some things to happen with the intent to rescue us *from others* so that we would remain in a *healthy* relationship of oneness with him.

"He has done this for the reshaping and remolding of us so that we *bite* down and remain strong as we journey to a state of existence with him eternally, and without becoming sidetracked so often during our sojourn and resisting our pursuing assailants. He has even allowed, or even caused us suffering in order to discipline us and even to make us stronger in regards to our faith, therefore we need not be ashamed. He even teaches us this in, The Epistle of Paul the Apostle to the ROMANS. Here it is just as he writes it in ROMANS 5:3-5, KJV:

"And not only *so*, but we glory in tribulations also: knowing that tribulation worketh patience; And patience, experience; and experience, hope: And hope maketh not ashamed; because the love of God is shed abroad in our hearts by the Holy Ghost which is given unto us."

He also has caused for, and or, allowed us to have great joy in our lives too, in order that we remember his love for us as his own children; both instances are indeed interchangeable and give us balance in our minds and hearts.

"Some things have humbled us and others have caused us not to forget who he is in our lives. You see, if we never experience trials and tribulations, we would eventually forget about God altogether; or at best, slowly, but surely. However, it is because of these trials and tribulations that

we can turn to God for relief and counsel; that we can return to him as he welcomes us with open arms and compassion; as he welcomes us home. He does this to us even as non-believers too, acting out in hindsight in order that we become true believers as he acts out in foresight, even while pushing us to the brink of a *thing*.

"Listen to me very closely, allowing Jesus Christ to hear your mistakes, 'opens up' his invitation to, and for you, to cast your cares upon him. Do not be afraid by assuming that he will reject you because of the mistakes you have made. Mistakes are conduits and catalysts that have the potential, and opportunity to lead to teachable moments and learning curves, and he knows that. Do not forget what so many fail to remember…Jesus' compassion and ability to forgive. My brother, Peter, makes mention of the caregiver that Jesus is in one of his letters-epistles to the church.

"Think about this as well, if only good things happen to us as Christians, then all would be turning to God in order to capitalize on these good and wonderful things. It would constitute a sense of falseness in our search for a Savior—superficial actions. Knowing that suffering comes with the territory as our Savior suffered, and trusting God regardless of said suffering constitutes a sincere heart before Almighty God.

"Then there is this: suffering for being a Christian is the Christian way; we should not let that deter us. For just as our Lord and Savior suffered as the *Suffering Servant* so shall we suffer from time to time. We do not have to be *happy* 'about' our suffering but we can find *joy* 'in' our suffering; my hope is that you find *solace* 'from' that.

"It is because he is the Alpha and the Omega that he knows the beginning from the end, even in reverse order and therefore, has already mapped our lives out for us. It is true in the writing of his Holy Bible, too! However again, for some it is as if it is difficult to read or gather knowledge from for the average person because it seems to go back and forth and back again towards the middle, and may become very confusing. This, I have heard with mine own ears from individuals and even in small group studies and settings. Although, it is true that in hindsight, we do not really have a clue (?) as to what we may choose to do in the right now, through our freewill/choice, concerning eternity but even so, God knows (!)."

Beloved and friends, we, as human beings created by God, just live out our lives in a state, or in the many states—levels—of brokenness. We live out our lives in a fallen state of existence in essence, individually, and collectively, too. This, until we personally put our trust in God through the Savior, Jesus Christ, as an individual, or collectively even, and wait for the slowly but surely, rebuilding process of our minds and hearts through the work of the Holy Spirit.

However, do know this; God is always at work drawing us close to him so that with everything that is going on in our everyday lives—the good, the bad, and the ugly—we can freely choose to exercise our faith, freely. We can do this without the threat of being a robot suffering under a dictatorship from God. It is because of freewill/choice—which in its *sheer* essence is God's love for us, that we can appreciate this small gift, from God.

Now, through *determinism*, we can also freely exercise this freewill/choice we have, to cry out to God for help, or to curse God and reject his help in any given circumstance, or situation we may find ourselves to exist. Sometimes we are unaware of the inner workings of God and sometimes we are aware of the inner workings of God, but through *his* urging. It is mercy and grace…it is love…it is wooing you and I back to him by his Spirit…it is patience.

Here is a thought or two to place in your mind's pocket for a rainy day…*the green light means go but wait for the red light to change; you never know when the rains will come but it is always nice to carry an umbrella in case they do fall on that day. This is your signal light; this is your umbrella.* Join me in light of my previous rains of thought… It is what God desires from us. It is to be *one* with him.

"Peeples family, listen to me, he desires for us to return this love back to him instead of dictating to us that we have to return this love back to him as a demand; love is not a demand, love is a command, it is a hope *for* someone to exist *from* someone. This in addition, we can truly appreciate as a small gift from God, also. Loving God and his truth as established in Jesus Christ is what the heart of a loving God brings forth in us as Christians, and as we return this love back to him, through the love we give to our brothers and sisters, and the aid we give to the world. The Holy Spirit reminds us of this and the Holy Bible does as well.

"As sheep, our attention spand is short and even *we*, stray away sometimes. We stray away seeking some, *out of reach*, desires and wants. Thank God for his reminders that our way is not always the best way or even good for us, at least not as it stands right now, but possibly as it might stand down the road a little ways, amen. Thank God for his mercy; thank God for his grace. Even when 'serendipity' enters in, it is still a grace-laden image manifesting itself unexpectedly.

"In summary, we all have the freedom to choose and truthfully, we have already chosen, although unaware. Some have chosen to place their faith in the Messiah; Christ and some; well…some have chosen not to put their faith in him and may be destined for *hell* where there will be weeping and gnashing of teeth; anguish; frustration—eternal separation from God.

I will deliver God's message about that at another time. Although we do not know, how our lives will play out on a day-to-day operational standpoint—in the right now—, God knows how it will play out because he is the Alpha and the Omega. He is the End from the Beginning and he knows the end from the beginning. We are simply playing out the roles God has already established in the earth and within us because he already knows our actions, and us.

"I do thank him for his Holy Bible and Holy Spirit to help guide us along the way, though. This is for those sheep who are his children through faith in his Son—Jesus; by this we know we are not alone. He works this very subtly in the lives of non-Christians, also. His Spirit is always working to enter in through the many hearts of God's people so that they can become God's own children adopted and grafted into his family.

"I say that because the same 'Is Love' is for the non-Christians too; they are not alone for God's Spirit is still in this world ready to be received by them, after Jesus ascended to heaven and he is *standing* by ready to receive them jus the same. You see God knows our heart (s)—each one of us as individuals, and collectively also. We cannot hide our hearts from God even in the midst of a crowded room. Sure, we can hide our hearts from the other people there in that same crowded room, but not from our Creator, Jesus Christ—God. As a side note, I must say this too; ignoring and or, rejecting Christ will not stop his return. It just very well may, expedite it instead... It's just a thought?!

"Now time is indeed *catching up* to itself and someday time will have *caught up* with itself altogether; maybe it has; maybe it hasn't. Perhaps it's by God's will and design that I could one day lay all this out in detail through another *truth discussion*; perhaps through the *writing* of another book, *lyrically*, or as a Speaker *speaking* in person even, amen. That is my hope. These are some of my goals, amen. I will keep hope ahead of me and stay active in my faith. In the meantime though, I will be patient and listen to his instructions for my life with relevancy, expectancy and even unexpectedly, both while aware, and even while, unaware...for a time."

Peeples child one:

Excuse me sir, whatever happened to June, where is he?

Peeples child two:

Yeah and does he have any friends or relatives who can vouch for his story!

Peeples child three:

In addition to that, also there is this, what was your part of the Gospel message you preached to the multitudes who sat in the grass that day so long ago while with Matthew and the other disciples, your brothers? What is your take on the Gospel message being distributed in today's times? Please, may we have your honest opinion?

"Well dear ones and the rest of you, beloved Peeples family, time has truly caught up with itself in that regard. I know this small boy, *June*, is still around because I see him every morning as he goes about his day. I am very close to him I mean, I practically experienced him in my own life while growing up.

"You see, every morning he travels past the reflective glass windows that are situated from within, and throughout my own home. He stops there in front of them so that we can talk awhile before he leaves for the remainder of the day. He still offers up the word through his little faith, too!

"He has told me that since growing up and maturing, he really loves ministering the word of God. Aside from that, he says that even though his ministry overwhelms some and others say that his preaching is slightly overbearing, he believes the balance is quite healthy. He has told me many stories of how others equate him to being the 'black eagle' amongst the family of 'bald eagles.' His response to them is this: 'Hey, at least I am an *eagle created by God* nonetheless, and I can still soar with the best of them despite the fog sometimes.'

"He admits to being uniquely different just like the black eagle though, due to its long primary fingers, and yellow hues, to name a few, and the only one in its class (Ictinaetus). Jokingly, he compares them—long primary fingers—to his pointing right index finger, as like the stereotype for prophets or seers. His birthstone of topaz, he jokingly equates it to being the yellow hues the black eagle emits, hahaha!

"He also says that the Lord gave him specific instructions, and that as like it was in the time of my, sometime, in time, U.S.A.R. days. He references it to when some would befriend me just to turn around and leave or shun me for lack of understanding me, so shall it be with him, but in the Lord's Army—sadly, even amongst friendly fire. For these reasons, he has become even stronger in his mission (s) set before him. To that, I say, amen!

"Getting back to his leadership-messenger ministry campaign and whereabouts though, you see they both—overwhelm and overbearing—take root and are truly motivated by his love for others around him (even though some may not see it), and even those beyond him in places he cannot

reach physically. He says God is with him and that it has not become a major problem for him, you know. Knowing that he cannot reach them is not a major problem for him at all because God's Spirit is always with him, and has him covered in that particular area in his life, and even in those out of reach areas, as well; he knows the Spirit of God *does* have reach.

"And so, yes, his *employer* along with his *handler* reminds him, through assurance, that he may not reach the people physically, but spiritually and prayerfully he can reach them instead. To him, he believes both instances are necessary. Oh yeah, I almost forgot to mention, he told me he is thinking of writing a book, too, as well as lyrical songwriting; he is also interested in screenwriting as well as other projects he will address in due season; hmm...can you imagine that!

"I asked him what type of writing he will engage in; what style of writing he will engage us with. He said he goes wherever the Spirit takes him gathering up information for research and storing away Intel from the word of God to present to us sometime in the future. He says that it is enough for now just wait for the blitz attack! Wait for the surprise he says. As far as him, he will just wait for further instruction from his *handler* that which has been handed down from his *employer*. I guess that's fair enough, you know."

Beloved and friends, I too, can relate to Lieumas' reply to the Peeples children concerning June, in a most telling way. Now I am not *rich*, humanly speaking, nor am I a *precious metal*, existing as currency or jewels, even. Over the last *seven* or more years however, spiritually speaking, I spend my days basking in silver. Why is this so? It is so because I rest at night surrounded in sapphire, and I wake up the next morning feeling golden. All of these things thanks to God, Jesus Christ and the Holy Spirit being involved in my life. Also sending me to be involved in other people's lives, as well as presenting other people, before me, too! I have had the pleasure of being sent by the Lord to deliver prophetic/personal and apostolic/dispensational messages to individuals and collective small groups. He has even presented me with opportunities (to which I have accepted and experienced) to instruct/teach in church and classroom settings, as well, and for this, I am grateful to God.

You see, when I spend time alone in communication with God's Holy Word, and in God's Holy word (Bible), occasionally from time to time, I spend my mornings and evenings reflecting on June. You see, I am reminded of that little boy who offered up his little lunch in the message and story to which he has been nicknamed, *June*. His name reveals as such, to get us to become familiar with him on a personal level. In addition, as a character depiction of myself within God's Holy word, I am able to resonate

and empathize with the Holy Scriptures as though I was there, as though I am there, with them all, even right now.

In addition to that, June's little friend in Lieumas' tale, who goes by the name, *Lydnis (July)*...well that, too, is a reminder for me, of my own wife,—flesh of my flesh, bone of my bone, helpmeet, helpmate—as an imaginative character depiction, also, but in the right now realism of today's timeframe. Now she does not appear in the biblical account with June, however, I like to think that she does; I mean this little boy in Matthew's biblical account can represent any gender of us—male or female—you know? For right now however, I will continue following Lieumas' Tale and God's Message, the Collaboration of Their Story in its integrated form.

I will continue using her—July—, along with June's character, as an illustration for this book inner woven within the fabric of God's Holy word, amen. I will continue in this regard because she and I unify as one. It is true we often played outside unsupervised countless times with our neighboring friends and our cousins back then as we roamed about aimlessly playing foolish games, just like this story portrays. However, it was not until later on in our older years and through mutual friends, that she and I began running together in the same circles. We eventually became engaged, and then later, united as one through marriage approved by God, himself.

Now I mentioned that we played outside while unsupervised and it is true. However, in the future, times such as these are threatened. In fact, the times of that threat are in these days; yes, even right now. At least in certain parts of the country it is that way. For children to be caught playing outside unsupervised, is considered wrong by some.

However, aside from that beloved and friends, yes, and she, Lydnis (July in the tale), has been my helper in the faith. She has done this in real life even, (just as depicted in this book), but her name is not Lydnis nor is her nickname *July*. She does this even to this day as my beloved Wife and me, her beloved Husband in Holy Matrimony, a divine, *affaires de coeur* (love affair from the heart), so to speak, which brings me back to that special sack lunch, amen?

Let us talk a little bit about that sack lunch, amen! That little lunch sack with the combination of bread and fish in it was our tiny little faith that we humbly presented to the Lord, and at different periods in time. As we became adults, he multiplied this lunch for us repeatedly through our relationship *with* him and our love *for* him.

Eventually we rededicated together, our lives and our service to him as well as the renewing of our Marriage Vows. Surely, it is tough, you know our ministry tasks at times due to our differing gifts interspersed with our differing, *everything else*, but I can say without any doubt that it

is growing longer as the days grow shorter and by this, I mean our faith, gifts, and our personalities, amen? We actually compliment one another as seen *throughout* our differing gifts, just as it should be for all who are in the body of Christ.

"Now you mentioned my Gospel message and my take on it little Peeples children, and well...the part of my Gospel message preached to the multitudes that day along with my brothers, the disciples; apostles; messengers, while immersed in the Spirit, was presented to you all at the beginning of this book. The story line and the timeless message itself... well, it has continued in many different parts *throughout* this book.

"You see, I remember myself so very long ago through these apostles within the word of God as I read and study it, and when the Lord called me to minister his word and blessed me to walk in it. It was a precursor, and a process, and at the same time, states of progression that had to be made. In other words, just like *they*, he was also gearing and ramping *me* up for what was to become, the Gospel message, for all generations and the distribution thereof; this I would have to learn while idly yet, patiently standing by. In other words, I would have to learn this before fully engaging the multitudes of people on this side of life and currently while immersed in the Spirit. Yes, I would have to become equipped for the task and or, tasks to follow that I was training for, just as my brothers were.

"Now as far as the way the Gospel message presents itself today— through church leadership—, well, let me just say that as I walk on this side of life, I know that for the most part it is not presenting itself in a way that is very pleasing to God. Many so-called ministers of God are compromising the word of God in order to update doctrine and or, make it relevant to today's society. Moreover, because of this they are leading many astray; leading many down a road to destruction. I do not want to be that *person*. The Holy Bible updates itself just fine as it is constantly 'scripturally shape-shifting' in order to meet the complexities of life and to contour to our specific needs accordingly. You see, the truth of God's word taught by his selected leaders in and of, the faith, should be a balance...otherwise, what is left is biased teaching, and really, that wouldn't be fair to anyone.

"Also there is this issue, many of what I find today is to the tune of ministers, and the like, bragging and talking about how much righteousness they have dripping from their head down to their beard and downward to their toes even, without any mention of the One who empowers them to live this way. Let us not forget the One, who sustains us and empowers us to live this way. Let us not forget about the One who reminds us to turn away from where Temptation leads us so that we do not *continuously* slip and fall into Sinful deeds quenching and or, grieving the Holy Spirit guiding our lives.

"Instead, be honest in your human struggles and or, earthly desires, amen. Erase trying to hide them from God and others until you are able to overcome them on your own, come out from hiding, and then speak of your successes as if *you* did it on your own apart from the Holy Spirit aiding you, and all this for sake of embarrassment. Remember leaders, God's judgment begins in his own household first and travels abroad, amen? I'm just saying! On the other side of the spectrum…, be careful about 'bashing' God's people and his children over the head with the word. You see, the idea is not to turn the world on its ear. The idea is to turn it upside down, or rather…right side up!

"Now, I hope to (along with the many others' God is using) continue being a part of this move of God that is in position to remedy this cause for being 'disingenuous' as opposed to being 'genuine' within the church for this age, amen. With genuine truth spoken comes genuine revival reached. Now, I'll continue moving forward in hopes of encouraging you even more as I myself receive encouragement from the Holy Spirit because believe me, it isn't easy all the time being righteous, but necessary nevertheless. I will do this because you, too, are a part of my tale to you, God's message for humanity and the story it represents of all people, both Jew and Gentile alike. It is a story that is *ours* and it has timelessness in its time sensitive appeal, amen. It's true."

Oh, beloved and friends, and even spectators, you did not think this small interlude was all about my wife and I now did you. Of course it is not about *June* and *July* alone, beloved and friends; it never was; it's all about Jesus. We all have seasons we go through in life and in these seasons come some inviting and not so inviting company in the form of *January* through *December*. May I remind you to have your letter opener ready, and to cast your cares?

Remember what Lieumas stated early on in this story and timeless message. He said that we, to include you, are not alone in this world, but that we are all in this thing together, I as well. Yes, throughout many parts of the world and in all cultures both Jew and Gentile—non-Jew—we all have played a small part, if not, major role in the Holy Bible as it was written by God, himself and shifts through time zones via the Holy Spirit making it always relevant for our lives.

Beloved and friends, we also have all played a part in this book that I have written at one time or another, as well. If you have not, then you may be playing a part in it later on as you go about your days here on planet earth. I mean, who has not had an "Andrew" in their life at one point or another? Some of us who are in Christ have indeed presented our small faith to God through the hands of a Minister or Saint—Christians. Of course, for some others, the experience of salvation through Christ was at

the *special, personal,* and *revelatory* hands of God, himself—you know, that special and personal encounter!

You see my point in all of this, is this, and I want you to listen carefully okay. Here it is! You may have been the one sitting in the grass alongside the others that day feeding on the word of God as it distributes to you as depicted in the Gospel of Matthew. You may have experienced it in a park setting somewhere while listening to an evangelist as he preaches the word of God. You may have been at an outside Gospel music ministry venue while feeding on food donated by a local food pantry type of ministry, even.

You may even know someone who might have turned away from Jesus. Perhaps they may have done this because of some sort of a misunderstanding concerning his manner of speaking because of what they may have heard, or read in the Holy Bible itself, or from a preacher of the Gospel even. I will be the first to admit that not all preachers are accurate in their messages although the message and messages within the Holy Bible itself indeed shows poignancy and accuracy. Am I mad at them for preaching? The answer is no, at least the name of God is being preached, and last I checked, he is still in control.

Wait, I am not finished yet! Perhaps this may even be you, or some of your own family members that is a depiction within this book or in the Holy Bible, itself. You may even have been the one who fell ill and as a result, called upon the name of the Lord, Jesus Christ for healing. Perhaps you may have done this for a loved one or your own child perhaps, who may have had a severe fever at some point in their life. Perhaps you found yourself asking Jesus to place his healing hand atop your child's forehead and then his healing power placed within the mind and heart of the child—adult even.

You see, the potential circumstances of these characters, both nonfiction and fiction, portrayed through art, in this book's Tale, bound up in God's Message; a collaborative work of Their Story produced through this integrated piece, do in fact carry with it, a *timeless message* all its own, and in an interesting way, amen? The same revelation goes for God's Holy Book, alone—The Bible—which is the true Authority here, amen! In addition, all characters inside of it are indeed real and without partiality, amen!

Listen, the bottom line regarding the Good News is that Jesus multiplied our faith that special day and we honor God by giving back to him through our own personal Leadership Ministry of, ©Rose Point Ministries SM that he has given to us, and our ministering duties there. We are not perfect but ours is a "mightily" small work in progress, and through it, we strive to help feed the hungry, and clothe those less fortunate, both, spiritually

and physically. Through it, we strive to give to other ministries' and many charities' also.

What timeframe do we have in completing our duties, this I do not know? However, we would love to continue being a part of this awesome move of God until he says otherwise, even so; its fruit will continue lingering on. Our ministry also helps in many other areas as well, as we follow the leading of God our Father, and Jesus Christ, our Lord, and through the power of the Holy Spirit, our Counselor.

You see beloved; dear friends and spectators, the most important thing we do is this: In a *two and two* system, my wife and I, along with our ministry team, as well as business partners and associates, assist each other in spreading the Gospel of peace with God through Christ, our Lord. We are able to partake in this very tedious, but fulfilling ministry deed for God on different planes and by his Spirit on different levels and plateaus. We are able to do this all because of our tiny, yet humble, little faith we placed in the hands of Jesus.

Does opposition stand ready to meet us sometimes? Yes, they are standing ready indeed, even right now as we speak. Nevertheless, by God's grace, we are able to feed on his faithfulness, amen! We are able to trust Jesus as his Spirit leads us in our everyday adventures, and again, on different plateaus, as well. For this, we are all grateful. We are all in awe of God's mercy, grace and righteousness, and we respect his justice, all of which defines as, His Love.

Our faith comes through that which his holy apostles and prophets write and record within the Holy Bible. Imagine that, for you have, or can get your hands on the same Holy Book (Bible) of God, too! As we have sent many copies of God's word to nations beyond the sea and we are looking forward to distributing many more copies there. This Holy Book is the foundation of Truth with Christ Jesus, himself, being the Chief Cornerstone *of* that Foundation—of this *truth.*

Yes, just like the faith of small children who trust their parents to come through in the crunch, no matter what the circumstances may look like, is a special kind of faith to have. The faith of small children, placed in the hands of their parents, is genuine that way because theirs is true, and it comes from the heart—it is not disingenuous. Yes, even when it seems as though the ship is sinking, they trust their parents to save them from drowning underneath the heavy waves and dark watery depths. They trust their parents to keep them from falling from the cliff of that mountain they are all mischievously climbing. Children naturally generate curiosity, but what is most important is that they are able to trust their parents, no matter what.

That is the faith that God, our heavenly Father, wants from us. To know

that even when it seems as though the ship is sinking, or the altitude is thinning out our air supply, Christ Jesus will keep us afloat; he will keep us breathing at safe altitudes. To know that he will do this even while we are (in our own minds stranded) in the middle of the bottomless watery depths in our swimsuits and swim trunks is actually building our faith. Moreover, to know that he will keep us hoisted above the Rocky Mountains in our climbing gear settles our minds and places peace in our hearts as this rebuilds our, faith. Yes, this type of faith is what God is after.

Listen, the storms in life may indeed come for some no doubt about that! The height may advance at times for others, that is for sure; but Jesus will still be there, right through the middle of it, and on top of it, holding our hand and umbrellas, and sharing air supply through his breathing apparatus, with us, as he is Omnipresent, Omnipotent and Omniscient, amen. It is because we feed on his faithfulness, the Fullness of His Faith!

You see for he was the Perfect sacrifice for our imperfection (s). Just like small children to their parents, we too, should trust him as our Father no matter what. That is why he is very fond of little children this way, just as the villager spoke to Tom about early on in chapter VIII, and as his word teaches this. Now that is *Good News!*

"The better news, humanly speaking, and as *love*, not *luck*, would have it, is that you, too, can be that little power couple that the story's characters capture, portrayed by me—Lieumas—, consisting of *June* and *Lydnis; July*, and even the others—in the sense of fictional characters—were, also. Think about it, we all desire to leave behind a legacy of some kind here on planet earth. We all want to leave our *stamp* which implies to others coming after us that we were indeed here for a *brief time*, and that we were placed here to help for a *lifetime*, long after we are gone if some of us even leave at all; by God's grace, some may just stick around until Christ's return. After all Peeples family, we all have a little faith from God to start with and that is why Jesus said the following in, The Gospel According to JOHN 14:1, KJV."

"Let not your heart be troubled: ye believe in God, believe also in me."
KJV

Small voice one of the Peeples family:

Therefore, what you are saying is that we should not put our faith in ourselves just as Satan was trying to get Jesus to do; but instead, we should put our faith in God, but through Jesus Christ? Mr. Ettesorde, you

are saying that Jesus is teaching us this in the desert scene when he was alone with Satan. Is that it, sir?

Small voice two of the Peeples family:

And he is teaching us that all other forms of religion has fallen prey to what Satan was trying to get Jesus to do by putting his faith in himself and or man, apart from placing it in God? Moreover, that's why Jesus is representing humanity as he is the Gate and not us, or other things-nature, idols, other humans, etc.-by which we as a Human Race should enter, into a Right Relationship with God? Also, Satan misleads those other religions in the sense that they place their faith in themselves and or God, apart from faith in God's own Son. And that God is saying that without the Son (Jesus) we cannot have the Father (God himself), that when our faith in whatever we are bowing to has exhausted itself, that his is an open invitation to which we can feed on; we can feed on his faith? Is that also it, as depicted in JOHN 14:1, and pretty much throughout his word, sir?

Small voice three of the Peeples family:

Also in this teaching, the Holy Bible is showing us that in JOHN 14:1, he (God-Jesus) is one in the same, which makes sense in the desert scene where Jesus is alone with Satan being tempted. It makes sense in the fact that Jesus, although he is God, is placing his faith "in" God. In addition, Jesus does this as a Human Being with limitations (by choice) like us. By us following his (Jesus') lead, we as human beings can place our faith in Jesus Christ for salvation. Therefore, we do not have to place it in anything, or anyone else, because Jesus is God!

"All three of you are correct in your assessment of what I have presented to you." "Uh um, excuse me sir, um, Mr. Lieumas is it?" said small voice four of the Spectators family. "Yes small voice four it is as you say; that is my name have you not been paying attention? Perhaps you are, or have been confused. More so, perhaps are you just politely easing into your question such as a 'breaking the ice' moment. It's quite alright, the approach, either way, how may I help you."

"Wow," he says. "That's a beautiful melody; can you explain more of what small voice three is saying? In addition, who is this 'intriguing twin' you have been speaking of throughout, is it Thomas you speak of or someone else! Will he reveal to us and them, of course, all these things because it seems to me; *he* wasn't a *fallen from grace* angel like some of his cohorts, if this was the case, but that *they* were angels *sent from grace* to live and grow

230

up among us, instead?" Well, beloved and friends let us wait and see what Luminous would have us to understand regarding these things.

"Sure small voice four," I said. "I can do that for you and perhaps the rest of you in the Spectator family who may be interested in knowing more. I may have spoken about it throughout my truth discussions in this piece, but even so, I do not mind reiterating or elaborating; thank you for your question. Although, I do have to say that as far as 'twin' is concerned, we will just leave that to the Head of Security. Perhaps in another place and time I may explain more to you, in another venue or other platform, if you will.

"You see, God, through Jesus Christ, is teaching us this way because this is the best possible way to teach us. Why is this so? It is so because of the limitations of our human minds, and that which we can grasp. His *Power* is excessively powerful; too much for us human beings to perceive. Therefore, we relate to things better on a human level first because that is how Jesus designed us, to connect with things *in* this world and of course, other humans *from* this world; again, this is by God's design, not random science.

"We as a people relate to things of that nature this way far better than we could relate to things on a spiritual or supernatural level, which comes second. It also comes off a bit easily and bringing with it, more wisdom after receiving truth in our hearts. In short, God designed us to relate to physical things and socially connect to our fellow human beings, and so, we relate to them because we connect to, and socialize with them as people.

"Such cases in point where society pulls together that we see, are during acts of terrorism and or, natural disasters even. Take for instance in this present year of 2015 in relation to the Paris, France shooting spree of the French magazine, Charlie Hebdo, and what immediately took place regarding the aftermath of this horrific event. Taking place was this amazing wave of outcries online, offline and even on television; it was worldwide. The streets were chanting *'Je suis Charlie'*—'I am Charlie,' in honor and support and even, the opposing of non-free speech.

"Other attacks and disasters over the years were the tsunami in Japan, the earthquake in Haiti, and the Twin Towers (911) collapsing in New York City. This is not all, take for instance also, the movie theater shootings in Colorado, the Columbine shootings as a terrible historical event in the year, 1999, also in Colorado. And one must not forget the Sandy Hook Elementary School shootings which took place in New Town, Connecticut years after Columbine. Even during the Boston marathon bombings, the explosion in West, Texas, both incidents in the year of 2013, we as a people pulled together.

"Let us not forget about the wildfires in California, Arizona and Texas either, or a most recent incident regarding China's massive earthquake, and not to mention Bangladesh regarding the garment factory building collapse a couple of years ago. It is here, in these special and personal cases, we see ourselves reaching out to connect and assist our fellow Man. However, why stop there. We should be reaching out to each other in times of peace also and I believe many are doing just that. This also highlights our deep human love for one another; or at least it should.

"The same can be said of the 'twin hurricane sisters' of New Orleans and Lake Charles Louisiana, Katrina, and Rita (in 2005), and their long lost cousin, 'Super-Storm Sandy' in New York City in the year of 2012, and tornadoes and floods throughout the regions, too, such as in Oklahoma and along the 'tornado alley' stretch. Moreover, it is not limited to our continent alone but throughout all seven continents and the many countries worldwide. In special and personal cases such as these, we find people running toward the threat of imminent danger during these catastrophic events instead of running away from it; you know, in reverse order.

"Sure, at first glance most would immediately run away to safety. Yes, most people would just look on through the lenses of their smart phone cameras without offering aid to potential victims. Such is the case in the year of 2013, in the incident (allegedly) concerning five women who set out to attend a bridal function where the limousine they were passengers in caught fire burning and killing them.

"However, I do not want to lose focus on the positives by over saturating the negatives. I say that because many do migrate inward from the position of aiding and rescuing our fellow human beings in such events while putting their own safety at risk. Take for instance the case in Cleveland in the year of 2013. Here we have a situation where three young women go missing many, many years ago, and a concerned neighbor finally finds and rescues them. Because of that neighbor's concern and getting involved, these three young—now adult women—have been reunited with their family and friends. Sure, we can ask more questions. Likewise, we can give more answers. At least they are free!

"Here is more… When our fellow human beings cry out to each other, and in some cases, God, for help in a crisis, and in sincerity, we as seen from a relational standpoint and connection to them have a sense to want to reach out and help them both, physically and spiritually—through prayer. The actions by which we take are not by luck but by love, by compassion. For instance, take Adam and Eve in the Garden of Eden and before the fall of humanity takes place. Through the deception of Satan, Eve fell victim to Satan's scheme and brought Adam down the rabbit hole with her.

"However, before this happened, they enjoyed peace in the Garden that God provided for them; again, its name was Eden. Humanly speaking, their *luck* ran out in a sense but not God's *love* for them. He—God—took action and *covered them* with animal skins after by which they sewed aprons together to *cover themselves* in the form of fig leaves. Moreover, he took future action in the form of his own Son—yes, even Jesus, the Messiah— the Christ, to cover and ultimately redeem those who are freely willing to choose and surrender to his aid instead of covering themselves, well…themselves.

"You see, Peeples family, before Adam fumbled the ball of life, and before Christ recovered it, Adam had a relationship with God, and God's animals, but in God's heart it wasn't enough—Adam was or would become, lonely—God foreseen this. God saw it appropriate to create another human being to help Adam. God creates Eve from Adam in order for him to relate to her in oneness and connect harmoniously and socially with her. The result would be so that he would not be alone. And like so Mr. and Mrs. Peeples, in our cries of brokenness and loneliness, God saw it appropriate to be incarnated himself, and in the form of Jesus Christ no less, so that we as human beings could someday relate to him in *oneness* (Holy Spirit), and *harmoniously* connect socially (Through Prayer) with him.

"Humanly speaking, in our relation (relating) to and connectivity (connection) with him (Jesus Christ), we view him in his pain and suffering and overall ultimate triumphant reliance upon God. This shined forth as he would do the same with us in our pain and suffering—this after we looked back on it. He shows us and teaches us in his word, but on our human level, in hopes that we would in turn trust him and thus become triumphant on a higher level *in* him as we, ourselves, cry out to God *through* him. Moreover, this would be acted upon so that we would continue to rely upon God and the counsel from the Holy Spirit in this right now, fallen world that we live in but soon, brand new world to which we will come to live in—God foreseen this, too.

"Once we allow ourselves to be open to truth on a *human level* and begin to understand and accept truth in our minds on a *physical level*, we then receive truth in our hearts on a higher *spiritual level*. Therefore the result of more truth will become visible to us more and more as we feed on God and Christ through his Holy Spirit on the inside of us as a 'new creature' in Christ. After all, it is the mind of Christ on the *inside* of us, which allows for understanding of the supernatural spiritual things of God on the *outside* of us. Having the mind of Christ not only means that we are constantly thinking about him but that he *must* be constantly thinking of us, as well.

"We still connect and relate to things and reach out to our fellow human beings (both Christian and non-Christian), but we do so now with a Christ like mindset and new heart from, and of God. We do this using spiritual *analysis* and *discernment* too. Remember that God—Jesus—sends us out as lambs amongst the wolves but we are sent out nonetheless, amen!

"Really, not all of this is difficult to understand but simple instead; so simple a little child and or, children could grasp this truth if we present it to them the correct way. We just have to act on it in terms of giving it to God by receiving his Son, Jesus Christ. It is true, and this is another lesson God is teaching us here in this book: 'FIVE + TWO = PERFECTION, Does Luck Hold The Key To Life Or Does Love Have It?' Again, this premise is based on, The Gospel According to MATTHEW 14:13-21, KJV; I hope that helps."

Now beloved and friends, in getting back to our discussion about presenting our faith to the Lord, let me ask you a question... Do you see the partnership between the Lord and us within this book? Hear me when I tell you that you, too, can take your little sack lunch and present it to Jesus by faith. This is so, because he wants to establish you further in the faith, too! He wants to use your body as a vessel from which he can operate and spread the Gospel to the ends of the earth, too! Now to that I say Halleluiah glory to God, Christ in you the hope of glory! What better stamp, indention, or footprint to leave than that!

It does not matter if you are poor, middle class or rich even, have a beautiful gifted voice for singing, are a musician, have a great mind for thinking and writing, a preacher, teacher, builder, remodel expert, inventor, drama artist, screenwriter, publisher, poet; you are somebody worth God's time. It does not matter if you are a Christian rapper; rapper of differing genres, painter of the arts, sculptor, baker or chef even, pro wrestler, boxer, MMA fighter as well, you are somebody in God's eyes. Perhaps you have the gift of administration, like my wife, the gift of helps, and healing. Maybe you are called into law enforcement and or, as security agents even, Chauffer and or, shuttle service entrepreneur, actors or actresses and models even, or whatever your case of ministry, or non-ministry may be, you are worthy of being a worker for the King of kings and Lord of lords, and all this for his glory.

God can take what you *do* have, and take it to another level in him. He is good at that you know; in fact, he is *perfect* at it. Moreover, because he went to the Father, he will do greater things, through us; we will do greater things because of him in us.

It does not even matter if you are speaking out as a testimony unto the Lord even, etc... He simply wants to use you for whatever purpose he

has called you. "I am not any of those things you just mentioned; where do I fit in?" Great question, God can use you too! I was not any of those things either but he still used this ol' truck driver, by profession and not only asked me, but also, equipped and *empowered* me to communicate his message of truth to you through the writing of this book, Lieumas also, through his tale. You see, because of God's loving grace unto me, I now consider myself to be, not a *truck driver* who writes, but more so, a *writer* who drives a truck, and I accept that now!

Give back to him—God—the passion that he has instilled within you. Give him—Jesus—your little sack lunch and allow him to make it flourish for the sake of all others who may be seeking a personal relationship with God through Christ Jesus—those who are hungry for truth. Allow him— Holy Spirit—the courtesy of using your little sack lunch for the purpose of fishing for those men, women and children who may not be fully aware of God's power in and through Christ Jesus, and the Holy Spirit thereof, and through their Perfect Integration as ONE.

Listen, one night the voice of God said a very interesting and important thing to me. He made known to me that the important element in all of this is his suggestion to "Feed no determination with self will." In other words, the key is putting God first in everything you set out and are determined to do. Ultimately, we do this first by putting our faith in his Son, Jesus Christ. Yes, we feed on his faithfulness. This type of faithfulness dear beloved and friends, brings glory to God because God so adores his Son—Jesus Christ. Moreover, when he looks at us as Christians, he is actually seeing us as his own Son. He sees us as Perfect beings. Now who—in their imperfection— would not want to be a part of that?

What are you releasing to God through faith in the Son of God? The answer is your very life beginning with his Bread, *Jesus Christ*, and his Living Water, *Holy Spirit*. In fact, the Books of MATTHEW, MARK, LUKE and JOHN and well, the Holy Bible as a whole to include all 40 authors, in and of itself, riddles with Jesus explaining to us that he, himself, is the Bread of Life and the Living Water, amen. Please take the time to read about it first, and study it out second. Yes, it starts there, and it will end with God.

Listen, God says to me these words, "If you are afraid of soaring then put your confidence in me (him), flex and stretch your wings and take flight..." How beautiful is that? He wants you to succeed in him, amen! Listen, the time for some of you has not come yet, but it will. For others of you, your time has indeed come, but it will not stop there. Trust me, as a *seer*, I know this all too well, for God is in my ear. The Holy Spirit is in my heart. Jesus Christ is on my mind and the vision of his will for your

life is manifest *right now* before my very eyes. Perhaps your own eyes will experience it too, when the time is right for your heart of course, when time catches up with itself. You will go on to do great things for God, amen! Be encouraged but be patient as well.

Here is one more word of encouragement, amen? God, through his Spirit shows me the good before the bad. He shows me the bad after the good but sometimes it is quite the opposite, it is in reverse order. This keeps me on my toes as I seek him for bold confidence in his promises set forth, through, not only his Spirit, but also set forth in his word. Remember, the first generation prophets and apostles and even the saints had not the completed word before them—the Holy Bible. However, they *did* have the guidance of the Spirit of the Living God nevertheless, amen.

Please do not be fooled into believing that the same God operates differently in and throughout times of today. I mean not everyone has the luxury of obtaining a Holy Bible of his or her own. I say this however, it is my hope that most would; it helps. My wife and our team, through our ministry, as well as I, hope to continue remedying that situation, amen! What I am saying is this: even though many may not have possession of God's word, sincerely seeking his face still activates his mercy and grace. This makes up the difference of not having a Holy Bible in your or their possession.

His Holy Spirit is still in the *Guidance Counselor Business*, amen; did you know that. Even in this moment and right on cue, I hear the letter "Q," and the words *Fresh Air*. I do not know fully of what that may mean, in hindsight though, I will wait upon the Lord for this manifestation to take place. Moreover, I will wait even if it takes a *360-365* degree day turn to come forth. I will wait upon the Lord and no one else because we are compatible. He—God—is my *affinity* type. My faith is in God and God is my faith; therefore, he trusts me to deliver for I was born unexpectedly; I was born abnormally, out of the blue. Again, blue means loyalty, amen.

From the bottom of my heart and on behalf of my wife and team, I ask you this very important question: Will you trust God and receive Jesus Christ into your heart, allowing him to be the Lord of your life? Moreover, from the very center of our hearts we ask you this question as well: Will you continue in your relationship with him in the power of his Holy Spirit. Will you do this as you yield to him and his counsel, and his comfort? It is our hope that you will. It is our Refreshing Hope, indeed.

This may be a bit random however, in the food sense, Team RPM and our faithful co-laborers in the faith are no longer crumbs detached, but a part of the main meal. We have reserved seats at the wedding feast of God. The good news is that you too, are invited to join us.

Now I want to say thank you for taking this journey of physical, spiritual and emotional truth with us for we feel that you (us included) have learned a lot from Lieumas' tale to us, bound up in God's message for humanity in this integrated piece and collaboration of Their Story! We hope to see you personally somewhere down the road, God willing. No doubt, you will indeed see us in our ministry though, as we execute it throughout the ends of the earth, amen, for this special and personal meet and greet, this I am convinced. Remember, even in our darkest *Hour*, there is still sixty *Minutes* worth of Light! Do not miss the Light. Yes! Amen!

"Peeples family, now, the Miracle in the concluding chapter is a metaphor for the God-Man. The Ravens, Buzzards and Vultures symbolize destruction, doom and gloom as we have concluded early on in chapter II. The Dove, however, symbolizes the Peace, Purity and Grace of God through the Holy Spirit. The Falcon represents a swift bird that is *sent*; a trained bird for hunting. The Eagle represents God's Sovereignty and Strength for the Spiritual journey.

"Now, mention was made to you early on in chapter IV of this book that I would remind myself, and that we would indeed find out just what miracle was accomplished by the Sent One. Well may I say to you all that the answer to that has been presented to you all along throughout this presentation, and these writings, overall, this truth discussion? Are you surprised? It is this: Jesus Christ is not a myth; his words to me in 2007, after he breathed on me were, 'Tell them I Am alive!' Eight years later, his breath sustains my courage to speak out loudly on his behalf. He was raised to *Life* even after having experienced *Death*. You see, it was not by *luck* at all, but it was by the grace of God because of his *Love*; it is not the outer beauty that distinguishes us for Man has his own distorted conclusion of that. However, it is the inner beauty that God judges from, for this inner beauty supersedes that of Man's judgment."

Mr. Peeples:

Wait a minute Lieumas, what ever happened to the crowds of people who ate from the five loaves of bread and two fishes that evening? Surely, they are all important as human beings. I mean to say, how did most of them fair after this meeting out in that desert field?

"Well Mr. Peeples, the next day they met up with Jesus. You see, for they were anxiously waiting to speak with him. Instantly Jesus knew that many of them only followed zealously after him because he had fed them

with physical bread and fish earlier the previous day, in other words it was a material substance.

"You see Jesus made it known to them that they were not seeing the miraculous bigger picture in eternity's sake. They were only seeing the temporal for the sake of the, here and now and not the, *right now*, spiritual meaning behind it. Partly, this was because they had known him growing up and his family too; surely, this man was the same man they had known all along? Surely, this man was *not* the same man they had known all along!

"Some of these people even turned away from Jesus as he went on to explain more to them concerning his body and blood used for consumption. Sadly, they did not understand what he was saying. His manner of words offended some of them as well; they turned away.

"Let us see Jesus for, not what he can *do* for us temporarily in this world, but for whom he *is* eternally in this world, and the new world to come. He wants us as a people; as humanity, to believe on the One God has sent. The One he is referring to is he, himself. The way to consume him is to ingest him. The way to ingest him is by faith!"

Beloved and friends, let us also take heed to what Lieumas shared with Mr. Peeples, amen? We too, must not be caught up in the physical aspects of this world either as if *Lady Luck* and or, her alter ego—*Lady Luck in reverse order*—pays a poor soul a visit from time to time. There is indeed a bigger picture in the nomenclature of eternity; love's key to eternal life. That bigger picture, beloved; that nomenclature, my friends, is the Perfection of Jesus Christ! To really live in the "know"—the, "here and now"—, is to know Jesus Christ; to look for things he reveals to you, even right now!

It is not about the physical food sustaining our lives but the spiritual food is what is important for our lives, it is the revelation we are after. Being a beautiful soul on the inside as God's Spirit lives in our heart through this personal relationship with Jesus Christ, as opposed to being vainly beautiful on the outside is the real potential treasure within reach buried deep in the fabric of humanity, even in reverse order. We all have the *same creator* who only wants what is best for us, a relationship with him through obtaining a right relationship with the *same Savior*, the only Savior, his Son. This goes for the poor, the middle class, the rich, the faithful, the faithless, and everywhere else in between.

We have come full circle my dear beloved and friends. It is time for us to enter the exit doorway. Yes, it is time for us to exit the entrance doorway to life!

CHAPTER XV

His Holiness Unrestricted

Temporal is not eternal
Eternal is not temporal
The choice of one
Outlasts the choice of the other.

Man teaches us
To have faith in the temporal
However, it is God who teaches us
To place our faith in, Another!

"Alright listen up you proud Roman soldiers lay the cross down and then get the hammer and the nails will you? Take his right hand, bound it to the right side of the cross, and begin nailing. Now take his left hand, bound it to the left side of the cross, and begin nailing. Take his left and right foot, overlap them, and bound them as well, to the bottom of the cross. Now begin nailing...

"Men, according to Caiaphas, the high priest, and the Jewish leaders of the Sanhedrin, this man walked around on foot using his hands to heal people and he did it unauthorized. He claims that he can rebuild God's Temple in three days, they say. He claims to be the Messiah, a king, *King of the Jews*, they say. He claims to be the, *Son of God*, which according to their Jewish Mosaic Laws is punishable by death, they say. For the reasons noted, we must crucify him, they say. Therefore, men, we as Roman soldiers under Governor Pilate's rule, shall carry it out. This is what *we* say! Moreover men, we have the authority to do so!"

Pause right here for a moment, and just think... Just think for a moment. Before all of this took place, Roman Governor, Pilate, had the authority, opportunity and the option to release Jesus Christ before reluctantly opting to release another prisoner by the name of Barabbas, that day. Giving this turn of event, to me, he even had the audacity to do such a thing! However

giving what I know right now, maybe not so much. Anyway, this personal pardon was due to a special Passover celebration that the governor (s) conducted each year by their custom. Even so, albeit under pressure from the Jews perhaps, Pilate *did* have the final say-so concerning Jesus' death; he put the final nail in the coffin, so to speak. However, did he, really?

Now the Sanhedrin was the ruling body—religious and political governing officials of the Jewish people—but they were still under the ultimate rule of the Roman government. They policed themselves in other cases involving their Jewish communities but when it came to being put to death or in Jesus' case, putting someone to death, namely him (Jesus), they—Jewish Sanhedrin—needed permission from the Roman government in order to carry out this death sentence. This supports my personal opinion that we both—Jews and Gentiles—had a hand in the death of Jesus; for no one class of people can place the blame on the other, even in reverse order. Nevertheless, my views on certain subjects do not end with my opinion. Neither do they start there.

Even so, the question remains as this, "Was Barabbas perhaps lucky that day? Was Jesus perhaps unlucky that day?" In addition to that, the very materials he, himself, used, as a carpenter (wood, nails, and hammer) was the very materials used in his own crucifixion. Some may indeed find this ironic and a bit of a coincidence. However, is it? Was it? Let us continue…

"Put the crown of thorns on his head. Yes men bound his mind. Injure him with the crown of thorns. Let us humiliate, embarrass and disrespect him further for somehow thinking that he is some sort of king or something; King of the Jews, he admits to being. I tell you for this Jesus; it is the only crown he will ever receive. Now lift him up! Men, I need you all to heave-hoe, heave-hoe, and heave-hoe, some more!"

The sky darkens across the whole land as the time, in its sixth hour three times removed from the ninth, is about 12:00 o'clock noontime. The crowd begins to cheer louder at this point. Hours later at about three o'clock as he innocently hangs on the cross betwixt two thieves, he speaks seven last words to include these words spoken by him, whom he asked of his Father:

And about the ninth hour Je'-sus cried with a loud voice, saying, E'-li, E'-li, la'-ma sa-bach'-tha-ni? that is to say, My God, my God, why hast thou forsaken me? —MATTHEW 27:46, KJV

Now then, the question remains as this, "Did he forsake him? Did he leave Jesus to die on that cross all alone because of humanity and their wickedness? Did God forget about Jesus, his own Son, because of your sins and my sins as well?" This we shall find out soon enough!

Again, we have this message of, **"My God, my God, why hast thou forsaken me?"** **KJV**, spoken to his Father in heaven up above who acts as a witness (two) to this heinous, but necessary act from the Jews and Gentiles. Three hours later, he, Jesus, faithfully gives up his spirit. Suddenly! The veil in the Temple, right now tears in two from top to bottom! The earth, right now shakes! The splitting of the rocks, right now occurs! The tombs, right now open! A later point arrives; these words from the Roman brass are spoken...

"Is he dead Roman? Pierce him in his side Roman soldier (5) to make sure he is dead! Now do not worry if his heart is punctured and damaged in the process death is what we want and death is what we shall get!" At this point death seems to have succeeded in conquering Jesus...

Behold, three days later there is a pulse! One heartbeat sounds! Two heartbeats sound! Three heartbeats sound! Over two thousand years has, right now passed and Mr. Lieumas Leumas Ettesorde hears something. His ears notice a strange but yet, familiar silence.

"Wait a minute, I hear a rushing of wind and I hear the sound of horses. I hear the beating of hooves like great horses and the squeaking and squealing of wheels like those of a chariot too, wait perhaps two or more chariots... Are my mind and heart playing tricks on me right now after being trapped in this state of desperation for so long? God I hope not! Please hear my cries and answer me Lord! My soul cries out and longs to be filled!

"For my mind did not resist you a fourth time as I heard your Word knocking at the gray door of my mind, and as the eyes of your word pierced through the peephole of my red heart as I finally opened it up and answered you!... *What just happened? What is happening?* My God, it's happening again!"

16) ...to the effectual working in the measure of every part, maketh increase of the body unto the edifying of itself in love.

17) This I say therefore, and testify in the Lord, that ye henceforth walk not as other Gen'-tiles walk, in the vanity of their mind,

18) Having the understanding darkened, being alienated from the life of God through the ignorance that is in them, because of the blindness of their heart:

19) Who being past feeling have given themselves over unto lasciviousness, to work all uncleanness with greediness.

20) But ye have not so learned Christ;

21) If so be that ye have heard him, and have been taught by him, as the truth is in Je'-sus:

22) That ye put off concerning the former conversation the old man, which is corrupt according to the deceitful lusts;

23) And be renewed in the spirit of your mind;

24) And that ye put on the new man, which after God is created in righteousness and true holiness.

25) Wherefore putting away lying, speak every man truth with his neighbour: for we are members one of another.

26) Be ye angry, and sin not: let not the sun go down upon your wrath:

27) Neither give place to the devil.

28) Let him that stole steal no more: but rather let him labour, working with *his* hands the thing which is good, that he may have to give to him that needeth.

29) Let no corrupt communication proceed out of your mouth, but that which is good to the use of edifying, that it may minister grace unto the hearers.

30) And grieve not the holy Spirit of God, whereby ye are sealed unto the day of redemption.

31) Let all bitterness, and wrath, and anger, and clamour, and evil speaking, be put away from you, with all malice:

32) And be ye kind one to another, tenderhearted, forgiving one another, even as God for Christ's sake hath forgiven you. — **EPHESIANS 4:16-32, KJV**

Twin's Exit Strategy: "My God, some food and water, and rest would sure be wonderful right now! I need to build up my strength to carry on. There are huge black ravens (caw caw), gray and white buzzards and gray and white vultures circling above me and I think I do not have much time left. I thought I was in good enough shape to survive these current conditions on my own, but I now realize that I am not. I feel like giving up and just throwing in the white towel; I feel like waving the white flag of surrender. That would certainly be better than this! I am so tired... I am so weary while I trudge, and my immune system is becoming quite vulnerable.

"I have no more water left in my canteen bottle and I have not any food left in my backpack. My identity is in grave condition and my name is, Despair. My heart is in pain, my mind is restless as the yellow and black hyenas, and the gray wolves too, are beginning to howl. It frightens me to know what may come for me... I wish twin were here. I'm frightened, by what may, become of me..."

"O God, again I cry out to you for help! I cry out by faith this time! If

only you would have mercy on me and send someone to come along and rescue me. If only you would extend your grace toward my direction and send someone to snatch me from the jaws of *death*, itself, after having searched for me day and night because you, in your infinite wisdom, knew that I was lost out here on my own, eeekk! I feel like you are at war with me, God. Perhaps it may be that I am actually, at war with you, even.

"Wait! What is that in the background so far away and yet, so close up? It looks to be a huge black wall cloud hanging there, in the balance, stalking me with its intensely electrifying eyes of lightning. The bottom of it has the remnants of a swirling tail, as like if nephilim or even archangels with an enormous spoon are stirring it like a beverage. This tail like image, and there are many of them, which I witness across the sky, is spiraling downward toward the earth's landscape. Sparks from the stones are ricocheting off each other and the earth, and are projecting from its tails! They are tossing up and raining down causing hail like damage and brushfires all around, like smoke and brimstone or some other catastrophic disastrous thing! Woe is me, for I cannot survive its wrath; lo and behold, it is coming right towards me! My luck just ran out, 'for the love of God,' help."

"Behold my God! At a distance, I see a God-Man. Wait a minute could this be right? His coming is on his white steed and with its bonny physique, pulling behind it a gold chariot with bronze wheels spinning and skipping over the earth like twin tornadoes. He is moving rather swiftly across the desert floor escaping, himself, the jaws of death, itself, and it is not a mirage! It is a miracle! This is amazing!

"Above him, I see *white doves*, black falcons and black and white eagles, chasing the *black ravens*, gray and white buzzards and gray and white vultures away, and then circling back around and encompassing him. The brown horses that he brings along with his winged transparent troops riding atop their backs are frightening the yellow and black hyenas and the gray wolves away, too! Also, and I see with him attached to the right and left sides of his thighs are what seem to be, what looks to be… food and water!

"Yes! LORD, he is coming into focus now, and I can clearly hear the white stallion's hooves beating against the floor of the hot desert sand. Sounding louder and louder and even, louder than before, simultaneously in twin with his own heartbeat, he, upon it, moves closer and closer to me. I can hear it right now!" *Clickety clack-thump thump! Clickety clack-thump thump!! Clickety clack-thump thump!!!*

"Yes, he has found me, and love, new life, liberty and salvation have indeed come for me. He looks like a Knight in white shining armor with four distinct colors in reverse order, from, top to bottom, of sapphire, gold,

silver and bronze that is racing against the backdrop painted the color of night, and all this in order to rescue me? As he leans over the side of his white horse in full gallop towards me ready to give me a brand new identity, even as I gasp, I will wave the white flag of surrender; I will cast the white towel at his feet. I will stand to my feet. Yes, I must stand to my *feet* ready to receive him and his providence. Even so, if I am *unable* to stand due to my weakness, I will surely lift my *hands* to him, instead.

"Indeed, with the food and water that he brings, Faith, Hope and Love integrated with Peace, Strength and Rejuvenation and Rest will become my new names! He even has a chestnut brown horse and a gold chariot for me too! He even has a third and fourth horse along with their chariots; perhaps there are others who are *still lost* out here somewhere in the dry desert and needs rescuing besides me?

"His eyes are like fiery red laser beams perfectly fixed upon me as he reaches for me with his outstretched arms. He has a rainbow colored name badge affixed to his righteous white robe! For the life of me, I cannot seem to make out what it says though; is he friend or is he foe? Am I right, or could I have been wrong all this time! Will this be the *death* of me or the new sustaining *life* of me? Wait, his silhouette is in full view now! I think it reads... Yes, I can see it right now! Oh gracious me! Despair I am, no more! It reads like this, King of kings and Lord of lords, Faithful and True. It reads, JESUS CHRIST!"

So you see beloved and friends, it does not matter what continent out of the seven continents you call your dwelling place in the world. It does not matter in what, average of about 250, countries or so you are living in within the world. It doesn't even matter what states, or cities within those states, or towns within the cities, or villages within the towns, or neighborhoods within those villages you find yourself in, it doesn't matter where you call home...4000 block far off, 5000 block near to, Christ Jesus is the Savior of all people; especially to those Peeples who believe.

In conclusion of this tale; message; story, I am reminded of this: I remember a time long ago when I was asked the question of: "Did Jesus Christ die for the whole world or just for some people in the world?" In all fairness to the person who asked the question, I consulted the Lord before giving my answer. It did not take long before God responded. It did not take long at all. The answer was twofold with the second fold contouring to, and privy to me, only, just for right now. Here in lies the first fold:

In a message from the Lord and as the heavenly skies opened, through the power of the Holy Spirit, I seen what looked to be the world globe spinning on its axis (representing a progression of time). Suddenly! I saw what looked to be blood spewing from the inside of the globe outward

(representing death and burial) unto the globe and thus covering it (representing the whole world). You see, God's love is so rich that it bleeds into everything. *I see the symbolism of the death and burial but where does the resurrection of Jesus Christ come into play?* Great question, anonymous, and well what remains is this…if in fact Jesus was not alive then how could his message to me manifest shortly after my inquiring directly of him on behalf of the person who sincerely sought an answer concerning the well-being of humanity.

God did in fact send his one and only Son, not to condemn the world, but to save the whole world (people) for it is already condemned. However, here in lies the crucial crux of the gray matter. It is those of us (people) within the whole world who chooses, through the red muscle, to believe in him (Jesus Christ) that have experienced, are experiencing, and will experience salvation from God—both, Jew and Gentile—since the world has been judged already (we are just fulfilling our roles). The Jew and the Gentile are both created by God and both make up Humanity as two types of a one created group—two distinct groups (Divergence). However, God wants the *two* to become *one* in him; *one* in Christ Jesus; a *new type* and *Creation* of people belonging to *one* group (Convergence).

Listen, one of the great gifts out of his many gifts God has given us is the capacity to *think*… May we use this gift, not sparingly, but wisely instead? May we go from the possibilities of wondering (?) to the possibilities of ideas (!) in terms of "wondering?" You know what I mean right, like when the "light bulb" *aha* moment takes shape above your head after thinking deep and then digging deeper resulting in a eureka moment or perhaps, a voila inception! Yeah, it's kind of like that.

You see it is important that you come to understand that in this life of chess it's always somebody's move… We have to patiently "process" things as they are put before us instead of impatiently jumping to conclusions, which, if not processed carefully, may lead us as well as others around us, to harm. This may include, even our loved ones.

Did Lieumas have an original name like Peter, Paul or perhaps some of the others in the Holy Bible? If so what was his name from the beginning if you do not mind me asking? Do you even have an answer for that, sir? In addition, I noticed that he did not give detail to his last name when explaining the whole of his name to Mr. and Mrs. Peeples very early on. Why is that, if you do not mind me asking, sir?

Just at that moment, another biblical character steps out of the shadows with a riddle… *"Uh-hm… Wherever I am so shall is he, for God, a listener*

of thee, hears him. What be'ist thou his name?" he says and then quietly slips away into the shadows from whence he came. Excuse me, beloved; excuse me, friends; I give you, Judge Samson, with all due respect…thank you, sir, for visiting with us, unexpectedly, and many of us shall see you soon.

Yes, I would certainly like to answer you and in so doing please know this; Mr. Lieumas Leumas Ettesorde answered that very question for some members of the entire Peeples family, and spectators too, before he was mysteriously carried off again to, God knows where! Before departing though he asked if need be, and if I would like to, I could pass it on to you as well, my beloved and friends, for he foreseen your inquisitions concerning the derivative of his full name.

He claims that some even say he travels in the territory of borderline narcissism because of his *so called*—in their own mind as he puts it—Gnosticism of his genuine character, and for this some have turned away, but he knows better for God has taught him different; God has taught him better. Therefore, with that being said; he humbly left it up to me to explain. Now keep in mind that it is twofold.

You see, before he was to become, *Someone who replaces another*, before he was a, *Lion of many faces*…let us just say that from the beginning he was, *Heard by God*. Moreover, he was rooted in his love like a *Precious flower* in the earth. His, I Am Love, made Lieumas' own love grow you know.

It caused him to develop a genuine love of, not only people but nature as well. It caused Lieumas' love to dig deeper and deeper past the soil into the roots of his own mind and heart. He developed a passion unlike he had ever known before for God's *people*, for *us*, for *humanity*, for *nature*, even within *himself*, for his *twin*. Yes, from the beginning that was his name, which is the first fold.

Now it is time for the second fold. The last portion of his last name, Ettesorde, "sorde," being that second portion, derives from the Middle English word, *Sorde*, from *Sorden*. It means to rise up in flight. Moreover, it comes from the Old French, *Sordre*, and from the Latin, *Surgere*, to rise.

In short, it depicts the Mallard duck or flocks thereof, that rises up into the skies and soars; that rises to the occasion, in other words. Just imagine if there were two of him, perhaps a softer version, you know; kind of like a missionary to his apostleship, perhaps in reverse order. They would be like etherical twin beings whose wings could not be clipped; one having wings of wind and the other, wings of fire, for their wings would not be clipped!

Better yet, imagine if there were *300* of him… I know from my own interpretation of him over the last few decades of special cases involving

studying him and even, getting to know him personally, he is one of the most "down to earth" Ministers of God I know. I wish there were more ministers like that. I even told him that before. His reply, "Thank you, in my humble opinion, perhaps it is God's way of bringing, 'heaven on earth' to the forefront once more; for it truly is a perpetual, lost and found, art form."

He once told me that many believe his writing and preaching methods, and even his actions thereof are in many ways, "pushing the envelope." As I looked him deep in his eyes after he slightly lowered his shades, I found myself lost, but then found, as I saw the seriousness of his eyes looking back at me. He said to me these words: "But it is the contents within the envelope I AM pushes." I then asked him of the contents within the epistle he speaks. He ended with these words: "The King is coming the King is coming. Hear ye all peoples of the world the King is coming! The King is coming!! The King is coming!!!"

...Somewhere in three popular States situated in the United States of America, one being in the state of California, the other being in the state of New York and lastly, the other being in the state of New Mexico, the month of the year is January, a new season, and the day of the week is Friday. We have since narrowed it down to three major cities within these United States. One of the three is the city of Los Angeles, the other being, New York City, and lastly, the other being the city of Albuquerque.

Here we have a young teenage woman who is a retail store clerk by day and a baby sitter by night. She sits in her closed room right in front of her open window staring up at the sky and daydreaming. She is off from work that morning and she will be off from work that afternoon, and evening as well, and so she thinks it would be nice to just relax a little from the stressful workweek she had just endured.

She pours herself a cup of freshly brewed coffee and unwinds by feeding her mind through the reading of a soft cover book. She is also an aspiring songwriter and songstress but finds it somewhat difficult to transfer her talent and giftedness onto paper, record them in studio for her would be audience, and perform her dream on stage for the masses. She is the opposite of being shy and is quite popular among her peers, but she is also reluctant to pursue her dream.

Across the country, we have a young teenage man who is a "clean-up man" for studio sets. He too, is off from work that day and is enjoying some alone time with his family. After spending valuable time with them, he looks forward to making up lost time for himself and God through the reading of his favorite hard cover book.

This man is a devout religious person and seeks God everyday through prayer. He also thinks of becoming a worker in front the scene someday

instead of behind it, and feels he has picked up quite a few knowledge bullet points concerning the field of film and directing. However, in the back of his mind he knows it probably will never happen and thanks God for the job he does have, already. Still, he desires the opportunity in his heart but is fearful in his mind, of the outcome.

Yet again midway across the country, we have a married couple who share responsibilities in the farm and ranch business. The wife and husband are winding down for the evening after a strenuous day at the ranch. They put the twins down after a nice warm bath and hot supper, for a quiet night's rest and peaceful sleeps, and unwind themselves through the reading of a bedtime story.

Afterwards, the wife nestles in the corner of the room of their log cabin home and begins to read her own book, a romance novel. The husband on the other hand, sits in his chair next to her and begins reading a book of his own. He has always wanted to build a church house on their large acreage of land for the neighboring villages, towns, and surrounding cities to meet. He cannot seem to shake this desire and his wife cannot seem to shake the thought of it either, as it has been with him since he was of young age but still, he is scared to fall into debt.

Now the times for each of them on this Friday in the new season of January are about 1:00 o'clock in the evening in the city of Los Angeles, 4:00 o'clock in the evening in New York City and 2:00 o'clock in the evening in the city of Albuquerque. The year status for their perspective regions is A.D. (after the death of Christ). Suddenly, all three of them being hundreds and thousands of miles apart and not knowing one another—even in the world of social media—simultaneously hear a slight distorted voice and a bold knock...

The verse they had been reading that faithful day from within their special and personal books were from, The Book of REVELATION 3:20, KJV. It was found in the Holy Bible where Jesus is speaking. It reads:

"Behold, I stand at the door, and knock: if any man hear my voice, and open the door, I will come in to him, and will sup with him, and he with me." —KJV

...it only shifts the dynamics, just a little. Checkmate!

(Ω) The End.